The art treasures of Europe

The art treasures of Europe

Charles Wentinck

Simon and Schuster
New York

N 750
6 W44

Contents:

Introduction

The writing of a history of art within a brief compass is a difficult task; based not so much – as in the sketch – on the fascination of the moment as on the endurance of hours. Perhaps it would therefore be better to compare a history like this one with a small-format reproduction, instead of with a sketch. A sketch usually precedes the monumental work; in this case the monumental work is available in many forms in beautiful bindings and standards editions. This book brings nothing but a reflection of what has already been performed; it is a summary of what has been learned elsewhere, formulated with a succinctness which tries to make a virtue of existing necessity.

Every reduction, however, is based on choice, and this might contain the justification for a history of art in short compass. It is the same sort of choice that faces the writer of a sketch. He leaves out what does not seem to him pre-eminently essential, and puts the accents where in his opinion they weigh heaviest. However impersonal a history of art is – as a reproduction in small format – it becomes personal as a sketch, which indicates more than it fulfils.

This quality, too, is accompanied by its shortcomings; in the opinion of some, a certain period will have been given too much, a certain figure too little attention. In this case, however, a writer will achieve most by a haughty indifference. If one resents that he unreservedly admits to his dislike of Raphael and devotes to a minor master like Coorte, a line which was denied an illustrious master, it will be quite immaterial to him. The work of art never speaks alone, it carries on a dialogue, every time anew, with each generation. In a dialogue there are always two parties concerned; the present writer may therefore perhaps be excused for occasionally having betrayed his own standpoint. He has tried to move within the bounds of the recommended discipline; given his disregard for discipline in general, however, – and for its pernicious results in particular – he has only moderately succeeded in the execution of his intenion.

Charles Wentinck

Prehistory

Prehistoric Painting

Baron Sautuola, who headed the first exploration in 1868 to the cave of Altamira (near Santillana del Mer, Spain), went again in 1879. This time accompanied by his twelve year old daughter.

It was she who looked up and spotted the colorful paintings that her father had missed 11 years before.

At first the authenticity of the paintings was in question, but in 1902 it was recognized that these paintings were the work of Stone Age artists. Ever since, one discovery has followed another in both the north of Spain and the south of France; adding an unexpected chapter to the history of art.

This period was described as the "Franco-cantabrian".

It was not confined only to this area. In 1931 discoveries of cave paintings were made in Scandinavia. In 1936 discoveries were scientifically researched in Russia. At about the same time small human figures were found in the Balkans, and in Czechoslovakia, Hungary and Russia. Also the art from the so-called Hallstatt-time – located in the Austrian Salzkammergut and dating from the Iron Age and part of the Bronze Age – and art of the Celts entered the historical consciousness of humanity.

These discoveries – and others – like the Lepenski-Vir in Yugoslavia still continue.

Every discovery throwing new light on the generally accepted civilizations; history being made to be discussed. History's beginning receding further into the past. The oldest and bestknown artworks are those of the Stone Age, female figures, commonly described as Venuses. They represent goddesses of earth and fertility, accordingly the body and the genitals are over-emphasized as a sign of fertility.

The last *Palaeolithic* period – between 25,000 and 10,000 years before Christ – where the Venus figures originated, is also called the *Magdalenian period* – named after the cave of La Madeleine in the Dordogne area of France. This period with its cold and dry cli-

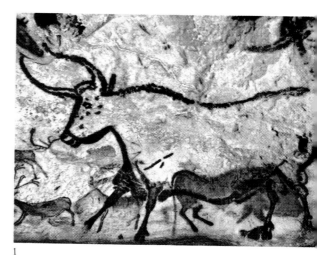

1

1. *Lascaux*
Bull and Cattle
Rock-face painting
15000 - 10000 BC

2. *Lascaux*
Wounded Bison, Man and Rhinoceros
Rock-face painting
15000 - 10000 BC

2

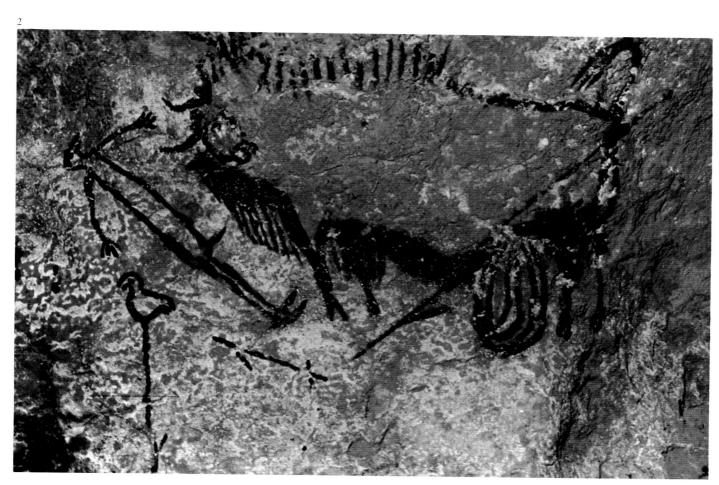

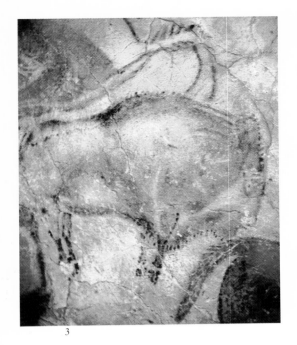

3

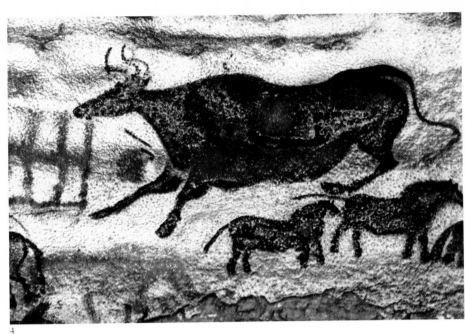

4

3. *Altamira*
Standing Bison
Rock-face painting
Ca 13500 BC

4. *Lascaux*
Cow and small Horses
Rock-face painting
15000 - 10000 BC

5. Venus of Willendorf
Ca 21000 BC
Limestone
Naturhistorisches Museum, Vienna

5

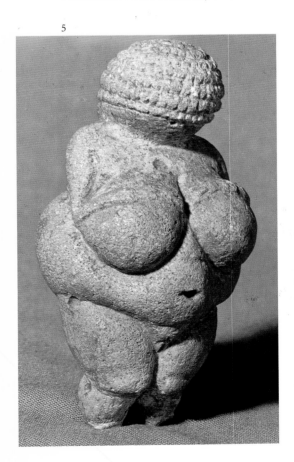

mate, forced the people to look for protection in the caves and mountain holes, thus reviving the art of painting. On the walls of the caves appeared portraits of animals, painted with simple brushes or applied with the fingers. The idea of these paintings is not just decorative, but a part of a magical ritual in which a connection was underlined between what was on the wall, in the painting and the solemnizing of reality.

Altamira

Scratched drawings and paintings (based on imitating reality) were concentrated in the caves of South-West France and Northern Spain.
The so-called *Altamira* consists of paintings of animals: bison, deer and wild boars. These representations are not only painted, but are also in relief form. Natural vaultings in the walls of the caves, projections and so on

are ingeniously used. The colors are applied with earth paints – light and dark ochre, black manganese, earth and iron oxide.
The impression is overwhelming. These paintings close the gap of thousands of years, between the art of that era and the present, to almost nothing; not only from the freshness of the paintings, but from the form of expression that can be compared with art expression today.

Lascaux

The cave of *Lascaux*, which was discovered in 1940, has at its leading theme paintings of animals.
From all the caves found with prehistoric paintings, this is the richest, for the artwork, approx. 20,000 years old, is as fresh as ever today.
In the cave are pictures of the rhinoceros, the bison, the deer, as well as the cow and a small kind of horse.

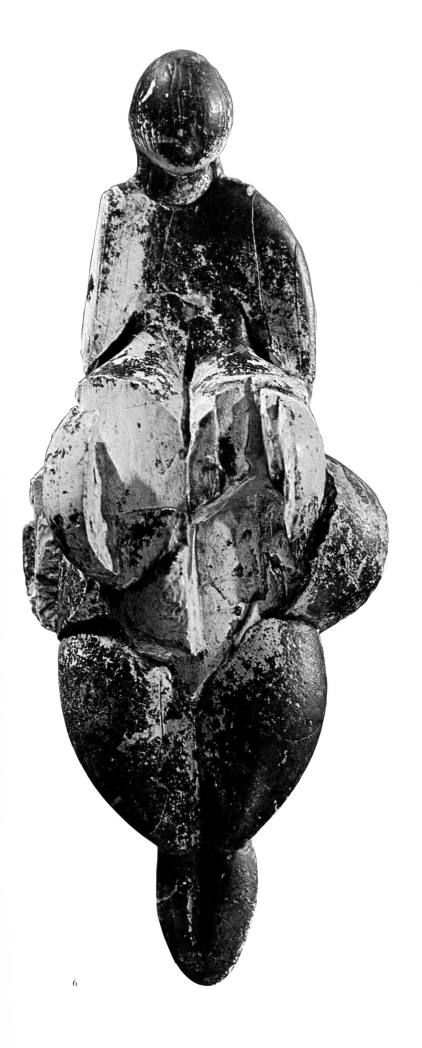

6. Venus of Lespugue
Ca 20000 BC
Ivory
Musée de l'Homme, Paris

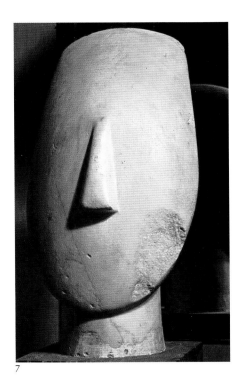

7

7. *Cycladic*
Head of Amorgos
2600-2100 BC
Marble
Louvre, Paris

Reindeer and bulls appear on different walls. In spite of a clear imitation of reality there are distortions that intensify the expression.

Prehistoric Sculpture

We have a tendency when talking of prehistoric art to think especially of painting.

In spite of a few already mentioned idols, the sculpture from the Stone Age period remained less known than the painting.

Nevertheless, there were, in the area of Lascaux, near Les Eyzies in the French Dordogne, reliefs found which were not accepted as sculpture, but should be called sculpture. The bison personated there dates back to approx. 21,000 years before Christ.

The horse of the Montespan cave in the Haute-Garonne is from approximately the same time.

Earlier there was talk of a drawing

11

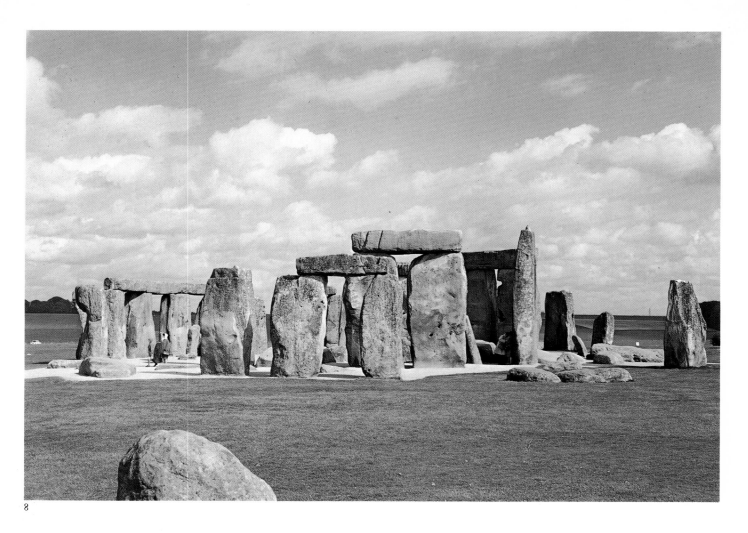

8

8. Stonehenge
Megalithic Sanctuary
First half 2nd millennium BC

rather than of three-dimensional art-work; it was different from the bison of the Tuc d'Adoubert cave in the French Ariège. This was modelled in clay, but cracked when it dried: the model, in spite of its fragility, has only kept because deposits of stalami-tical material were in its structure – the limestone deposits that create stalactites.

Primitive Figure of Venus

The earlier mentioned female figures date from the same period – around 21,000 years before Christ – as the standing bison from Les Eyzies. These Venus figures were character-ized by their large buttocks and were carved in stone, kneaded from earth or carved from ivory. The most famous being those at *Lespugue* and *Willendorf*, impressive for expres-sionistic accentuating of the forms.

From the Pyrenees to Siberia, in Northern Italy and in the middle of Europe, sculptors appeared – show-ing a clear technique as well as an artistic tradition – plastic art, usually made from one model with small vari-ations, corpulent women with enor-mous pelvises and genitals, massive

bosoms and hips. No individual trait is perceptible. The prehistoric sculp-tor paid no attention to the face, concentrating only on body.

The limbs were also ignored, al-though part of the body. No time was given to proportions.

This conception continued until the *Neolithicum* era and after. Even in the Bronze Age, for example, the art form closely resembled prehistoric art. Figures discovered in Anatolia and dating from 6,000 years before Christ, clearly showed fertility sym-bols, with the usual exaggerations of body form.

Also the idols of the *Cyclades* – naked female figures – closely resembled the form of a violin; the lower part of the body being well rounded with the head as the cylinder. An evocation in the most elementary form of the fe-male figure.

Nevertheless a change in sculpture art had been introduced – in relation to the prehistoric figures – that could be considered a breaking away from the traditional. Not only the harmonized modelling of the Cycla-dian sculpture, with a sense of pro-portions, characterized this change-

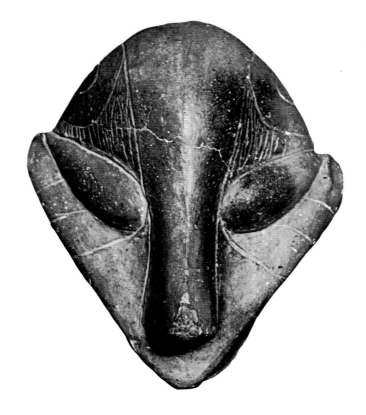

10

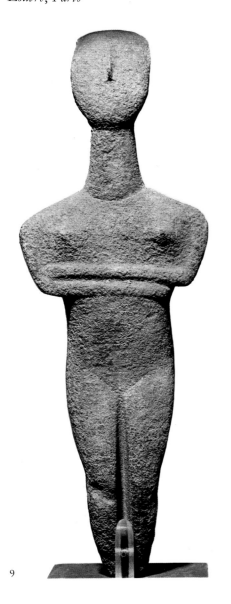

9

over period; it was this tendency towards the abstract which helped start a new era in world art history.

The person being no longer dependent on the powers of the earth, on fertility and motherhood. He accepted these latencies and gave them a shape – like the idols of the Cyclades – but this creative power was dominated to idealizing the form.

The lands of the Mediterranean, especially the areas defined by art style, have been subjected to many influences. Long before the Greeks and Phoenicians asserted themselves, there arose conquerors along the coasts who, while plundering and robbing, helped in the development of culture.

For a long time the influence came from the east, but from the moment the Romans conquered the Carthaginians (in 202 BC) and subsequently Spain, the Greek influence vanished from the Western Mediterranean. Until then the cultural pattern had been defined by the religion and life style from the east. An example of this is bull worship, started in prehistoric times, transmitted to the Iberian peninsula and surviving today in the form of bull fighting.

Sardinian Bronzes

Malta still has monuments from the Bronze Age; the style of work strongly influenced by Crete and Mycenae. *Sardinia* is especially rich in archeological finds; bronzes discovered here date back to the first half of the millenium preceeding our era, and are made by the "lost-wax" method.
This technique makes every bronze unique and of great value.
Often because of the expressiveness of the small figures. There is a certain similarity between these and the figures of the Iberian peninsula. The art of the Phoenicians has a clear resemblance to the art of Sardinia mainly due to the commercial relationships the Phoenicians established with the nations around the Mediterranean.
One only has to place a Sardinian bowman alongside an Iberian bronze to see that the differences are more in the method of construction than in the style. The Iberian bronzes were mass produced, but this is only part of the explanation.

The Art of the Hunters

The animal figure, as well as the female figure, appears in the art of the

13

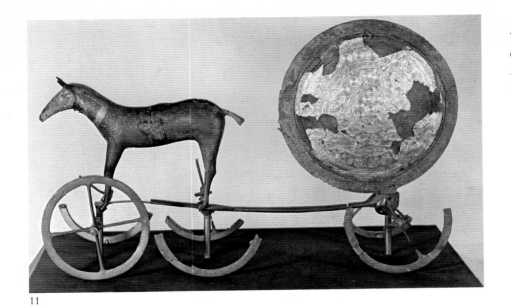

11

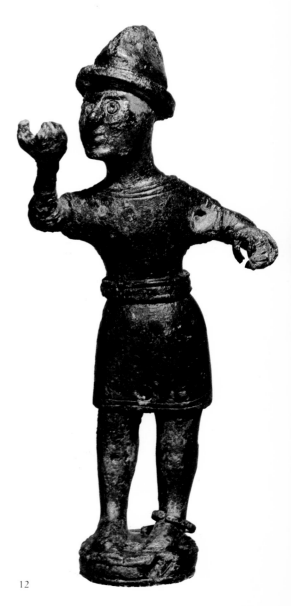

Stone Age. The art was not created purely for aesthetic pleasure, but for its magical properties. The prehistoric hunters thought that the animals they hunted were protected by supernatural powers.

The best examples of animal figures come from South West Europe – the area of the cave paintings mentioned earlier. Weapons and tools were decorated with animal figures.

The wild horse being more favored as a subject here than in the cave paintings or sculptures.

The horse found in *Les Espélugues* is an outstanding example of realism – it gives an impression of listening to a distant sound, waiting with outstretched neck for something to happen. It is clear that this art comes from observing life – a typical hunter's art.

The Route of the Early Culture

The Neolithic – the late Stone Age – shows the different levels of culture. The testator for all was the area around the Mediterranean. The Danube played an important part by spreading northwards the art and culture of the Eastern Mediterranean. Along this road Central Europe was reached; another route led to the Iberian peninsula, and from there north into Western France, and the British Isles.

During the Bronze Age the influence continued along this route to Scandinavia, which was still adjusting from the Ice Age. The delayed adjustment from the Ice Age resulted in forms of Stone Age work remaining longer in Scandinavia than anywhere else.

The paintings discovered on cave walls in Northern Europe differ from those of South West Europe. It is true to say that they belong to a later era – the Neolithic – but the time difference caused by the delayed development of this part of the world is not the only definition. Similar to aboriginal paintings they represent scenes from the lives of fishermen and hunters in late Stone Age Scandinavia.

A good example of cultural penetration via the movements of the Danube are the idols founds by Strelice in Moravia. The type of women of the Palaeolithic Venus idols are influenced by pre-classical Mediterranean forms. Czechoslovakia was also influenced (again via the flow of the Danube from the Mediterranean) as seen in the findings near Pristina of figures with dramatic expressions – the accentuated eyes being a new tendency.

14

12

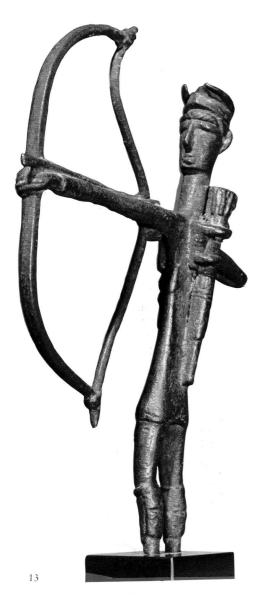

13. *Sardinia*
Archer
7th-5th century BC
Bronze
British Museum, London

In France more than 6,000 graves from the late Stone Age have been discovered. More than half of these in Brittany. The relics where place and manifestation are indicated with *Menhirs* – upright monoliths – dating from the beginning of the third millennium before Christ. Enormous pieces of stone set up in the form of a horse-shoe give the impression of the power of the divinities worshipped.

For about thirty centuries or more, the naturalism of the cave wall paintings appeared to part the high Palaeolithic era from the Neolithic era (around 7,500 years BC).

Then people appeared who built enormous monuments on flat ground like Stonehenge (England) – which is one of the oldest and most impressive – and those in Brittany. The magic stone circles prove that the society had reached a more organized form. Most probably the stones were placed in those forms for sun worship – not for the worship of the living or dead – thus representing a temple or a sundial of an enormous size.

The Trundholm Wagons

During the Bronze and early Iron Age (after 3,000 years BC) the horse and cart (four-wheeled version first) was introduced in different parts of Europe.
The famous Trundholm wagon has had of course its point of contact with other carriages. Here we mean the symbolical wagon, in the cosmogonical sense; it symbolizes phenomenons in the universe. The horse is seen as a mythological animal aiding the resurrection of the sun. This sun consists of two convex parts, joined together by a ring. Gold-leaf covers both halves. This piece is dated about the 14th century before Christ.

The Hallstatt Culture

During the last thousand years BC there was a continuous movement from Central and Northern Europe to the south. The Hallstatt people conquered Greece, Northern Italy and North East Spain.
They experienced the creative influence of Southern Europe; north of the Alps was hardly touched by this. A form of ornamental art – industrial art, arts and crafts – prospered. The area north of the Alps is not Teutonic or Celtic in origin – but was established by a tribe which got its name from the habitat of Hallstatt in Austria, namely Illyrica; the power of which lasted for only a short period. Obviously it is a vanished race which has been replaced by other people. The charasteristic of the Hallstatt culture is the connecting element between North and South.
Especially towards the end of the Hallstatt era, the commerce between North and South Europe was intensive; with the Greek colony Massilia (the present Marseille) running a systematic business.
The imitation of the Greek examples led to a considerable increase in trade in North and Central Europe. In the handling of bronze the Hallstatt citizen yielded no more to the South.

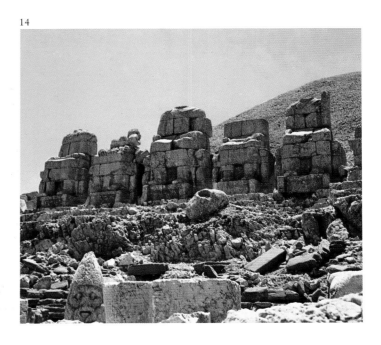

14. *Anatolia*
Sepulchral Sanctuary of Antiochus I
at Nimrud-Dagh
1st century BC

The Birth of Europe

The Birth of the West

Europe was born in and with *Greece*. That civilization which originated in *Athens* differed from its predecessors: took none of them as its example: and founded what can only be called Western civilization. The spirit of Europe, Western spirit, can be considered as primarily a Greek discovery.

What distinguished the Greek world – and let us hope, ours – from the Old World was the supremacy of intellect in all human activities: that supremacy originated in *Hellas* and took root there. In a world where the irrational had reigned supreme, the Greeks became the protagonnists of Intellect.

Most of our present views about the value of man and the human spirit date from the Greeks, apart from the influence of "Old Testament" Judaism which prohibited the representation of the human form and therefore can hardly be said to have produced figurative art.

The world in which Greece came into being was a world in which reason had played a minor role, only the unseen was of importance.

For a brief period there was, in Hellas, a meeting between East and West. The rational character of the West met the spiritual legacy of the East and its great creative activity came from the conjunction of mental clarity and deep emotionalism. With the coming of the Greeks came the birth of the world as we know it.

Of course the Greeks had not been totally uninfluenced by the Old World. There had been contact with the Egyptians, if not directly, then certainly through *Crete*. It is safe to assume that the Greeks during their early period took examples from the Egyptian culture. Though just how important that contact was, is questionable.

The aristocratic world of archaic Greece could not have produced any other style than that of stately representation: that of formality.

Mycenaean and Minoan Naturalism

In *late-Mycenaean* art opposing tendencies are noticeable.

On one hand a naturalistic view remains, continuing the Cretan tradition, on the other a new idea of form is seen, characterized by a sense of order and simplicity, and particularly by a tendency to the abstract.

That the Cretans were no Greeks is clear from their art. The Greeks looked for the ideal form, had a strong sense of order, and – certainly in the beginning of their culture – the study of nature was of minor importance. The *Minoan* artists were clearly inspired by nature, and were very aware of visible reality, which did not necessarily lead to mindless imitation.

Egyptian Death Wish, the Greek Love of Life

There is a notable distance between Minoan naturalism in art and Greek

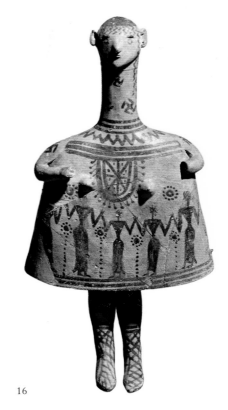

16

16. *Boeotia*
Female Figure
8th century BC
Terra-cotta
Louvre, Paris

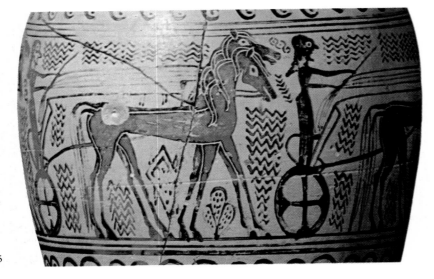

15. *Attica*
Analatos painter (?)
Chariots and Drivers
Early 7th century BC
Louvre, Paris

art, but even the most hierarchical, archaic sculpture of the Greeks shows traits which make it very different from the Egyptian style. Even from archaic Greek sculptures it is possible to discern human personality. The nature of man was formed by the Greeks from an organic experience. Egyptian sculpture was not organic but completely abstract: the rigidness of expression, the timeless conciousness, the belief, not in the present life but in the hereafter.

Even at its best Egyptian sculpture has the solidness of stone, its construction is strictly frontal, strictly symmetrical. The Greek statue is freed from its support, breaks through the formality, is dissolved in organic, natural movement. A slight, natural turn is imparted to the posture.

Behind the difference in form, lies a difference in attitude to society, towards life and death.

The Egyptian statue represents a political order in which the individual is completely subordinated to an authoritarian state and a religion with terrifying godheads and a mighty priestly caste.

The Greek statue springs from the joy of a prosperous life, from considering each moment to be precious and experiencing the meaning and value of freedom. To judge Greek sculpture purely on its sensual beauty is to make a superficial judgement.

In contrast to the Egyptian style it places the highest regard on human freedom. The Egyptian statue represents a Being controlled by external laws, resigned to a power which baffles him. He is beyond time, directed only to death – and eternity.

Paradoxically this view of the Empire of Death as the significant destination of human existence, made it possible for the Egyptians to accept life and all its contradictions.

When the Greek statue, in the archaic period, freed itself from the Egyptian rigidity, it was more than a formal procedure, it was the escape from externally enforced laws.

Instead comes an order springing from within and accepted in freedom. With the Greeks, for the first time in history, a fountain head of free humanity enters the world.

Geometrical Styling and Archaic Restraint

The decline of the Mycenaean world coincides with the invasion by the *Doric tribes* who settled in the various Mycenaean centres.

The art that appeared, especially the vase paintings, was geometrical and at first without any representationalism. However, early in the 7th century BC representation creeps in, still in its archaic formal style; as shown by a vase, decorated with chariots and

17. Mycenae
The Lion Gate
Ca 1250 BC

18. Geometric
Mare suckling her Foal
750-700 BC
Bronze
National Museum, Athens

17

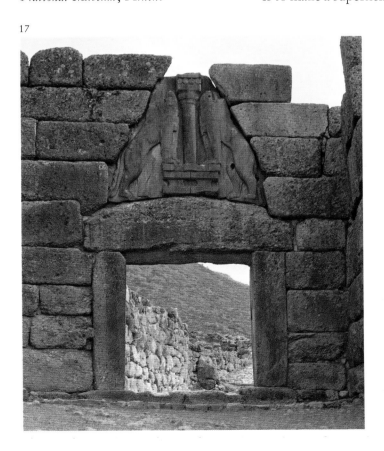

18

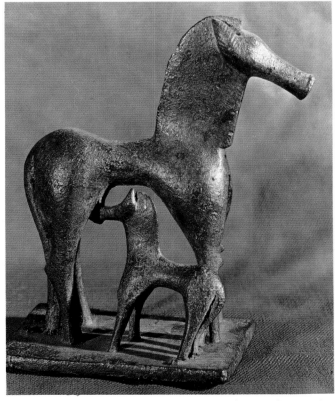

drivers and accredited to the painter *Analatos*.

From the Mycenaean period only the *Lion Gate* remains, and there is little evidence of monumental sculpture during the early Doric period. There are still quantities of small bronze and terracotta figurines.

Of the small bronzes the *mare suckling her foal*, from the second part of the 8th century, is a typical example. Most of the little horse bronzes of that time have short cylindrical bodies, almost cylindrical heads, long legs and well developed fore- and hindquarters. The human figures which begin to appear around that period, such as the small bronze *Apollo from Boston*, are also characterized by a strong geometrical styling. The face is triangular, the neck long and cylindrical, the body angular, supported on well developed thighs.

During the course of the 7th century BC monumental sculpture began. It was still characterized by the same geometric form that characterized the small bronzes.

But in spite of that the geometric era was in sight. Greek society was on the move, with new historic, economic and social perspectives. The time was characterized by feverish activity and by a creative urge both in the old and new areas of the Greek world, the progressiveness of which is striking even now. The Greek people stood on the threshold then of a grandiose development and clearly passed that threshold towards the end of the 6th century. A time in which Greek activity spreads out over a number of areas of human activities, a time in which art shows a series of new developments – one could say: make new discoveries – which later systematically raised classical Greece to unknown heights. Many factors have contributed to the creative spirit of the Greeks.

In the first place their strong geographic expansion with which internal social and economic difficulties were conquered. Further the contacts with the old civilizations of the Near East, which strongly multiplied and created in Greece itself a market for foreign technical refinement, for new modes in many fields, for new colors and new ornamentation. And finally travel is generated and in the Greek towns opened up the prospect of new trade possibilities, new ways of life and, simultaneously for the Greek artists, the prospect of new expressions.

The human figures, the main theme of Greek art, even the gods had human forms, had at the beginning of the 5th century, two main subjects: the *Kouros* a naked figure of a boy, and the *Kore* the draped figure of a girl.

The archaic restraint persisted but it was no longer rigidly formal. Anatomy began to play a more important part as more mobility was imparted to the poses.

Human experience became more important than the geometrical abstract concept, and bronze took its place alongside marble as a sculptural material.

19

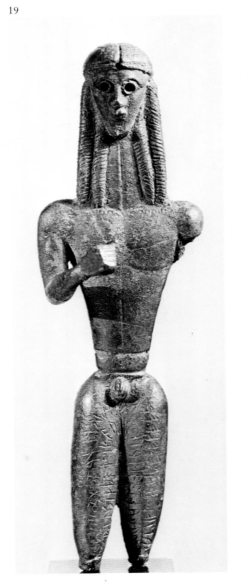

20

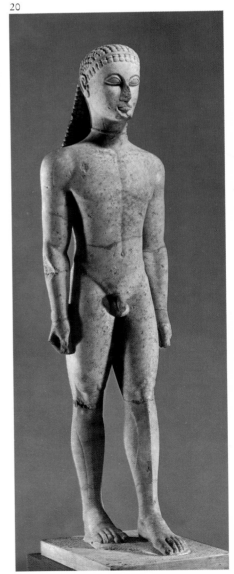

19. Greek
Apollo Figure
Early 7th century BC
Bronze
Museum of Fine Arts, Boston

20. Archaic
Figure of a Young Man (Apollo)
615 - 600 BC
Marble
Metropolitan Museum, New York

18

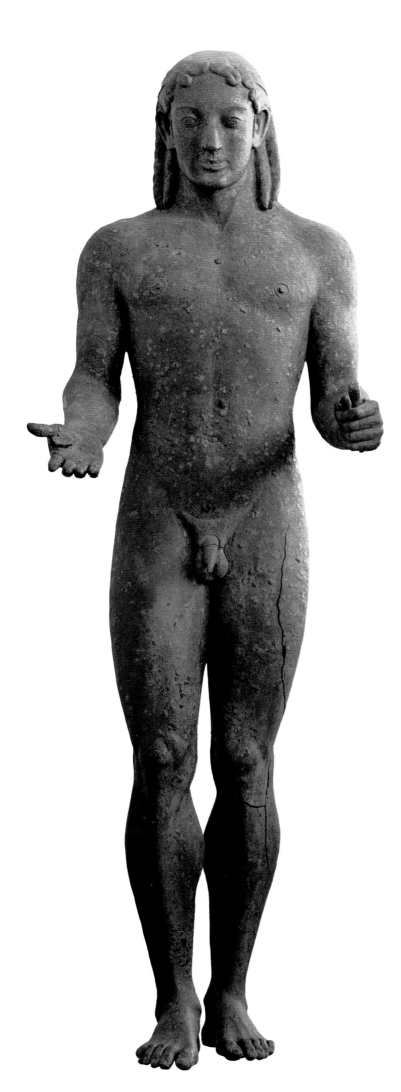

21. *Archaic*
Kouros of Piraeus
Ca 500 BC
Bronze
National Museum, Athens

22. *Rhodos*
A running Man and floral Motives
Ca 540 BC
Amphora from Kamiros
British Museum, London

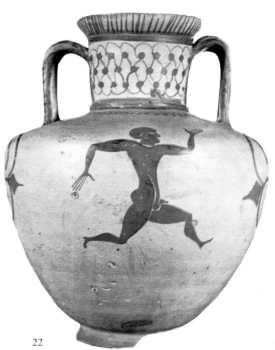

21

22

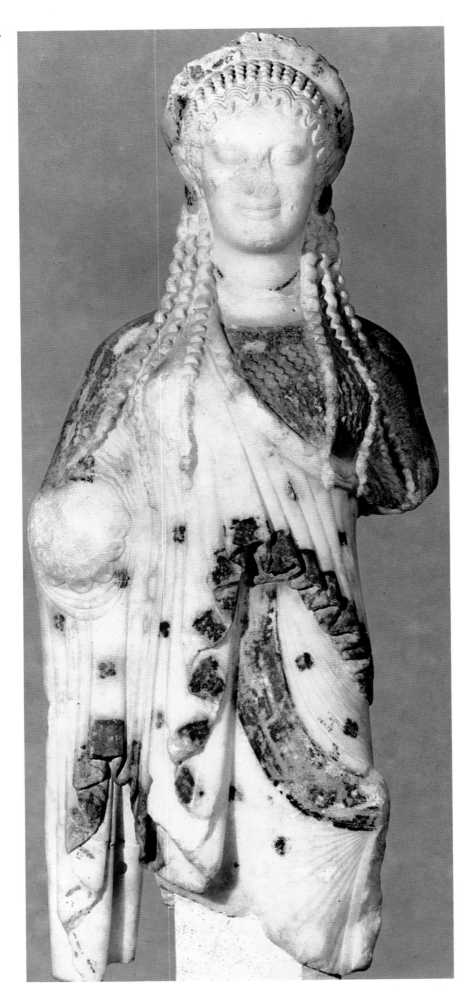

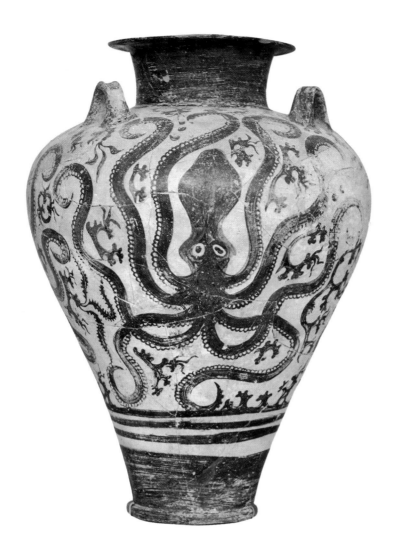

24

The discovery of bronze casting had a tremendous influence on the development of Greek sculpture.

The Non-Painting Art of the Greek Art of Painting

The Greek art of painting has manifested itself in two ways: as vase painting with figures, since the 7th century and as painting as we know it now, since the 5th century. Of the second style we know little although recent discoveries at *Paestum* have provided some knowledge. The only art form that gives any continuous impression of Greek painting is ceramics.

The painted vases are practically the only source of information about an art form, the rest is only conjecture. It is still true that the ceramic and painting art have at no other time been so closely related as in ancient Greece.

The use of the term "painting" is a confusing generalization. Painting as we know it today has only really existed since Renaissance Italy and the Venetian school.

Before that period painting took the classical form of the plastical contour, which could not in any way be called "malerisch" like the Venetian "school of Bellini". What the Greek vases show us – whether they are from *Exekias*, the *Arkesilas* master, or from the *Achilles* painter – is the classical, plastical contour. In Athens, in the 9th century BC, representation of man had already penetrated the world of vase decoration, which in previous centuries had only known geometric abstraction. At first it was very stylized without any personal expression or any indication of the living form.

The human being was reduced to a sort of cubist form with no suggestion that the body could have a third dimension. Such figures could be fitted completely into the geometric decoration, and the pictures were only about death. It seemed that the human figure had entered Greek painting as a kind of written sign, in modern terms, as a logo, and not for its own sake. However, the way for it was paved and the development was irresistibly started. Greece saw its myths and legends as a valued part of

their cultural inheritance. Singers contributed their part to make the works of Homer popular. In the 8th century the change was complete: vases for various household use were painted with complete scenes. The theme of death is abandoned; the vase announces the Greek's interest in themselves; the pictures develop the theme of the siege of Troy or the wanderings of Odysseus.

Animals appear, first the horse and the dog, later – under the influence of the international contacts already mentioned, the sphinx, as well as hunted animals. The artists do not seem to be interested in the plastic form.

The expression remains strictly two dimensional, to which Oriental influences – from Syria, Anatolia, Phoenicia, – contributed their parts.

Only towards the end, when Hellinism falls into decay, did linear drawing make way for a kind of "clair-obscur" and the artists strive for spatial depth. With that the fate of Greek painting art was sealed. It made way for the Romans.

21

25. Exekias
Dionysus in his Boat
Ca 535 BC
Dish from Vulci, Etruria
Museum Antiker Kleinkunst, Munich

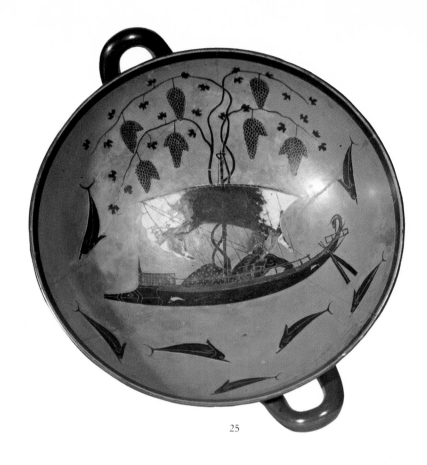

25

26. Classic
Caryatid
417-409 BC
Marble
Erechtheion, Athens

26

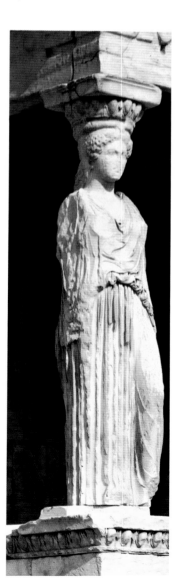

But before the Romans developed came the *Etruscans*.

In common with the Greeks, Etruscan art has a strong linear element and elegant controlled line.

Movement in Bronze

During the 5th century bronze was favored more and more by sculptors and the use of stone declined.

The main reason was the greater freedom and the subtlety of form that could be achieved in bronze.

This is particularly noticeable in anatomical detail, the figures become more and more lifelike. As modelling skills gained more control over the nuances of form, so the statues assumed more individuality in pose and facial expression. The only loss, though perhaps a major one, was the tension that had previously characterized Greek sculpture.

Gradually there was a break with the formality of the archaic sculpture. Movement is more accentuated, and with this change in structure comes a change in expression.

The smiling archaic face makes way for an expression of introspection which declines into the rather neutral charm seen in the *Apollo Sauroktonos*

Etruscan Art

In many respects Etruscan culture is still an unsolved puzzle.

Where did the Etruscans come from? If we can believe Herodotus – a Greek historian of the 5th century BC – then they came over seas from Lydia. But about four centuries later Dionysius of Halicarnassus claims – the Etruscan culture had already been absorbed definitely and completely by Roman culture – that the Etruscans formed an autochthon population. Anyhow, the definite answer has still not been found. In artistic affairs they derived much from the Near East and from the Greeks. However, they created a very original visual culture in which their religious ideas were reflected. Their relentless preoccupation with the hereafter inspired fantastic heterogeneity, from Oriental sources. For example the bronze Chimera (found near Arezzo, now in the Archeological Museum in Florence), an exotic monster with the body of a lion, not in itself the product of irrational imagination, but it is allied to a second goat's head and a tail which is a serpent. However, this bronze was not meant to provoke amusement. A related irrational ima-

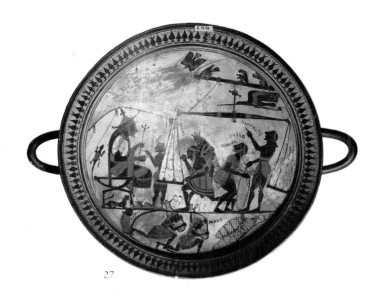

27

gination occurs in Etruscan decoration, not just of vases but also of tombs. But in the Etruscan soul there is another pole: e feeling for reality and for living creatures. In contradiction with their strange imagination is their representation of animals, which is the most accurate and the most natural of that age. Horses, birds and fishes appear in a wide variety of well observed natural movements. The line can be traced to the famous 5th century bronze she-wolf of Rome. Full-uddered – made well visible by the refined position of the paws – must be considered a masterpiece of Etruscan sculpture.

The peak of Etruscan culture occurred in Italy between the 8th and 6th century BC. The Etruscan civilization reached Capua in the south and Bologna and the Alps in the north. Its decline started during the 5th century, and by 280 BC had lost its independence to Rome.

This process had started in 396 with the capture of the Etruscan town *Veji* by the Roman Camilius.

From then on the Etruscan world was absorbed into that of Rome.

Until the 6th century Rome had been an Etrurian town ruled by Etruscan kings. When the Romans finally

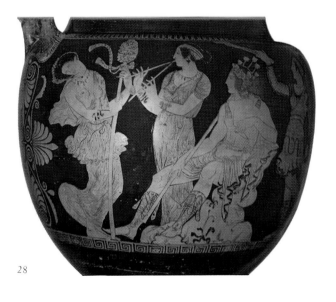

28

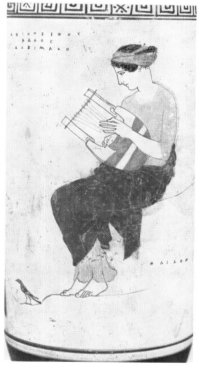

29

23

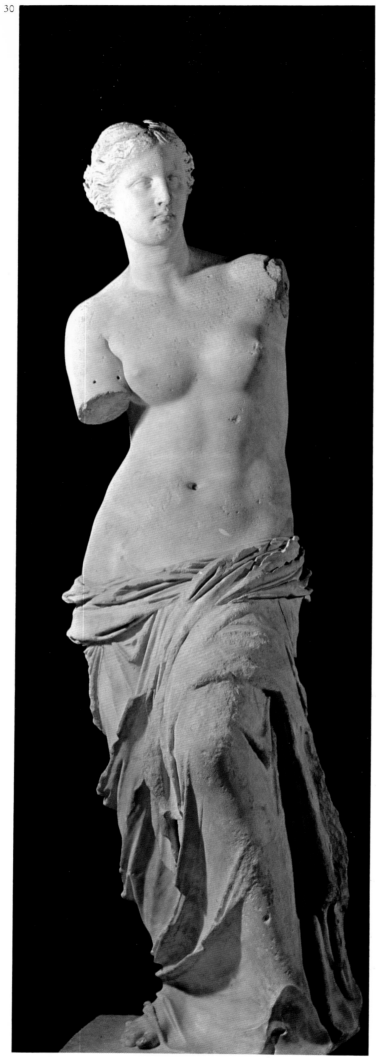

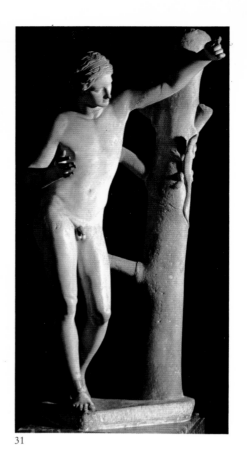

31. After Praxiteles
Apollo Sauroktonos
Ca 350 BC
Bronze
Louvre, Paris

30. Hellenistic
Aphrodite of Melos, *Known as Venus de Milo*
2nd or 1st century BC
Marble
Louvre, Paris

32. *Etruscan*
The Cithara Player
Ca 470 BC
Wall painting from the Tomb of
Triclinic
Museo Nazionale, Tarquinia

conquered the Etruscans, most of the towns were mercilessly robbed of their works of art, especially the bronze and stone statues, which were used to embellish the public and private buildings of Rome.

In Etruscan art there is a provable Hellenic influence.
Etruria formed the western border of the Hellenic empire that reached eastwards to *Cyprus, Lycia, Lydia* and *Phrygia:* and northwards to *Macedonia* and *Thrace*. All these regions absorbed Hellenic culture and, incidentally, contributed to its birth.
For Etruria this involvement with Greece was so strong that Etruscan art, from the beginning of its archaic period to the late-Hellenic period, reflects the various development phases of Greek art.
It is not surprising therefore, that the question has arisen – how far, and in what way can we talk of Etruscan art? Some authorities are of the opinion that outside of the Greek influence, Etruscan art offers nothing of importance. They even deny that there was ever any artistic originality in Etruria. Certainly the Etruscans missed the characteristically Hellenic feeling for freedom, which was coupled with a creativity that extended to all areas of life.
The vigorous creative urge of the Greeks, caused a break with the old world surrounding them; with them a new chapter in the history of art started.
This cannot be said of the Etruscans. Originally their art did not distinguish itself from the "oikoumene" of which they were part.
Comparisons arise between eastern artifacts and the bronzes of Sardinia and Luristan, and Cretan, Mycenaean and archaic works of art.

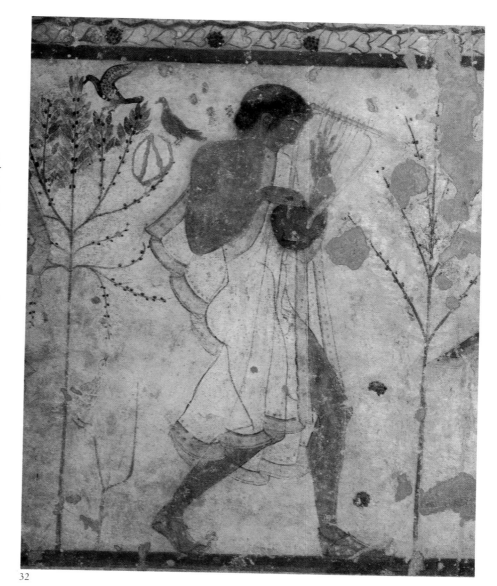

32

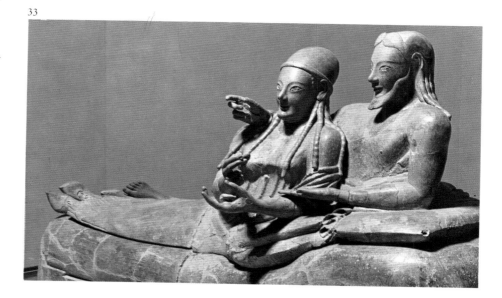

33

33. *Etruscan*
Husband and Wife
Late 6th century BC
Terra-cotta of the sarcophagus from
Cervetri
Museo Nazionale di Villa Giulia, Rome

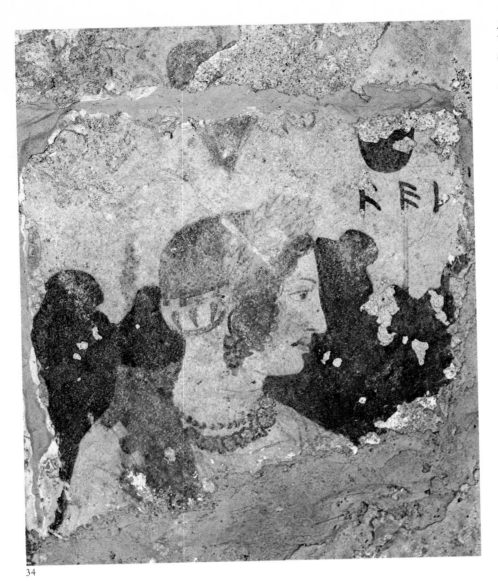

34. *Etruscan*
Velia, Wife of Arnth Velcha
Ca 400 BC
Wall painting
Tomb of Orcus, Tarquinia

35. *Etruscan*
Bath Scene
Ca 520
Wall painting from the Tomb of
Hunting and Fishing
Museo Nazionale, Tarquinia

34

35

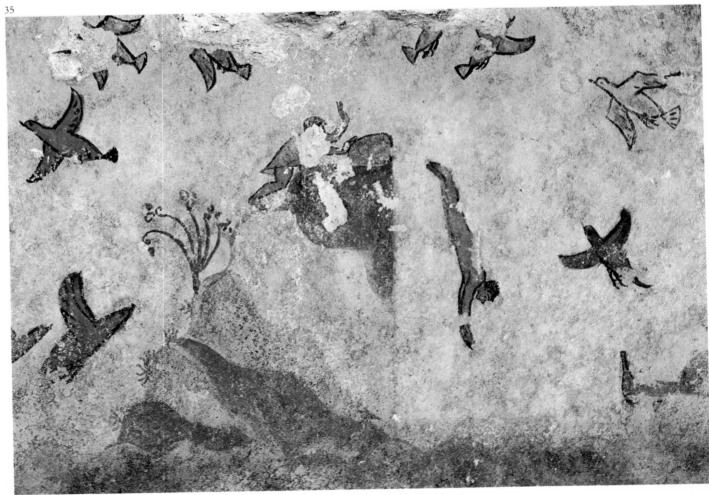

26

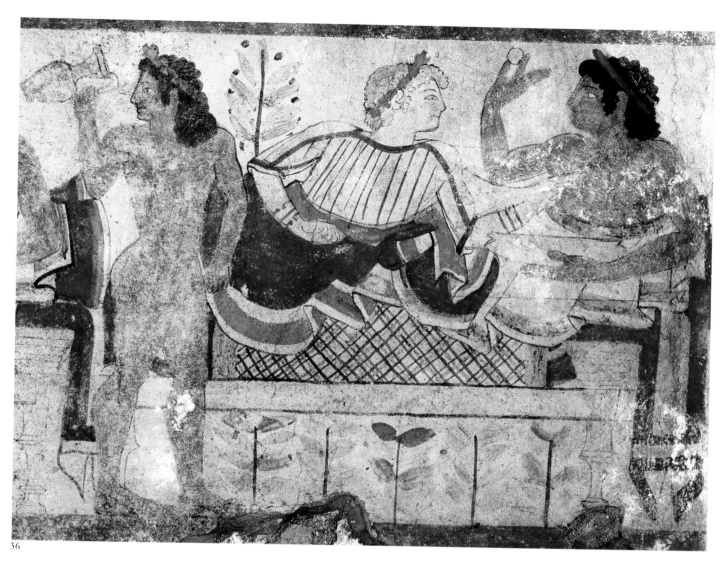

36

36. *Etruscan*
Banquet Scene
Ca 460 BC
Wall painting from the Tomb of the
Leopards
Museo Nazionale, Tarquinia

The Greek Influence on Etruscan Art

Later in the 6th and 5th centuries BC, when Etruscan art had assumed its enormous proportions, it bears all the hallmarks of Hellenic art. Who can prove whether the highly appreciated frescos and friezes of the tombs in *Tarquinia*, the dancing ephebe, the head of *Velia* and the drinking, music making and dancing figures, were not made by a Greek painter from Cumae, Capua or Naples, commissioned by a rich Tarquinian merchant?

The large, free-standing statues bear no comparison with Greek creations. Their most noble masterpieces are, with few exceptions, small and often of insignificant size.
The few important objects which have been preserved are enough to get a good impression of Etruscan sculpture, a good example of which is the married couple on the sarcophagus from *Cervetri*.
Such work is also enough to confirm the peculiarity of Etruscan art: one could search Greece in vain for a comparable work.

Though the forms are Greek, the Etruscan purpose was not.
The feeling for life of both peoples differed too greatly.
One culture was orientated too much on life, the other too aware of death.

Prolonging the Present

At the same time the Etruscan death-orientation did not lead to the neglect of earthly things. In fact, the opposite seems to have been true – the joy of here and now is continued in the there and later.

For the aristocratic Etruscans the grave was equipped as a house in which the dead resided.
Consequently furniture, ornaments and idols were placed in the grave with the body.
The frescos in the graves show the joy to be had in life.
A luxurious, almost voluptuous life, with banquets, dancing and music.

Between the years 530 and 500 Etruscan painters were mainly inspired by the *Ionian* vases: from 500 to 470, the

27

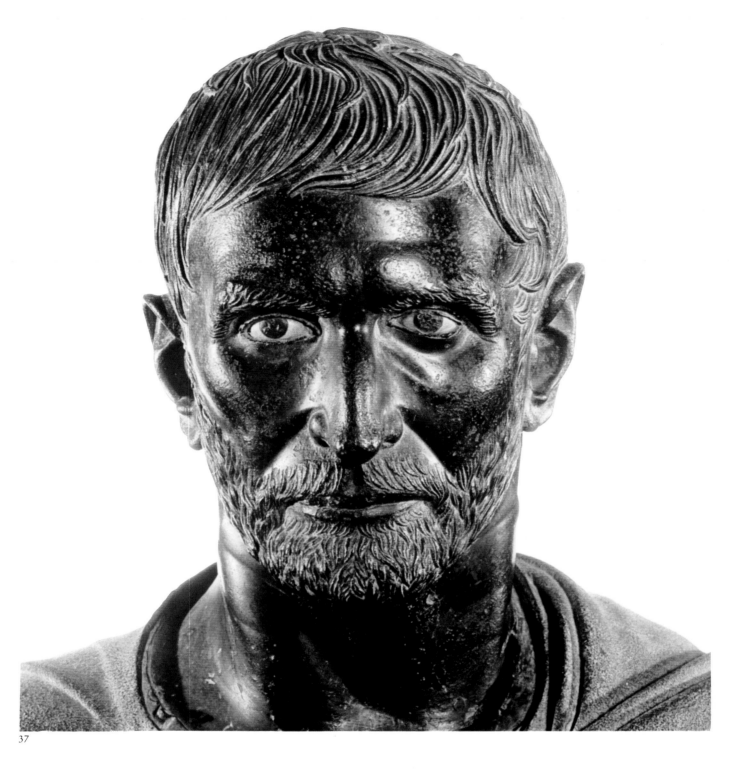

37

37. *Roman*
Head of a Roman
3rd century BC
Bronze
Palazzo dei Conservatori, Rome

red-figured Attic vases were the example for a new technique and a richer palette.

It is striking just how important a part nature plays in Etruscan art.

With few exceptions nature was never of great importance in Greek art. With the Etruscans it was often a primary subject.

More emphasis was placed on liveliness and mobility in the figures. In some of the tomb paintings there is a sharp feeling for individuality, the fleeting moment, and outspoken dynamic expression. There is little of Greek idealism in the style, but a lot

of real joy, liveliness and sensual pleasure.

Probably that latent everyday sensuality of the Etruscans made them look for the individual and special, in contradiction to the Greeks, who tried to represent the general truth, the absolute in their art.

That individuality was already visible in the faces of the early Etruscan grave figures, on canopies and urns. The highly individualistic representation of the dead developed slowly: they are portrayed on urns, sitting or lying, and at the banquets of the immortals.

38

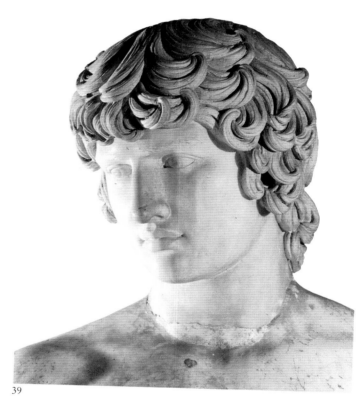

39

Etruscan Emotion

This individuality goes further than the temple figures and the statues of the gods. Even in the period of the archaic smile, Etruscan heads are more individual and lively. They have more human presence than the idealized Greek statues. It is a question of almost intangible nuance, it seems possible to "feel" their heart-beat and know their sentiments.

Even apart from that, Etruscan art displays more dynamism, emotion and ecstasy: in short, the striking domination of Dionysian components' Here is the fierceness of the two great themes – love and death.
They obviously occupied an important position in Etruscan life. It was not by accident that the only figure that the Etruscans added to the Greek world of gods was Lasa, a female counterpart of Eros.

Friendship, melancholy, love, mortal fear, mourning, irony, expectation, resignation, desire, playfulness, bliss. The scale of feelings that is expressed in Etruscan art is different from and probably richer than in Greek art.

29

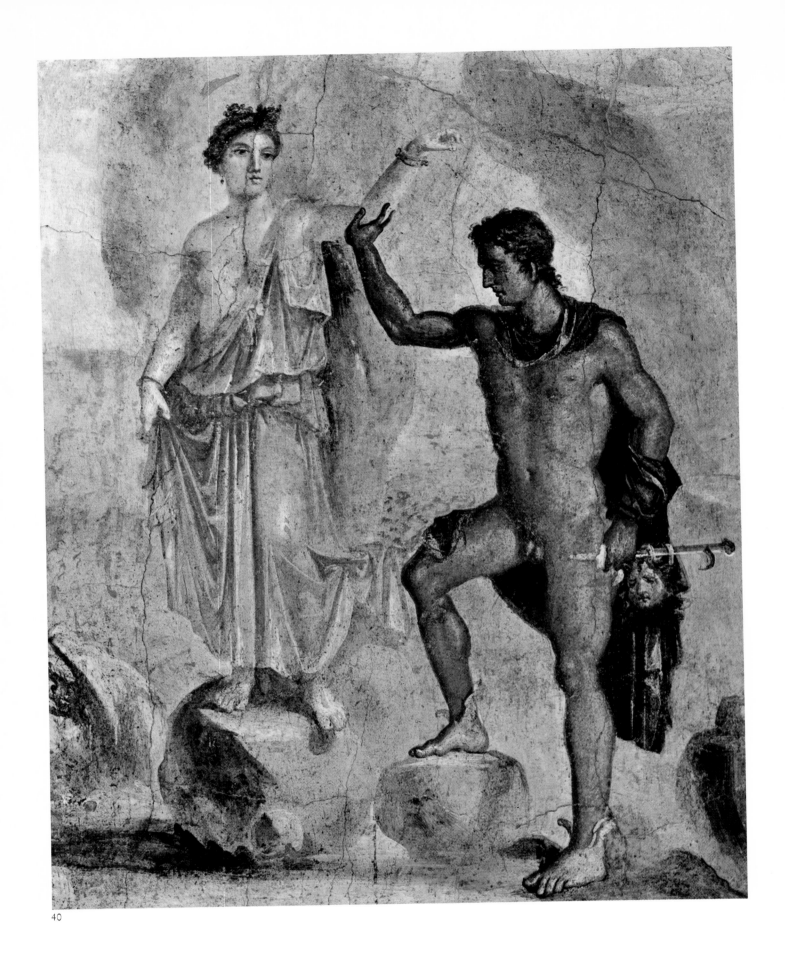

40

40. *Pompeii*
Perseus and Andromeda
65-70 AD
*Wall painting from the House of the
Dioscuri*
Museo Nazionale, Naples

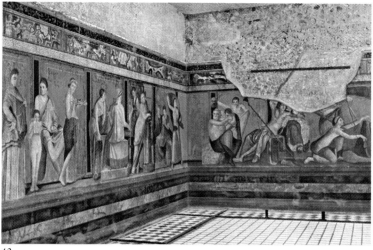

42. *Pompeii*
Wall painting
Ca 50 BC
Villa dei Misteri, Pompeii

42

The Teachers of the Romans

The Etruscans, like the Greeks, became teachers of the Romans. For the greater part it was Greeks and Etruscans, in Roman service, who devoted themselves to art, while the Romans concerned themselves with political and military life. In this respect it is possible to speak of a second Greek colonization of Italy – the aesthetic one.

Rome which ruled the world in a political way, became a Hellenic colony in an intellectual way.

But it was not only in Rome that Greek artists met the demand for works of art.
In the old Greek colonies, especially *Ionia* in Asia Minor, works of art were manufactured in the Hellenic tradition of naturalism, or in the spirit of eclectic classicism, for export to Italy and Rome.

The Art of Pompeii

The Romans were the first to create the psychological portrait.
Men and women of Rome live on in portraits busts which are surprisingly close to life. In the frescos of Pompeii we meet the same realism.

Pompeii is of course one of the best preserved examples of a town from Antiquity. It provides us with a complete inventory of life in the first century AD, in a domestic, social and cultural sense. Pompeii was already a very old town, where Greeks had settled. In the Roman era, and particularly during the rule of the emperor Augustus, it became a fashionable villa-town. The first signs of the approaching disaster which would later fall upon the town appeared in the year 62, when there was an earthquake that caused considerable damage. The Pompeiians were still carrying out repair works when in the year 79 an eruption of Vesuvius took place that made an end to Pompeii and to everyone that lived and worked there.

The town disappeared in a torrent of glowing ashes, and remained buried for almost 1700 years. A town of twelve to twenty thousand inhabitants swept away forever in one catastrophic eruption.

41

41. *Alexandros of Athens*
The Knucklebone Players
of Herculaneum
1st century BC
Painted marble panel
Museo Nazionale, Naples

31

43. Pompeii
Primavera
60 AD
Wall painting from Stabia
Museo Nazionale, Naples

43

44. Pompeii
Still Life with Fruit
69-70 AD
Wall painting from the House
of Julia Felix
Museo Nazionale, Naples

The excavations started in 1748 and have continued ever since.

Those excavations have provided extensive examples of incalculable value to the understanding of the development of Roman art and the Hellenic influences on it. Two essential characteristics of Pompeiian art are obvious: a preference for nature and a striking feeling for spatial arrangement. The appreciation of nature made the Roman decorate his house with paintings of gardens and landscapes, the feeling for order gave life to architectural fantasies that on the flat surface created the illusion of harmony in three dimensions. Frescos could be found in the rooms and loggias of the patrician houses in Pompeii, as well as in shops and public buildings. Especially in the houses of the rich there is a strong academic influence from Greece, but completely separated from it there exists a native style that is more expressive and directed to self caricature.

Finally, the repertoire of subjects that is developed in the various Pompeiian styles covers not only portraits and landscapes but also old legends (the

44

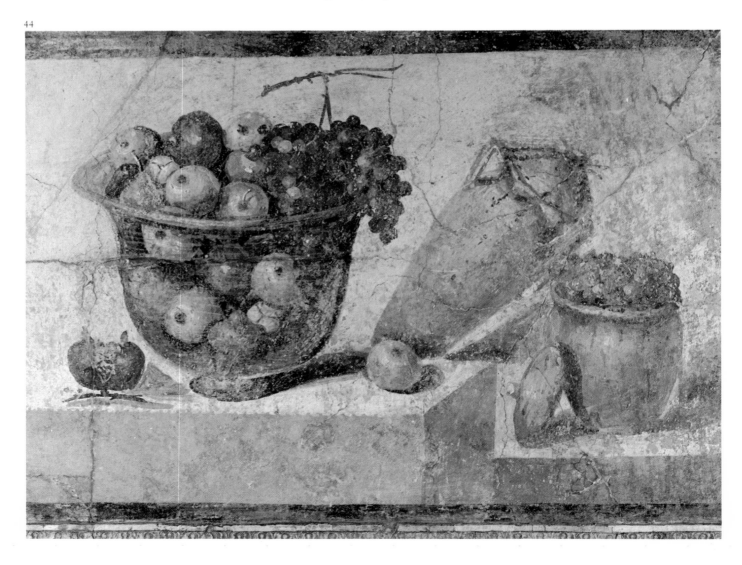

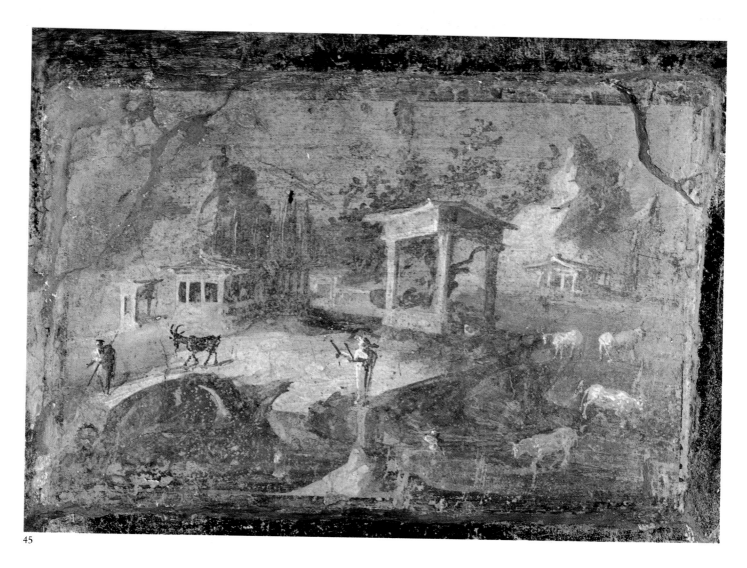

45

45. *Pompeii*
Bucolic Landscape
Ca 50 AD
Wall painting
Museo Nazionale, Naples

stories of Homer of mythological events and valor, for example of Hercules, Theseus of Perseus) and even still life, that seems to testify to an appreciation of present day emotional feelings. There was also found a rather satirical representation of the judgement of Solomon as told in the Old Testament.

Many of its famous frescos are of minor artistic merit, the work of journeymen. But among them are a few works of extremely high quality. What is most striking about these works is the melancholy beneath the frivolity. Here, at least, Roman needs go hand in hand with the traditions of Hellenistic art. The obvious frivolity of a very earth-orientated, sensual life is colored with the prescience of the coming downfall, the inevitable end. For some people the world of the fresco is still outstandingly Greek. In contrast to the simplicity, the freedom, the Greek desire to realize an inner balance in all areas of life, the Romans led a hard, disciplined, closed life. That's why the imitation of the Greek example degenerated into an essentially uncomprehended, reproduction. A temple, often bigger and

more majestic than the Greek, looses its inspiration with the Romans. It becomes heavier, more clumsy, lacking subtlety. The same goes for paintings, for example those in Pompeii, that in its Greek form still had the innocent charm of youth, became with the Romans, mere decorative frivolity.

The paintings decorating the houses of Pompeii are mainly based on themes from mythology. At the same time the landscape was considered to be a worthy subject for a painting, even more than in Etruscan art. Not so much a real landscape but an idyllic collection of such elements as shepherds and sheep, mountains and huts, villas and so on. It was the artist's intention to create a peaceful picture.

From here we got the *Pastoral landscape* and the lovely *Girl picking flowers*, both in the museum in Naples. There are also examples of still life and some of the details have great pictorial charm. The frescos in the *Villa of the Mysteries* are in the forefront, not only of Roman paintings, but of the best of the total painting art of human endeavour.

Under the Sign of Christ

*Catacombs, Coptic Art, manuscripts,
Byzantium, Romanesque Art,
Gothic Art.*

After a bitter internal struggle, Christianity was at last accepted by the Roman government of the emperor Constantine the Great, at the beginning of the 4th century.

It was even given favored treatment to the cost of Greek-Roman pantheism. The change from pantheism to Christianity, from a late-Antiquity to a christian religion, is reflected in the arts. Temples were christianized; including the Pantheon in Rome that was dedicated to all gods. But, the churches were built using the example of the classical basilica.

The Legacy of Rome

The first christian artists were Romans. They came from the workshops of heathen masters and were unable to express themselves in any other way than in the form language of their teachers. The content is indeed different.

Yet the style is so attuned to classical taste, that the pictures in the catacombs must be seen as a kind of christianized Pompeiian art.

To represent Jesus, the artists use classical symbols.

The classical picture of Hermes with the ram is just differently interpreted; the Hermes Kriophoros becomes a Christ.

46. Sarcophagus of Junius Bassus
Christ entering Jerusalem, *ca 359*
Marble
Vatican, Rome

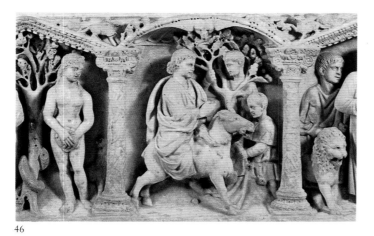

46

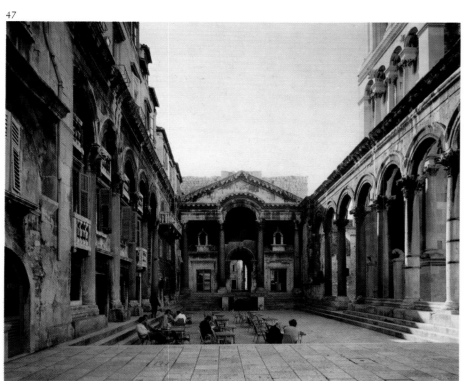

47

47. Palace of Diocletian, Split
Ca 300

48. Madonna with Child
3rd century
Fresco
Catacomb of Priscilla, Rome

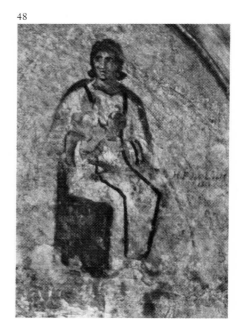

48

34

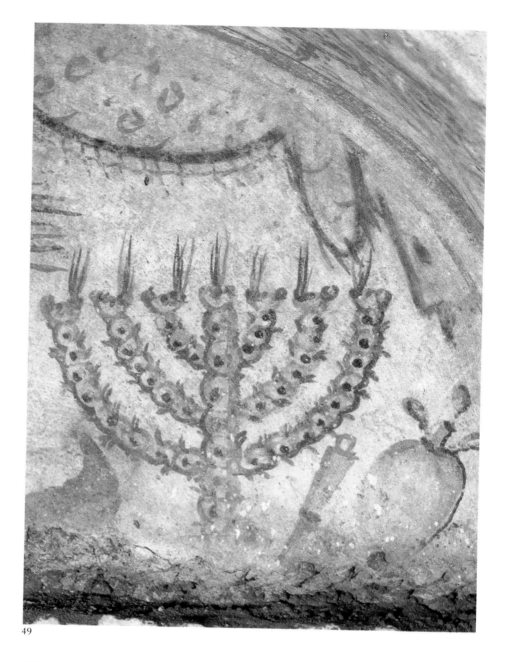

49

In other works Christ appears with the Phrygian cap of Bacchus; in the catacombs he is seen as the repetition of Helius – Apollo. For Christ had said: they who fear God's name, will see the sun rise in justice.

Reason enough to put him on the same level as the sun god. Sometimes he is shown as a young man, standing in a vineyard, surrounded by twelve naked boys, busily gathering grapes; Christ said: I am the vine, you are the tendrils. The Christ on the sarcophagus of Junius Bassus also appears in the form of a beardless young man, more the incarnation of the Apollo-idea than of the suffering Saviour.

Art of the Catacombs

Catacombs are underground areas, used by early Christians as collective burial places. The most important are in Rome and consist of greatly extended labyrinthian passages. The oldest paintings are no more than symbolic signs: a palm, an anchor, a pigeon with an olive-branch, etc. As well as the simple graves there are vaulted areas, with walls decorated with paintings.

The art of the catacombs developed in a period that still stands as classical culture, which reached, in many ways, its pinnacle only centuries after Christ's birth.

The villa of Hadrianus, from the year 118, shows a refinement which could be seen as the crown of the empire's style. And the Diocletian-palace in Split, in Yugoslavia, built about 300 years after Christ – when the Pax Romana was moving to a close – is the oldest grandiose monument of the Roman empire.

It fully demonstrates the Roman talent for experiment.

Certain decorative elements, like the wall with pillars supporting arches,

35

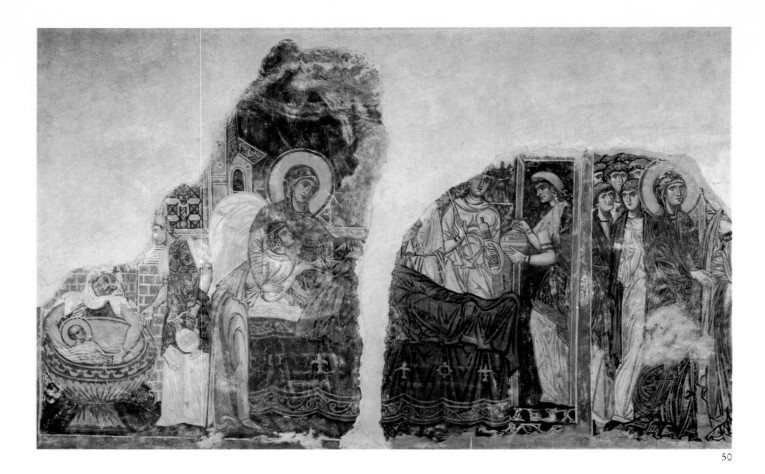

50. The Birth of the Virgin
Saint Pantaleon, Nerezi, Yugoslavia
Ca 1164

51. *Grave stone*
Coptic, late 3rd to early 4th century
Ikonenmuseum, Recklinghausen

51

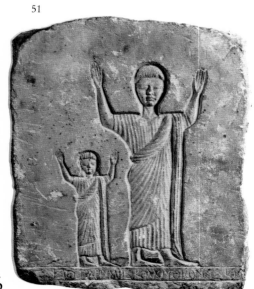

project the form language of Byzantine architecture.

The *Good Shepherd* from Ravenna, of the 5th century after Christ, has remarkable classical traits. A contradiction with a late 3rd century Coptic sculpture, a grave stone, which in its sculptural naivety, clearly announces the birth of a new art.

After the establishment of Christianity as a state-religion, that is since the 5th century, the supply of commissions led to the development of a style, that while combining classical elements, attempts to formulate christian ideas in an independent way. Churches were built everywhere. For their decoration the simple "underground"-art of the catacombs was not enough.

Art was demanded with pompous, representative effects.

And here the poverty of art in early Christianity came to an end.

The Town of Peter

Rome, the town where one had to descend into the catacombs to worship the new God of the Christians, again became what it had always been in Antiquity: the centre. The town of Augustus became the town of Peter. Alongside the buildings of the heathen period the first Christian basilicas rose: the Peter Church, the Paul Church and many others, dedicated to various saints.

The mosaic in the apse of the *Santa Maria Nuova* is very beautiful. In the middle, Mary is enthroned, over her figure a golden coat is draped, decorated with red and green stones. The Christ child stands on her lap. At her side, separated by arcadian pillars, approaching her are John and Jacob, Peter and Andrew swathed in white, classical togas: grave philosophers, quietly striding along with great dignity.

Also in Byzantium, Christian art blossomed.

The mosaics in the church of the "Holy Wisdom", the *Hagia Sophia*, built by Justinian, must have been of an incomparable beauty. In Venice the old mosaics in the *San Marco* still give an impression of the grave beauty of Byzantine mosaics.

Ravenna

The most outstanding example, of early-christian art is in *Ravenna*, a town that immediately lost its importance after its political mission was fulfilled.

Perhaps for that reason it kept the style of the period almost completely intact. In the year 402 Honorius mov-

ed his seat from Rome to Ravenna; it seemed safe to him to have the sea close by. Later, when Galla Placidia, his sister, took over the government for her son Valentianus, the prosperity of the town began.

This continued up to the 6th century when Ravenna became the seat from which the East Roman government directed the destiny of Europe.

In Ravenna one can still see how the catacomb style finally developed.

The *Mausoleum of Galla Placidia* looks like something left over from Pompeii. The ornaments and flower tendrils seem almost classical in their elegance.

Classical – in the heathen sense – is the central concept: a sunny, southern landscape, white lambs grazing, watched over by a youthful Apollo – Christ, the good shepherd – wearing his aureole like a Phrygian straw hat. The baptistery San Giovanni in Fonte is in a more serious style.

But there also, the elegant still lifes – painted under the dignified procession of ancient philosophers – make one think of Pompeii. The mosaic in the dome is indeed a remarkable example of how the old gods live on. Christ appears as a narcissist, looking at the reflection of his beautiful body in the water.

In the background there is the river god Jordanus, the equal to a Triton; apparently the old river gods and well nymphs were not yet dead.

The mosaics in the *San Vitale*, created round 547, and in the *San Apollinare* created about 560, both in Ravenna, have great grandeur. Here every pastoral character is strange; they reflect the dignified seriousness of the Byzantine court. The long rows of the saints on both sides of this basilica are impressive. Further the mosaic in the San Vitale-church, dedicated to Justinian and Theodora is incomparable. Theodora started as an actress and became ruler of the morning- and evening land.

The hieratical beauty of Theodora, is both morbid and supernatural and her regal bearing dominates the mosaic. The outsides of the churches give no warning to the visitor of the beauty that waits inside. Yet behind the monotonous walls, there are pillars with fantastic heads which are unforgettable, and a mosaic art which will remain a miracle for ever.

Against a luminous blue sky stand saints of everlasting beauty.

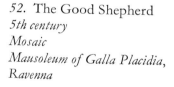

52. The Good Shepherd
5th century
Mosaic
Mausoleum of Galla Placidia,
Ravenna

52

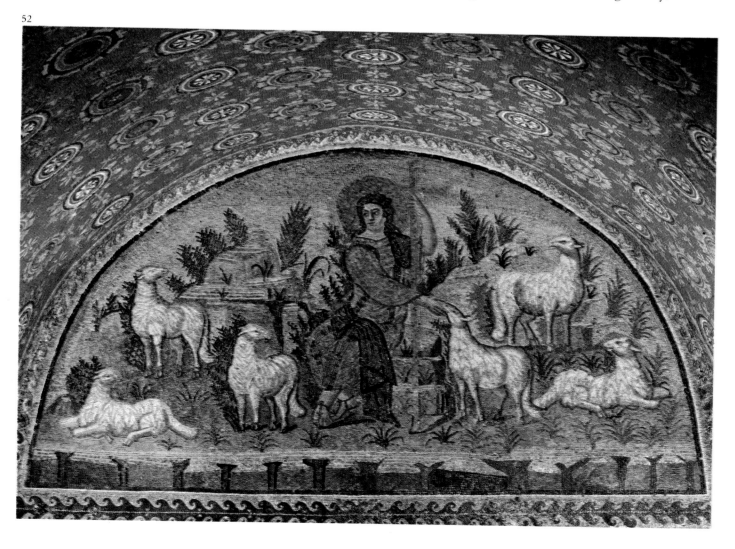

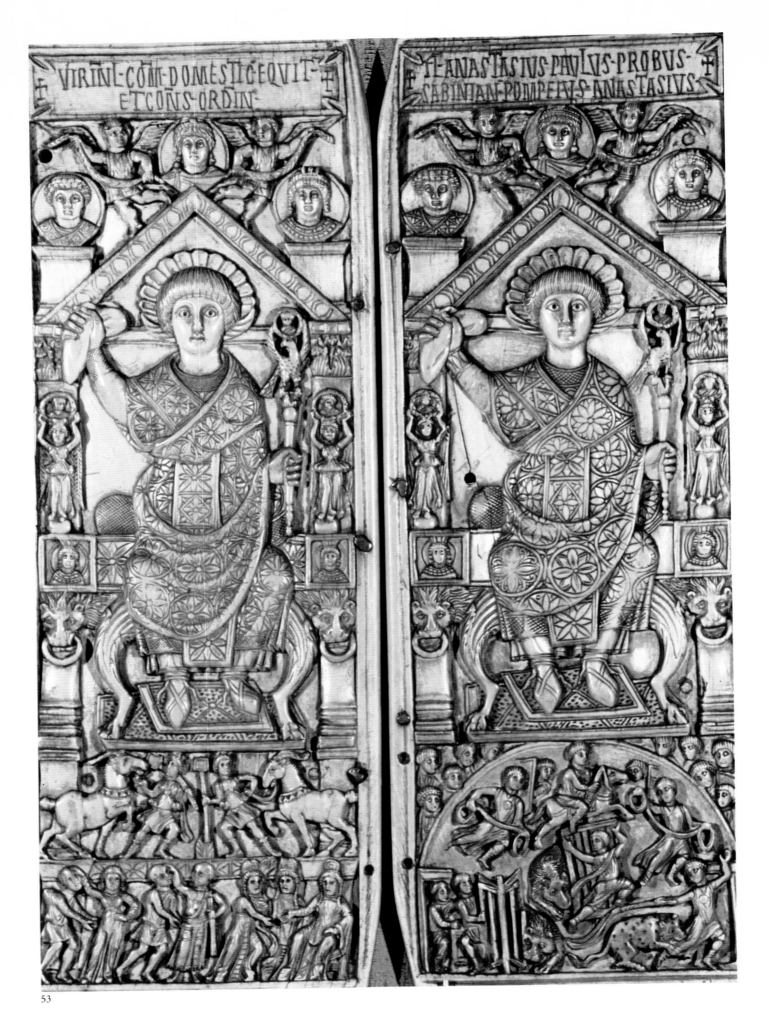

VIRINL·COM·DOMESTICEQVIT·
ETCONS·ORDIN·

II·ANASTASIVS·PAVLVS·PROBVS·
SABINIAN·POMPEIVS·ANASTASIVS·

53

53. Diptych of Anastasius
Byzantine, early 6th century
Ivory
Cabinet des Médailles, Paris

A last glimpse of the beauty of the ancients was saved before the seriousness and the imposing severity of the ceremonial Byzantium began.

Ireland and the Manuscripts

Elsewhere in Europe other forms of christian art, tied to local situations, came into being.

Contrary to the human-orientated naturalism of the Greek-Roman art, in Ireland an abstract style appeared. The Irish art entered Europe in the form of manuscripts, which came into the possession of monasteries on the continent.

The christian art of Ireland was proportionally great because of the high academic level of the abbeys, which were centres of culture; Latin, Greek and astronomy were studied.

The copying and illustrating of manuscripts received a lot of attention.

The *Irish miniature* had a great influence on the continent, especially on the book illustration art of the Carolingian renaissance.

From here the Irish example worked fruitfully on the Romanesque minia-ture and even on the ornamental style of Romanesque sculpture.

The Carolingian Renaissance

The Carolingian renaissance lasted from the ascension of Charlemagne in 786 to the death of Charles the Bold in 877. During this renaissance the art of the miniature flourished. Once again Latin forms were introduced, with Irish influences that decreased but still remained. From the Reims school came the famous Utrecht hymn book, a late (1150) copy of which survives. And from the same school a 9th century manuscript which was preserved in Epernay. The miniature shown here portrays *St. Luke.*

Romanesque Frescos in Catalonia

As far as style is concerned the Romanesque paintings in Catalonia cannot be said to come from local sources.

There are two distinct trends: a northern style that had probably started in Poitiers, and a style, with By-

54. Empress Theodora
6th century
Mosaic
Church of San Vitale, Ravenna

54

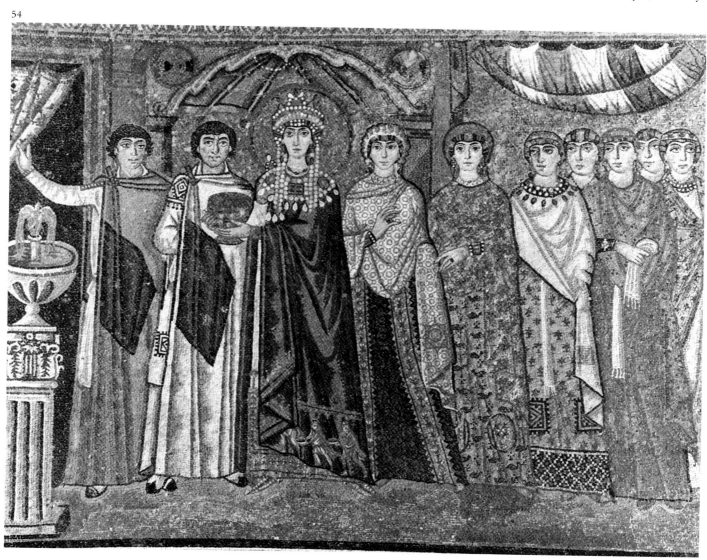

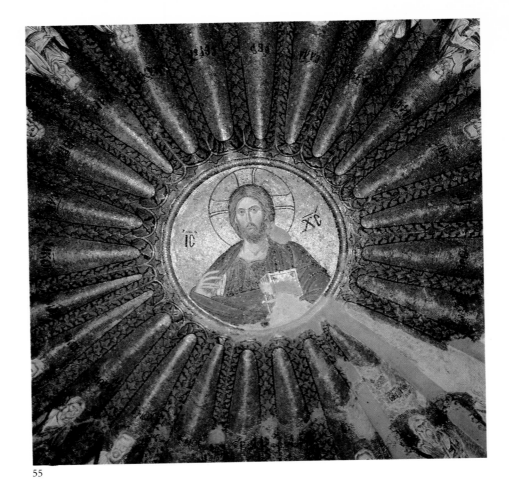

55. Christ Emanuel, *detail of the dome*
14th century
Mosaic
Chora Church, Istanbul

55

56. *Capital decoration in low relief*
Ca 525-547
Porphyry
Church of San Vitale, Ravenna

56

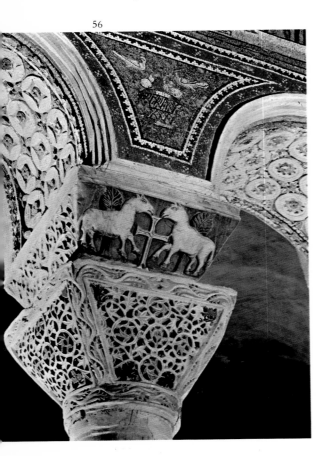

zantine traits, influenced from Lombardy. Individual figures and large compositions, predominantly two dimensional and very stylized, characterize the early period.

In the last ten years of the 12th century the Byzantine influence increased. In Catalonia itself, the monastery of Ripoll was the cultural centre, as it had been since the 9th century. Even today the miniatures of the *Ripoll school* are well known. In addition to these the monastery had a great influence on the frescos at Bois, which are simple and expressive.
The color is intense and clear; black contours delineate the colored areas.

The frescos of many churches in the Gerona area, especially Osomort, Mareya and El Brull, originated from the Ripoll school via the influence of the Bishop of Roda, who had been a monk at Ripoll. This area offers a great richness and variety of Romanesque frescos; the best known are those from San Clemente in Tahull, now kept in the Catalonian Museum of Barcelona.

Around the year 1200 there worked in this same region a painter who became known as "Master of Espinelves"

He created the frescos in the apse of St. Mary in Egara (Tarrassa), with their stylized figures. Towards the end of the 12th century many painters in the north east of Catalonia worked in the Byzantine style. This style probably entered Spain via Perpignan.

A masterpiece of the final period of Romanesque art in Spain can be found at the monastery of Sigena (Huesca) that was, unfortunately nearly destroyed by fiire in 1936.
This monastery was founded at the end of the 12th century; the frescos were painted about 1300.
Even at the beginning of the 13th century, works were being created with the characteristics of the Catalonian-Romanesque style. The followers of *John Pintor* – the only Catalonian artist who signed his work – continued in his style for a long time. The beauty of this style can be ascribed to what to our eyes is "modern" styling and strong contrasting colors.

Islamic Architecture

In the part of Spain that was ruled by the Arabs, Islamic architecture developed, reaching its peak during the course of the 9th century. The sculpted decorations on the porches of the

Cordoba mosque may show some relationship to Gothic forms but they remain strictly ornamental. Islam prohibited the representation of living creatures, so the Islamic architects and artists were limited to decorative ornaments such as the arabesque, geometric ornament and calligraphy.

With the combination of these three they reached great heights, which is amply demonstrated by the Cordoba mosque and the Alhambra Palace at Granada.

The Christians' Passion for Building

Elsewhere in Europe a passion for building and a creative urge took possession of the Christians.

Architects like *Santo Domingo*, goldsmiths like *Fredericus*, (the monk from San Pantaleon), bronze moulders like the Abbot *Bernard von Hildesheim*, inspired their contemporaries. A previously unknown enthusiasm was born; not without results. Skilled stone-masons decorated pillars. The churches were enriched with arcades, tympans, and porches. Courts and galleries were added to monasteries.

In the paintings of the apses a lot of Byzantine formality remained, but on the walls of the churches a greater freedom was given to the artist. He was allowed to place the Acts of the Evangelists in a landscape which he knew, and to present the holy lives as they were told to him.

The richness of the artistic language of these Romanesque artists is overwhelming; the forms were not born from the imitation of reality but out of subjective inspiration. No area of human experience was excluded; exalted majesty combines with naive humility, cruelty stands side by side with purest innocence.

The language of Romanesque art was not fully understood or appreciated until this century.

57. Saint Matthew *from the Book of Durrow*
7th century
Illustrated Manuscript
Trinity College, Dublin

57

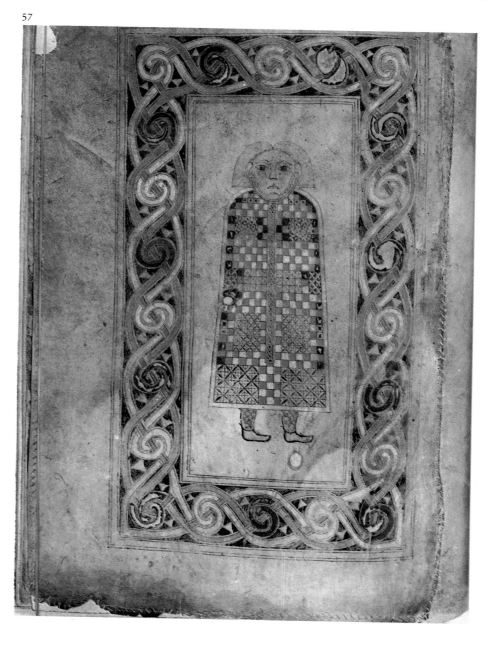

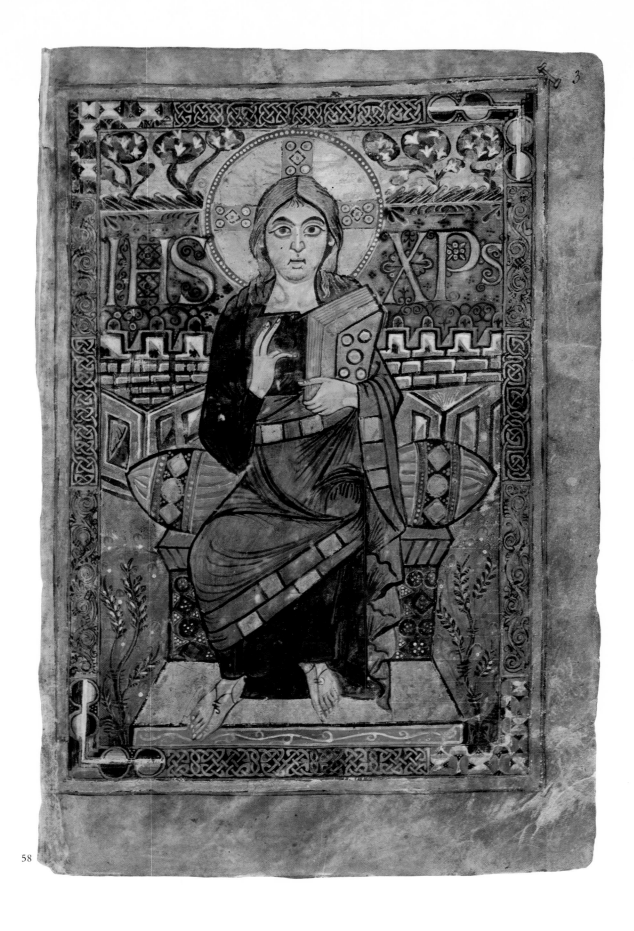

58

58. Enthroned Christ
*Godecalc Gospels, made by
Charlemagne
and his wife, Hildegarde
781-783
Illustrated Manuscript
Bibliothèque Nationale, Paris*

Voltaire, who had spent a day at *Autun*, thought it "Relics of a barbarian time". Others were also blind to the achievements of the "Dark Middle Ages".

Today the *Eve with the Forbidden Fruit* from Autun is considered to be among the highlights of European sculpture.

Paradoxically, it is thanks to that lack of comprehension and judgement that a lot of the Romanesque culture has survived. As long as the hand of man saved it, the stone could stand the effects of time. The Pyrenees, Spanish and French Catalonian valleys are a good example.
After the "reconquista" they lost their importance as a refuge. The

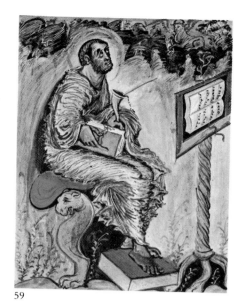

59

59. St. Luke *of the Gospels from*
Ebbo, School of Reims
Early 9th century
Illustrated Manuscript
Bibliothèque Nationale, Paris

60

60. Christ on the Cross *(Gero*
Crucifix)
Ottonian, late 10th century
Painted wood
Cathedral, Cologne

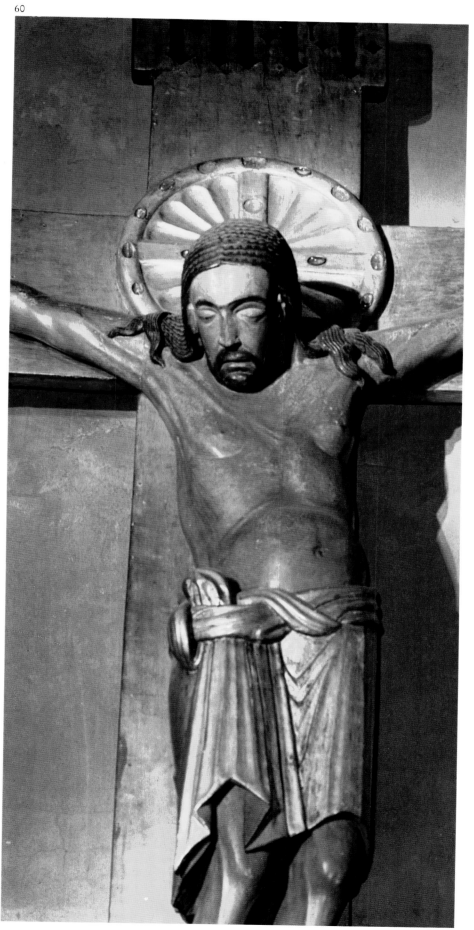

population moved to more fruitful
areas and the Romanesque churches
and chapels fell into disuse and were
thus saved from modernization.
Romanesque wood sculpture, with all
its restraint, is grandiose and impres-
sive. The *Madonna and Child* in the
Louvre – 12th century French – may
be considered a good example of this
hieratical art. All humanity is strange

61

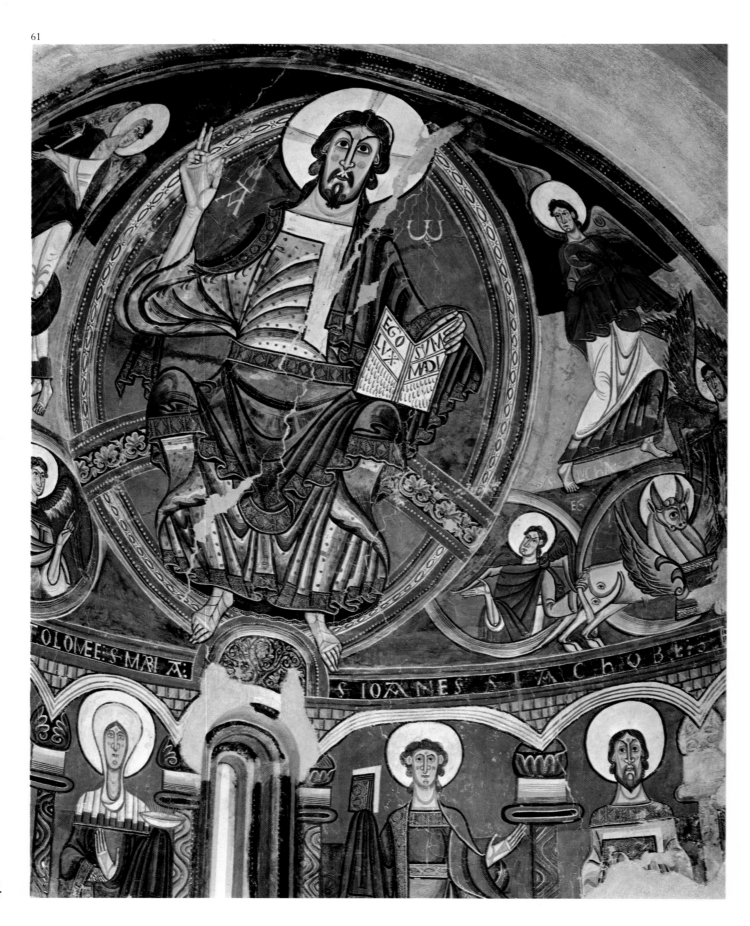

44

63. Two Archangels, *detail of an antipendium from Basel* Ottonian, 1002-1019 Gold and jewels Musée de Cluny, Paris

63

62. *Capitals at the entrance of the Villaviciosa Chapel* Islamic ca 970 Great Mosque, Cordoba

62

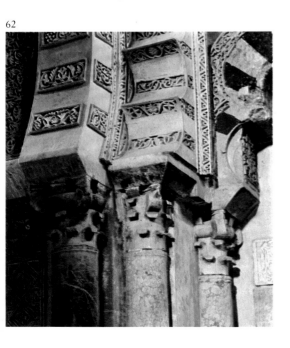

to this figure, in the sense of a "Menschliches-Allzu-Menschliches" between mother and child there is no emotional relationship; there is only a majestic seriousness, a superhuman dignity, represented in an apparently awkward form. Here are none of the elegant folds that characterize Gothic and later styles.

The Meuse Valley

Liege was the most important gateway through which southern culture could reach the northern areas. Even from west to east, the way led thru Liege. The influence of Liege on Aachen was stronger than the reverse. The French accent dominated.

Under the government of Bishop Notger, around 1000 AD, art began to flourish. Music, calligraphy and book binding; miniatures, ivory carving and working in precious metals, excelled. A number of influences are still visible, as is shown by ivories from before 1000. In the 11th century the art of the Meuse valley gains a character more of its own; a century later the art of precious metals achieved an unprecedented prosperity and an elegance that was unique for its time.

Germany also contributed sculpture of great importance.
The *Imad-Madonna* from Paderborn, created about 1050, radiates a purity

45

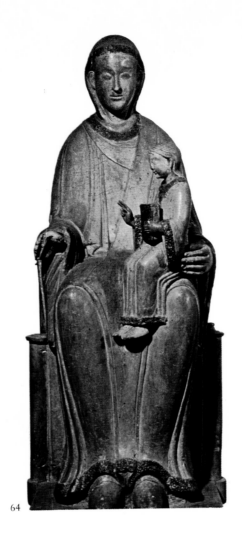

64

and tranquility, which in its mystic intensity, echoes the finest Buddha statues.

The form is earnest and stylized; here again there is no sign of a mother-child relationship. In general the early Romanesque Madonnas combined the distinguished distance of Byzantine "Sedes Sapientiae" with a purity that has a mystical quality.

Santiago de Compostella

The role that pilgrimages played in the extension of Romanesque culture cannot be over-estimated; as can be seen in Santiago de Compostella.
The first Spanish missionary, Jacob, son of Zebedeus, was first revered in Santiago. Due to the close relationship with Cluny, the town became an important goal for pilgrims. Bishop Diego Gelminez, a man who had studied in Paris and was a protégé of Cluny, had a strong influence. About 1075 this bishop commissioned the church in Santiago. A porch of which is shown here. In the course of the centuries this church underwent many changes before it got its Baroque facade.

Pilgrimages and Routes

Pilgrimages to Santiago were organized from Cluny.
There were four routes, and churches and chapels were built along these roads. An order of knighthood was established to protect the pilgrims. One route ran from Paris, via Orleans Tours, Poitiers and Bordeaux.
A second from Vézelay, via Limoges and Périgueux; a third from Le Puy via Conques and Moissac. The fourth from Arles, through Montpellier and Toulouse.
Shown here are the fronts, or fragments of sculpture, from Moissac, Toulouse, St. Gilles, Poitiers, Arles and Santiago de Compostella itself.

At the French towns of departure were links with routes starting in Flanders, Germany and even Poland and Hungary. The English arrived via Normandy.
Many of the places mentioned have famous cathedrals, others simple

churches. The pilgrim roads met at Santiago de Compostella.

The French Influence in the Romanesque Art

Naturally, the Romanesque monuments in this town show strong French influences; the architecture is related to that of Southern France, for example Saint-Sernin in Toulouse. Even the oldest sculpture of Santiago, the goldsmiths' porch, points to influences from Languedoc.

The Glory porch of the cathedral in Santiago, is no longer seen at its best as it is hidden behind the 18th century façade. However, it is still a match for the famous French porches, such as those of Chartres. There is no doubt that the artist who created it (Master Matthew) looked to the sculpture of Northern France for his examples. This porch is a transitional step to the Gothic.

It does not have the purity of style of the goldsmiths' porch which was completed at the beginning of the 12th century and probably started during the 11th.

In this porch authentic Romanesque art is shown in all its expressiveness and allure. The same can be said of the figures of this porch as can be said of those of Moissac: the curbed expressiveness of them, the inner ecstasy, the mystic diffidence, betraying pose, look and gesture.

Nowhere do they attempt realism; all forms have the restraint and simplicity of style that reached its peak in *Vézelay, Moissac, Arles, Saint Gilles* and *Santiago;* as far as Southern Europe is concerned.

Elsewhere in the West the developments in Germany, upper Italy, Tuscany, and Yugoslavia, under the Ottoman emperors, produced in those areas achievements of a different nature. Notably in Germany are: the *cathedral in Speyer*, the church of *St. Michael in Hildesheim*, the *Pfalz chapel in Aachen*, the church of *St. Pantaleon in Cologne* and the *Benedictine monastery church of Mary in Laach*. In Italy fine examples are: the church of *St. Ambrogio in Milan*, the *cathedral* and *baptistery in Pisa*, which was started in 1063, the church of *San Marco in Venice* (from the 12th century), and the church of *San Cataldo in Palermo*. To the east the Romanesque style spread to the coast of the Adriatic, to *Tragira*, where the

65. The Second Arrival of Christ
Tympan from the southern porch
1110-1120
Saint Pierre, Moissac

65

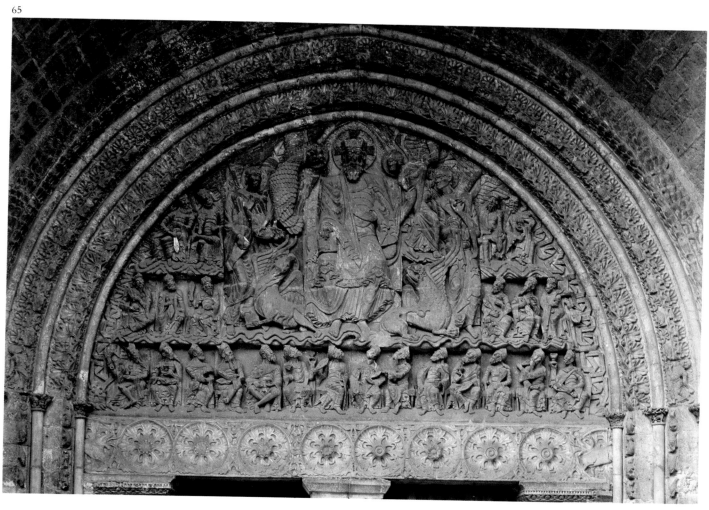

66

67

67. Eve with the forbidden Fruit
St. Lazaire Church, Autun
Ca 1120-1135
Musée Rolin, Autun

cathedral has an extremely impressive porch, created by *Master Radovan*.

Classic Highlights in Germany

The Romanesque style in the Germany of the Middle Ages, culminates in the figures on the *cathedral of Bamberg* – the most beautiful cathedral of the late Romanesque period. The figures date from 1250, when the Romanesque period passes to the Gothic. Gradually Gothic sculpture steps away from the wall. The statue is freed from its link with architecture and is given individuality.

Combined with that development is a movement towards a certain realism in expression. But the figures decorating the royal porch of the cathedral at Chartres, show clearly how little attention was given to natural proportions. The length of the body is nine to ten times the length of the

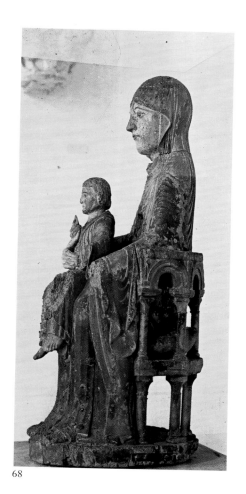

68

head. They are almost non-corporal, they lack body weight. Impassive, elevated, with archaical seriousness, they stand petrified in their pose of absolute spirituality, placed against the wall like candles.

Gothic Architecture

The years between 1190 and 1240 were the most fruitful years of the Middle Ages for French Gothic art. In *Chartres*, *Le Mans*, *Bourges* and *Reims*, *Paris* and *Laon*, cathedrals arose which are miracles of mathematics as well as grand monuments. Unlike Romanesque architecture, Gothic is not heavy and massive, not earth bound but soaring. The massiveness of Romanesque building was softened, the pillars reach for heaven. The windows become larger; the walls do not appear to be built of stone any longer, but of colored glass. Gothic art suggests dematerialization, idealism, weightlessness.

The beauty of Gothic cathedrals is mostly ascribed to architectural qualities, but it is also due to the sculpture. It is possible that the façade of Reims cathedral owes its impact to its decorative sculpture.

Compared to the Romanesque period, Gothic style is a step towards natura-

69

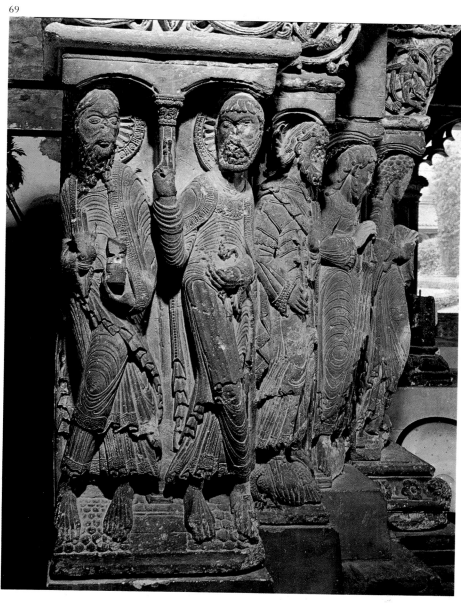

49

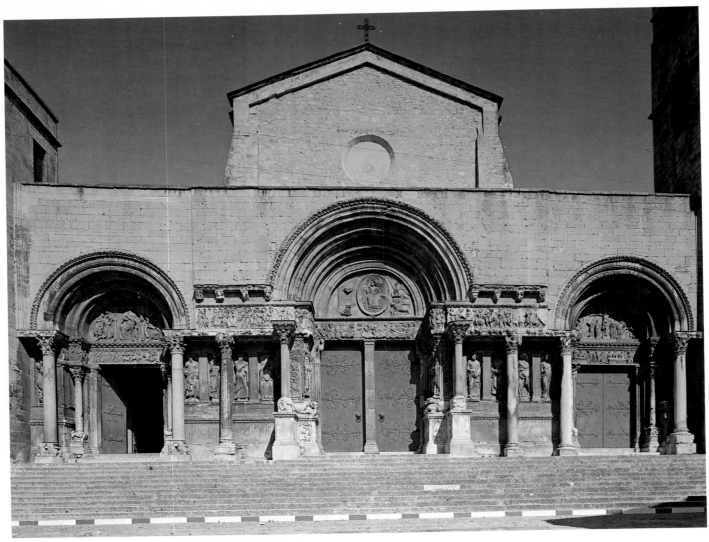

70

lism. Whereas the Romanesque artist preferred to portray Christ as a crowned king in a robe, Gothic naturalism brings the spiritual royalty nearer to the people. The authority, the hieratic and the stillness of Romanesque art began to disappear. In Gothic art can be seen the victory of strength of movement over the static elements of Romanesque art.

That victory was then celebrated by the continuously increasing height of the Gothic vault. Those enormous Gothic vaults would not have been possible technically, if out of the former supporting walls the flying buttresses had not developed. The *Notre Dame in Paris* is one of the first examples where the flying buttresses along the nave are placed in a clearly visible position (building of the nave started in 1180). Outbreaks of fire gave new life to a series of triumphal examples of Gothic art. Fire prevention had not yet been invented. In 1194 the *cathedral of Chartres* was almost burned down. It was decided to build the present cathedral, a grandiose monument. It was consecrated in 1260. In 1218, the *cathedral of*

Amiens burned down. Two years later the rebuilding started; by 1236 it was ready for use. It is the largest cathedral of France; the nave is 15 meters wide like at Reims but, it is also an impressive 45 meters high. The influence of this building in Amiens, that in spite of its enormous dimensions, seems to strive after an almost weightless grace, has been perceptible in the Low Countries. The plan of the *St. John in Bois-le-Duc* was inspired by Amiens. Building started at the beginning of the 15th century (after fires had destroyed previous churches). Still, the French were not satisfied and planned to build a *cathedral in Beauvais* that would outshine all the others. But, there were technical difficulties about the strength of the foundations and the cathedral remained unfinished: the nave was not completed. The name of the building master remained unknown, like so many other technicians and artists from the Middle Ages. But not all. Some building masters were buried in the church they had created, and documents about their work handed down. For example it is known that

70. *Front of the Cathedral St. Gilles du Gard Started in 1116*

a certain *William*, the creator of the *cathedral in Canterbury*, England, had also worked on the *cathedral of Sens* in France. Reims was created by four building masters, whose names are all known: *Jean d'Orbais, Jean le Loup, Bernard de Soissons* and *Robert de Coucy*.

The architects of Amiens were *Robert de Luzarches, Thomas de Cormont* and his son *Renand de Cormont*.

Some building masters were artists in demand, who worked in various places and whose names we know. In the background of this change to large buildings in Gothic style stands the increasing power of the cities. New social principles attacked the authorities which had, up to then, been con-

servative-feudal, with a Byzantine social background. From the remote and motionless style of Byzantine art, and the related Romanesque style, appears the Gothic and then the Renaissance.

The first moving figures, in contrast to the motionless figures in Moissac, can be found in book illustrations. The church window (a sort of transparent mosaic) and the fresco had stuck to figures without movement.

In book illustration, however, painting becomes transportable, painted with tempera or, later, with oils on a panel, something which characterizes a bourgeois period.

71. *Front of the Notre Dame La Grande, Poitiers 1100-1150*

71

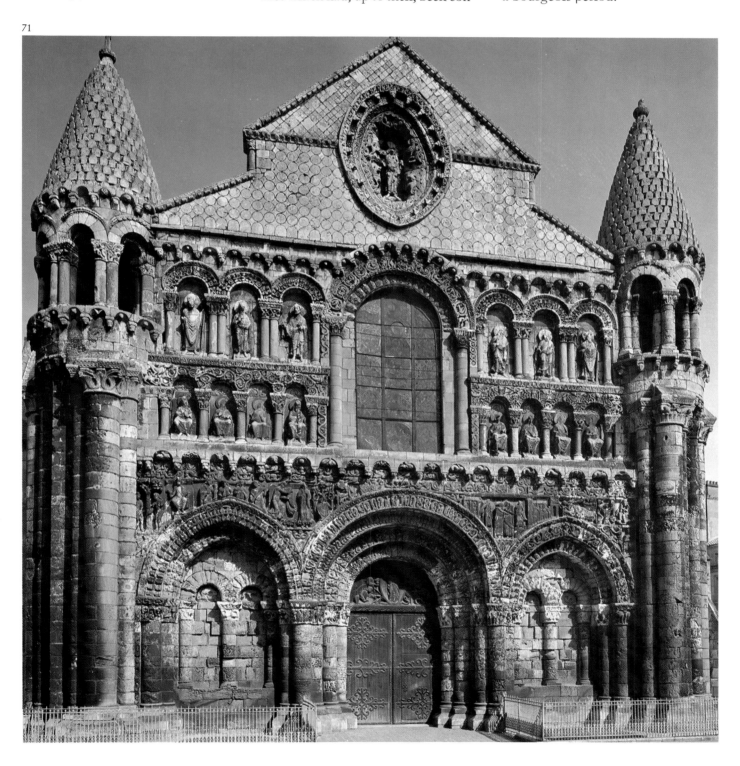

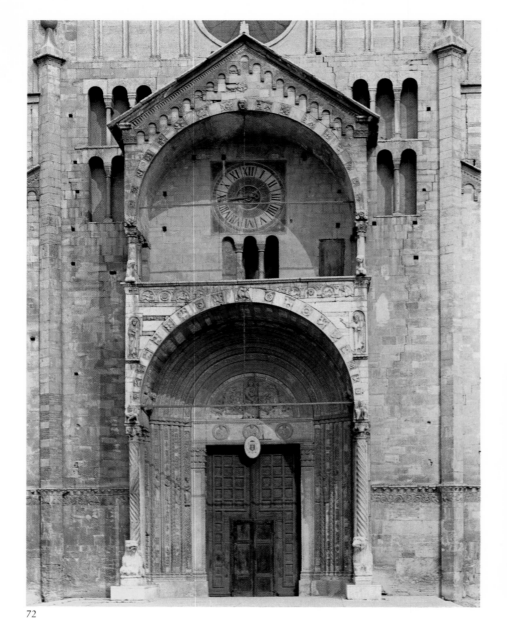

72

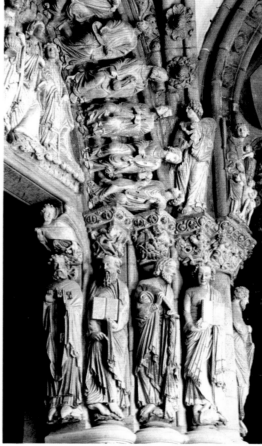

73

74

72. *Main porch of the Cathedral in Verona 1140-1150*

74. The Apostle Peter
Saint Pierre, Moissac Marble, ca 1100-1101

At first the transportable painting still looked for a location, the altar for example. But this disappeared and with the loosening of the painting from its fixed, predestined place, there came a certain loosening of the style. The painting of the Middle Ages once detached from the hierarchical tightness of the mosaic, became freer and more mobile in its expression.

From Mosaic to Fresco

Of course this does not apply to the icon; for example those painted in the *monastery of Athos;* this form remained bound to the canons of Byzantine art and adopted the same severity as the Byzantine mosaics.
But from 1300 in Italy, parallel to the rise of the city states, a style develops that accepts the expressive gesture, even in the fresco.
The severity of the Byzantine style had already been attacked in other

75. Monastery Saint Trophime,
Arles
12th - 14th century

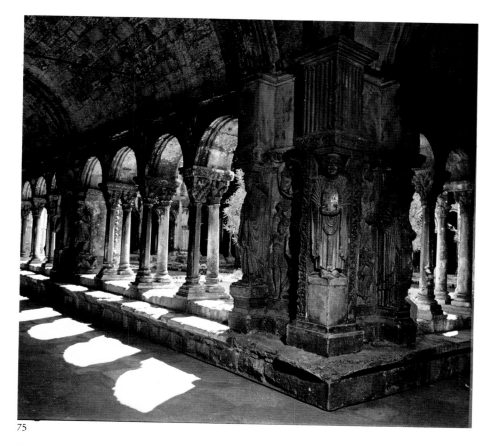

75

76

76. History of Charlemagne
Enamelled window
Cathedral of Chartres

53

77

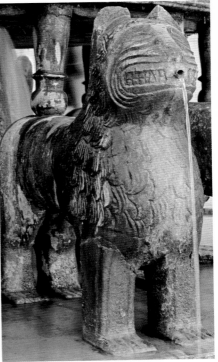

78

78. A Lion *from the Harem
Court-yard Fountain
Islamic, 1350-1400
Alhambra, Granada*

77

77. *Small Metropolis
(or the Church of St. Eleutherea)
Athens
Byzantine, 11th-12th century*

places – for example in Serbia and Macedonia, in the frescos decorating the churches, monasteries and chapels. These give an impression of more individuality than the tradition had permitted elsewhere.

In Italy the frescos in Padua, by *Giotto*, are a good example of style development starting about 1300 AD. How much more emotion is already realized in them will be clear when this work is compared with that of *Cimabue*, who worked in Rome, Pisa and Florence during the last part of the 13th and the beginning of the 14th century.

In Cimabue's work Byzantine solemnity remained. The background is of gold, as in the mosaics and miniatures. The faces do not have a personal expression. The figures are almost abstract. It is difficult to realize that under these Byzantine costumes there should be human bodies. In a madon-

na figure, the fingers are like ivory sticks, her face betrays no emotion; she is enthroned on high, impassive and remote from the actions of mortals.

*Duccio, Cimabue and Giotto:
The End of the Middle Ages*

Duccio di Buoninsegna, known as Duccio, was born in Siena about the middle of the 13th century and died in 1319. Originally his work was similar to Cimabue's. His work "Maestà" from Siena cathedral, proves how far Duccio had detached himself from the Byzantine scheme. Although his Christ is still dressed in costly material and the fine folds of the Byzantine court dress, there is more mobility in the figures. The first formality is already broken. It is as if the breath of a new freedom blows over this painting. Moreover, the world is no longer the golden background of By-

54

zantine art, but – with abode and natural surroundings – it becomes real. For the first time a work of art gives the impression that the figures can move and breath.

However, it would not be correct to consider this development simply as an advance. The idea of "advance" in the sense of improvement is not always applicable in the history of art. Duccio's other work reproduced here, the *Madonna with two Angels*, is more closely tied up with tradition than the "Maestà" but from an artistic point of view it is not inferior. It is difficult to say which is more impressive: the majesty of the Madonnas of Cimabue or the life presence of Duccio's figures. Even in the latter there

is still some reflection of Byzantine solemnity.

Giotto di Bondone, born near Florence about 1270, became a pupil of Cimabue and successor to Duccio. Some historians go so far as to call Giotto the founder of modern painting. This may or may not be so, but Dante called him, in his Purgatorio, the most famous painter of his day, even greater than Cimabue. About the works that should or should not be ascribed to him there are different opinions. At one time it was assumed that Giotto was also the creator of a cyclus of 28 large frescos in Assissi, expressing St. Francis' life. Today this is doubted. The style of it does not correspond with that of other works.

79. Giotto di Bondone, ca 1270-1337
The Judas Kiss, *1304-05*
Fresco
Scrovegni Chapel, Padua

79

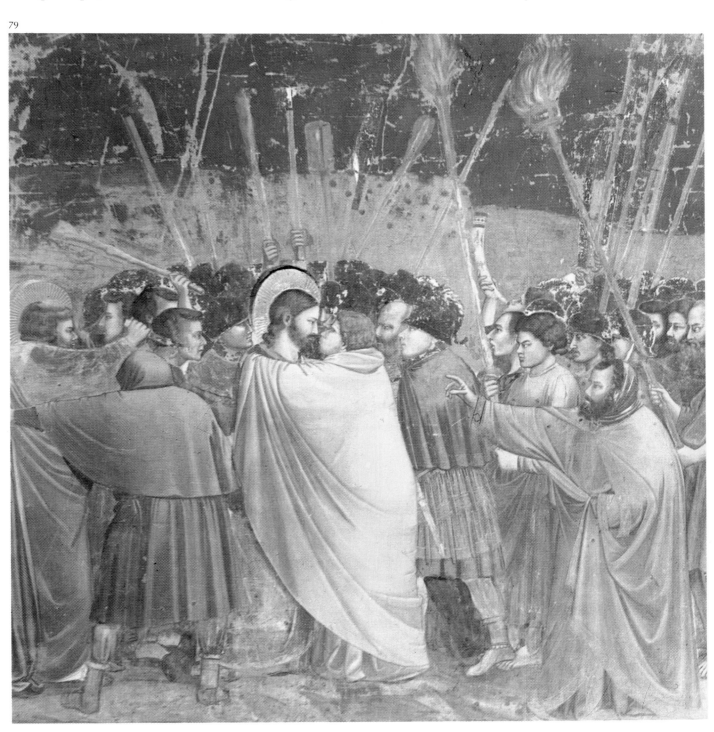

55

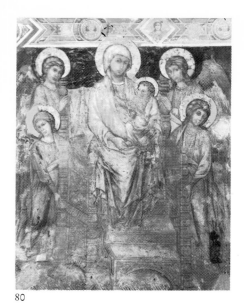

80

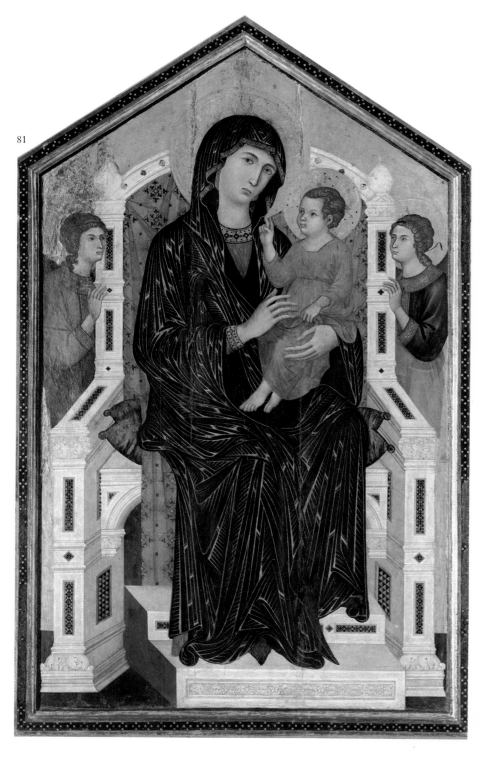

81

The style of Giotto meant indeed a break with the current traditions of the past.

Until his death, in 1337, he developed the new freedom and put a stamp on art which survived long after his death. He ended the Byzantine rules and laid the foundation of a style which had its starting point in the observation of life.

The somewhat mesmerized figure of the Byzantines went; the full face pose used by Cimabue and Duccio's semi-profile poses made room for movement observed from reality. The figures can bend and turn; posture and movement are based on life. The image space is filled with people like a Florence street.

All the profiles are different. Every face is that of an individual.

Art became worldly with Giotto. Life with all its human aspects enters the art world. Nevertheless there is still dignity and personality. The male figures of the *Santa Croce in Florence*, remind one of Roman senators. Only in Giotto's madonna – the one in the Uffizi for example – is there still some element of serfdom observable.

The frescos in the chapel at Padua are realistic and represent a decisive change in the style of the century. The 14th century will be recognized for that change, even though his suc-

56

82

82. *Giotto di Bondone, ca 1270-1337*
The Funeral of St. Francis
Fresco, 1317-1320
Bardi Chapel, Basilica of
Santa Croce, Florence

cessors failed to achieve the originality that characterizes Giotto's work. In the work of *Taddeo Gaddi* and *Simone Martini* the new element is no longer surprising and like all Giotto's successors, they cannot escape the destiny of being secondary: reproducers.

Apart from Giotto's work, only the frescos in the town hall of Siena, painted by *Ambrogio* and *Pietro Lorenzetti*, and (at the same place) the mighty horseman by Simone Martini, possess the impression of personality. The renewal in art was not always agreeable to those granting the commissions. Ambrogio Lorenzetti had this experience. An order for an annunciation to Mary for a chapel in the environment of Siena was brilliantly carried out by him: the angel arrives, Mary is frightened by the message, she shrinks away trembling. This in accordance with the gospel of Luke, saying that Mary became frightened by the first words of the angel. The wise churchfathers found it unseemly. And Ambrogio Lorenzetti had to start repainting his own creation in a more traditional way; peace and devotion was desired, one did not desire at all an indication of what the painter experienced of human reality. Mary was changed to a conventional stand-

ing figure, accepting modestly the message, with the hands crossed over her heart. How was it discovered that Lorenzetti had to reconsider the execution of his commission?

After the last war, due to the destruction of many monuments in Italy, a technique was developed for removing the frescos from the walls, in order to preserve them. Under the frescos was revealed the original design drawings on the wall. In this way the original drawings of Lorenzetti's "Annunciation" were discovered.

In that design drawing an almost "Rembrandt" vision can be recognized... that later he was obliged to alter.

The artists who created the frescos of the *Camposanto in Pisa*, remain anonymous; although the name of *Benozzo Gozzoli*, a pupil of *Fra Angelico*, is mentioned, it is by no means certain. After Giotto these frescos are the first move of decisive importance.

Neither Giotto himself, nor any of his followers could have painted the taut neck of a terrified horse or the plague infested corpses.
What was said about the paintings in the Camposanto in Pisa, applies equal-

84. *Simone Martini, ca 1282-1344*
Guidoriccio Ricci da Fogliano, *1328*
Fresco
Palazzo Pubblico, Siena

84

83

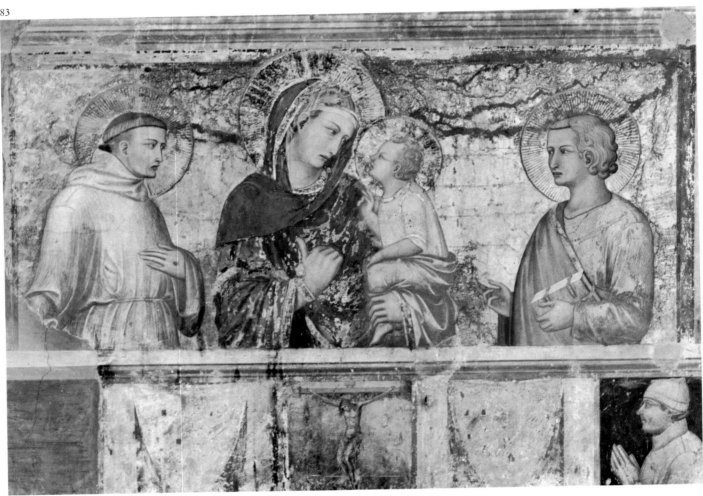

83. *Pietro Lorenzetti, ca 1280-1348*
Madonna and Child, *ca 1326-30*
Fresco
Basilica of San Francesco, Assisi

ly to those by Lorenzetti in the Palazzo Pubblico in Siena.

A heroic art changed into a genre art. The subject was daily life with all its variety.

One sees bulls for the plough, donkeys with sacks on their backs, peasants with flails over their shoulders. A new idea of landscape also appears. Lorenzetti does not style in large lines like Giotto anymore; he paints what is before him day by day: trees, woods, plants, cornfields, vineyards, farms and the crowds in the streets of Siena. The development towards naturalism went so far that a pupil of Giotto, a certain Stefano, got the nickname "ape of nature" for his naturalistic style. Such a title obviously went too far; but most of the painters of the Trecento considered their object reached as soon as they had succeeded in telling a story in a comprehensible way.

A great artist who was influenced by Giotto, as well as the Sienese masters, was the Florentine *Orcagna* (1344-1368). He was not only a painter, though he saw painting as his most important activity. Nevertheless he was the most important executor of the large sculptured tabernacle in Or San Michele in Florence, the style of which clearly indicates the change from Middle Ages to Renaissance. Further he contributed to the mosaics in the front of the *cathedral of Orvieto* and then to the design of the *cathedral in Florence* – under the supervision of the building master *Arnolfo di Cambio*. His paintings and frescos show originality and his influence on Florentine painting at the end of the 14th century was such, that later masterpieces that were made by other hands, were attributed to him. (This goes for two frescos in the Camposanto in Pisa, which Vasari wrongly attributed to him. For the Santa Croce in Florence he painted an enormous fresco 7 × 18 meters (!) that consists of three parts, with the themes: the triumph of death, the last judgement and hell. Undoubtedly a most important masterpiece from the middle of the 14th century, it has been mutilated irreparably by the building of altars and monuments in the cathedral in the last century.

It was probably painted shortly after 1348, when a horrible plague was still fresh in the minds of the Florentines. Fragments of the fresco were rediscovered in 1911 and 1942 behind the altars, particularly a part of the Triumph of Death with beautifully painted shouting beggars, trampling a heap of dead bodies under foot. As appears from fragments from the original fitted text, the beggars shout: "Oh, death come!
Oh, medicine for all sorrow and pain.
For us prosperity took to its heels.
So come! Prepare our last meal."

85. Ambrogio Lorenzetti,
Ca 1319-1347
The Effect of Good Government
in the Town, *ca 1338*
Fresco
Palazzo Pubblico, Siena

85

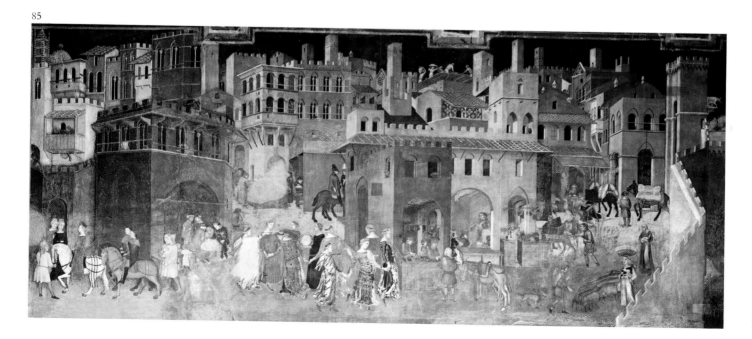

The Conquest of reality

At the end of the Middle Ages France was absorbed with the striving of their kings for a united country, through centralization of government and the withdrawal of fiefs. The crown became hereditary.

War was waged against an England, that had taken over large areas of France; the Hundred Years' War was going on, and Joan of Arc, peasant or royal – a point the historians cannot agree on – but, certainly a legendary woman who liberated parts of English occupied France.

The towns grew in importance, and when a cathedral rose to tower above the surrounding houses, it was not only a spiritual monument, but in the eyes of the citizen, a mighty symbol of the importance of his native town.

The Gothicism of the Ile de France

The Romanesque style in France had already left its mark, with the first indications of the Gothic. The move from Romanesque to Gothic building principles was confirmed in the "Ile de France", where they continued building mainly on the experiments started in Normandy, (e.g. in Caen). In those days "Ile de France" derived its great importance from being the centre of the French monarchy.

The origins of the Gothic, are found in the west of "Ile de France", and are closely related to the Romanesque churches of Normandy. But, the actual birth of the Gothic style is found in the *cathedral of Sens* and in the *abbey church of Saint-Denis*.

Later the *cathedrals of Senlis, Arras* and *Laon* were a witness to the successful break-through.

Around the year 1200 the originating phase of the Gothic ended. The style was established and soon reached its zenith, its classical moment. All this happened in a rather short period (the first years of the 13th century) and in a rather limited area, the area between the Rhine and Loire (Strassburg to Utrecht, Tours to Beauvais). *Chartres* is the first in that glorious row of Gothic cathedrals. Here the new building style is established and the hesitations of the transitional stage are gone: the flying buttresses break almost completely the upper longitudinal wall.

The façade of the *cathedral of Reims* is a masterpiece of clarity and res-

86. Cathedral of Bourges, front 1230-1265

86

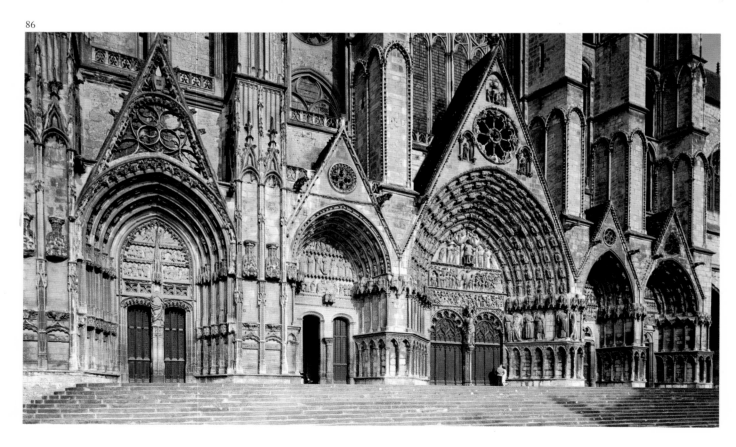

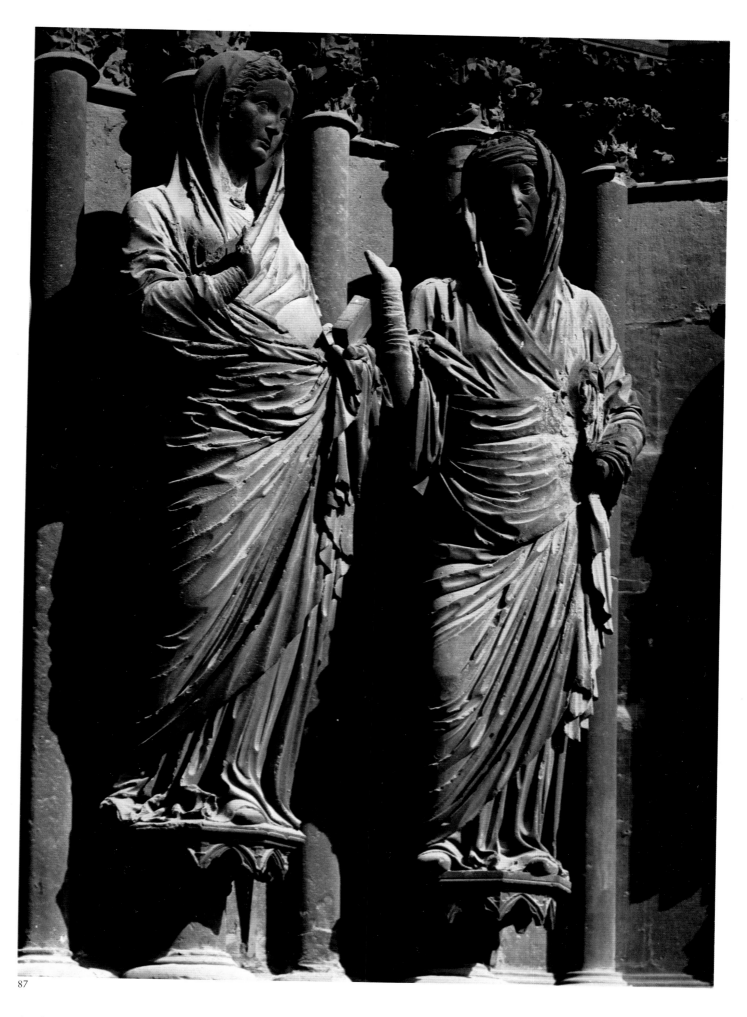

87

87. Mary and Elizabeth,
Detail west front
Ca 1220
Cathedral of Reims

88. Ekkehard and Uta,
Detail west choir
1260-1270
Cathedral of Naumburg

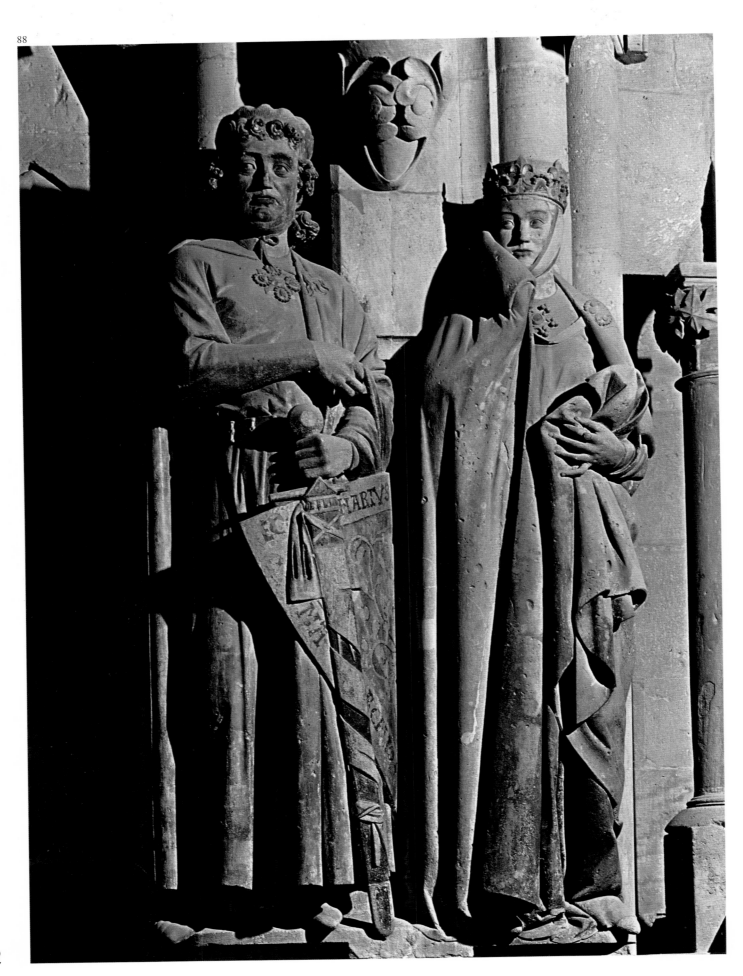

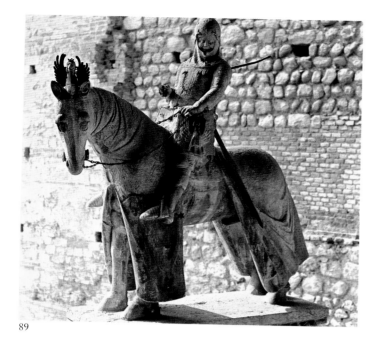

89

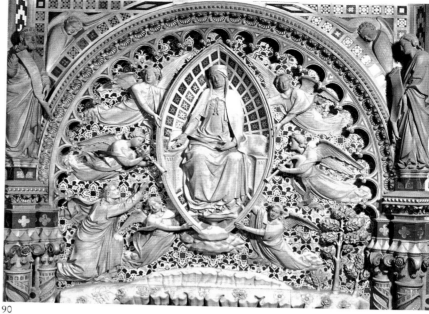

90

89. *Equestrian Statue of*
Can Grande della Scala,
Museo di Castelvecchio, Verona

90. *Andrea Orcagna, ca 1304-1368*
Assumption of the Holy Virgin,
Marble, 1355-59
Tabernacle of Or San Michele,
Florence

91. *Lukas Moser, active early*
15th century
The Crossing of the Saints, *1431*
Tiefenbronn Church

91

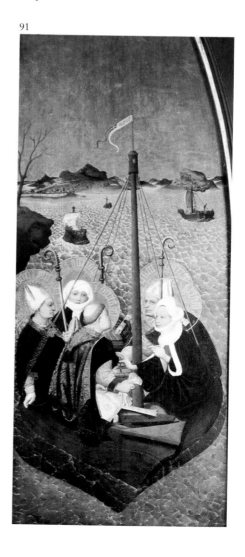

traint; a pinnacle of achievement.
The *cathedral of Bourges,* a contemporary of Chartres, begun in 1190 and not completed before 1270, does not quite belong here.

The different heights of the inner and outer side-aisles, allow the structure to climb in steps to the centre.

In all Middle Ages architecture, including the Gothic, the sculpture and painting perform purely a service. The creators remain nameless; between sculptors and stone masons, the difference is not shown.

Both contribute something to God's house, each from his own talents. A lot of sculpture in the cathedral of Reims shows strong influences from Chartres and *Amiens;* indeed some of the figures seem to come out of those workshops, but other masters appear too. Firstly the great unknown, who created the remarkable figures of the visit of *Mary to Elizabeth.* It almost seems as if the style of both these figures in the west hall has been inspired by ancient examples. The courtly element is clearly perceivable in the stance and expression of the two smiling angels.

Gothic Sculpture

In Italy, Gothic sculpture cuts a completely independent figure – not a part of any architecture: take the *Equestrian statue of Can Grande della Scala* of about 1330. With this sculpture a tradition started which was originally confined to Verona – the home of the Condottiere and which grew out later, in the Renaissance, to a style that in the *Gattamelata* of *Donatello* (in Padua) and the Colleoni of *Verrocchio* (in Venice) found its ultimate expression.

French influences spread over the borders, in the first place to Germany. The more gentle character of French art brought some softening in Germany.

The interaction between the German and the French mind, led to good results, as the most important example of it shows: the *cathedral of Bamberg* built in the second quarter of the 13th century.

In the famous Horseman of Bamberg the ideal of this period, the chivalrous human being, has found its most beautiful and worthy embodiment.

63

92

92. *School of Jacob de Gérines*
Anna of Burgundy as Modesty,
1445-48 (or 1476)
Rijksmuseum, Amsterdam

There are also undeniable resemblances to works at the *cathedral of Strassburg;* like the Elizabeth of Bamberg, that is of an unequalled spiritual and sculptural level. The generally unknown *Master of Naumburg,* who originally worked in France, created his most famous works in Germany. It is probable that German sculpture reached, in the Naumburg figures, its only classicism and at the same time its highest expression.

Because of the severe and yet very feminine beauty of her strong head, the figure of *Uta,* daughter of Esikos V von Ballenstedt, and wife of *Ekkehard II* is remarkable.

Ekkehard II played an important role in establishing the cathedral of Naumburg. These figures are of great human depth and dignity, crowning a rare phenomenon in German history.

Painting in the North

The painting of the Middle Ages began later in the north than in the south. Panel paintings rather than frescos. The intimacy of the format goes hand in hand with the difference in character between the south and the north.

Gothic painting starts in Germany with Master *Bertram von Minden,* who was born in the middle of the 14th century. He started with the altar of the Niederwildungen church, that was eventually completed by his pupil *Konrad von Soest.* This clearly represents the Gothic element in German painting; von Minden possesses the spiritual striving, the human body of the Gothic.

His figure of Saint Joseph was built like a cathedral; reaching up to heaven. With *Master Francke* the Gothic reached a distinguished elegance. In Cologne the tone is given by the Bodensee painter *Stephan Lochner.* His name is often mentioned in the Cologne archives, where he married, settled down and became a member of the municipal council. He died in his thirties, probably from the plague. His work is characterized – as well as the complete Cologne school of that period – by a distinguished, intimate and graceful noblesse; German art historians talk of the refinements of the trade-aristocracy. The art of

93

93. *Konrad Witz, 1400-1445*
St. Catherine and St. Magdalene
Panel, ca 1440
Musée de l'Oeuvre Notre Dame,
Strassburg

64

94

94. *Martin Schongauer, ca 1430-1491*
Portrait of a Young Woman
Panel
Private collection

95. *Claus Sluter, active 1380-1406*
A Mourning Man *from the Tomb of*
Philip the Bold
Marble, 1404-1410
Musée des Beaux Arts, Lyon

95

96

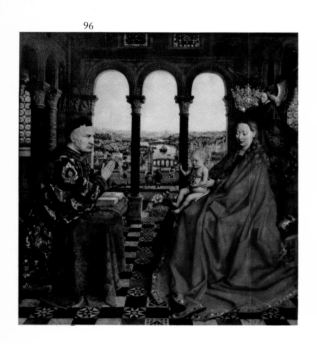

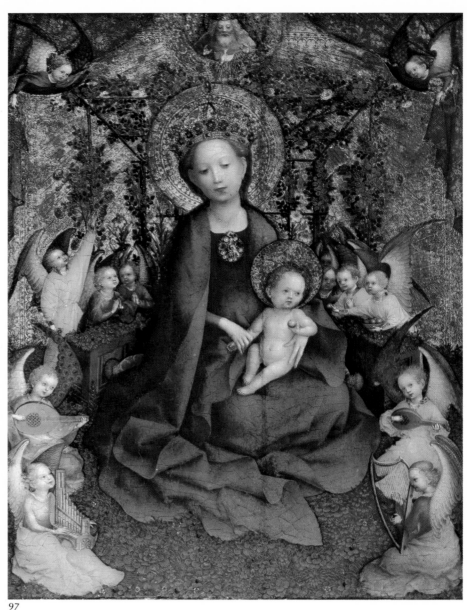

97

the "Kölner Schule" could be a reflection of this. Lochner distinguishes himself, in other respects from his predecessors by the atmospherical in his art; the tender "sfumato" that completely loses the sharp contours of the preceding painters. This "sfumato" gives the works of the Cologne school a naive sentimentality, a kind of earnestness, that is traceable in the famous *Mutter Gottes im Rosenhag,* painted between 1430 and 1440. The mystical earnestness, which also had its effect on the theology of that time (e.g. with Master Eckhardt) could have softened Lochner's contours. In the upper Rhine areas it is *Konrad Witz, Lukas Moser* and *Martin Schongauer* who set the style.
Schongauer, with his famous Madonna of Colmar, repeats the type, created by Lochner, of the Mother of God, surrounded by flowers. This painting is also full of tenderness; however this precision does not detract from its monumental qualities.

Witz, who worked in Basel and Geneva, had a style that was characterized by a dignified simplicity; yet, his personal life was somewhat different and he was often before the magistrates: a notorious troublemaker. Moser did not agree either with the direction art was going in those days: "Weep, art, weep and wail" he wrote, „Nobody cares for you anymore".

Liberation of the Landscape

Moser and Witz are of importance because they gave the landscape, for the first time in German painting, an independent value; from a fundamental relationship with the landscape they came – also in paintings with religious themes – to an art in which the landscape no longer had a subordinate, decorative function. The landscape breaks through the background; heaven is painted as heaven, as a sort of atmospherical firmament, in an airy blue with

98. Jan van Eyck, ca 1390-1441
Giovanni Arnolfini and his Wife
Oil on panel, 1434
National Gallery, London

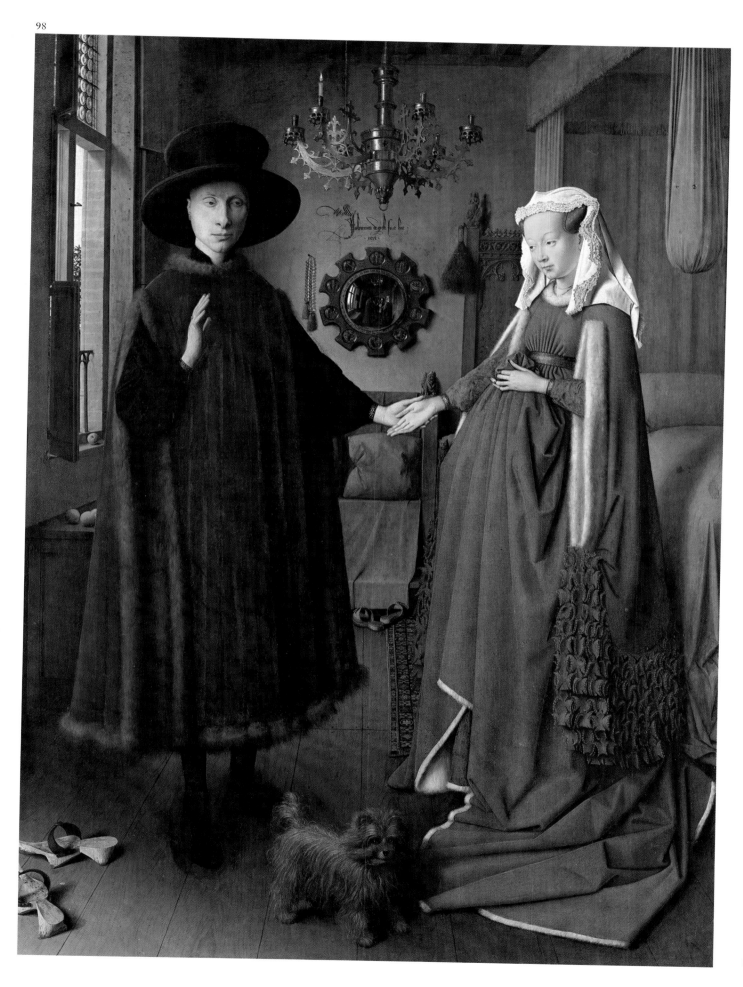

clouds. For centuries nobody had the idea of painting a real "heaven" instead of a golden background or a decorative space.

Burgundy

Burgundy deserves a place in the history of art with and independent of France. John II of France, called "the Good", gave Burdungy on loan to his second son, Philip the Bold. Philip married the heiress of Flanders. Under the third duke, also called Philip the Good, Burgundy reached the heights of territorial ambition and power.

A culture developed of great refinement. The centres were Dijon – with the dominating figure of *Claus Sluter* – and Flanders, where the so-called Flemish Primitives – *Van Eyck, Van der Weyden* and others – brought painting to its first blossoming in this part in Europe. Around *Sluter*, from Holland several other sculptors and bronze moulders worked for the Burgundian court. Sluter had a strong influence on Burgundian art, and via this on the total French sculpture of the 15th century.

Jacob de Gérines, who was credited with the figure of *Anne of Burgundy*, the personification of Humility, worked in the Flemisch part of Burgundy.

Under Philip the Good the Flemish towns became particularly important as art centres. Consequently, many artists in Burgundy got orders elsewhere. This, of course, contributed to the spreading of their style.

The Flemish Primitives

Among the briefly mentioned Flemish Primitives, *Jan van Eyck* had a leading place, not only in a chronological sense. He was born about 1390 and died during 1441 in Bruges. Little is known about the life of Jan van Eyck, except his appointment as a painter and "valet de chambre" to John of Bavaria.

Three years later he became a servant to Philip the Good, duke of Burgundy. His major work possibly with his brother *Hubert van Eyck*, is the "Adoration of the Lamb of God" in the St. Bavo in Ghent; there is some disagreement among the art historians about this. Some reject the idea of Hubert's participation; some even reject the existence of a Hubert van Eyck, altogether!

What is remarkable about the Van Eycks is – as Friendlaender has already said – that their work apparently originated out of nothing.

But there must have been something before them.

99

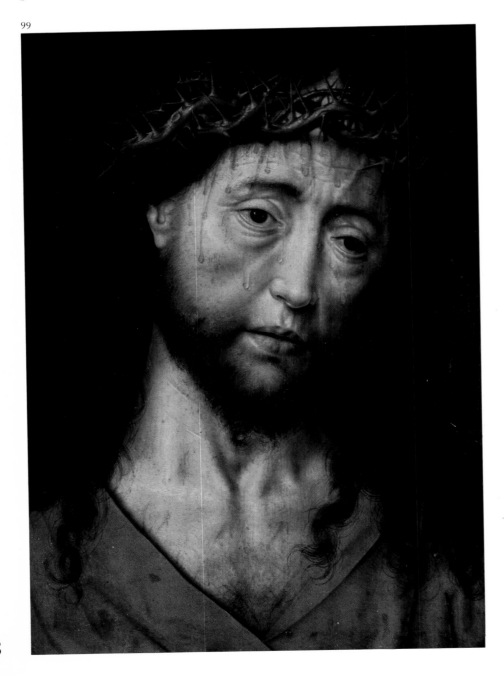

99. Dierick Bouts, ca 1415-1475
Christ in Pain
Panel
Musée des Beaux Arts, Dijon

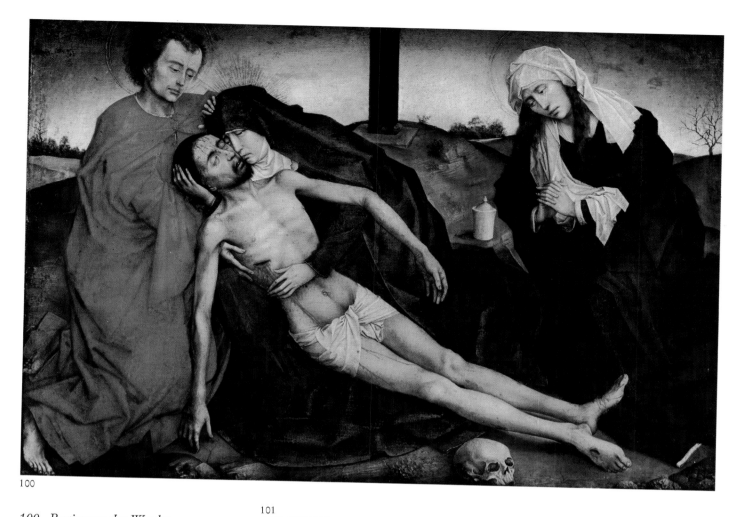

100

100. Rogier van der Weyden,
Ca 1400-1464
Pietà
Koninklijk Museum van Schone
Kunsten, Brussels

101

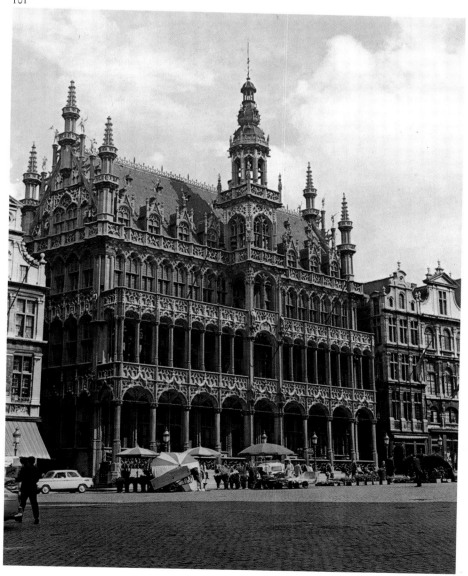

101. Main Square in Brussels
Ca 1402-1454

69

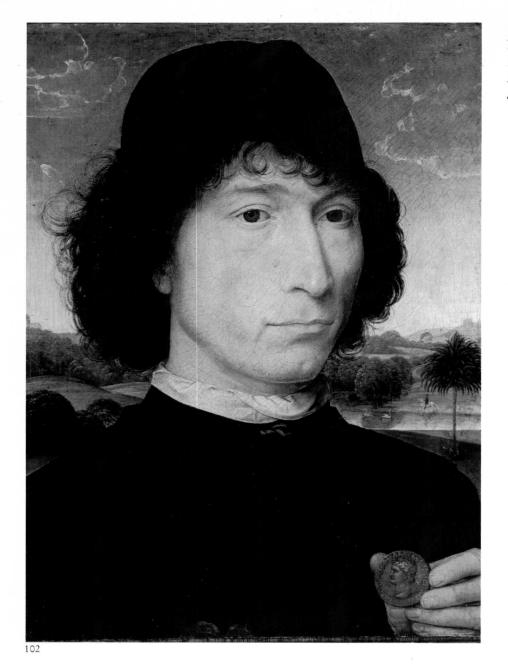

102

102. Memlinc, ca 1435-1494
Portrait of an Italian, *ca 1478*
Panel
Koninklijk Museum voor
Schone Kunsten, Antwerp

Nothing comes from nothing. But what proceeded the work of Jan van Eyck is outside our field of vision. This goes not only for the technique used by Van Eyck: the oil painting. Often the explanation of the characteristics of the painting of Jan van Eyck is looked for in his use of oils.

In fact the opposite is true; the urge to paint as he did could not be satisfied with the techniques that then existed. Van Eyck experimented, and discovered the oil painting process. The discovery of a "book of the hours" – "Les Heures de Turin" – has contributed a lot to clearing-up some questions surrounding the pictural origins of Jan van Eyck.

This book, brought to light in 1902, – since burnt – was illustrated with miniatures generally ascribed to Jan van Eyck. In Turin we still have the "Heures de Milan", in which the most beautiful miniatures are credited to Jan van Eyck.

Van Eyck is also the painter of madonnas, like the *Mother of God with the chancellor Rolin*, now in the Louvre, and of portraits which have seldom been equalled.

These portraits are painted with an eye to naturalistic detail, but in that very soberness is so much piety that the reality revealed becomes even more mysterious.

The portrait of the *Arnolfini married couple* for example, is not just two married people standing hand in hand. There is something inexpressable, that surrounds them, an intangible aurora.

The reality covers more than the sum of the represented objects; something abstract has been added to the clarity. To a certain degree this goes also for the other masters who are called col-lectively – and wrongly – the Flemish Primitives.

Rogier van der Weyden, born about 1400 at Tournay, died in Brussels in 1464, is much more the diligent and dedicated artisan than the inspired artist.

Rogier married young and was an ideal, faithful husband for forty years. He was a good, well-intentioned citizen, who had only one exceptional experience: a pilgrimage to Italy in the Holy Year 1450.

As far as his life and his thoughts go he was close to Jan van Eyck, but in an important respect he differed; a little Gothic was still alive in him, finding its expression in an angular, rather linear style, in the asceticism his figures breathe and in his neglect of the landscape.

Dierick Bouts, who died in 1475 in Louvain, owed a lot to Van der Weyden, yet his art reflects a form inter-

104. *Master of the Virgo inter Virgines,*
Active ca 1470-1500
The Sepulchure
Walker Art Gallery, Liverpool

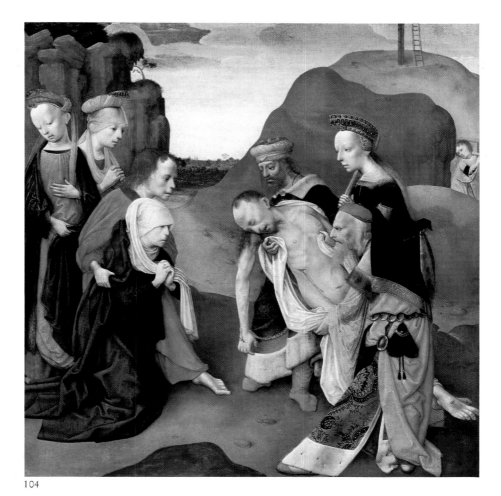

104

103. *Hugo van der Goes, ca 1440-1482*
The Adoration of the Child, *ca 1475*
Panel
Uffizi, Florence

103

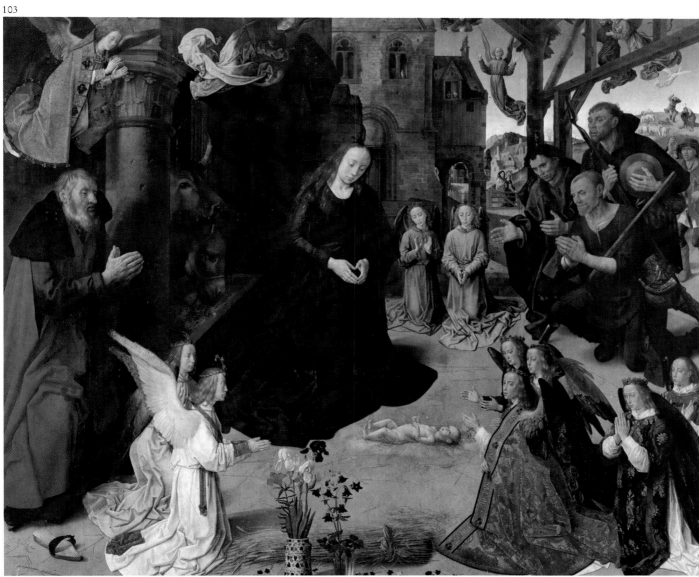

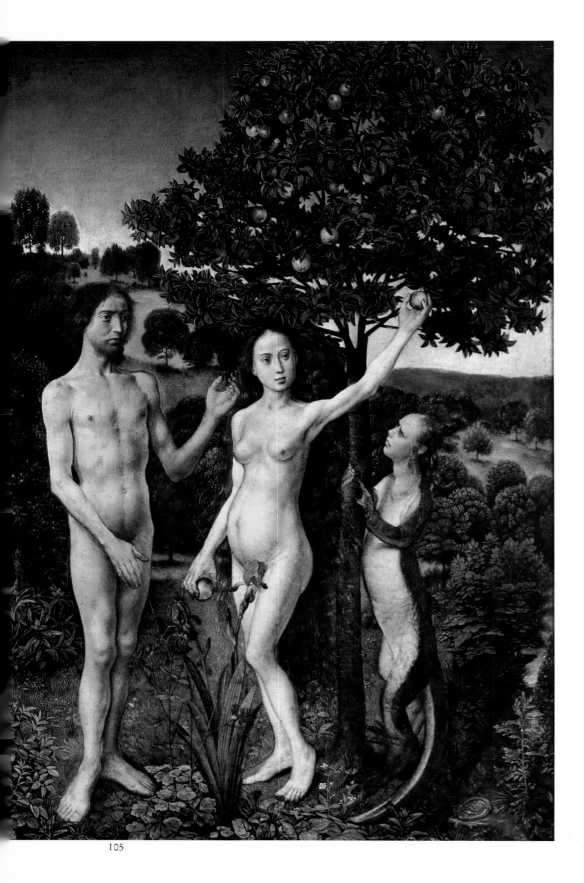

105

pretation that captures the influence of the contemporary Italians.

Hugo van der Goes, born about 1420, died 1488, insane in Brussels, has been presented as one who first brought genius and insanity together in art. During the last seven years of his life he was a maniac, depressive with suicidal tendencies. He spent those years in a monastery. However, he was allowed – as a privilege – to see high personages, like the archduke Maximilian.

Van der Goes is the creator of the great Portinari-altar in the Uffizi in Florence; in this remarkable painting – an *Adoration*, rather unhewn, almost infatuated shepherds suddenly enter the tender world of the Mary figure. The people, shown as shepherds, rough and strong in their features, are in sharp contrast to the dignity of the saints and the spiritualness of the angels. A new form of piety had reached the altar: the devotion of the shepherds, ennobled by emotionality and sincerity.

Memlinc and *Gerard David* belong to the Bruges group of the Flemish Primitives. What goes for Van der Goes, goes for these artists too. Vermeylen said of Van der Goes, he does not belong to the family of great severe creators but he applied a more pleasing taste, to a more advanced open-minded technique and a more intimate naturalness. Memlinc completely misses the tragedy that Van der Goes demonstrates in the "Death of Mary"

Even Van der Goes displays in a few works an intimacy which can hardly ever be found in Van Eyck.

Memlinc was born about 1440 and when he died in 1494, well off and much respected, he left behind a wife and three sons, as well as a reputation as "the best painter of all Christendom". His paintings have a surprising equilibrium, a great mastery, a sacred restfullness and a lofty allure. His portraits of which a lot have been saved, were well received especially by the Italians who lived in Bruges. This is put down to the "agreeable resemblance" to which the painter has added something of his own serene and pure nature.

Of the many Dutchmen, who established themselves in Flanders –

105. Hugo van der Goes,
Ca 1440-1482
The Fall of Man, *1467-68*
Panel
Kunsthistorisches Museum, Vienna

Petrus Christus, Dierick Bouts, Hugo van der Goes, Gerard David – Gerard Jansz. David was the last. It is assumed that he was born between 1450 and 1460. His early work shows the influence of Geertgen tot St. Jans.

Later he was influenced by Van Eyck, Van der Weyden and Van der Goes. Nor did Memlinc leave him entouched. In his later work the Flemish influence is dominant; this becomes evident by an increasing sense of refinement, luxurious grace and charm. This Dutch trait, which could be called sobriety, separates David from Memlinc.

The Northern Netherlands

The *Master of the Virgo inter Virgines*, *Hieronymus Bosch, Geertgen tot St. Jans* and *Albert Ouwater* remained in Holland.

Geertgen tot St. Jans worked in Haarlem, but was strongly influenced by the art of the Flemish towns.

He was born about the same time as Gerard David – 1465 – and died the same year as Memlinc, in 1495.

For insight into the importance of Geertgen to Dutch painting, it is enough to point to the role that the landscape plays in his art. The landscape is depicted in its natural rela-

106. Hieronymus Bosch,
Ca 1450-1516
The Prodigal Son
Panel
Museum Boymans-van Beuningen,
Rotterdam

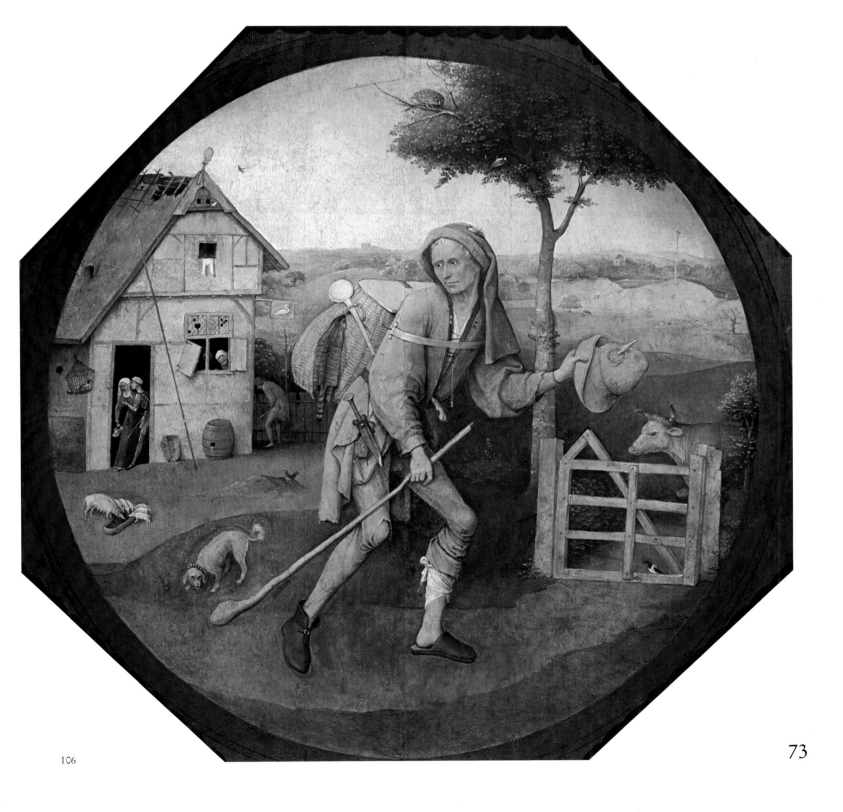

106

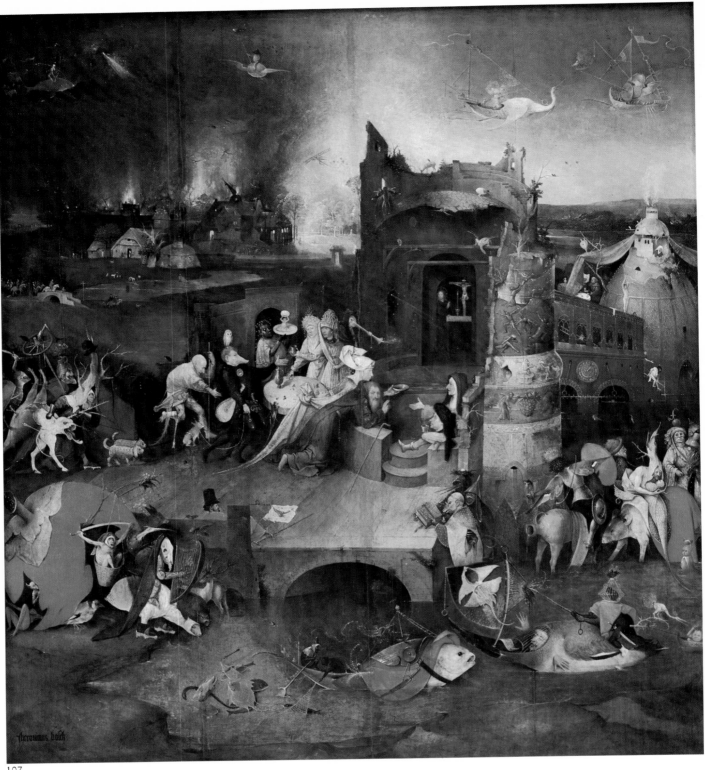

107

107. *Hieronymus Bosch,*
Ca 1450-1516
Temptation of Saint Anthony,
ca 1500
Panel
Museu Nacional de Arte Antiga,
Lisbon

tionship to the figures; it is not just a background element. It cannot be left out without nullifying the whole. The strength of expression in his paintings comes mainly from his landscapes. In this respect a statement of *Van Mander* takes on a special meaning: "Of the earliest painters it is proven that especially in Haarlem – in early times – the first and the best landscapes came into being".

The *Master of the Virgo inter Virgines* is so called from a work of his in the Amsterdam Rijksmuseum; on that work Mary is shown with the child,

in a cloister garden, surrounded by the Saints Barbara, Catherine, Caecilia and Ursula. Many believe that this painting is neither the most expressive, nor the most characteristic from this master; Dr. H. E. van Gelder considers the *Entombing of Christ* a more representative work because of the deep divinity and the fierce naturalism. In the person of *Jeroen Bosch* European painting had one of its most remarkable painters. The autumn time of the Middle Ages is shown by him as the dying and perishing of an old world into a demoniacal situation. In visionary paintings as

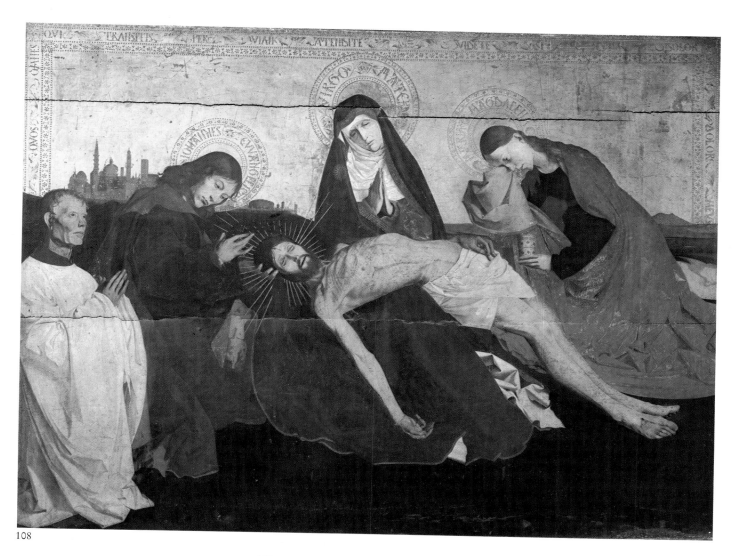

108

108. *Master of the Pietà of*
Villeneuve-Les-Avignon
Pietà, *ca 1460*
Tempera on panel
Louvre, Paris

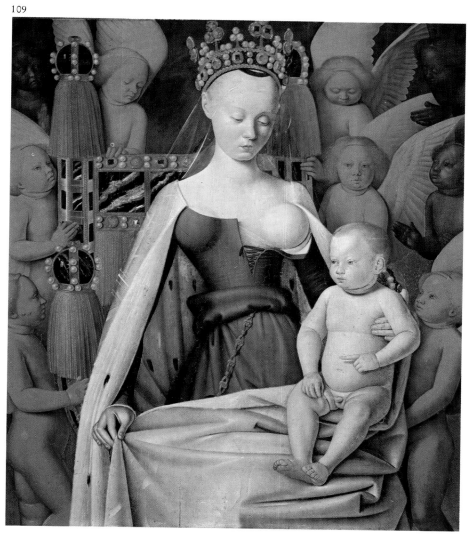

109

109. *Jean Fouquet, ca 1415-1480*
Madonna and Child,
Surrounded by Angels, *ca 1450*
Detail of the Melun Diptych
Panel
Koninklijk Museum voor Schone
Kunsten, Antwerp

75

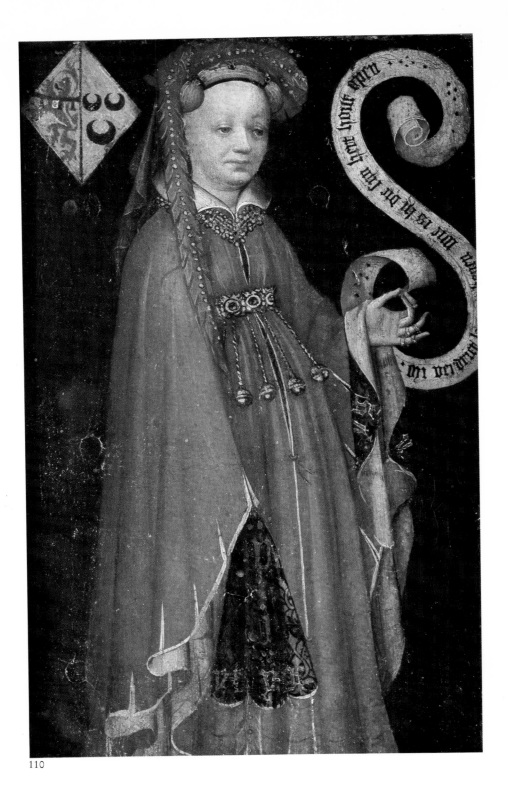

110

110. Anonymous
Portrait of Lysbeth van
Duvenvoorde, *ca 1430*
Parchment,
Mauritshuis, the Hague

the *Temptation of Saint Anthony* man
and nature are in rebellion as if in the
passing of a world.

All fantasies from Middle Age believe
that demons are brought to life and
take on three dimensional art forms.
The earth seems to produce new and
more horrible monsters. Men, ani-
mals, fishes, birds and dead things
grow together into creatures that ha-
rass and frighten the Holy Anthony.
Mountains change into buildings;
buildings into plants; everything is
continuously changing in form.

As nobody had ever done before,
Bosch showed how the visible world
is peopled with the invisible. Both
heavenly and diabolical powers re-

vealed by the artist. It is remarkable
how the whole diabolical cosmogony
can find expression from the imagi-
nation of one artist.

Painting in France (Dijon and
Avignon)

The art of the Flemish Primitives is
an urban art: from the towns Ghent
and Bruges. These towns were con-
nected commercially to Italy; that is
why masterpieces from the low lands
found their way to Italy. Apart from
the connections with Italy there were
those with Burgundy and the France
of the late Middle Ages. Dijon be-
came a centre of Dutch painting.

About 1400 the painter *Melchior Broederlam*, who was born in Yperen, worked in Dijon in the service of the duke of Burgundy.

From the north French painting received a Dutch influence; from the south an Italian influence. The popes, resident in Avignon, sent for Italian painters; it is known that *Simone Martini* from Siena worked in Avignon. He must have been happy there. He painted frescos in the cathedral and was friendly with the famous poet Petrarca who treated him as "il mio Simone" and mentioned him in his sonnets. Simone painted a small portrait of Petrarca's great love, Laura. It exists today in a doubtful replica.

Both influences, from the north and the south, worked to stimulate French art, while it still kept its specific nature. One of the earliest French painters, at one time called *Jean Maloyel*, at another time *Henri Bellechose*, has a complete character of his own.

And the work of *Nicolas Froment*, in the south of France during the second part of the 15th century, shows clear Flemish influences.

The strongest artists in Gothic painting in France are *Jean Fouquet* and *Enguerrand Chareton*.

The word Gothic here must be used with the same reserve as with Italian art. Both are far from the spirit of the Gothic. Only in a few exceptional works does this spirit make a clear appearance; like in Enguerrand Chareton's *Pietà d'Avignon*.

This painting is one of the finest expressions of mysticism, and combines in an admirable synthesis the monumental with psychical intensity. The sculptural form in this work has an abstract beauty that holds its own with a Florentine out of the Quattrocento.

The same goes for Fouquet, who rejected the Gothic spirit and mentality, and offered a French version of the expressive endeavours of the Italian Quattrocento. He took over the Italian predilection for ancient architectures.

His madonna in the Antwerp museum is considered by French art historians as one of the most perfect works of his century and as a sister to the madonnas of *Baldovinetti*.

Also the portraits of Fouquet have the grandeur of Italian art, with a greater degree of truth. As a miniature painter Jean Fouquet opened the way to the Renaissance of French art. Jean Fouquet was born, very illegitimately, in 1420 in Tours: his father was a priest, and his mother an unmarried woman. This troubled background did not prevent him becoming the king's painter, and going with a delegation of the French Court to Rome.

There he had the rare privilege of painting the Pope.

And it was there he probably met Fra Angelico.

Fouquet died in 1481 in his home town.

111

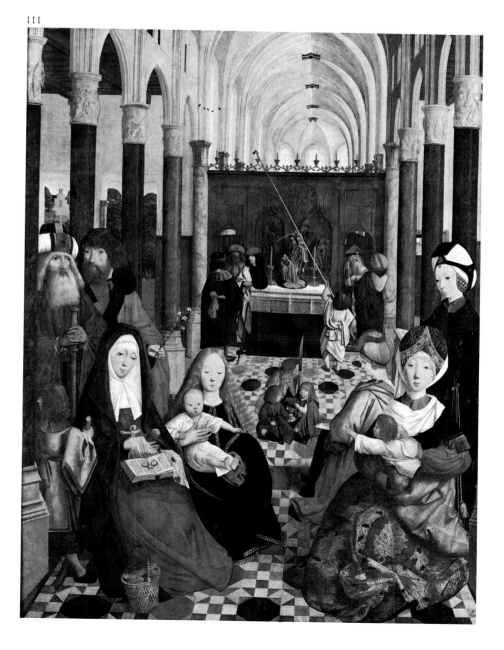

111. Geertgen tot St. Jans
Ca 1465-1495
The Holy Virgin
Panel
Rijksmuseum, Amsterdam

Rediscovered Antiquity

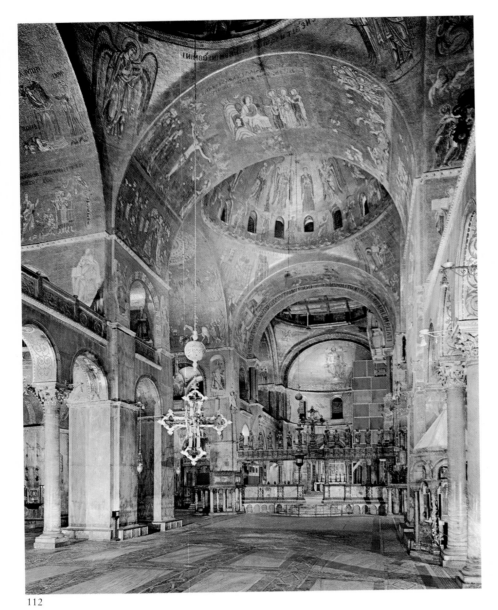

112

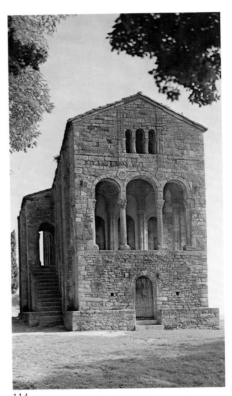

114

113

The 15th century is known as the Renaissance period, the period in which Art was reborn. A rebirth linked with classical Antiquity. Moreover the study of Antiquity played an important role in the development of the Quattrocento, as the 15th century

114. The church of Santa Maria de Naranco, Oviedo
9th century

112. The interior of San Marco Venice,
13th century

113. Lorenzo Monaco, ca 1370-1425
The Crowning of the Holy Virgin
Panel, 1413
Uffizi, Florence

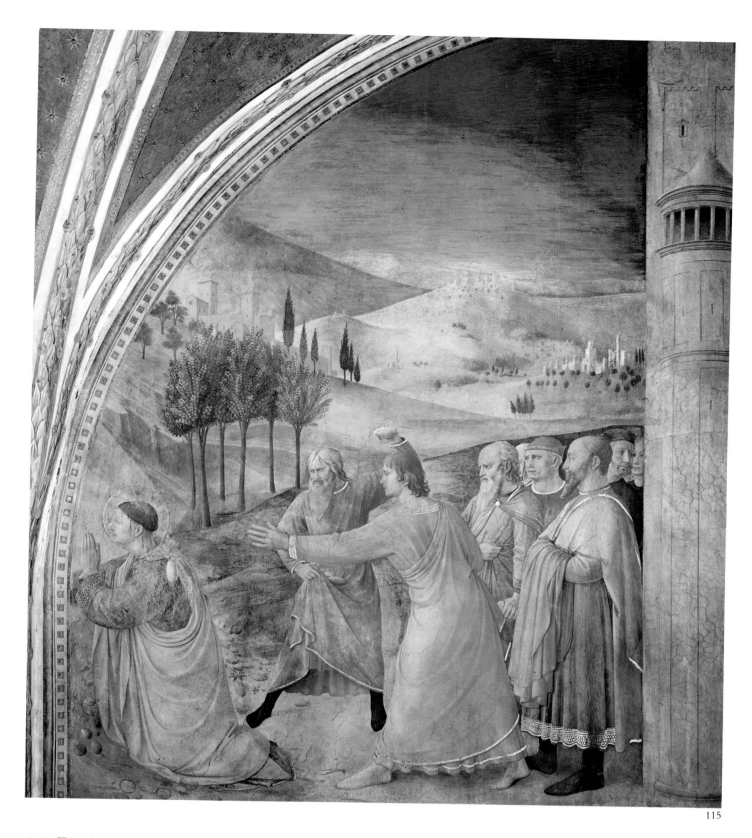

115. *Fra Angelico, 1387-1455*
The Stoning of St. Stephen
Fresco
Chapel of Nicholas V, Vatican,
Rome

is called in art history. The work of pre-christianity writers found enthusiastic readers. Alberti based his treatise about painting completely on the ideas of Antiquity.

Architects used forms derived from classical buildings; and sculptors adopted classical Greek standards as their own.

At the turn of that century the Gothic spirit still influenced Italy. *Lorenzo Monaco* (Laurens the Monk) was a Benedictine brother who painted altar pieces. He was born in Siena at

about 1370 and died in Florence in 1425.

His madonna-figure is still Gothic. The angels of the Dominican monk *Fra Angelico* are similar, in the style of the school of Lorenzo Monaco. He was born in 1387 in Vicchio di Mugello and at the age of 20 entered the Dominican monastery at Fiesole, near Florence. There he was given the name Fra Giovanni (Brother John) but his devoutness and way of life earned him the nickname "Fra Angelico". He started painting when he was over 30. For more than fifty years

he painted – from a peaceful mind – saints and angels with clarity and precision. Even Fra Angelico's work has classical overtones; his frescos and panels show the linear precision of the Greek vase paintings. Fra Angelico's paradise has the timeless serenity of Antiquity.

In 1447 the Pope sent for Fra Angelico; he stayed in Rome until his death in 1455. His long life had been filled with glory and honor, after death he was considered almost a saint.

Integration with Elements of Antiquity

Venice's relationship to Antiquity is based on the Byzantine tradition; for the Byzantine style combines the beauty of the Greek form with the excesses of the Orient. In Venice's San Marco this synthesis has been crystallized in an unique way; what was originally Romanesque, formality is transformed into a playful yet elegant rhythm: the final blooming of an Antiquity overgrown by the East.

The mosaics in San Marco make an ecstatic contribution to the majesty of the interior. The maximum integration of the two elements – christian Gothic and Greek Antiquity is demonstrated in the sculpture of *Andrea Pisano;* with him the relief approaches the humanity of the classical Greek reliefs.

In Quattrocento painting ornamentation takes on a Greek or Roman character instead of a Gothic one. Ionic columns, antique fruit garlands and sportive cherubs decorate the throne of a madonna. The birth of the Christ Child and the adoration of kings is enacted in classical temple ruins. In the second half of the 15th century themes from classical mythology were used.

It would be wrong to assume that because of these influences there is an essential difference between the art of the 15th century and that of the preceeding centuries. In the 14th century the sculptor *Niccolo Pisano* was interested in classicism; there-

116. *Ambrogio Lorenzetti,*
Ca 1319-1347
The Effect of Good Government
in the Country, *ca 1338*
Fresco
Palazzo Pubblico, Siena

116

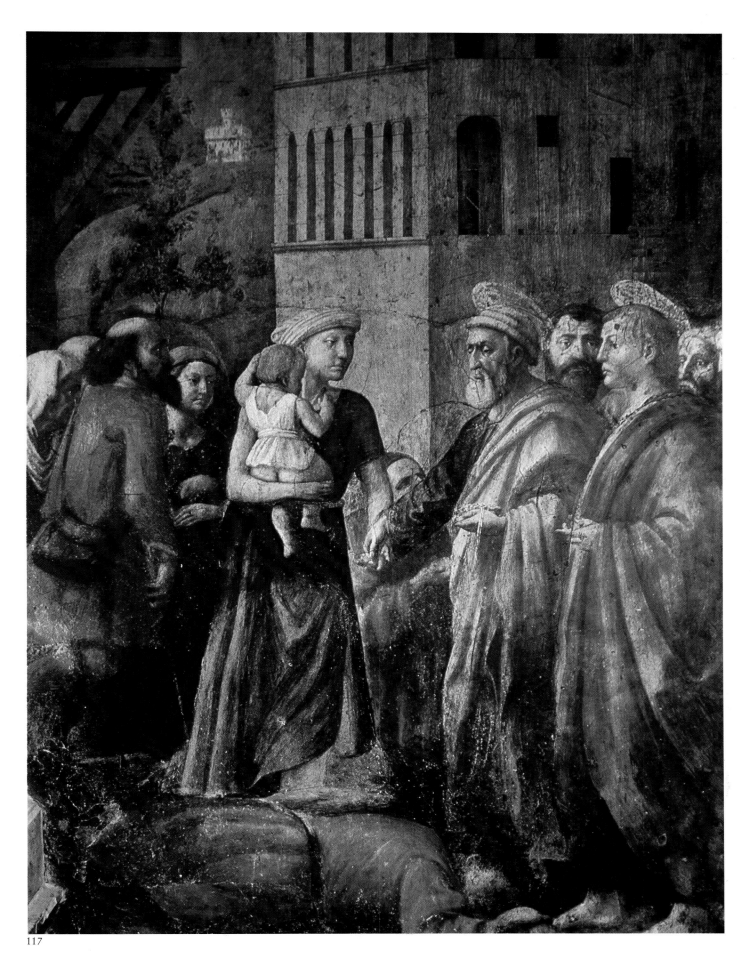

117

117. *Masaccio, Tommaso di Giovanni, 1401-1428*
St. Peter serving out Alms, *1427*
Fresco
Santa Maria del Carmine, Florence

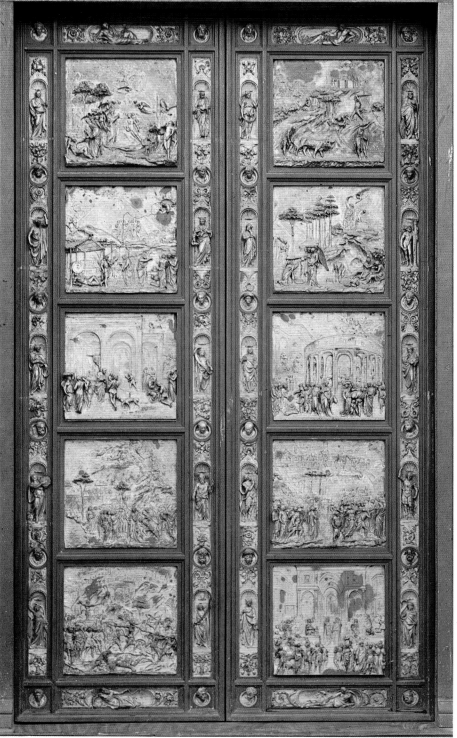

119

118

118. *Donatello, 1377-1446*
St. George, *1415-1417*
Marble
Museo Nazionale, Florence

fore he taught himself from the antique sarcophagi of the Camposanto in Pisa. With *Giotto*, christian and classical tendencies go hand in hand; he portrays the prophet Elias ascending to heaven in a classical chariot drawn by four horses. Among his symbolic figures are Daedalus and Hercules and Phidias representing the art of sculpture and Apelles representing painting. Giotto was a great artist, whose work was of enormous influence both on the Renaissance in general and on Italian painting in particular. Vasari, the Renaissance painter cum art critic and historian, explains Giotto's genius as God given, for his style could not have been learnt from his contemporaries. Vasari's admiration was justified; Giotto who lived from 1266 till 1337, was far ahead of his time. His works are evidence of this.

There are just as many classical elements in Trecento art. *Ambrogio Lorenzetti's* frescos in Siena reminds one of the Pompeiian frescos; in the depiction of the Last Judgement in the Santa Maria Novella in Florence, Charon picks up the dead in his barge. As in the Camposanto in Pisa here is an art full of classical elements.

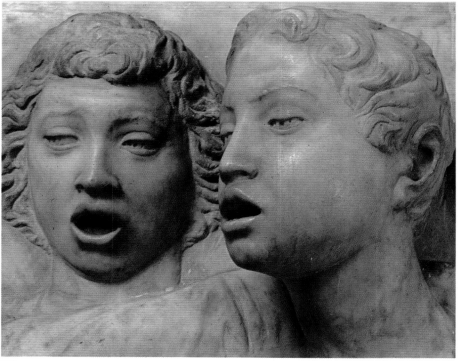

120. *Luca della Robbia*
1399/1400-1482
Singing Angels *(detail of a cantoria)*
Marble, 1431-1439
Museo dell'Opera del Duomo, Florence

120

The Renaissance and Earthly Happiness

The strong influence of classical Antiquity should not be confused with a leaning towards imitation. The greatness of the Renaissance lies in its originality in applying classical lessons to the problems of the time.
The real relationship with Antiquity was based on a similar philosophy of life.
Both cultures were part of the present; the philosophy of the Middle Ages was strange to both.

In the Middle Ages, Earth was considered to be a vale of tears and only the hereafter was important. In place of christian humility came a new feeling, of self-respect, a realization of own strength. Humans were no longer content with the prospect of the hereafter, but started to see the earth as their natural inheritance.
In architecture, sculpture and painting, the domination by religion was over.
In painting, once again artists used themes from history and the legends of Antiquity. *Botticello* painted the

121. *Paolo Uccello, 1397-1475*
The Battle of San Romano,
1456-1460
Uffizi, Florence

121

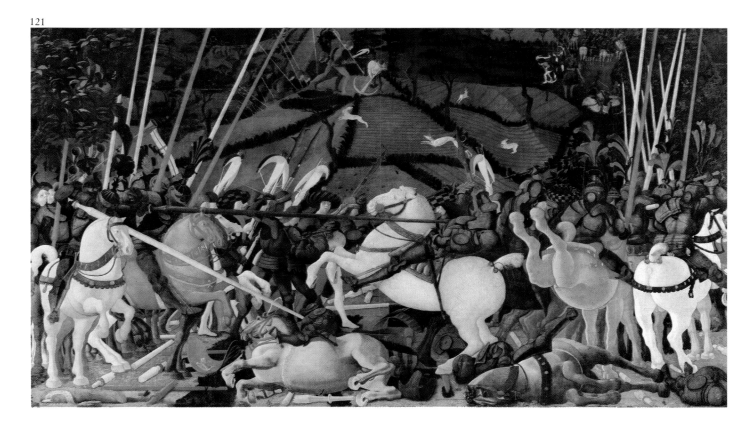

83

birth of Venus, *Mantegna* the triumph of Céres. *Signorelli* the education of Pan. But these themes are not the only ones.

The school known as "genre-painting", generally thought of belonging to 1600 AD, can be traced back to the 15th century. It arises from an intense interest in reality.

In the equestrian statue of *Colleoni* by *Verrocchio*, there is a surprisingly strong sense of realism.

Masaccio's Mastership and the Human Figure

Realism is a major element in the frescos by *Masaccio*. His most important works were completed during the first 30 years of the 15th century, and with his works the Renaissance really begins.

His real name was *Tommaso di Giovanni*, but he was called Masaccio, the "unmanageable Maso". He must have made a strange impact, and he was largely misunderstood. The best of his work can be seen in the fresco's in the Brancacci-chapel in Florence's Santa Maria del Carmine, the San Clemente in Rome, and one work in the Uffizi in Florence.

A notary's son, he was born in 1401, and died, very young in Rome, in 1428.

Masaccio's work has the naturalism that comes from painting directly from a model; the beauty of his figures is not second-hand, that is to say not imitated from a classical pattern. Masaccio was the first artist for centuries to study the human body with an open mind. He was able to represent rest as well as movement with a

122. Domenico Veneziano,
Ca 1410-1461
The Virgin with Child and Saints
Panel, ca 1442-1448
Uffizi, Florence

122

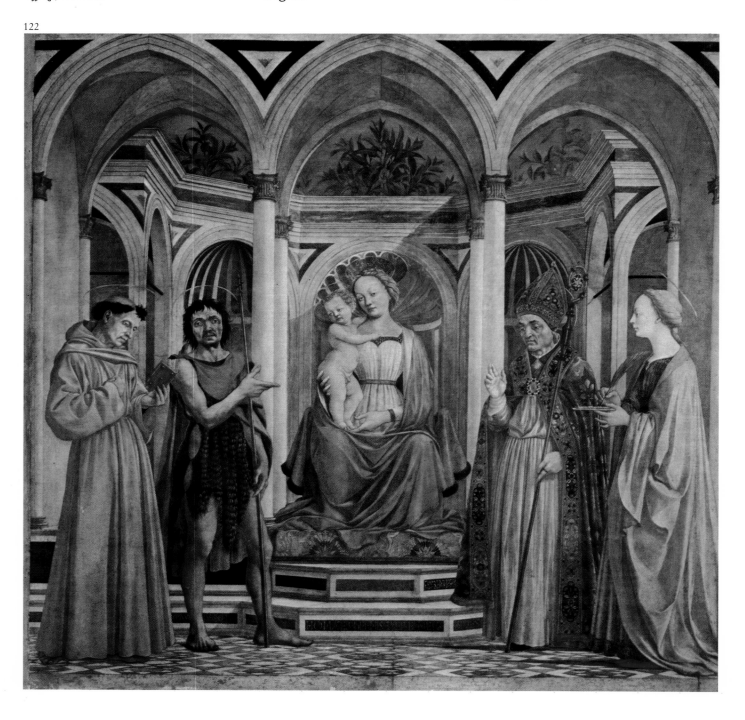

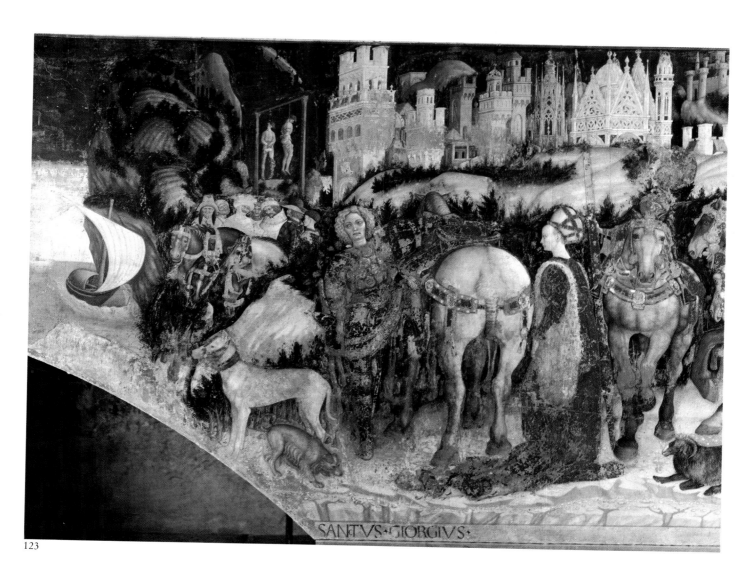

123

124

123. Pisanello, *ca 1397-1455*
The Legend of St. George and
the Prince, *ca 1435*
Fresco
St. Anastasia Pelligrini Chapel,
Verona

124. Donatello, 1377-1446
Head of Gattamelata, *ca 1450*
Bronze
Piazza del Santo, Padua

85

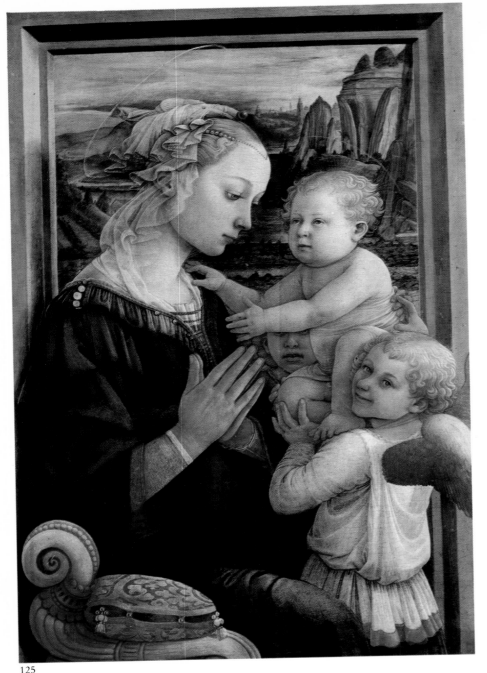

125

126. *Benozzo Gozzoli, 1420-1497*
The Journey of the Three Kings,
1459
Fresco
Medici Chapel, Palazzo Medici
Riccardi, Florence

127. *Front of the Carthusian*
Monastery Certosa di Pavia
Started in 1473

125. *Fra Filippo Lippi, 1406-1469*
Madonna and Child with two
Angels, *ca 1460*
Tempera on panel
Uffizi, Florence

certainty that was amazing in that
time. His Adam, holding his hand be-
fore his eyes and his Eve, weeping and
covering her bosom and the lower
part of her body, are the first master-
pieces of the nude study in Christian
Europe. It would be wrong though
to judge Masaccio purely on the natu-
ralism of his style. His greatness lies
more in the reserved stillness, and the
simplicity of his work. His successors
and contemporaries alike admired
Masaccio's work, especially for its
monumental qualities. *Michelangelo*
learned the basis of his own great
style in the Brancacci-chapel.

The Laws of Perspective and
Undisguised Naturalism

Other laws – those of perspective –
kept the painter *Paolo Uccello* (1397-

1475) busy; for him painting was
above all the solution of problems of
perspective.
The paintings of Uccello project a
feeling of strangeness. In his repre-
sentation of battle-fields, the horses
are surprising; they have the look of
merry-go-round horses. He painted
his horsemen with daring perspective
shortening: they appear to emerge
from the painting.
The landscape is built up in clearly
marked forms, that give it a strong
order. Uccello did not get around to
portraying human emotions.
In Pisanello's work as well as Masac-
cio's the psychical gap that opened
when the religious art of the Middle
Ages stopped, had not been filled.
Only with *Andrea del Castagno* (1423-
1457) did elementary passions find
expression in drastic mime. His most

86

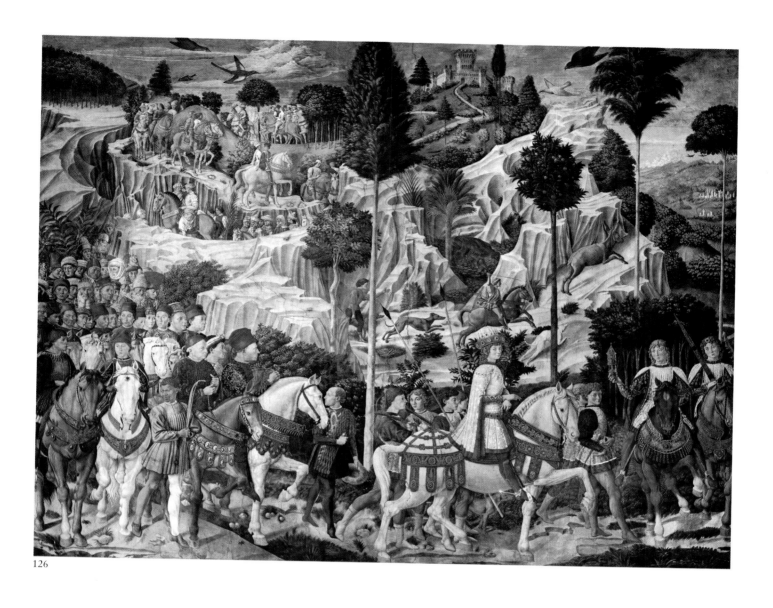

126

127

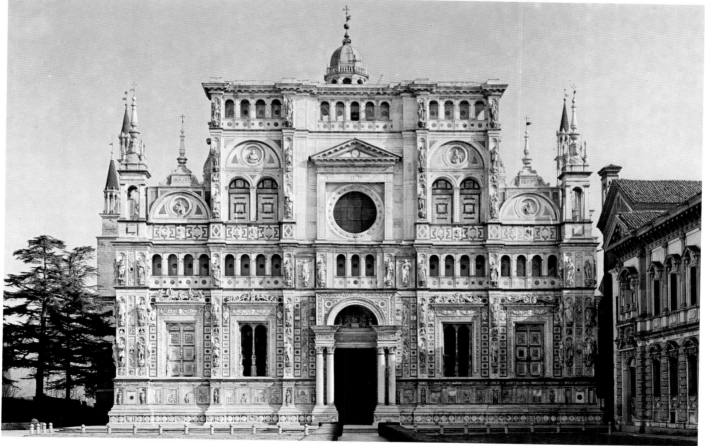

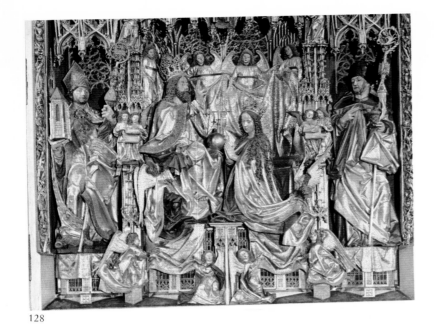

128. *Michael Pacher, ca 1435-1498*
The Crowning of the Virgin,
1471-1481
Painted wood
The centre piece of the Altar of the
Parish church, Sankt Wolfgang

128

129. *Piero della Francesca,*
Ca 1416-1492
Federigo Montefeltro, Duke of
Urbino and his Wife
Battista Sforza, *ca 1465*
Uffizi, Florence

important works were not afraid to exaggerate, if by it the figures could gain more character.

However, it is known that his Mary-series in the San Egidio Chapel, because of its undisguised naturalism shocked important academics. The few works that still exist show Castagno as a master of crude power with a grandiose style. His fresco of the crucifixion in the early church of San Matteo recalls what *Brunelleschi* said of a crucifix by *Donatello:* "You have nailed a peasant to the cross".

The Great Sculptors of the Italian Renaissance

About the year 1400 new forms entered the sculpture of Italy – especially in Florence.

Around 1415 *Donatello's* St. John the Evangelist was created.
Nanni di Banco was one of the first to

129

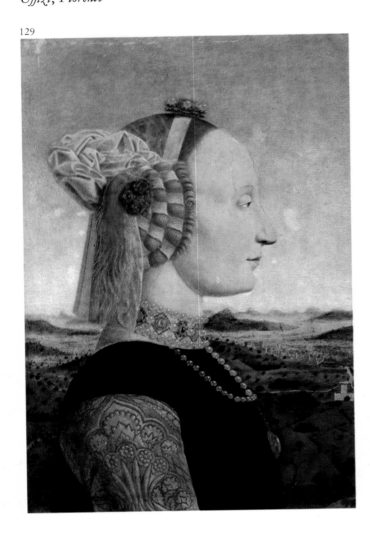
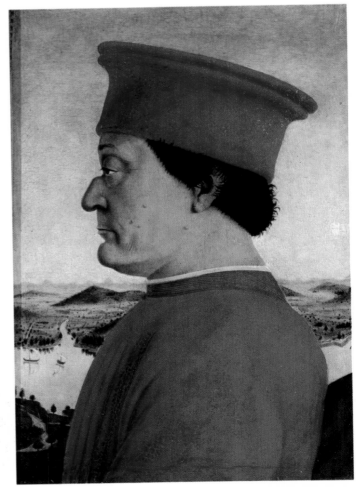

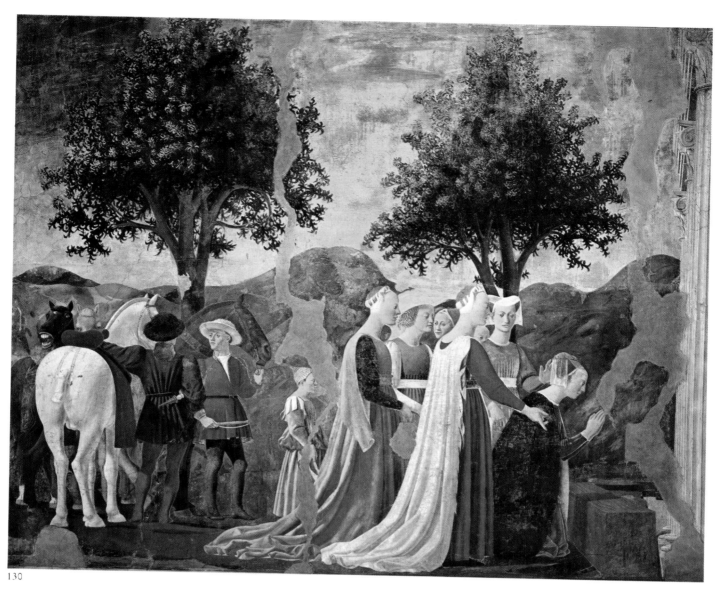

130

130. *Piero della Francesca,*
Ca 1416-1492
The Queen of Sheba and her
Attendants, *1452-1466*
Fresco
The Church of San Francesco,
Arezzo

bring back the majesty of classical sculpture.

For the Florence baptistery *Lorenzo Ghiberti* created his two famous bronze doors. The twenty-eight pictures in relief represent the churchfathers, the evangelists and the life of Christ. The second door shows scenes from the Old Testament; Michelangelo was so delighted with it that he made Ghiberti's door, the *Door of Paradise.* Representative of this renewal in sculptural art were the *Singing angels* of *Luca della Robbia;* singing children of an emotional realism. Realism with little emotionalism can be seen in the head of Donatello's *Gattamelata.*

The Experiment with Color

The first painter, who, independent from the Dutchmen, experimented with color, was *Domenico Veneziano.* Little is known of him, and some of his most important works are lost. His known paintings connect tenderness with elegance, refined color with

a clever use of light. He died in 1461 in Florence, and his art was really Florentine, although his name was Domenico Veneziano.

In the Florentine art of that time he introduced a color play that, after him, was continued by the Venetian painters.

Painters as Chroniclers

Apart from the artists of experiment and adventure, there were those who laboriously popularized what the others had found. To this category belonged *Fra Filippo Lippo* and *Benozzo Gozzoli;* they became the chroniclers of a period and did little experimenting. One was a monk, the other one of the most beloved pupils of *Fra Angelico.* Filippo Lippi was only eight years younger than the master of Fiesole, but differed from him like an 18th century abbot to a world rejecting hermit. The worldliness of Fra Filippo, explains why his paintings have so little in common with those of Fra Angelico. Also his works

89

testify to the joy, that Filippo derived from the new Renaissance architecture. When he paints a "Crowning of Mary", it is not his intention to express the humility and gratitude with which Mary accepts the crown from Christ. He shifts the scene, that previously formed the main theme, to the background and fills the foreground with attractive female figures. In his madonna he is concerned with a very earthly maternal happiness, with a lot of attention to "toilette" and jewels. Benozzo Gozzoli was even more productive than Fra Filippo.

In his frescos the narrative element plays a great role. In his early work is found an echo of the master from Fiesole, his teacher.

The realism and the romantic gives his work a certain charm. Later the romanticism disappears; the poet vanishes the chronicler takes over. The paintings Gozzoli made for Cosimo de Medici in the house chapel of Cosimo de Medici's palace show him at his best.

The Classical Simplicity of the Renaissance Architecture

In architecture there is a noticeable return to the forms and styles of Antiquity. But a simplicity more in line with Romanesque than with Gothic architecture. Romanesque vaulting was rehabilitated; the round arch took the place of the pointed arch. Pillard and other classic details combined make a balanced whole. The façade of the Carthusian monastery Certosa di Pavia is a strong example.

Perspective and Portrait: Piero della Francesca

In general one can say that the big town – in this case Florence – is the breeding-place of advance. The provinces, more conservative and stable, needed more time to free themselves from the old. This was not so at the beginning of the Quattrocento. From the provinces came artists who decisively influenced development. The

131. Andrea Mantegna, 1431-1506
The Dead Christ, *ca 1480*
Canvas
Palazzo di Brera, Milan

131

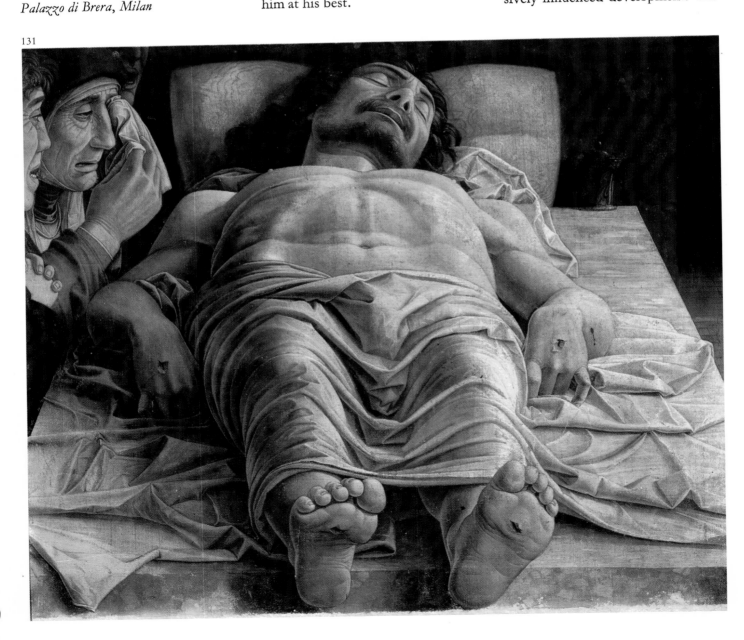

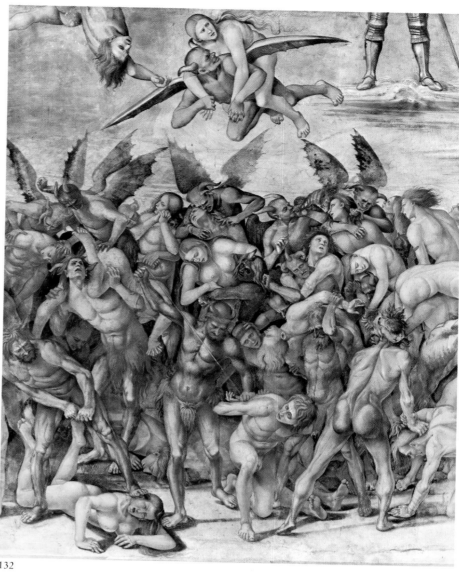

132

work of *Piero della Francesco* for example, who was born in 1420 in San Sepolcro, is different in every way from what came out of Florence. There is something heavy and earthy, something strongly realistic in his art. Piero della Francesca learned from Uccello about laws of perspective. He learned from the works of *Castagno*, the representation of the three-dimensional form. What were experiments to Uccello and Castagno became with him an unconstrained, quiet mastership. His great significance is his ability to present problems that nobody before had recognized. He was one of the first to break with the principle of terraced rising landscape. In his paintings one does not stand in a valley looking towards mountains, no, one stands on a high point and looks over a wide plain. He was the first to discover that objects in the distance get more indistinct and that the distance determines the intensity of the color. Nothing is painted on its own, between things there is an atmospherical, vibrating aura and he established that in nature no consistent color exists, but that the color of everything is determined by the environment.

His portraits of *Federigo da Monte-feltro and* of *Battista Sforza* (now in Uffizi, Florence) are the first Italian portraits in which the relief-style is replaced by the space-style. Again Piero registers the relief with great accuracy, but behind the figures a landscape stretches covering about one third of the image. A broad landscape with a clear blue sky. Because he stuck to the rigid profile, there is a discrepancy between the space-style of the background and the two dimensional-style of the heads.

Piero may not have been completely consistent, but he was responsible for a decisive step forward.
What Piero discovered, has been of far-reaching influence, for example, on the school of Ferrara. Piero's idea about landscape clearly asserts itself there; the "Autumn" of *Francisco Cossa* is an eloquent example.

132. *Luca Signorelli, 1451-1523*
The Last Judgement,
1499-1504 (detail)
Fresco
Cathedral of Orvieto

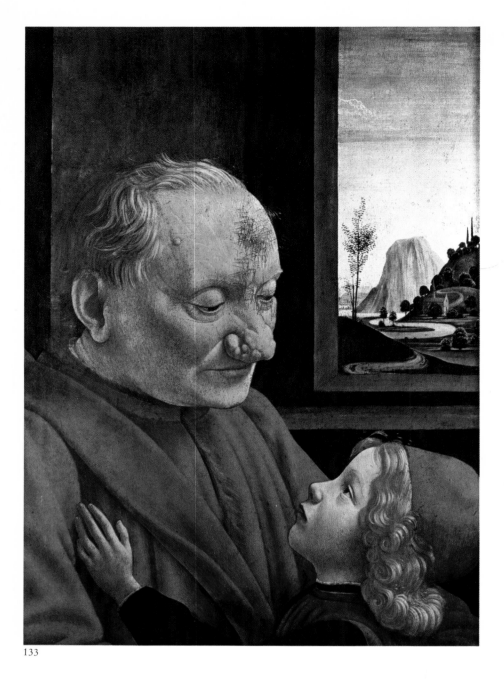

133

*133. Domenico Ghirlandaio,
1449-1494*
Old man and Boy, *1488*
Tempera on panel
Louvre, Paris

Mantegna and Signorelli

Mantegna is one of the very great. He was born in 1431 and had completed when only 26 years old a great commission: the frescos in Padua. Unfortunately they were destroyed during the war.

His fame grew quickly and 2 years later he came to the court of Lodovico Gonzaga in Mantua.

In the castle of the Gonzaga he painted brilliant wall- and ceiling paintings which are intact to this day and deserve, and get, great admiration.

Honors were not only showered on him in Mantua, but also in Florence, Pisa and Rome.

He died in 1506 in Mantua.

Mantegna also concerned himself with the problems of space and perspective. He painted a *Dead Christ*, with a very strong foreshortening, that was revolutionary in that time;

later, in the Netherlands, Goltzius (with his "Adonis") and Rembrandt (with the "Anatomy Lesson of Professor Deyman") were to follow him. Mantegna created a new, severely compositional beauty. For many artists working through the issues raised by Mantegna, would constitute a life's work. That's why the *Melozzo da Forli* without Mantegna is unthinkable.

In Florence, where Mantegna was staying in 1466, he had a follower, *Antonio Pollaiuolo*.

He made anatomy, following Mantegna, his own study area.

This orientation is carried farthest in the work of *Luca Signorelli*.

The significance of Signorelli is in his reputation as the greatest painter of the nude figure before Michelangelo. Luca Signorelli was born in 1441 in Cortono and died in the same town at the age of 82. Many paintings from him are known, but no frescos, except

for one world famous exception. When Luca Signorelli was 60 years old, he created his cycles of the *Last Judgement* on the walls of the Capella Nuova in the cathedral of Orvieto. All that Signorelli strove after – perspective, depth effect, monumentality and sculptural expression of the human body – is combined with overwhelming strength in these frescos.

Change in the Cultural Climate

Around 1470, the era, that could be called militaristic and heroic, came to an end. The initial wildness and intensity of feeling with which the Renaissance began gave way to refinement. *Lorenzo* and *Giuliano de Medici* are representatives of this development; one the aesthetic type who avoids "profanum vulgus", and retreats to his villa in the company of artists and poets; the other interested mainly in

134. *Andrea del Verrocchio,*
1435-1488
and Leonardo da Vinci, 1452-1519
The Baptism of Christ, *ca 1475*
Tempera on panel
Uffizi, Florence

134

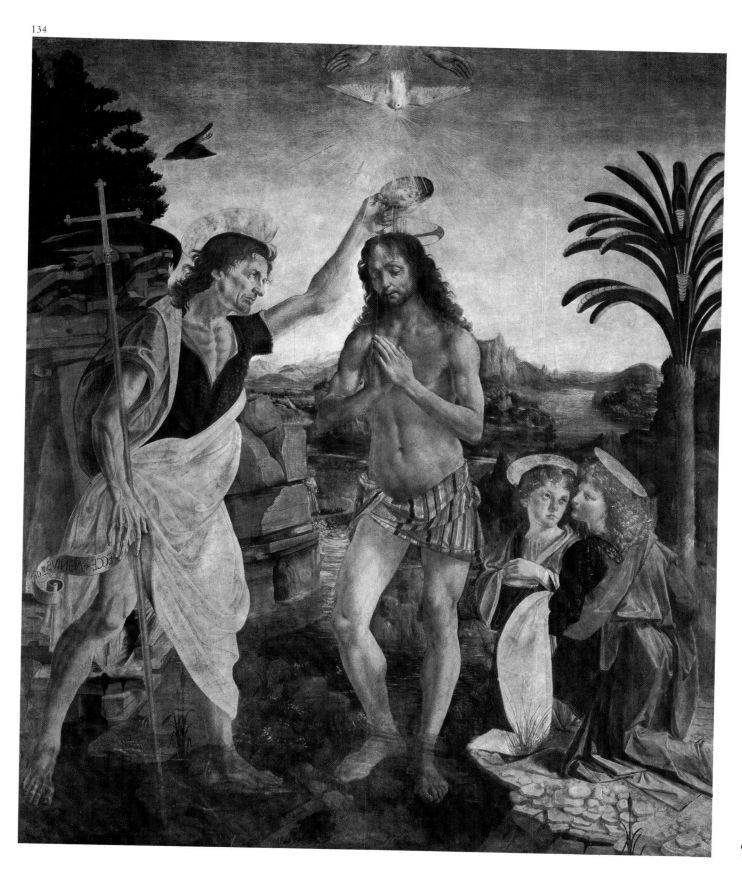

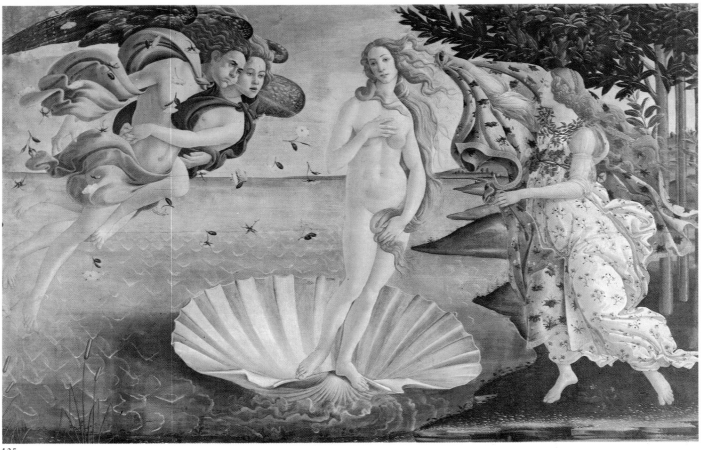

135

135. *Sandro Botticelli, 1445-1510*
The Birth of Venus, *ca 1485*
Tempera on panel
Uffizi, Florence

fashion and women. The change in the cultural climate is reflected in the portraits. The time of the wild condottieri past, a preference for the gracious, youthful figures appeared. The artists of the first half of the Quattrocento (14th century) were brave conquerors who seriously experimented and discovered new fields, while the artists of the second half were the exact opposite. The strong is superseded by the delicate: *Verrocchio*, for instance, presents Mary as a woman of the world, powdered face, a furtive smile about her lips, looking down on a polite, rather prim, boy. The wallpainter, *Ghirlandaio* was the universal heir to all the artistic capital from the preceeding generation. His compositions are magnificently arranged.

The illusion of space is created by simple, strong lines. The details of the landscapes are reduced to the purely decorative. When his frescos of St. Francis at the Santa Trinita in Florence are compared with the *Giotto* paintings in the Santa Croce, one realizes how immense a development had taken place during the Quattrocento. Although Ghirlandaio worked on biblical subjects, his work is in fact a glorification of the great period to which he belonged. The Florence of

those days was made eternal by the dignity and nobility of its culture.
The curious conflict apparent in Renaissance culture is also evident from *Botticelli's* subjects. He was originally a scholar of *Filippo Lippi*. Filippo Lippi was an undisciplined figure. While painting for the nuns of Santa Margherita he fell in love with one of the novices, chose her to model as Mary, and eventually took her away from the convent.
Botticelli, whose real name was Alessandro Filipepi, was born in Florence in 1444; his star rose so quickly that in 1470 he already had his own studio, where two years later *Filippino Lippi*, the son of Filippo Lippi, came to work as his assistant.
Botticelli developed a highly personal style, in which the lyrical lines, the harmonious colors and the sculptural, as well as the atmospherical quality, are important. While his work could, in a certain sense, belong to the primitives, he is, in that style, one of the greatest among the painters of the early Renaissance. The Medici family, who ruled Florence, with their particular interest in art, did not take long to recognize Botticelli's genius. When the artist finished the "Adoration of the Magi" (for the Santa Maria Novella in Florence) the wise men were portraits of the Medici family. They

also gave him a "political" commission, to paint condemned conspirators. The fresco was completed in 1478, but destroyed 16 years later. Also from 1478, is the famous "Primavera", a charming arabesque.

His most famous work, the *Birth of Venus* was completed a couple of years later. She floats towards the land, standing naked on an enormous shell, blown landwards as if on a little ship. The painting, expressing a legend from ancient Greece, shows a tender, but completely non-classical mentality. For this naked goddess of love is modest, covering herself with hands and hair, until the waiting cloak covers her as she steps ashore. No look of jubilant pride in her bodily beauty, but rather a certain sense of shame to be humanly and bodily a goddess. On the other hand the angels in his many religious paintings have the charming features of Greek ephebes. There is an atmosphere of delicate love, even in the religious works of Botticelli; this work owes its special charm to that tenderness.

It was hardly surprising that a monk who was very evangelical watched this development in art with distrust and indignation. *Savonarola*, a Dominican monk from the San Marco monastery in Florence was a sworn enemy of both the new, pagan inclinations in this art, and of the social circumstances that helped to create such an attitude. Under the influence of Savonarola, Botticelli himself came to recognize the conflict in his art; he turned his back on classical history, stopped painting heretical subjects, and began considering the existence of Heaven, Purgatory, and Inferno.

Return to the Romanesque Style in Architecture

Architecture kept, with unhampered enjoyment, its classical tendencies. Moreover, the appreciation of forms derived from the classical, were no

136

136. Filippino Lippi, 1457-1504
The Legend of Lucretia, *ca 1480*
Tempera on panel
Palazzo Pitti, Florence

137

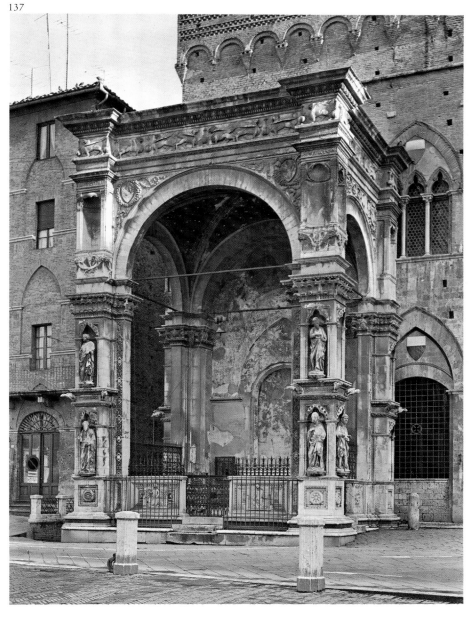

137. Antonio Federighi, died 1490
Capella di Piazza, *1460-1468*
Palazzo Pubblico, Siena

95

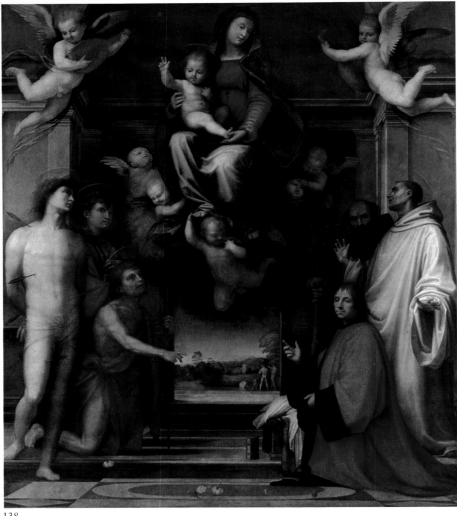

138

138. *Fra Bartolommeo, 1472-1517*
The Carondelet Madonna
Cathedral, Besançon

obstacle to the re-appreciation of Christian-Romanesque forms. It could be said that the renunciation of the Gothic attitude brought back the rehabilitation of the Romanesque stylistic principle in its original purity. The *Capella di Piazza* of *Federighi* is typical of this.

Advance of the Baroque Style

However, the conflicting situation initiated by Savonarola continued in painting; *Lorenzo di Credi* threw all of his nude studies on the fire, and started producing those contemplative paintings which can be seen in so many museums. The monotony of Lorenzo di Credi in contrast to the vivid versatility of *Filippino* (little Filippo) *Lippi;* the son of Filippo Lippi; only twelve when his father died, he eventually became an admired and celebrated painter in Florence. In the early days, he was the image of his tutor *Botticelli*. Later on he became a successor to *Masaccio*. At the age of twenty-seven he received the commission to complete Masaccio's frescos in the chapel of Brancacci. He cleverly and undetectably imitated

Masaccio's style, he took over the pathos of the time of Savonarola, which gives his work a hint of the Baroque. Indeed, everywhere a theatrical, melodramatic tone began to come into fashion. Alongside the discreet forms of the Quattrocento there are the theatrical constructions of the Baroque. In his last few paintings .Filippino Lippi expresses himself as a true son of the Baroque style; he eventually paints theatrical paintings exclusively for the Church. In Florence, art developed towards a decorative prebaroque style, e.g. the paintings of *Fra Bartolommeo* the son of a donkey man, who failed to escape Savonarola's influence. In 1497, aged 22, he burnt all his secular works. In 1500 he joined the Dominican order, but kept on painting.

Da Vinci and Michelangelo

Leonardo da Vinci, and the younger *Michelangelo*, are part of the Florentine world. Born in 1452 at Vinci near Florence, Leonardo started work as an apprentice in the shop of the sculptor and painter *Verrocchio*, stayed in Florence until 1482 and then

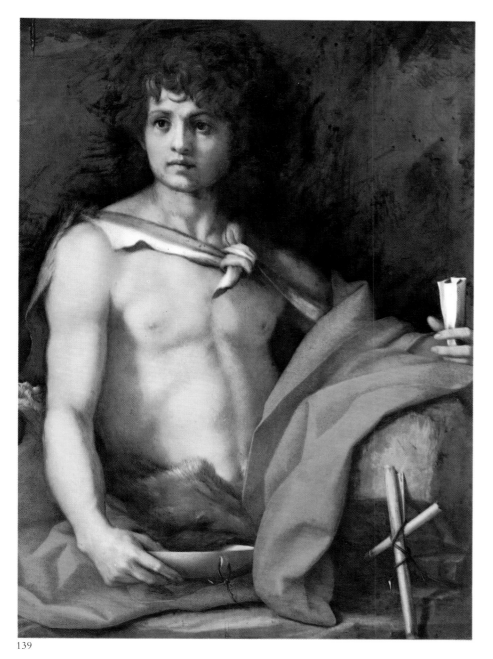

139

139. Andrea del Sarto, 1486-1531
The young John de Baptist,
1514-1526
Palazzo Pitti, Florence

140. Leonardo da Vinci, 1452-1519
The Last Supper, *1495-98*
Tempera on stone
Santa Maria della Grazie, Milan

140

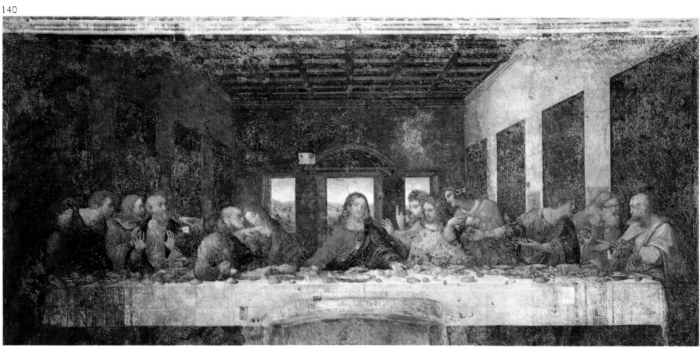

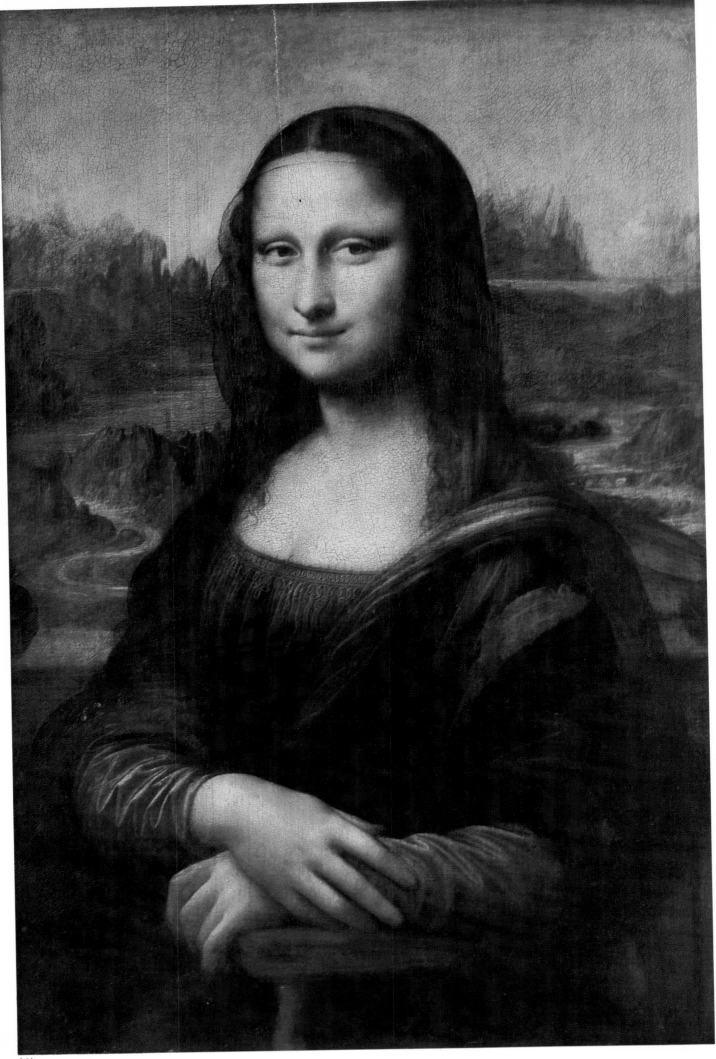

141

141. Leonardo da Vinci, 1452-1519
Mona Lisa, 1503
Louvre, Paris

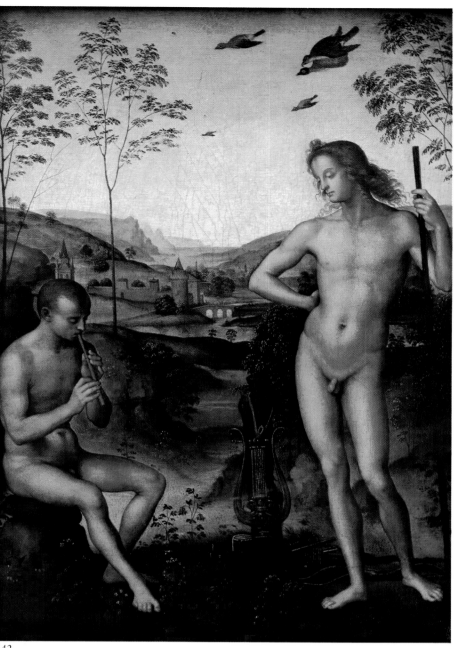

142

142. Perugino, 1446-1523
Apollo and Marsias, ca 1496
Panel
Louvre, Paris

looked for new approaches. In 1487 he was employed as a designer by the Duke of Milan. In 1500 he was in Venice, and from 1513 until 1516 in Rome. In 1516 he was invited to the court of Francis I of France, the first supporter of the French Renaissance. He died in 1519 at Cloux near Amboise in France, at the time a guest of the King who had taken care of him in the royal manner.

Da Vinci overcame the guilt feelings created by *Savonarola*. For the world he recreated the prospect of a dignified sensuality. Leonardo's portraits, as far as he displays a preference for the profile, are linked to the times of *Pisanello;* but there is also a completely new element: the eyes are mysteriously veiled, and there is a slightly sensual smile about the lips. His *Lord's Supper* too, introduced an unknown quality. In his interpretation

of the words of Jesus, "one of you will betray me" the twelve figures simultaneously react. Not only with their heads but with their bodies too. The composition is split up by arranging the figures in groups of three. With the color, Leonardo aims more at hints than at clarity. The unbroken color of the early Quattrocento was lost in the attempt to get harmony of tone values. The colors suggest moods and atmosphere. Thus Leonardo became the founder of the "picturesque", called in German the "malerische" style.

The tragedy round the work of Leonardo is in the sharp traces that are left behind in the art. *The Last Supper* is in a very bad condition. The church, in which it covers a wall, the Santa Maria della Grazie in Milan, was badly damaged during the war by shell-

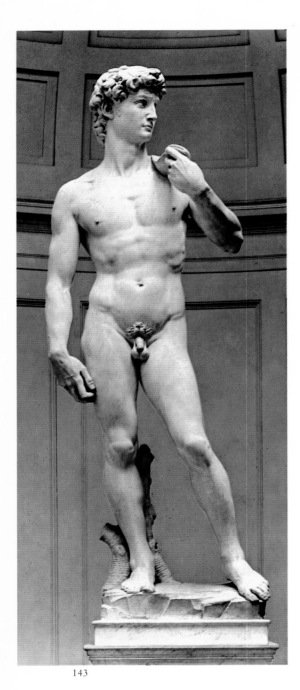

143

143. *Michelangelo Buonarotti,*
1475-1564
David, *1501-03*
Marble
Accademia, Florence

fire, and it is a miracle that Leonardo's fresco, protected by sandbags, survived.

The famous "Battle of Anghiari" had been lost much earlier and it is only known from engravings and other copies by contemporaries. The same goes for his "Leda and the Swan" of which good copies, painted by his pupil *Cesare da Sesta*, have survived. The Leda is also very interesting for a feeling of Leonardo's preoccupation with the mystery of life and reproduction is transmitted.

Leonardo was in fact not only a painter, but also a philosopher, scientist and engineer. His complete work gives us a peep thru the key-hole at the active spirit of a brilliant examiner of man.

Succession to Leonardo

Art had distanced itself from the pious simplicity of the Middle Ages, and the works of Leonardo's successors were full of irony, scepticism and doubt. Elsewhere in Italy, in the Umbric-Roman school a very different initiative developed. This style of *Perugino*, *Pinturicchio*, and *Raphael*. Perugino's work is remarkable for a certain peace, a rather slow, ceremonial dignity.

Despite the sentimental piety of his subject, Perugino, according to Vasari, was an impious man who denied the immortality of the soul. Sensuality and idealism join forces in the work of this master, called Perugino after his hometown Perugia. His real name was *Pietro Vanucci*.

Michelangelo

Michelangelo Buonarotti was born in 1475 and died in 1564. He is usually called great, and even titanic, and he was indeed an exceptional painter, sculptor, architect and poet. But, as a person, a frustrated, quarrelsome man, an erotic sensualist, a religious fanatic, and in spite of it all, a devoted family man. The Renaissance undergoes its apotheosis in his oeuvre; the traditions of the 14th and the 15th centuries, even of the 13th, the great sculptural ideas from *Pisano* to *Guercia*, from *Ghiberti* to *Donatello* are united in Michelangelo's art. In Michelangelo's early sculptural art there is the Florentine realism. But there was already an element that was to become his trademark. A feeling for the unlimited. It would be an understatement to only recognize him as the great initiator of the Baroque style. Eventually, he leaves all

144

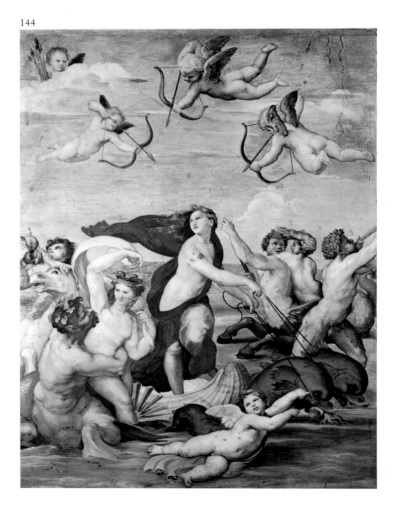

144. *Raphael (Raffaello Sanzio),*
1483-1520
The Triumph of Galatea, *1512-14*
Fresco
Villa Farnesina, Rome

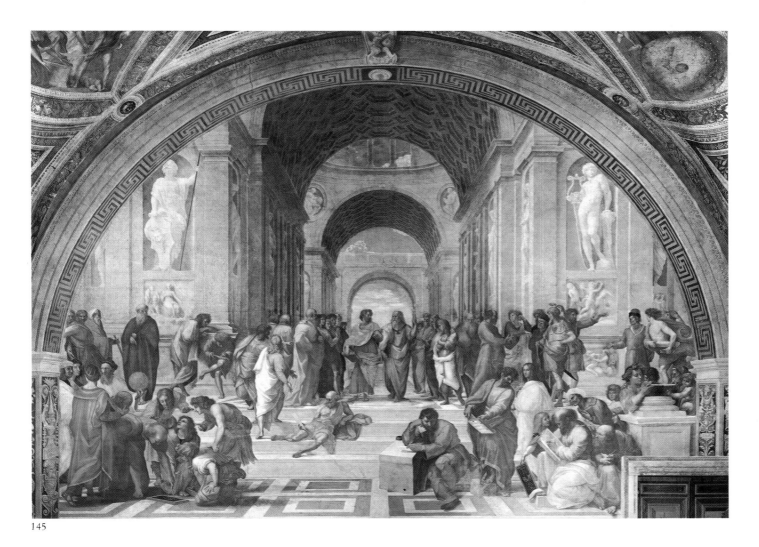

145

145. *Raphael (Raffaello Sanzio)*,
1483-1520
The School of Athens, *1508-1511*
Fresco
Stanza della Segnatura,
Vatican, Rome

creative boundaries behind. Both the classic and the Baroque styles are represented in his work. But he is much more than a combination of these.

For Michelangelo, as a painter and a sculptor, beauty lurks especially in the human body. (Deep in his soul he was more a sculptor than a painter.)

His frescos in the *Sistine Chapel* are a superhuman achievement. Between 1508 and 1512 Michelangelo covered the ceiling of the chapel with gigantic figures. For four years he laid on a high wooden staging, under which the Pope, now and then, came to see how things were going. In those four years he created 343 humans, or rather heroic figures, and several frameworks to give the illusion of different scenes. As a theme he chose the stories of the Old Testament, especially the book of Genesis: the Creation, the breach of the divine commandment, and Noah's Ark. As he carried on with the work, the figures became bigger, mightier, more heroic and more monumental. In one of the nine scenes, the Creation, the Almighty throws Himself into the Universe to bring Adam to life by

touching him with His finger. Only partly raised, the "new man" opens his eyes and looks at the God in whose image he has been created. Here the Creation becomes a thing of the spirit, of the transference of consciousness, feeling, thinking – faculties that up to then had been dormant. It is interesting to see that the Almighty, has the woman Eve in His arms, not yet alive, but ready to be wakened.

The human figures, who serve as decoration in the sequence of biblical scenes, are mighty, muscular, very sculptural heroes, who seem to free themselves by sheer strength from the building. The art of Michelangelo can be explained by his life. He knew no happiness or peace, his art exudes such deep depression, it is almost frightening. There is a massive manhood in all of his works, for in his works, as in his life, women played little part. The image of the human being is portrayed as a muscle-packed man with an enormous torso, arms of iron and legs like pillars. But even these manly figures give no suggestion of sensual happiness. They contain the release of the pressure put upon his soul. In one of his poems he

101

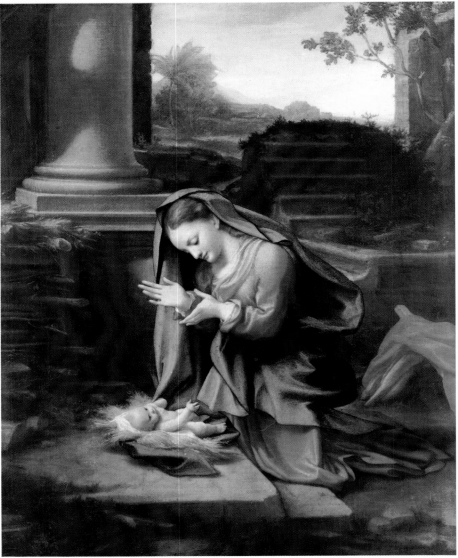

146

*146. Correggio, Antonio Allegri,
Ca 1489-1534*
The Virgin adoring the Child,
1520-22
Uffizi, Florence

admits this: "it always became a reflection of my own confusion, and it carried the sad offshoots from my own head."

The movement of Christ's arm in Michelangelo's "Last Judgement" is powerful, so imperious, that the others should shrink away. But even the doomed are denied humility, fear, anxiety, submission and tolerance. They do not shrink away from the athletic figure of Christ. They are not sinners that get what they deserve, but rebellious giants, storming the heavens.

A Life without Dissonance: Raphael

Raphael was, in every way, the opposite to Michelangelo. Raphael's life was almost free of problems and without anxiety; in his art there are no dissonances. Raphael typifies this in his letter to Castiglione: "If everyone doesn't flatter me, I have satisfied everyone". His life was very different from Michelangelo's; his amorous adventures were so numerous that Vasari attributed Raphael's early death to them.

Only after his arrival in Rome did he develop his real style and his talent for composition and decoration. He started by painting the *Stanza della Segnatura*. The *School of Athens* recognized a new master, although some of the motives reminded people of *Leonardo*, of *Melozzo*, and of the reliefs of *Donatello* from Padua. A new dimension opened up, with a festive, classical accent to it.

After the "Stanza" Raphael got so many commissions that to execute them he needed more and more pupils and helpers. The findings of archaeologists intensify the influence of classical Antiquity in Raphael's art. He even goes so far as to make sculpture the subject of his paintings. The *Triumph of Galathea* painted for the Villa Farnesina is a good example of

147

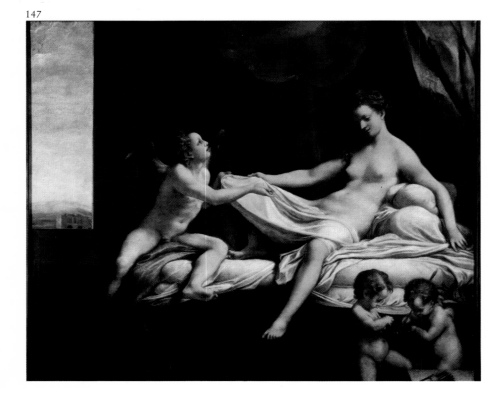

*147. Correggio, Antonio Allegri,
Ca 1489-1534*
Danae, *1531-32*
Galleria Borghese, Rome

102

this. Only the movement motif of the main figure can be associated with work from his own time: Leonardo's "Leda". The rest of it, the centaurs, the Neriads, the Triton, the putto with the dolphin, come from the reliefs of classical sarcophagae. The whole gives the impression of a painted relief.

In his last portraits Raphael reached a perfection that explains why this very academic master differs so essentially from all later academics. The "portrait of Julius II", which is now in London, tells us more about this impetuous person than a complete history book. The same goes for the portrait of the epicurean "Pope Leo X of the Medici". Along with the portraits of "Paul III" by Titian and of "Innocentius" by Velazquez these works of Raphael are the most magnificent ever made of popes.

Correggio

Of all the painters around Leonardo, *Correggio* was the most loved, at least, for his art. Vasari describes him as a sly, anxious and depressed man who denied himself happiness in life. If he did not attempt to paint sad scenes, but painted innocent, gay and gracious joy; if he did not paint men, but women and children, he was good. With him, there is no religious sentiment; its place is taken by a pure, sensual fascination.

Venice: the Apotheosis

The Italian art of painting in the Renaissance reached its zenith and its perfection in Venice. The essence of the Quattrocento is expressed by three masters: the brothers, *Gentile* and *Giovanni Bellini*, and *Vittore Carpaccio*. Giovanni was certainly a great painter, and Gentile, in relation to his times, only a first class one. In any other period he would also be considered great. Further, the importance of the Venetian painters *Antonello da Messina* and *Carlo Crivelli* should not be denied. But the zenith of the Venetian Quattrocento is represented by the two Bellini's and Carpaccio. Giovanni Bellini was born about 1430 in Padua or Venice; he died in 1516. He presented a more

148. Bellini, Giovanni, ca 1430-1516
The Transfiguration of
the Lord on the Mountain,
Oil on wood
Museo di Capodimonte, Naples

148

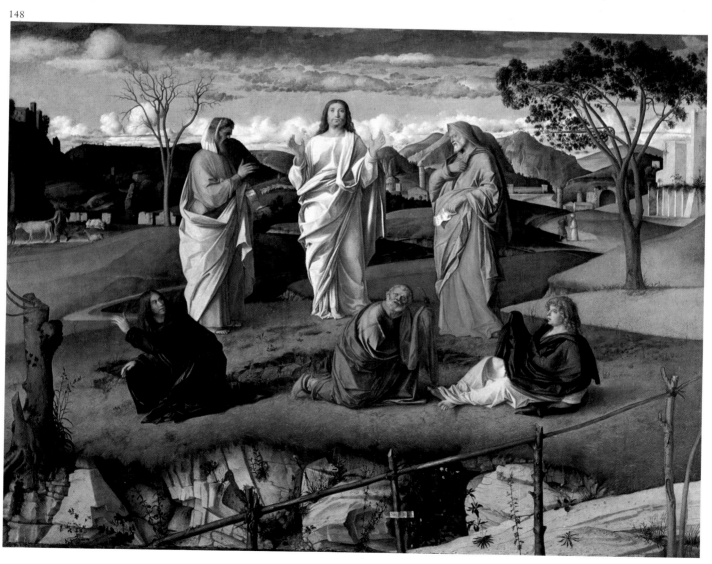

rustic madonna than Raphael. His earlier works in particular show an archaic hardness about the figures, and the landscapes are barren and hard. The change from the plastic to the picturesque style came into Bellini's works under the influence of Antonello da Messina. The painting in which this influence shows for the first time is the "Prayer on the Mount of Olives", now in London. Although the landscape is plastically divided, the linear sobriety is accompanied by a pictorial light effect. The "Pietas" and "Madonnas" are more subdued.

At the end of that century, an anecdotic art of painting flourished alongside the religious art of Giovanni Bellini. This group was headed by Giovanni's elder brother *Gentile Bellini*. What could be made of the subjects he chose, becomes evident when one moves from the paintings by Gentile to those by Carpaccio, in the Accademia at Venice. Carpaccio is more of a poet and gives reality attraction. In all of Carpaccio's paintings there is an element of the troubadour.

Giorgione: Art for Art's Sake

Giorgio da Castelfranco, called *Giorgione*, died so young that even the old Bellini, born almost fifty years earlier, survived him by six years. But he was able to achieve for Venice what Leonardo had done for the rest of Italy. He freed art from the Church's fetters, from the curse of Savonarola, and put it to the service of a beautiful earthly life. The earliest known work of Giorgione only gives a slight indication of this. The "Madonna" of Castelfranco shows some parallels with Bellini. It is a "Sacra Conversazione" in the traditional meaning. But Mary is a figure caught in dreams. She seems to be thinking of a distant love. The whole painting breathes the charm of a tender, transient eroticism. In Giorgione's paintings the love for music which is a characteristic of Venice, is clearly shown. The "Con-

149. *Antonello da Messina, 1430-1479*
Portrait of a Monk
Museo de Bellas Artes de Cataluña, Barcelona

149

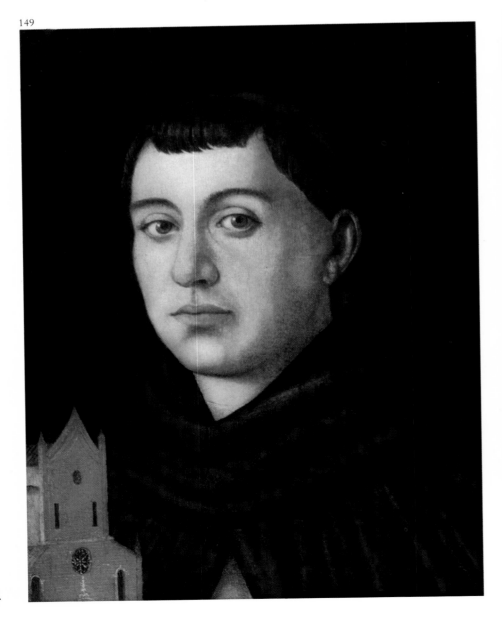

150

104

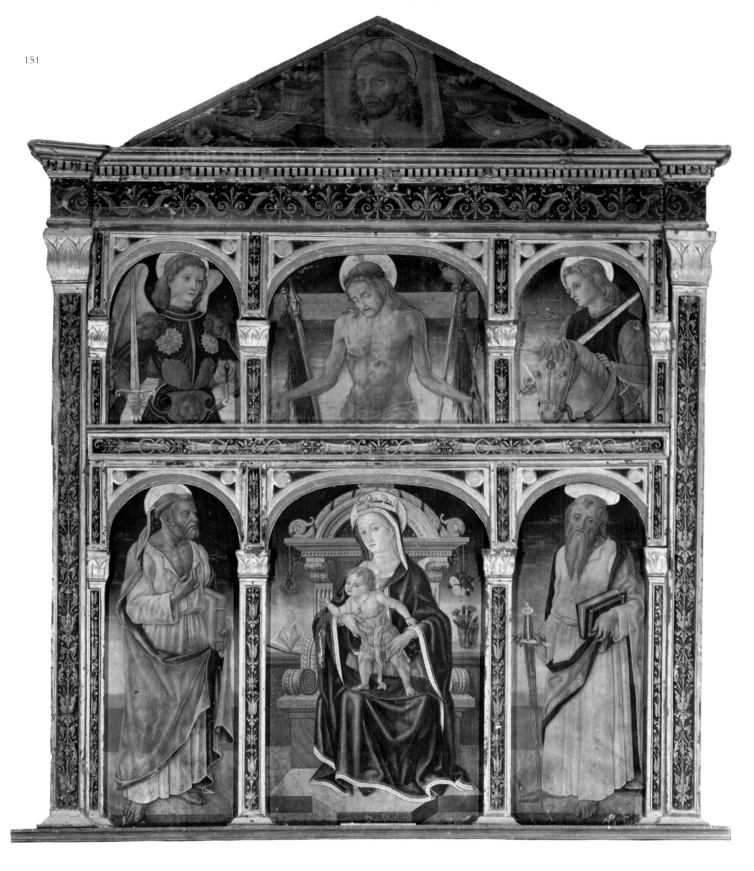

151

151. *Carlo Crivelli, ca 1430-1495*
Virgin and Child enthroned,
surrounded by Saints, *ca 1473*
Oil on wood. Polyptych
Monte San Martino
Santa Maria del Pozzo

150. *Michelangelo Buonarotti,*
1475-1564
Rondanini Pietà, *1550-1564*
Marble
Castello Sforzesco, Milan

cert'' in the Palazzo Pitti, which is
born totally out of the spirit of music
is well known.

Another aspect, remarkable for that
era, also found its way into Giorgio-
ne's paintings: the bucolic preference
for nature, arising from association
with the pastoral poetry of the An-
cients. Once again they dream of an
ancient Arcadia, of the golden times
before history. This bucolic element
is apparent in the *Fête Champêtre*
in the Louvre, and in that strange,

enigmatic painting named *The Tem-
pest*.

The ethereal chastity of the Quattro-
cento vanished completely. This is
even more valid for the ''Cecilia'';
this life-sized nude is exhibited under
the title of ''Venus'' in Dresden. The
painter's eye has run tenderly and
lovingly over the woman's naked
body. There is nothing left of the hys-
terical distaste preached by Savona-
rola; the chastity of the Botticelli
nudes has completely vanished.

105

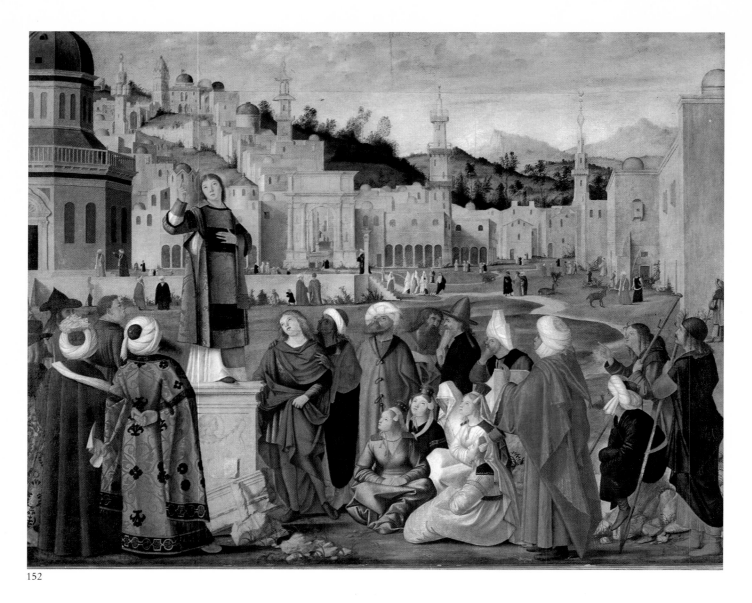

152

152. *Vittore Carpaccio, ca 1455-1526*
The Preaching of St. Stephen
in Jerusalem, *ca 1520*
Louvre, Paris

153. Gentile Bellini, 1429-1507
The Procession in Saint Mark's
Square
Ca 1496
Accademia, Venice

153

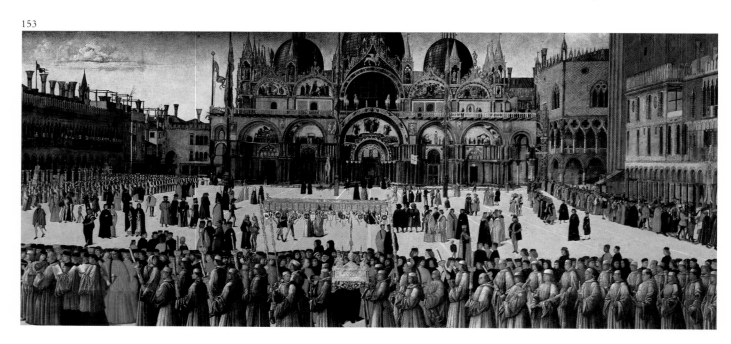

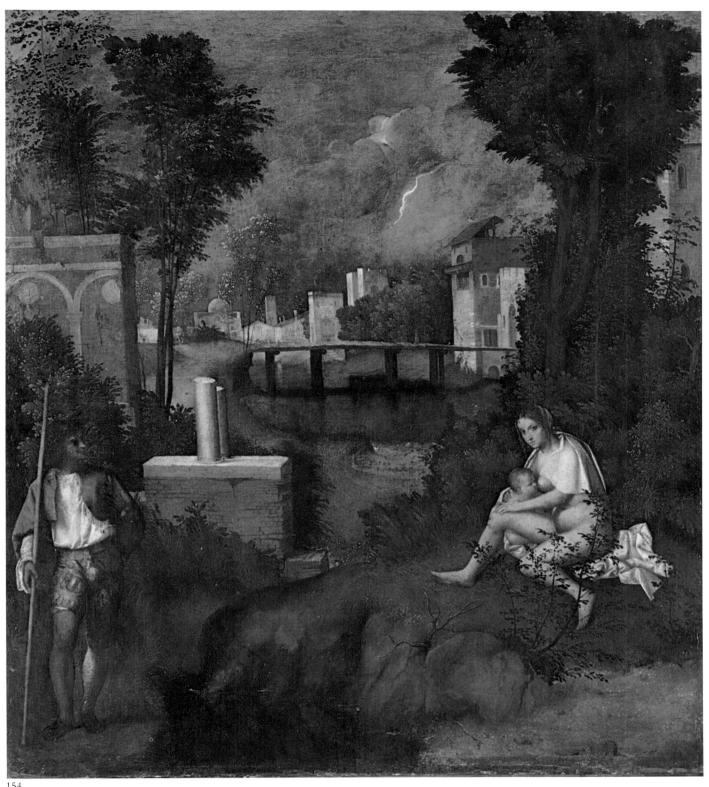

154

154. Giorgione, 1478-1510
The Tempest, *1505-07*
Canvas
Accademia, Venice

Titian and the Pure Art of Painting

Titian's stature surpasses the rest of the Venetian Cinquecento (15th century) in its splendor. Born about 1480, *Tiziano Vecellio* died in 1567. A plague ended his long life, and the lives of a quarter of the Venetian population. He had lived a life of his own, and created an art of his own without making a tragic offering of his life for his art. The beauty of his paintings, the fire of his colors, and his abundance of ideas, came from a wise self-control of an exceptionally rich talent.

This definition by no means completely explains the whole of Titian's work and stature. With the later art of Titian the pure artistic aspect of painting broke through with elementary force. In particular the painting *The Crowning with Thorns* in the Alte Pinakothek in Munich exudes a great flow of artistic instinct. It takes a great work like this to judge honestly the extent of Titian's control over his passions for the greater part of his life.

He was a painter of genius; a forerunner to Rembrandt.

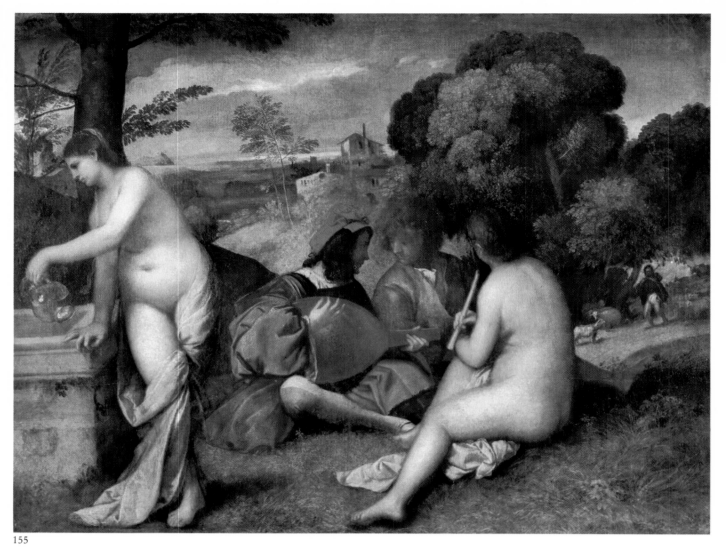

155

156

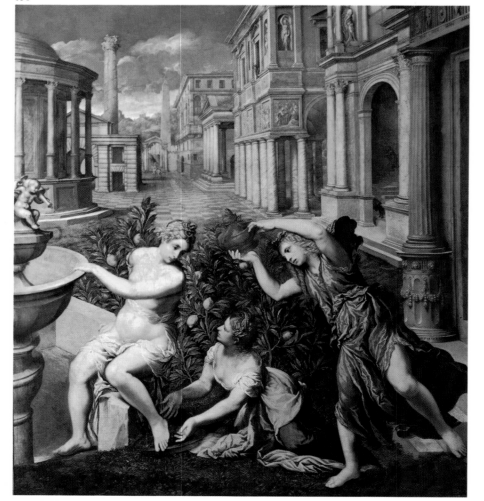

155. Giorgione, 1478-1510
Fête Champêtre *(Rural Concert)*
Louvre, Paris

156. Paris Bordone, 1500-1571
Bathseba Bathing
Wallraf-Richartz Museum, Cologne

As *Leonardo da Vinci* was the central figure in the Milanese school and *Dürer* was in Germany, Titian stands centre stage in Venetian art. He had a fruitful influence on many others. Jacopo Palma, called *Palma Vecchio* to identify him from his son, was a religious artist who got many commissions and was famous for his bright colors. He painted the blonde, well-proportioned type of woman that had always been accepted as being typically Venetian. A type you can look for in vain in the streets of Venice today.

After his death, his place was taken by *Paris Bordone*. Bordone has none of Titian's greatness, but he succeeded splendidly in showing light playing on reddish-blonde hair, on bare shoulders, and on silken, peach-colored robes.

Lorenzo Lotto is a much more complicated personality than Palma and Bordone. His life was filled with disruption and depression (he describes himself as "lonely, lacking support, and bereaved of my wits" in 1548). This mater is considered to be one of the Mannerists. His paintings show the cool harmony of tints, and the melancholic, masked impression inherent in Mannerism. His work is remarkable for a cool dignity, a characteristic of Mannerism, although in the case of Lotto, this is tempered by a certain impartiality.

Mannerism

The "Maniera" of the 16th century painters was in strong contrast to nature; one was not inspired by reality, but by the previous culture, styled after a dreamed-up ideal. The defining of the dream can be found in the "Idea del Tempio della Pittura", (Idea of the Time of the Picture Art of Painting) written in 1590 by Tomazzo, in which he recommends, as the best way to paint; take the drawing from *Michelangelo*, the brush-stroke from *Titian*, the proportions from *Raphael* and the color from *Correggio*. With this knowledge it is no surprise that mannerist painting neglects the content for the sake of the form.

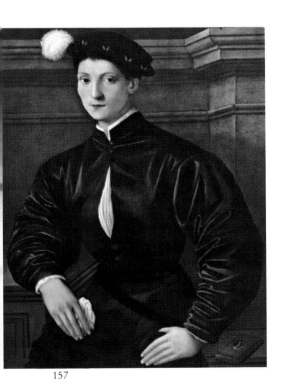

157. *Jacopo da Pontormo, 1494-1556*
Portrait of Ugolino Martelli,
Ca 1540
Oil on panel
National Gallery of Art,
Washington D.C.

157

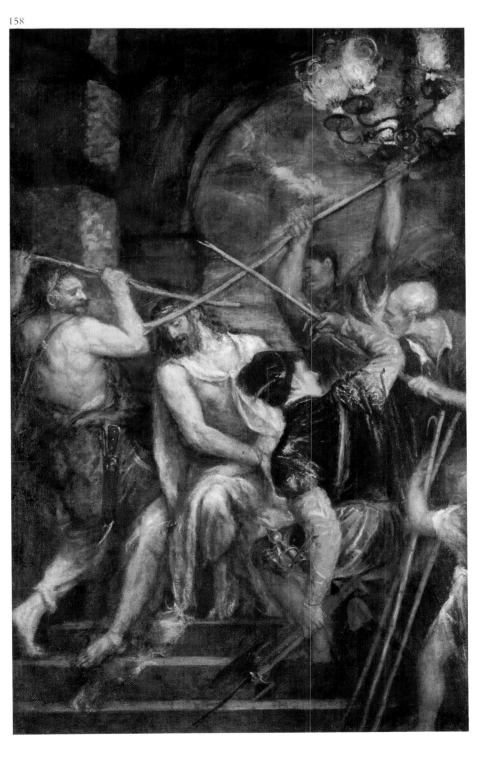

158

158. *Titian (Tiziano Vecellio)*
Ca 1487-1576
The Crowning with Thorns,
ca 1570
Alte Pinakothek, Munich

109

159. *Francesco Mazzola Parmigiamino,*
1504-1540
The Madonna with the Long Neck,
1534-40
Oil on panel
Uffizi, Florence

159

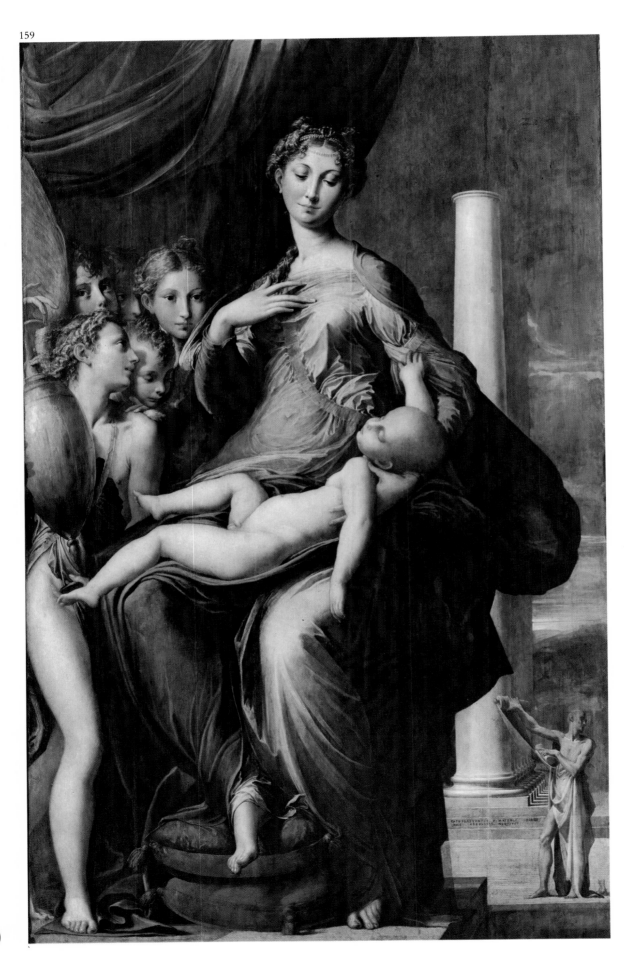

This also explains, why there are relatively few great mannerist works. It is also clear why one can only find these in Michelangelo's work, in which Mannerism had its origin, and with *El Greco*, its finale.

Michelangelo's Mannerism is the non-naturalistic, non-materialistic style which runs parallel with the last stage of his spiritual development. That of El Greco is the expressive spiritualization in which Mannerism itself is transformed to his highest, religious vision. Between these lies the rise of Mannerism with names like *Pontormo*, *Rosso*, *Bronzino*, and *Parmigianino*, and the transitional phase with *Tintoretto*, *Veronese*, *Jean de Boulogne*, and *Pieter Brueghel*. Typical of the first phase of Mannerism, is a canvas, Rosso's *Moses and the daughters of Jethro*. This painting – in spite of the tumultuous twisting of bodies – lacks the elementary power of its predecessors.

It fails to reach the heights achieved by *Salviati* in the magnificent "Caritas", or of "Mary with the Child" by Parmigianino: two paintings which so clearly express the aestheticism of Mannerism. Parmigianino gives elegance and refinement – an almost perfumed distinction – particularly in the *Madonna with the long neck*. The fingers are very slender and delicate; women have unbelievable delicacy. The Christ child is almost of a hermaphrodital beauty; Mary is no saint, but a charming, simply clad woman. Her small, pale, and elegantly dressed head is slightly bent, on a slender neck; while her hands, decorated with rings, make a gentle gesture towards her full bosom. Parmigianino is often accused of perversion, but nobody can deny that this master gave a beauty to life and a charm we can appreciate today.

In his short life, only 37 years, he changed from a tender, well-mannered youth to an impetuous, long-bearded, savage of a man. Insanity, alchemy, and finally complete despair.

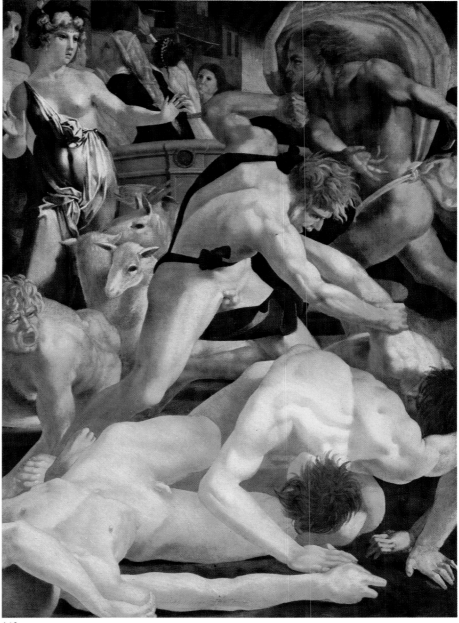

160

Parmigianino's portrait "Antea", and the *Ugolino Martelli* by Pontormo – just as the portraits by Bronzino-give a better impression of portraiture in Mannerism; perhaps, the strongest aspect of this style. No other painting proves so clearly the character of the mannerist portrait as "Martelli" by Bronzino; even though the face seems to be frozen and unfeeling, beneath this mask lies a secret life, behind the aristocratic posture there is an extremely subtle individualism.

One either likes the mannerist types or one does not. They can be found in both the art of painting and sculpture – of which the Nymph of *Ammanati*, the "Venus" by *Danti*, or the figures by *Adriaen de Vries*, a Mannerist of Dutch origin, are examples. The susceptibility to the margin, between that which is said and that which is meant, cannot be taught.

160. *Fiorentino Rosso, 1494-1540*
Moses and the Daughters of Jethro, *1523*
Uffizi, Florence

161

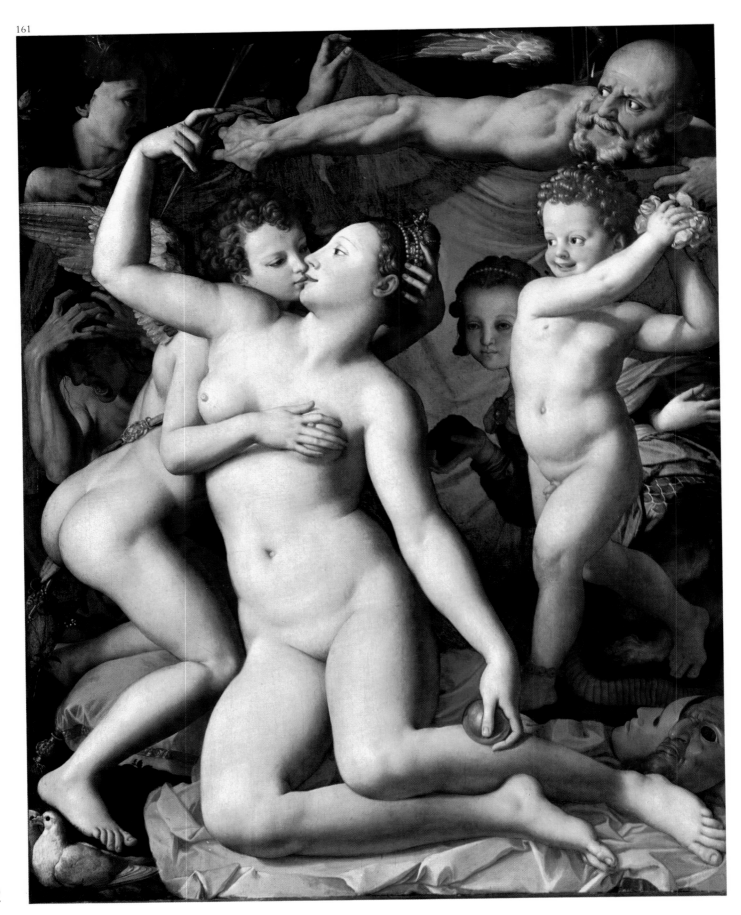

163. *Bartolommeo Ammanati,*
1511-1592
Nymph of the Neptune Fountain,
1563-1575
Bronze
Piazza della Signoria, Florence

164. *Vincenzo Danti, 1530-1576*
Venus, *ca 1570*
Bronze
Palazzo Vecchio, Florence

162. *Adriaan de Vries,*
1544/46-1626
The Victory of Rudolph II over
the Turks, *1609*
Bronze relief
Hofmuseum, Vienna

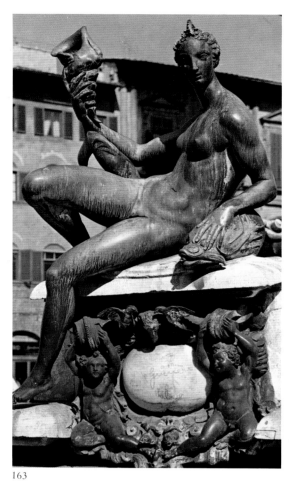

163

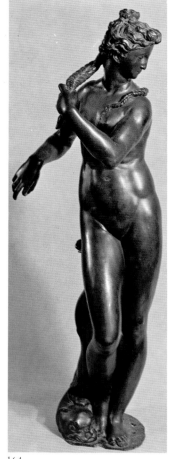

164

162

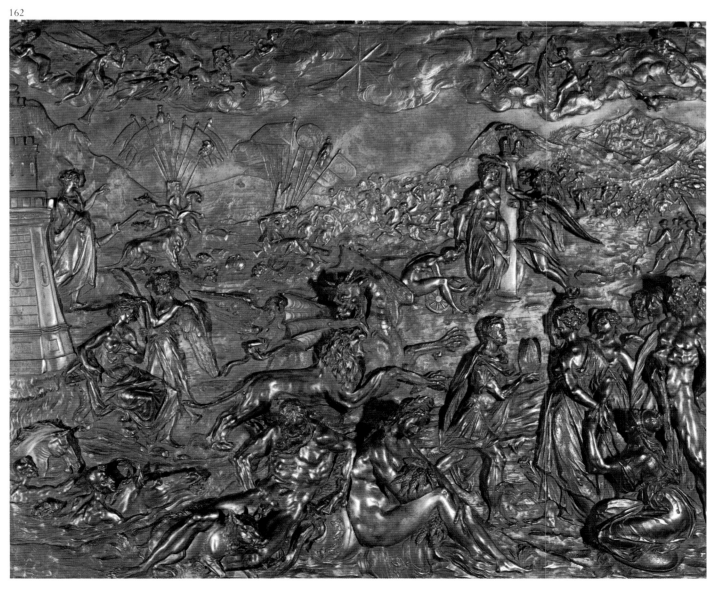

The Balance unfolded

Francis the first who ascended the French throne in 1515, was the political intermediary between the Italian Rinascimento and the French Renaissance. It was he who invited *Leonardo da Vinci* to France.

However, there is a difference between the French and the Italian Renaissances: the Italian was associated with the political system of the city state, the French with the monarchy. For this reason the Renaissance style in France was peculiarly a court style.

The first characteristics of the Renaissance soon became noticeable. Italian artists, working in Marseilles between 1475 and 1481, influenced the French artists.

Certain Quattrocento trends were evident in painting at an early stage and are found later in sculpture, like the sepulchre of Christ in Solesmes built in 1496.

The earliest example of a systematic application of Renaissance elements in architecture was in work by *Gaillon* in 1508. The St. Maclou in Rouen (started in 1417 and not completed until 100 years later), is a collection of Gothic and Renaissance details. Francis I was mainly responsible for the success of the Renaissance style in French architecture. The gallery in Fontainebleau, designed for him by Rosso, is an example of the degrading of the style by Mannerist excesses.

The French Renaissance Portrait

French painting of the 16th century was neither particularly rich nor particularly important. Its major contribution is the portrait.

In the field of portraits the two Clouets are most prominent.

Jehan Clouet (who probably arrived

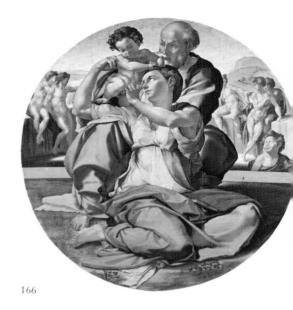

166

166. Michelangelo Buonarotti,
1475-1564
The Holy Family, *1503-05*
Panel
Uffizi, Florence

165

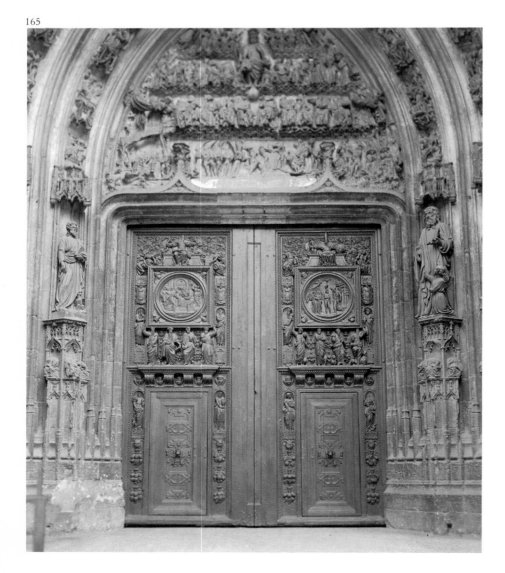

165. Doors of the Church St. Maclou
Rouen,
1437-1517

114

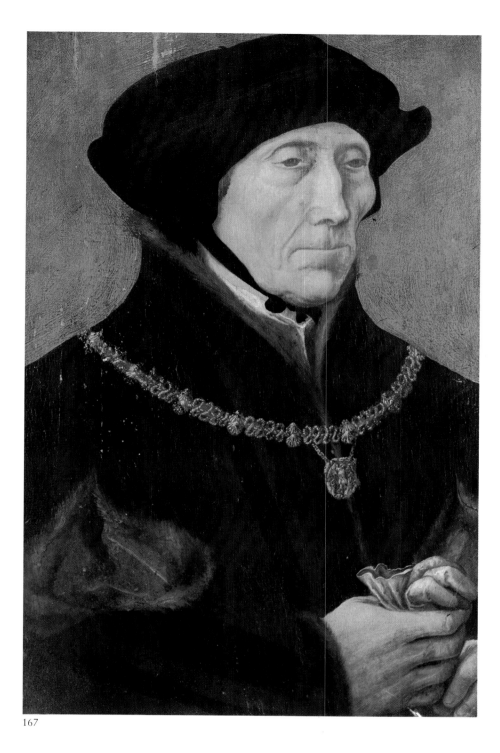

167

in France around 1516 from the Southern Netherlands, worked in Paris after 1529 and died there in 1540) received the highest possible distinction: painter and servant of the king's bedroom.

He was active in the court life of Paris and castles along the Loire, and painted portraits of the nobility. He united in his work personal likeness and aristocratic elegance.

His son, *François Clouet*, became court painter to the French kings from Francis I until Charles IX; he died in Paris in 1572. As well as the Clouets, there was the independent *Corneille de Lyon*. He came from the Hague. He subsequently established himself in the south of France, and became court painter for Henry II

and Charles IX. His output was quite high and it presents problems for historians in their attempts to confirm identities.

The Renaissance in French Architecture

During the reign of Francis I, architecture in France developed in harmony with ideas from Italy. Renaissance motifs occurred frequently and were, in certain cases, combined in a single large entity – as in *Blois* castle, built between 1515 and 1530. The most monumental application was achieved in the *Chambord* castle that, like the Blois castle, is one of the famous castles in the Loire area. *Fontainebleau* is the largest castle built for Francis I.

The Rosso gallery is a good example of the French version of Italian Mannerism. Around the middle of the 16th century, French architecture adopted a more individual form; the architects were French, but with their own ideas.

The most important of these was *Lescot*, who started with the building of the *Louvre* in 1546, and *Delorme*, creator of large complexes and a very capable engineer, who reintroduced the dome-style building.

Nicholas Poussin and Claude Lorrain

After the Clouets the first great artists in France in the 17th century were *Nicolas Poussin* and Claude Gellée (called *Claude Lor-*

115

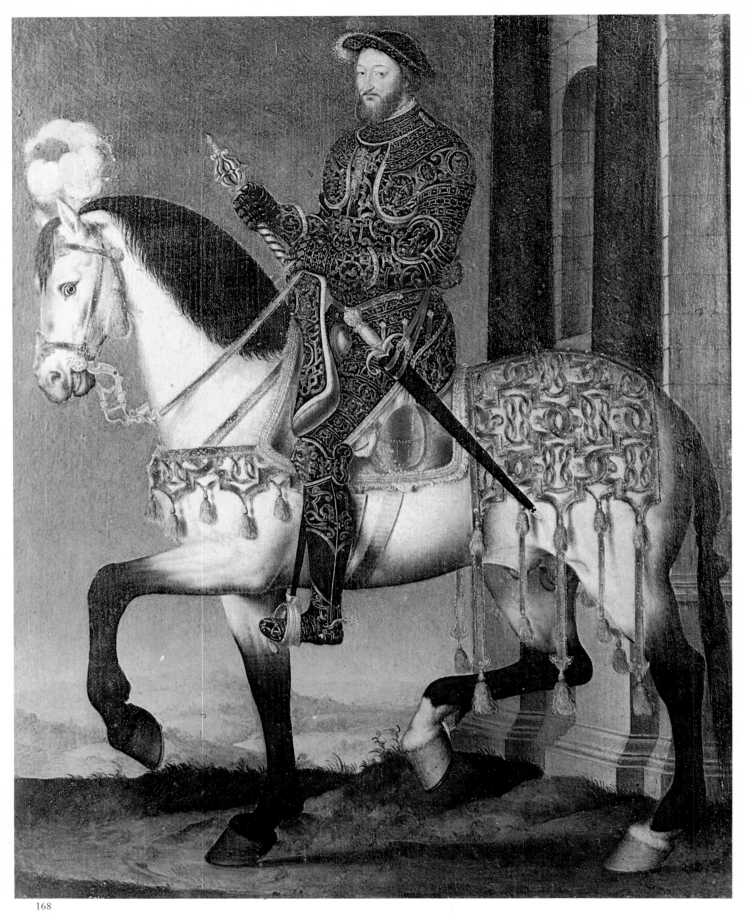

168

168. *Jean Clouet, ca 1486-1541*
Francis I on Horseback
Uffizi, Florence

rain) because of his Lotharingian origin).

Poussin, born in Normandy in 1594, died in Rome in 1665. He came from a farming family, but his talent and his determination to become a painter could not be subdued.

Claude Lorrain lived from 1600 to

1682; like Poussin, he spent the most important part of his creative life in Rome.

Although both painters really belong to the Baroque era, their works are more an expression of the classicism derived from the French Renaissance. Actually, nobody has ever

doubted that Poussin was a great artist; he has always been held in high esteem, both during his life and subsequently. However, few loved him.

Maybe it was the serene character of his work that kept the public at a distance. Possibly, like Raphael, he was too neat, too classical.

His compositions were too obviously the outcome of cool, calm deliberation. It was particularly for this reason that Poussin was considered an academic and classicist. Few had eyes for the discreet beauty and the harmony of Poussin's coloring. Few were able to feel the hidden sensuality in his work. Few recognized the great, retractive feeling of his apparently premeditated compositions. People even forgot to see the force and feeling of his lines – so valued by modern painters. In a time that preached contempt for the traditional, nobody could have any appreciation for a painter who said very modestly: "My only ambition is to continue the art of the old masters, like Raphael, and to take up where they left off".

In spite of his efforts to occupy a position in the traditional school, Poussin has become one of the "novateurs les plus hardis" of the arts.

He was an extremely objective and conscientious painter and, because of this, one of the most French. *Bernini* said of him – pointing to his own forehead – "E un pittore che lavora di là." Poussin himself said: "De la main d'un peintre ne doit sortir aucune ligne qui n'ait été formée auparavant dans son esprit", but did not deny that the object of painting was to give pleasure to the eye.

Claude Lorrain is probably the only painter to have started as a baker. He was barely able to read or write his native language or Italian, even though he lived in Italy for more than 50 years. He was highly respected and was considered the greatest landscape artist in the capital

169. The Stairs
Castle of Blois, 1515-1530

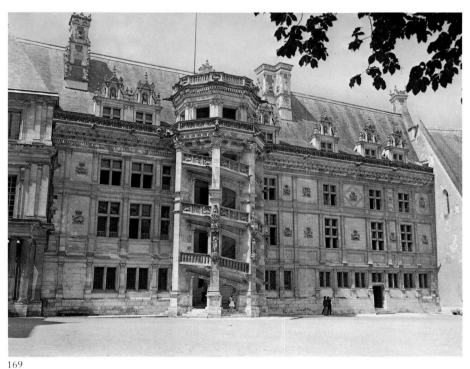

169

170

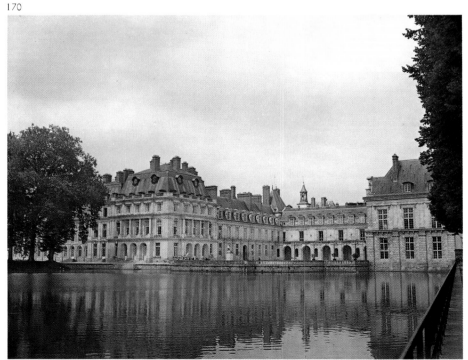

170. Façade of the carp-pond
Castle of Fontainebleau, 1528

117

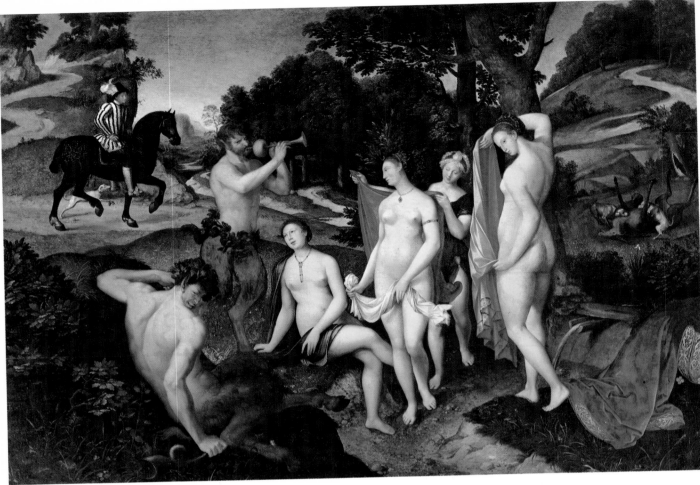

171

of the arts. He retained this reputation for several centuries.

Lorrain's landscapes show a new sensitivity for atmospherics, for sunrise and sunset and their effect on the landscape.

However, all these feelings lie as a golden haze over an undisturbed Classicism.

Neither Poussin nor Lorrain had any part in the Baroque, in the eccentric sense.

They are more the forces that poured oils of a classical equilibrium over the stormy seas of the Baroque.

Pierre Puget

This applies to a lesser degree to the sculptor *Pierre Puget*. Born in Marseilles in 1620, he was initially influenced by the extreme Baroque of Bernini and – even more decisively – of *Michelangelo*. He worked in Italy for a considerable period: in Genoa from 1661 to 1667 for example, and finally found commissions in Versailles, where his sculptures can hardly be missed because of their dimensions and almost classical allure. His later work, made in Marseilles, is however theatrical and melodramatic, in a style similar to Bernini's.

Versailles and the Baroque

If ecclesiastical Rome in the 17th and 18th centuries was the primary centre of Baroque art, the courtly world of Louis XIV's Versailles was the secondary.

It is for this reason that our image of the Baroque is partly determined by the classical tendencies of the French style. Without the classical element, that avoids excesses, the Baroque would not have shown the feeling for order and regularity that is now considered an integral part of it: and certainly not in France.

Jules Hardouin Mansart gave the palace of Louis XIV in Versailles an imposing spaciousness but managed to retain the classical feeling for proportions in his style.

Georges de La Tour: the Master of Light in Darkness

A remarkable master from the same century is Georges de La Tour, who painted between 1618 and 1652. The German, Hermann Voss, and the Dutchman Bredius established him in the history of art: before they gave a name to the "artiste français inconnu" in 1915, Georges de La

171. *François Clouet, 1505/10-1572*
Diana bathing
Musée des Beaux Arts, Rouen

118

Tour was unknown. His works were credited to Le Nain, and the Le Nain school, to Spaniards, Flemish, Italians, or to an unknown French artist.

Similarly, little is known of La Tour's personal life.

As a young man he visited Holland, possibly a number of times. But, even if it is possible to associate him with Dutch and Italian artists, La Tour followed his own path. He retreated to his birthplace and refused the chances offered to him in Paris. He was, therefore, quickly forgotten after his death.

An exhibition of La Tour's work organized in Paris in 1973, without unacceptable additions and enriched with rarely or never before exhibited works, revealed a great and unique talent.

A talent which had developed far from the Parisian centre of art into a strong personality in which simplicity combines both with intimacy and monumentality.

Georges de La Tour set his scenes in darkness and allowed a light to illuminate his subject, the light of a candle flame and the light of human purity. His world anticipates revelation knowing that it will be given. Here lies the religious character of his art, in which the holy do not need haloes nor angels their wings.

His best-known work is probably the "Mourning for St. Sebastian" in the Kaiser Friedrich Museum in Berlin. However, there are other examples of it, which are also authentic.

This "Mourning" is probably the best example both of the influence of Caravaggio, who is incorporated in a very personal way, and of La Tour's preference for personal dramatics. One of the copies of this "Mourning" was presented to Louis XIII, who was so impressed that he ordered all the other paintings to be taken away.

That this work can awaken the same emotion in the 20th century may be the best proof of La Tour's greatness. In his style of painting, limiting himself to the essential things and leaving out every decoration or decorative element, of all the 17th century painters, La Tour stands closest to modern art.

It should be pointed out that French art history knows different La Tours, one 19th century *Fantin Latour*, who usually created still lifes

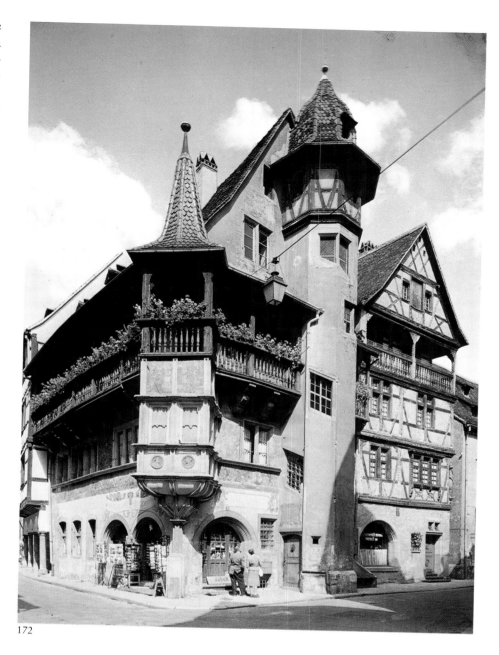

172

172. Pfister House, Colmar, 1537

173. Pierre Lescot, 1510/15 - 1578 Façade of the Louvre, Paris, 1546

173

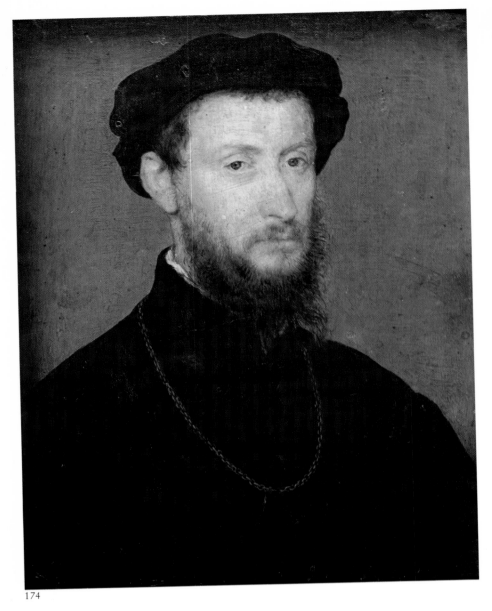

174

174. *Corneille de Lyon, ca 1510-1575*
Portrait of a Man
Musée Fabre, Montpellier

175. *Nicolas Poussin, 1594-1665*
Landscape with Polyphemus and
Galatea, *1646*
Prado, Madrid

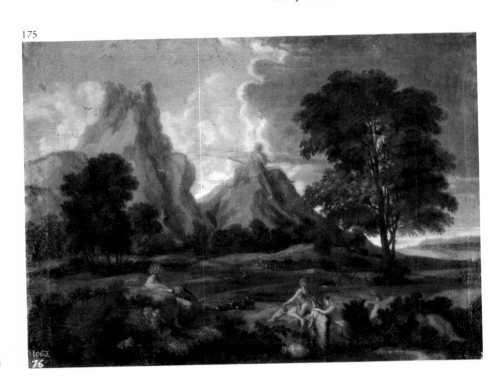

175

with flowers, one 18th century *Quentin Latour*, one of the greatest portraitists of his time (he worked with pastel only) and finally the 17th century La Tour, already mentioned; his name was actually *Dumesnil de Latour*, but he is always called in short Georges de La Tour, or briefly La Tour.

Aspects of Baroque
From 1479 a unified Spain enters history. In 1492 the kingdom of Spain drove the Moors out of Granada; and in the same year discovered America.
In 1504 the kingdom of Naples was brought under Spanish rule.
Charles V ruled Spain and Austria, the whole of Germany, the Netherlands and the Spanish colonies in America.
After his abdication this realm collapsed, but the Spanish part that went to Philip II was still a notable power.
The Spanish Renaissance, known to us as the Counter-Reformation occurred during the reign of Philip II. The religious basis of Spanish culture in the 16th century was a reaction to protestantism. It is associated with the Jesuit order, founded in 1535, and the related Inquisition.
This Counter-Reformation is one of the driving forces behind Baroque culture. This does not imply that, in the total international image of the Baroque, protestantism had no part. Just as a lot was taken out of the Renaissance by the Baroque, which was at the same time the opposite to the Renaissance, so has the Reformation a certain place, beside the catholic Counter-Reformation, in which the church of the Middle Ages returned with renewed strength.
There is a Spanish-catholic Baroque and, also, a Dutch-protestant Baroque. One of the first historical signs of the Baroque is the pictorial passion of *Titian*, as we see in the *Crowning with Thorns* in Munich.
Other signs of the Baroque were the dramatic expressiveness of *Michelangelo*, and the tendency to rhetoric by *Grünewald*. Baroque elements are also in the sugary art of *Andrea del Sarto, Correggio* and *Sodoma*. A characteristic of the Baroque is a preference for "das Malerische". This applies equally to paintings and sculptures.

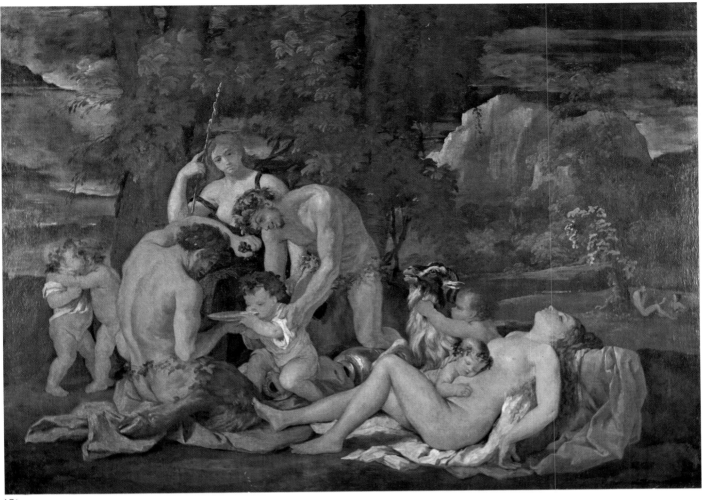

176

177. *Pierre Puget, 1620/22-1694*
Milo of Crotona, *1671-1682*
Marble
Louvre, Paris

176. *Nicolas Poussin, 1594-1665*
The Young Bacchus
Louvre, Paris

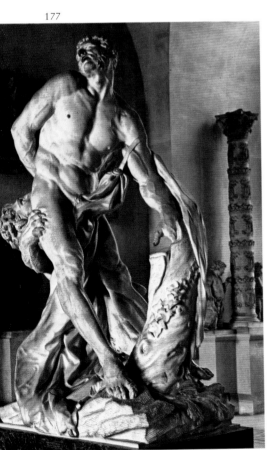

177

Another characteristic is the overstatement, the preference for superlatives. The lack of simple certainty, integral clarity, and obvious conviction in the Baroque period, was unsuccessfully shrouded by hollow phrases, excessive accents and an overstretched symbolism.

This unrest is a typical phenomenon of the Baroque. The restless need for strong expressiveness is, of course, associated with the previously mentioned "Malerische", because here the chance is given for high mobility and lively expression.

Veronese and Tintoretto or
Equilibrium and Mobility

At the beginning of Italian Baroque art is the sumptuous, sensual style of *Paolo Veronese*, the master of large canvasses. A faultless sense of balance and the classic feeling for composition, color and content. But it was *Tintoretto* who developed the Baroque tendencies apparent in Titian's work. Born in Venice in 1518, his real name was *Jacopo Robusti*, but he was nicknamed "the little painter" because of his father's trade, as a house painter.

For a while he worked in Titian's studio but apparently he was such a restless student that he fell out of favor with his master. He was an orderly, hard-working man, who gained great respect and soon led a studio that was as large as Titian's. Tintoretto painted for the churches and the Doge palace in Venice; he also painted portraits. Tintoretto's decorative (the word being used as a positive implication) compositions for the "Scuola di San Rocco" in Venice are his most Baroque. In fact, the style of Tintoretto's paintings is an encyclopaedia of Baroque characteristics, even though he belonged to the 16th and not the 17th century that brought the ultimate triumph of the Baroque.

121

In Tintoretto everything is present of what could be called the "floating element" in the Baroque. As though the laws of gravity have been put out of action. He also represented the Baroque feeling for the gigantic: his "paradise" in the Doge palace is twenty-three metres long and has several hundred figures. To the Baroque feeling for the gigantic – first noticed in Michelangelo – is added in Tintoretto a nearly undimensionable activity that is equally characteristic of the Baroque. Tintoretto's style is further characterized by powerful muscles, almost musical movement and composition. This musical element in Tintoretto belongs entirely to the Baroque which was, without exception, the most musical period in European history.

Spanish Baroque Painting

Italian Baroque painting developed a naturalistic element.
In the Spanish paintings this development is supplemented by the rising of the popular motif.

In the Spain of the 17th century reference can even be made to a naturalistic proletarian orientation of the Baroque. This transition started with *Giusepe de Ribera* – born, a shoemaker's son, in Valencia in 1588 – who did most of his painting in Naples, where he died, with the nickname "spanjoletto" in 1652.
The nationalistic naturalism of *Caravaggio* was his immediate example. Ribera, however, went to work even more radically and did not shrink from seeking his models for holy figures among fishermen and laborers.
The usual Baroque pathos is not evident in *Francisco Zurbaran* or, indeed, in any of the artistic tricks that Murillo was subsequently to use to communicate to the masses. Zurbaran put aside all attempts at conversion; he did not want to speak to the crowds. He worked for a close knit, encircled world. Within that world the subjects that he depicted were not wonders, but historical facts. Exaggeration was, therefore, unnecessary.

178. Claude Lorrain, 1600-1682
The Embarkation of Odysseus, *1646*
Louvre, Paris

178

122

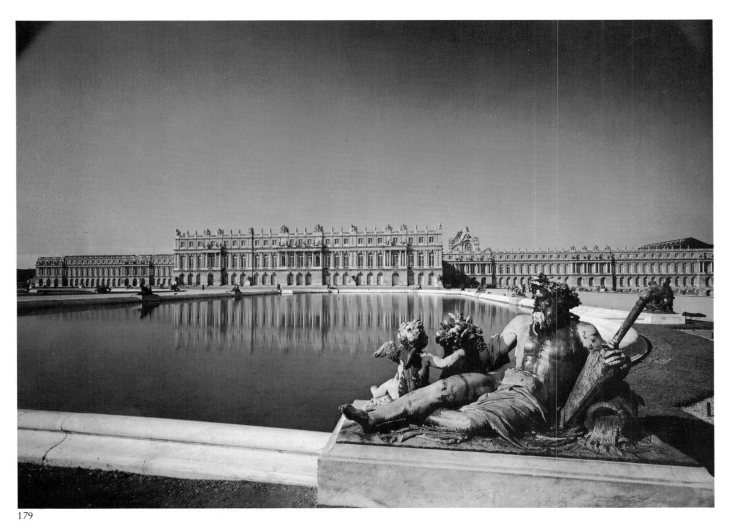

179

179. *Palace of Versailles, 1661-1708*

180

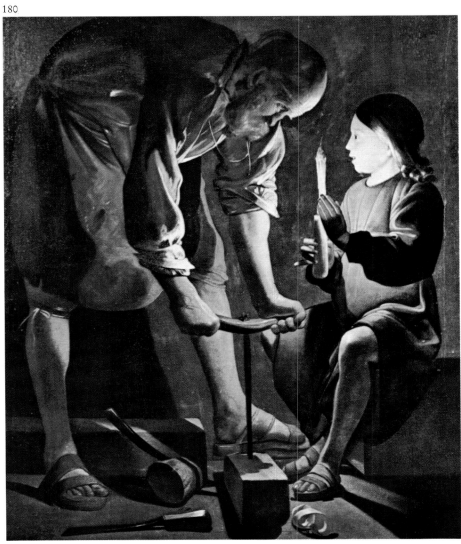

180. *Georges de La Tour, 1593-1652*
St. Joseph, the Carpenter
Louvre, Paris

123

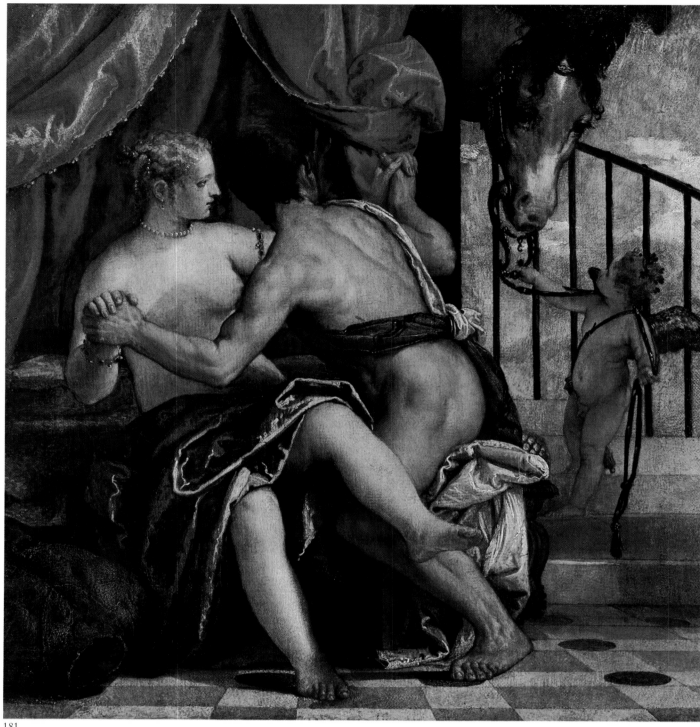

181

181. Veronese (Paolo Caliari),
1528-1588
Venus and Mars
Galleria Sabauda, Turin

This is why Zurbaran painted with a great deal of truth and, at the same time, with a simple purity and naturalness.

Instead of billowing drapes and violent gestures, Zurbaran produced only peaceful lines. His works have a style of exaltation, sanctity, monumental solemnity.

His portraits are impressive, due to a lack of dramatics.

If this style has a metaphysical element, this was missing in the added effects and pretentious religious sweetness of Murillo. *Bartolomé Esteban Murillo* is, therefore, frequently referred to as "the master of the sacharine madonnas".

Soon an orphan, he was brought up by relatives, including the painter, *Juan de Castello*, his tutor.

The Murillo Baroque is less expressive today. An ecstatic asceticism is lacking, which Zurbaran gives to the "Scripts of the St. Theresa"; Murillo, the painter from Seville who lived from 1617 to 1682, is more acceptable for his paintings without religious pretentions; such as the "Fruit-eating beggar boys".

Velazquez, Painter of Princesses and Proletarians

The art of Velazquez is also realistic. Even in his religious painting, there

124

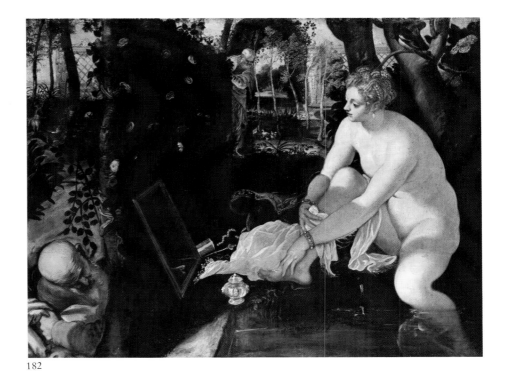

182. *Tintoretto (Jacopo Robusti),*
1518-1594
Susanna and the Elders, *ca 1560*
Kunsthistorisches Museum, Vienna

182

184

183

183. *Francisco Zurbaran, 1598-1664*
St. Dorothea, *1645-1605*
Museo Provincial de Bellas Artes,
Seville

184. *Jusepe da Ribera, 1590-1652*
The Adoration of the Shepherds
Louvre, Paris

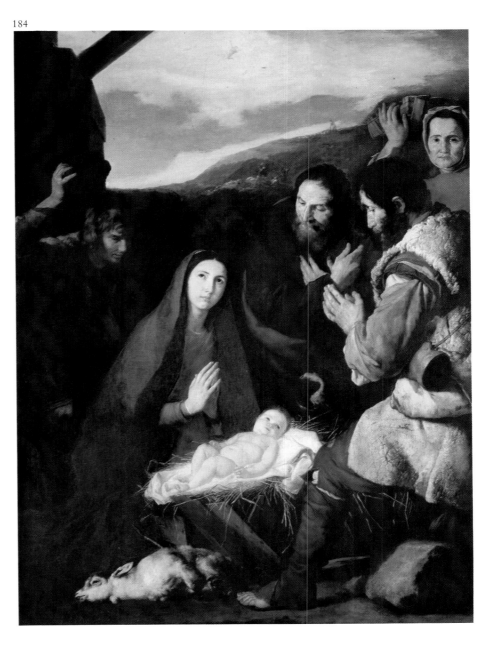

is a lack of the artificial atmosphere so popular with others.

When Philip IV of Spain was 17 years old, and had been king for only a year, he met the 23 years old *Diego Rodriguez de Silva y Velazquez*, and was so impressed by his personality and work that he appointed him painter to the court a year later. Velazquez was given a studio in the palace, and the king would sit each day and watch the master painting. You can say that Velazquez saw the art of painting – including the religious – as no more than a piece of nature viewed through a temperament.

In his landscapes no trace of the romantic can be found.

"He glorified nothing and falsified nothing; he saw things with a steady uncritical eye, and translated them with an unerring hand into paint whose quality is the envy of all painters". This comment – from Eric Newton – is a widely held opinion.

Velazquez continued this naturalistic proletarian tradition with several masterpieces. He was one of the first

185. Diego Rodriguez de Silva y Velazquez, 1599-1660
Las Meniñas (The Royal Family)
Ca 1656
Prado, Madrid

185

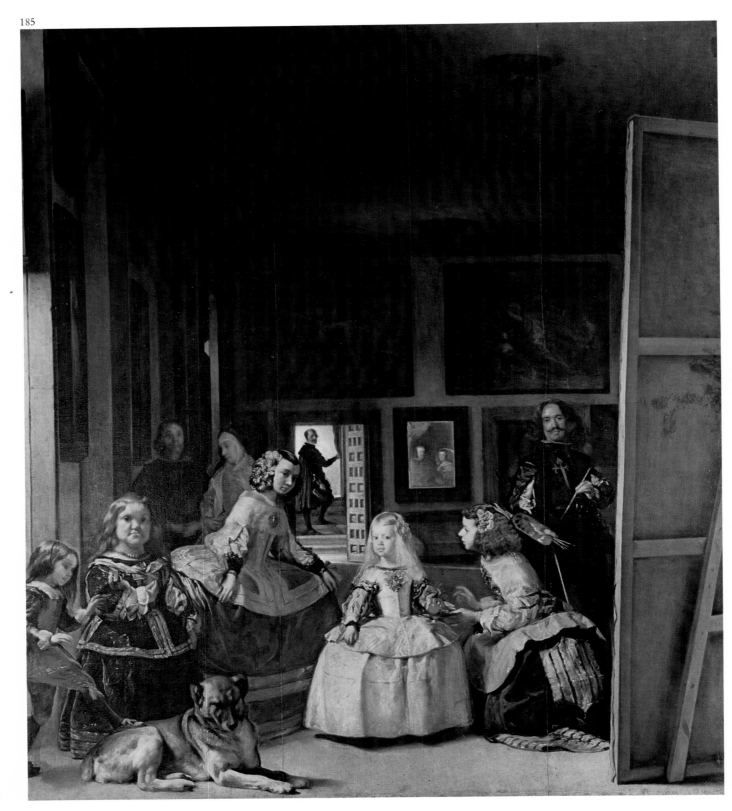

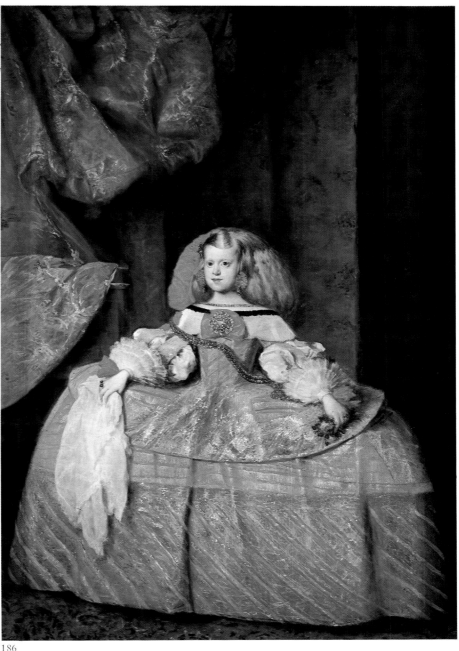

186

of the Baroque era, and in general, to paint cripples and dwarfs. He chose proletarian work as a theme.

He is the painter of the "water-carriers" and of the "spinners". He chose as model the princesses – the infantas – although the court portraits give the impression that the model was no more than the starting point for a free and magistral art of painting. The art of painting itself became the subject of the painter.

In Velazquez' artistic fanaticism something hides that constricts; his portraits show a sobriety and a lack of love that is almost sinister.

But, who could place so well, a red against a white, the black of satin or velvet beneath blond hair, or conjure up the peachy color of a child's face? Who, with pure artistic means, could change paint into a skin full of breathing pores?

Velazquez had surely gained the right to make people disappear behind his art.

At the end of the 19th century, some impressionists expressed great admiration for Velazquez; Manet initially followed his style of painting.

However, when Expressionism took the place of Impressionism, the respect for Velazquez made room for the admiration of El Greco.

The Spanish Greek

Domenico Theotocopouli was born in Crete, and was known as the Greek – *El Greco*. Even though he signed his canvasses with his real name in Greek letters. He was a rebel, an outsider, who painted according to his own ideas, whilst the Spanish born artists complied with

the official, pseudo, religious instructions. He learnt his trade in Venice, under the influence of Titian and Tintoretto, but the paintings from this initial period form no real part of his art. Once established in Toledo he shed other influences and his work gained the character that justifies his reputation as the most Spanish of Spanish artists.

He painted religious themes, with only one exception, the *Laocoön and his sons.*

El Greco's art is Baroque in the use of the light. It is as though the light itself expands to become human beings, taking away their earthly weight. The light determines the shape, allows unreality to retreat and gives reality a heavy and suggestive accent.

The light as a shaping element is a characteristic of the Baroque.

127

German Culture in the Sixteenth Century

Only to a limited degree can German 16th century art be considered under the term Renaissance.

In Germany it was impossible to refer directly to a rebirth of the classics, as it was in France, where the Latin element was so strong, or in Italy itself. If the Renaissance is seen in another way, as an emancipation, as a release from the ties of the religion and feudalism of the Middle Ages, then such a process can be seen in Germany between 1500 and 1600.

There was social unrest, culminating in the peasant wars, against feudalism. There was a theological revival namely through protestantism.

There was an intellectual revolution; the release of classical authors from religious censorship. This revolution freed academics from their theological chains.

This movement of the 16th century is referred to as humanism.

Further there developed an independent study of classical antiquity and the classical languages.

In this aspect the German and Dutch Renaissance is related to the Italian Rinascimento.

Art of the 16th century shows repercussions, on the one hand from the protestant revolution against Rome, and on the other, from humanistic ideas. Moreover, these new motifs in the German art of the 16th century appeared to have a close relationship with the Gothic style of the Middle Ages.

Grünewald, the Revolutionary Genius

If Dürer was the humanist among 16th century German artists, *Grüne-wald* was the mystic.

He was forgotten within 100 years of his death; when Maximilian of Bavaria wanted to buy his most famous work, the Isenheimer Altar, in the 17th century, nobody knew who had painted it. The remarkable aspect of this artist, one of the greatest of the German art, is that he earned his keep as a hydraulic

187. El Greco, 1571-1614
Laocoön, *ca 1610*
National Gallery of Art, Washington D.C.

187

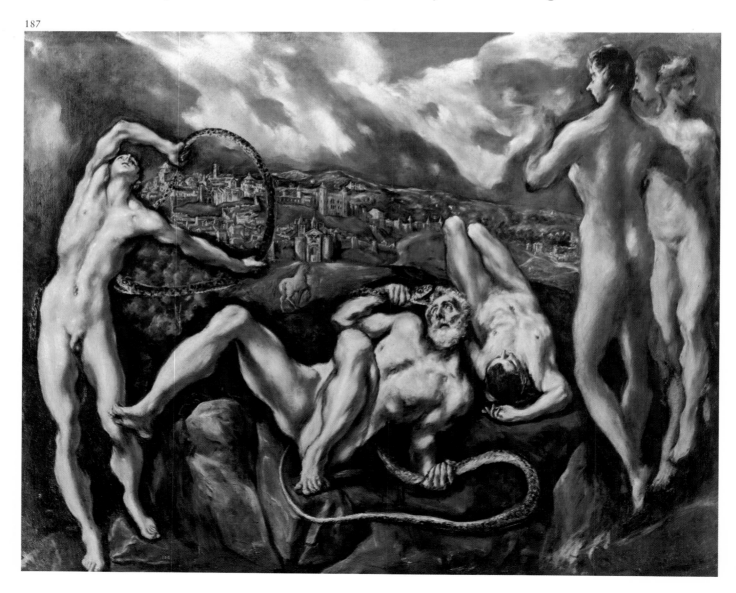

128

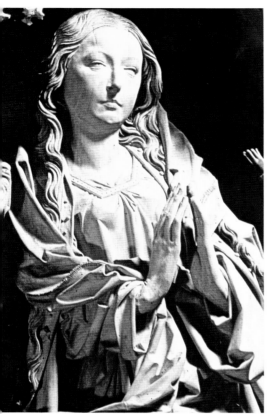

188

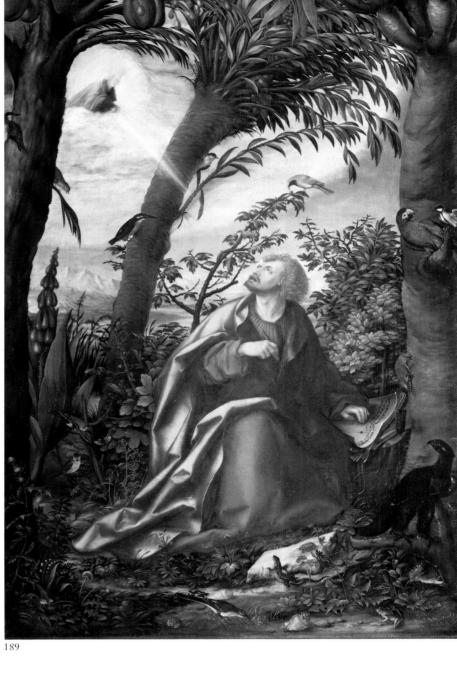

189

engineer and, some believe, as an architect. But very little has been written about him; he was seen as a dangerous character due to his sympathies with the teachings of Luther.

The revolutionary temperament in Germany in the 16th century is most convincingly expressed in the type of "Crucifixion" created by Grünewald: the *Crucifixion* from the great *Isenheimer Altar* in Colmar (Grünewald's major work) and from Karlsruhe and Donaueschingen.

None of them show any likeness whatsoever to the delicate, almost aristocratic Christ of the feudal and patristic Gothic.

On the contrary, Grünewald's Christ, is portrayed as a commoner. Equally revolutionary is the violence of expression; brutal, repulsive. Expression for Grünewald was surging feelings.

Grünewald was an artistic revolutionary too, he painted in colors that were not normally used during his time.

Whilst the majority of artists had a more graphical than pictorial conception of design, Grünewald's work combines demonic naturalism with a particularly aggressive use of colors.

Cranach and other Masters
of the Portrait

Cranach, Burgkmair, Baldung and Holbein have to a great extent per-fected the portrait that belongs to the Germain Renaissance and humanism. Probably Cranach's portraits are his best works: particularly that of the archbishop and the elector Albrecht of Mainz, depicted as "St. Jerome". Cranach's nudes – his *Eve* for instance – have the strange combination of an almost sensual provocation with a child-like chastity, a typical trait for the mannerism in Germany. Of Burgkmair there is no greater work than his self-portrait with his wife.

Hans Baldung, Painter of Sensualism

Grünewald had no direct influence on German art. The works of *Hans Baldung* have so little in common

129

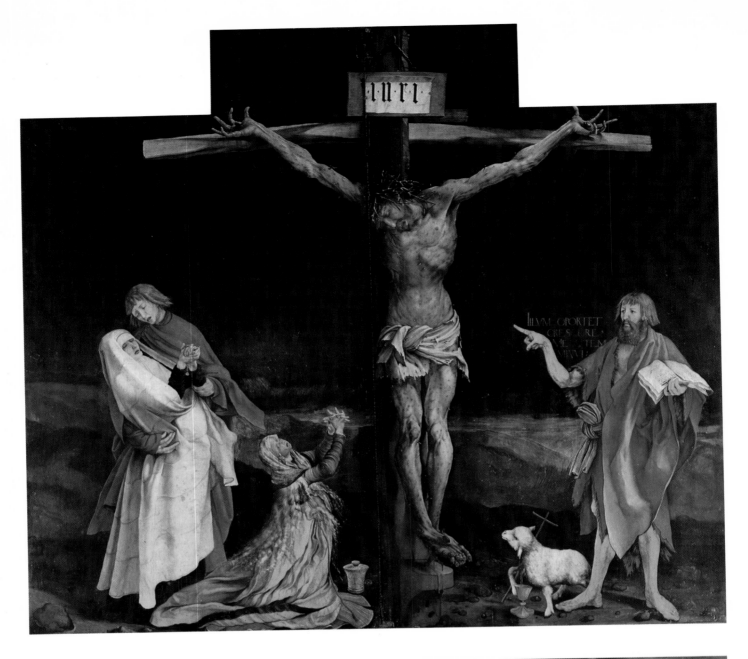

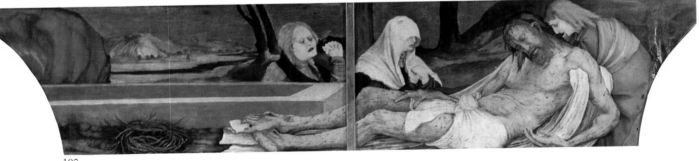

190

190. Mathias Grünewald,
1470/75-1528
The Crucifixion, *middle panel
of the Isenheimer Altar,*
1513-1515
*Wood
Musée Unterlinden, Colmar*

with Grünewald's style that it is impossible to refer to him as Grünewald's successor.

However, Baldung's altar piece from the Münster in Freiburg, shows how impressed he was with Grünewald's coloring. His naked figures have an individual character that displays a notable sensuality.

Albrecht Dürer, the Real Master from Nürnberg

Dürer and Holbein are honored as

the greatest German artists of the 16th century.

Dürer was the third child of a family of eighteen, and was intended to follow his father as goldsmith. But, at the age of 15 (in 1486) an artist called *Michael Wolgemut* saw some of his drawings and offered the young Dürer a place in his studio. At the age of 23 he, unhappily, married Agnes Frey, who could not accept her husband's interest in culture and humanism. She wanted a reliable artisan. One of Dürer's best friends

accused her of causing Dürer's death by her pious complaining and continuous demands for more money.

Dürer worked for a short time in Venice, the leading town of the artistic Renaissance.

Dürer's art cannot be compared pictorially with Grünewald's.

Contrary to the "Malerische" of Grünewald is the "Zeichnerische" of Dürer. Grünewald did have a highly developed feeling for drawing, but this is integrated in the art of painting. The opposite is the case with Dürer; biased towards the graphical in respect of nature and tradition. The art of painting merely served the drawing. Dürer's work, if translated into black and white, would lose little of its substance.

Dürer is the opposite of Grünewald in other respects too. There was more passion in Grünewald, more contemplation in Dürer.

The human body was a subject of Dürer, inspired by the Italian theories, especially those of Pacciolo who had written a treatise on proportions referring back to *Piero della Francesca*.

Dürer's real power was in his drawings. His graphical style is accurate and matter-of-fact, but in no way alienated from a restricted but intensive love of truth and actuality.

Dürer is German in his commitment to the Gothic, especially in his car-vings and engravings. His aquarelles have a special place in his art, especially the landscapes; they have the untainted charm of an experience and the unconfused expression of a technique, that offered Dürer's pictorial possibilities the best opportunities. Also there is the unforgettable drawing of his aged mother; a drawing that for content and truth – resulting from unparalleled observation – can be called unique.

Ordinary life and the provincialism of Nürnberg played a major role in the development of Dürer's talent. In other surroundings his talents would have expanded more freely. He did not, as with Holbein, stand firm immediately on the ground of the Renaissance; he did not grow up in a large city like elegant Augsburg, but in provincial Nürnberg. Moreover, there is a fundamental difference between both artists. To understand this it is only necessary to compare the self-portraits of the two masters. Dürer comes to the fore as a visionary ghost, as a christ moving among the people. Holbein, on the other hand, shows nothing that is sacred; he works prophanely and as a man of the world.

At the end of his life, Dürer collected together the results of all his efforts. His journey to the Netherlands, in 1520 and 1521, started a far-reaching simplification of his art. He saw Quinten Massys' paintings and the altar in Ghent.

191. Albrecht Dürer, 1471-1528
The Paumgartner Altar, *1502-1504*
Wood
Alte Pinakothek, Munich

191

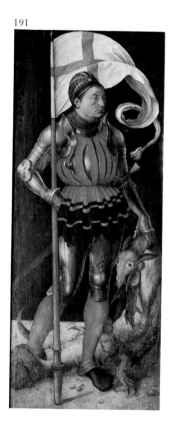
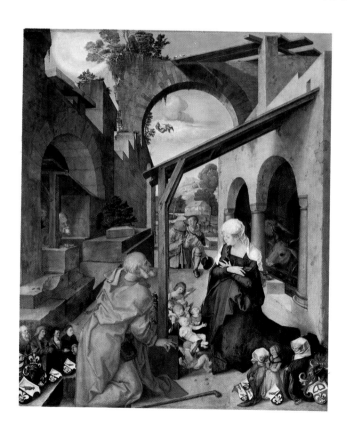
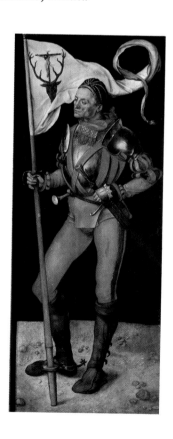

131

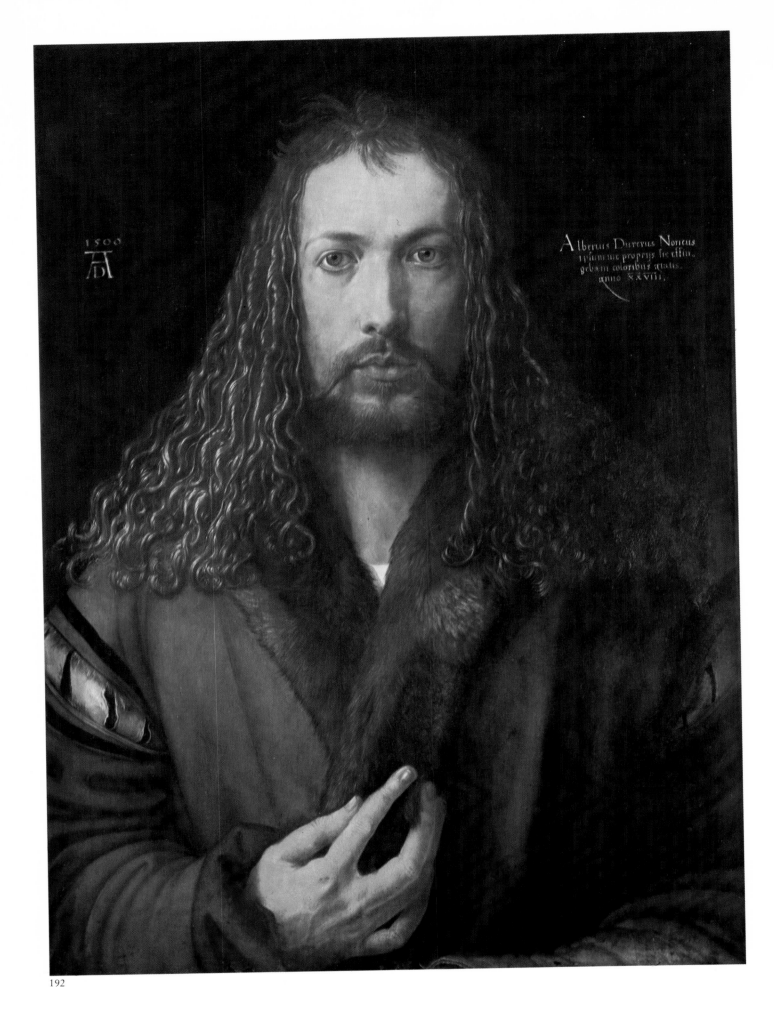

192

192. *Albrecht Dürer, 1471-1528*
Self- portrait with Wig, *1500*
Wood
Alte Pinakothek, Munich

Subsequently, as the grand revelation of what was to be called his heroic style, came the creation of the painting with the evangelists, in 1526.

A formal simplicity moves in these figures and a statuesque majesty; a happy marriage of a German, Faust-like temperament with an Italian appreciation for shape. The great, southerly shape is joined in unique harmony with the psychic intensity of the north.

The Distinguished Beauty of Holbein

The pictorial genius of Germany is represented by five great artists: Grünewald, Dürer, Altdorfer and Baldung Grien.

Holbein could be added to this list, but he has so little that is German in his work, choosing Switzerland and England in preference to his native country, that it is difficult to review him as an expression of the pictorial genius of Germany. He misses the fanatical, the problematic, the magical and the secretive. He is sober and dry. Intelligent, without depth.

To be a friend of Erasmus and Sir Thomas More required more than a soberly functioning brain.

In *Hans Holbein the Younger* the humanistic portrait developed into an art of international class. His style is infallible from portrait to portrait, and of an unchecked perfection. The uniformity of standard in his work is almost disturbing. It is as though they were not painted by a man subjected to the favorability or unfavorability of the hour, but by a sublime mechanism. There is something almost unhuman in Holbein's superiority. However, the beauty of Holbein's portraits cannot be attacked by suggesting that they reflect the mundane atmosphere of the English Renaissance court.

Holbein painted portraits based on emotional experience.

In an emotional moment he produced his most beautiful work; the portrait of his wife and children. A combination of Holbein's ultra-graphical style and an abundance of the pictorial. His *Erasmus portrait*, one of the several being challenged, sharply characterizes the personality.

Albrecht Altdorfer, Precursor of the Art of Landscapes

The German landscape of the 16th century must thank *Albrecht Altdorfer* for its fame. When this master painted the history of the Holy Florian, he really created a string of landscapes not a series of legends. All his efforts at beauty and elegance failed completely.

On the other hand some suggest they can hear the rustling of the

193

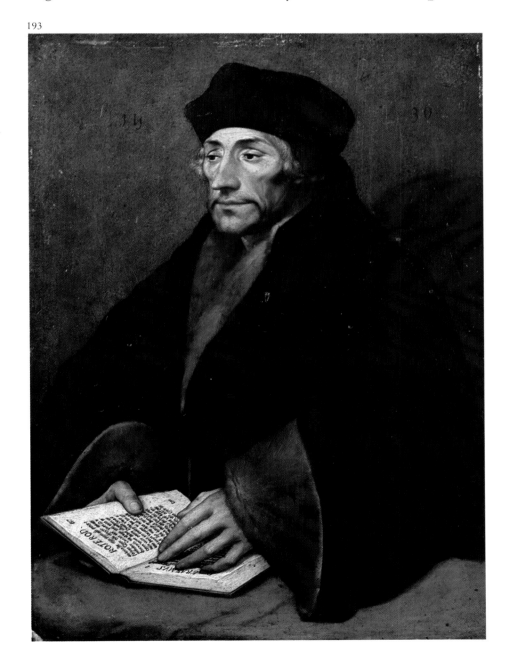

193. Hans Holbein the Younger, 1497-1543
Erasmus of Rotterdam, *1530*
Galleria Nazionale, Parma

133

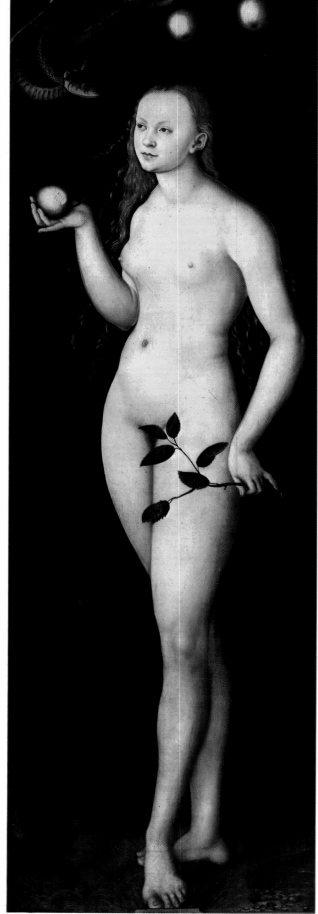

194

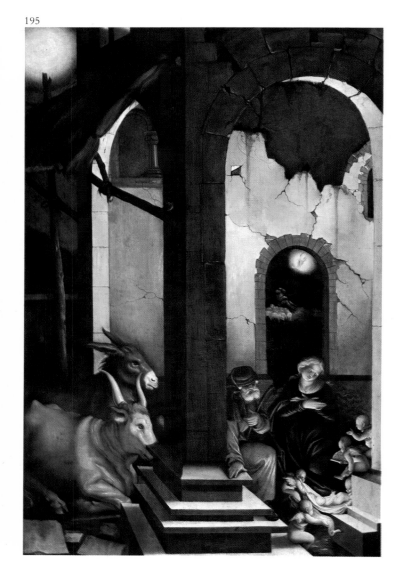

195

194. Lucas Cranach the Elder,
1472-1553
Eve, *1528*
Panel
Uffizi, Florence

195. Hans Baldung Grien,
Ca 1480-1545
The Birth, *1520*
Wood
Alte Pinakothek, Munich

mighty forests and the soft splashing of the mountain streams in his painting. His ''St George'' meets the dragon in a beech-forest where only foliage can be seen; no sky, not even the tops of the trees.

At the end of his life, Altdorfer made one more painting showing only unadorned landscape. This work, in the Pinakothek in Munich, shows a deep blue sky above a group of green trees, a small lake, a

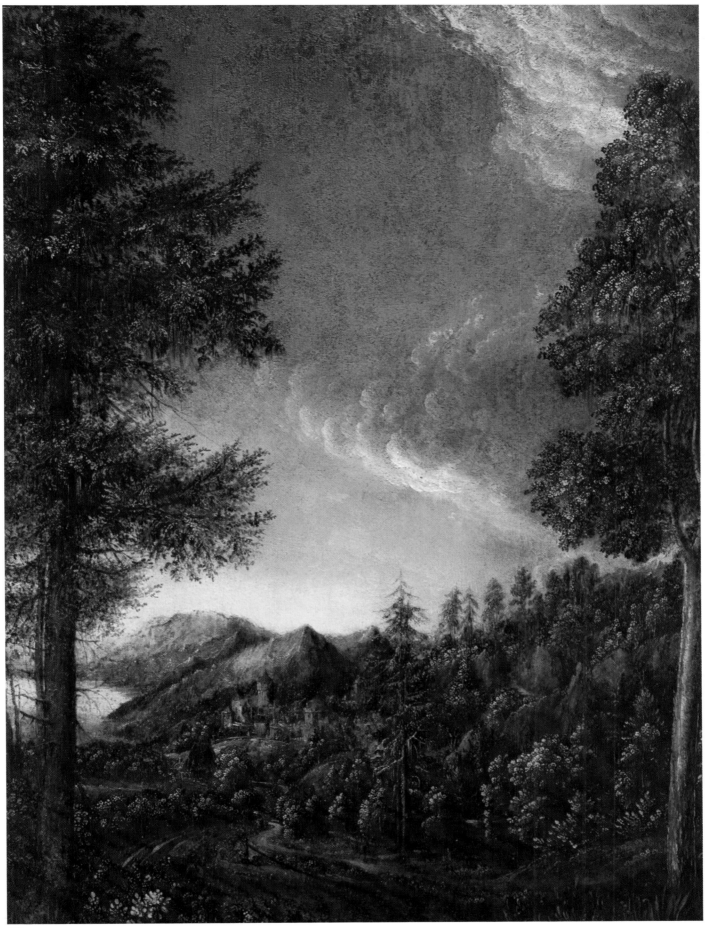

196

narrow footpath meandering over a meadow, and a scattering of houses. All previous landscapes clearly supported the relationship to religious art. Dürer did paint independent landscapes in his aquarelles, but did not attempt to break with the tradition in his paintings. Altdorfer dared to do this, and so became the predecessor of all the great landscape artists that were to come forward during the next century.

196. Albrecht Altdorfer,
Ca 1480-1538
Danube Landscape near Regensburg,
Ca 1520
Alte Pinakothek, Munich

The Awakening of the North

The 16th century stands on the threshold of a revaluation; up till now mannerism has been frowned on, and few kind words said about the "fin-de-siècle" elegance in the work of *Jan de Beer* and *Lucas van Leyden*. But is has become slowly evident that during that century varied forces were at work in the Netherlands; *Rubens* and *Van Dyck* can only be understood against the background of this 16th century development. Even the love for Italy and humanism is taken as a bad sign; nevertheless, the marriage of the Flemish and Italian tradition, as in the "Portrait of a Lawyer" by Quinten Massys, is no more than a fortunate continuation of a liaison that started with *Memlinc* and *Hugo van der Goes*. Without this relationship would the creation of such discreet and eloquent portraits as those painted by *Joos van Cleve* have been possible?

Pieter Brueghel: an Artist-Philosopher

To a certain degree *Pieter Brueghel* was the opposite to artists who were internationally orientated. Seeing Brueghel through his paintings, one arrives at many different conclusions. The legend of the lively artist, who enjoyed drinking and dancing with the farmers at their feasts can be seen in some: transforming village weddings and harvest festivals into genre-paintings. Through others Brueghel appears as a master, whose work can only be explained against a background of an egotistical and almost diabolical catechism. Indeed, he is an extremely complicated, philosophical artist, and one of the greatest of all times. His works completely lack the Renaissance selfconfidence, the feeling for greatness and dignity of the human being. His entire work is a confession of human frailty, despair and tragedy.

It has been said that Brueghel had been untouched by Italy and humanism; that he returned from the south both common and Flemish. Thus, the plebeian element in his work. In this respect Brueghel is a real child of the 16th century. Precisely because according to the

197. Pieter Brueghel the Elder, 1520/30-1596
The Blind, *1568*
Tempera on canvas
Museo Nazionale di Capodimonte, Naples

197

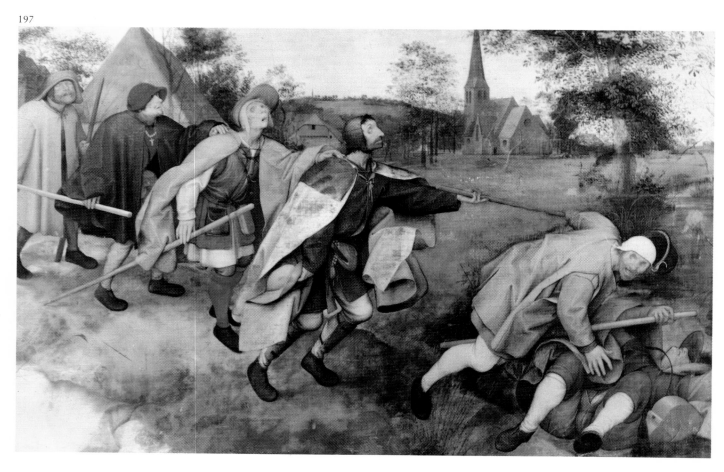

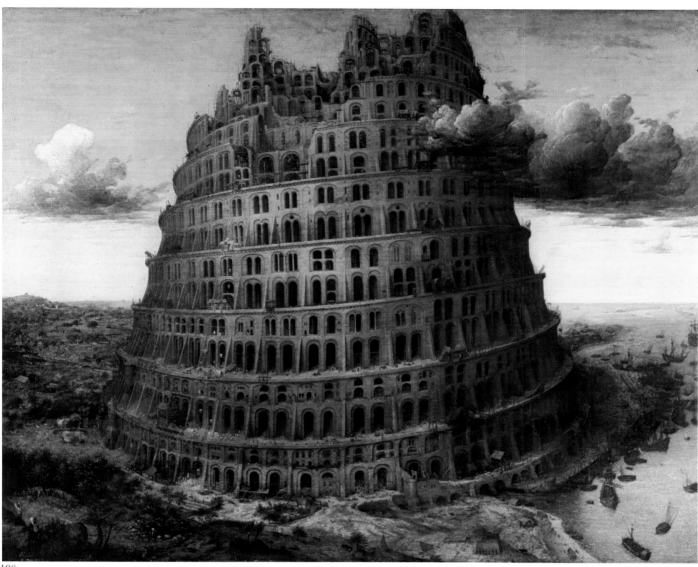

198

198. *Pieter Brueghel the Elder,*
1520/30-1596
The Tower of Babel
Museum Boymans-van Beuningen,
Rotterdam

199. *Peter Paul Rubens, 1577-1640*
Hélène Fourment and Her Children
Oil on wood
Louvre, Paris

199

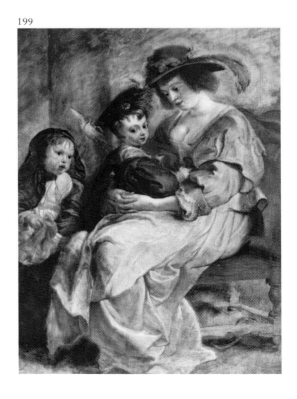

aesthetic conceptions of his time, only the noble were worthy of admission to art, he was not satisfied with the simple reproduction of reality, but made a parody of it, caricaturing the noble. Yet, to his field he has brought an undeniable monumentality; and the power of illustration with which he worked demands great admiration. Even the anecdotal in his work is given an accent of eternal humanity.

The plebeian element was continued in painting by *David Teniers* and *Adriaen Brouwer;* it was also at its highest at that time in the Republic of the Northern Netherlands.

The south, not yet released from Spanish rule, favorable to art, still

experienced a great climax in the art of Rubens and Van Dyck. Neither degenerated into the plebeian of the Teniers nor the appetite of the Northern Netherlanders for copying daily life.
The nobility they served saved them from this.

Rubens, the Reprieved.

Rubens' spontaneity was not curbed by his position as court artist and official painter of the Spanish Netherlands, nor by his diplomatic and artistic activities. He lacked a feeling for size and proportion, the Apollolike element of the early Flemish; on the other hand, with Dionysian temerity, he created man as a sort of demigod – descended to earth –

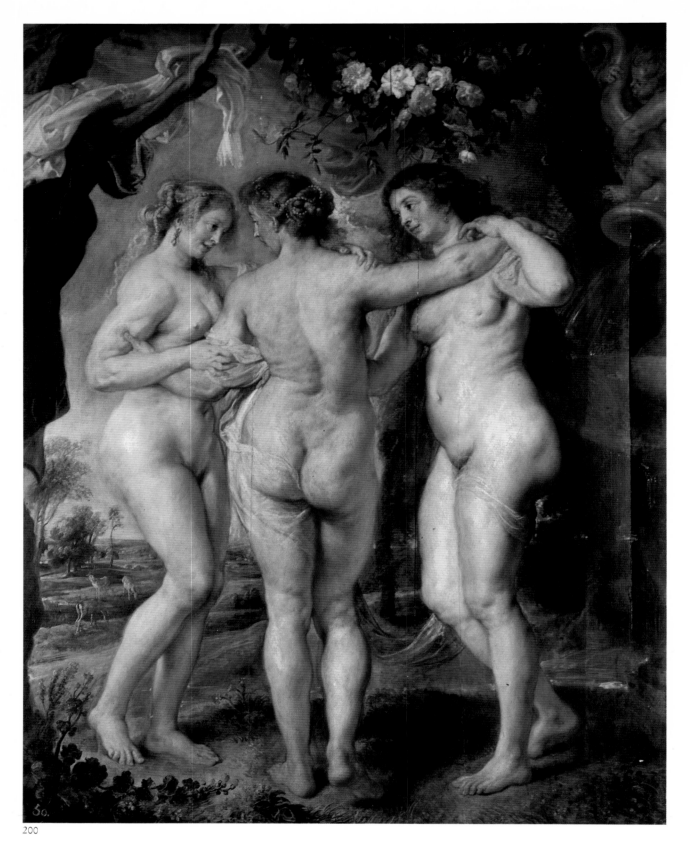

200

200. Peter Paul Rubens, 1577-1640
The Three Graces
Panel
Prado, Madrid

who gives rein to his inexhaustible powers.

With Rubens the human being is never ill or tired, never depressed, but a splendid beast of prey that hunts, eats, propagates and – preferably at the height of his powers – dies roaring. Rubens was born in Siegen, near Cologne, in 1577. As a young man, he trained for eight years in Italy, mainly as artist to the Duke Vincenzo Gonzaga of Mantua. He established himself in Ant-

werp in 1608. After 1622 he worked for the French queen dowager and queen mother of the Florentine house of Medici. Subsequently, he entered the service of Charles I of England. Rubens died, in Antwerp, in 1640 a distinguished personage, an artist and diplomat. He had held the title of confidential secretary to the Spanish crown and carried the rank of Knight to the British monarchy. The universal character of his position in society was closely

201

202. *Lieven de Key, ca 1560-1627*
Former Meat Market, *Haarlem*
1602-1603

202

related to his nature that, in every way, was universal. In Rubens the diplomat and the artist are united in one person. He was a cavalier of the courts and, at the same time, a true representative of the people. When the workers from the Antwerp harbour area appear as hangmen who erect the cross or as heroes from mythology, it is an acknowledgement of his ties with the people. His great love for all forms of life is so healthy, there is only one word to describe it – democratic. At the age of 53 Rubens married the 16 year old Hélène Fourment, his second wife. She was the idol of a man who craved not only a lady of distinction but the sturdy reality of a woman from the common people. However, even greater contrasts lie in Rubens' genius. He envelops Catholic life in the religious elan of the Counter-Reformation but, as heir of the Renaissance, is fascinated, at the same time, by the sensual pleasures of the world. His perception extends from the lofty heights of Baroque feudalism, Baroque church, and Baroque royal courts, down to Flemish peasant life. The aristocratic Rubens was also a follower of Brueghel.

139

203

203. *Anthony van Dyck, 1599-1641*
King Charles I, *1638*
Louvre, Paris

Catholic and heathen, nobleman and plebeian, cavalier and painter, realist and Baroque artist. On one side voracious and pathetic, a vehement character, on the other, well-ordered, self indulgent yet self-controlled. Pictorial and plastic, Germanic and Roman, Flemish and Latin, Dutchman and cosmopolitan, all at the same time: these contradictions made Rubens the synthesis of all possibilities in the Baroque era.

To understand him, it is no use starting with his major works. His personality appears chiefly in the sketches and subsequently in three paintings totally by him.

204

204. *Jacob Jordaens, 1593-1678*
Pan and Syrinx
Koninklijk Museum voor
Schone Kunsten, Brussels

An outstanding example is the Parisian portrait of *Hélène Fourment with the children,* or any of his masterly landscapes.

Anthony van Dyck, the Aristocrat.

Rubens encompassed the feudal as well as the democratic energy of the

Baroque. His most famous pupil, *Anthony van Dyck,* born in 1599 in Antwerp, and educated during his journeys to Italy in the years from 1621 to 1625, was completely committed to the aristocratic side of the Baroque. He went to England to work at the court of Charles I, a sovereign who in feudal allure, could

141

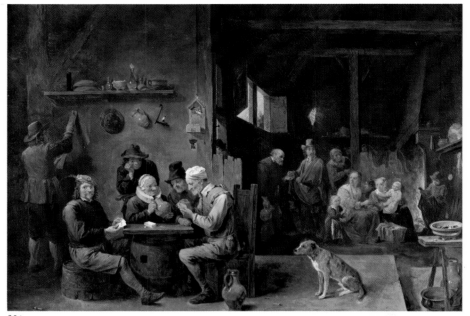

206. *David Teniers the Younger,*
1610-1690
Card-players in an Inn
Musée des Beaux Arts, Grenoble

206

207

205. *Michael Vervoort, 1667-1737*
The Pulpit, 1723
Cathedral of Mechlin

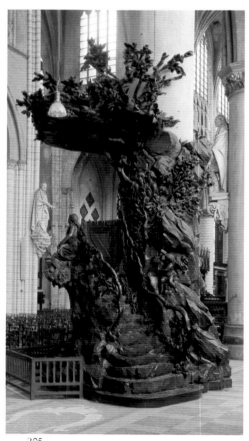

205

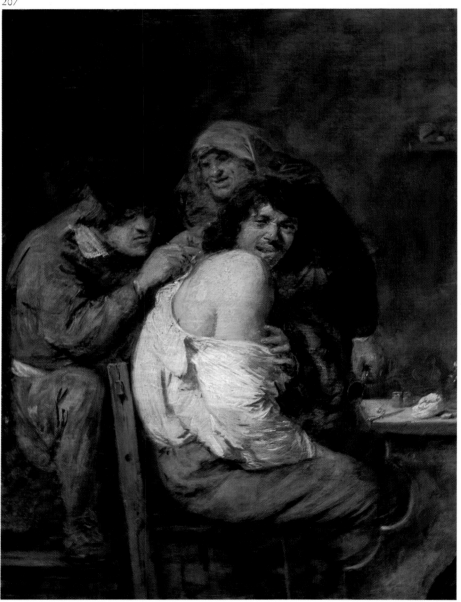

207. *Adriaen Brouwer,*
1605/06-1638
The Spinal Operation
Städelsches Kunstinstitut, Frankfurt

match the Baroque sovereign Louis XIII of France. Van Dyck died in 1641 in London. The allegation that he developed unfavorably during his stay in England can now be considered disproved, especially by those with a keen eye for impressionism. They find in Van Dyck a vivid similarity and an immediate contact with Manet. His spontaneity may be presumed from his drawings, and confirmed by a detail in "Lords John and Bernard Stuart": the hand that holds a glove. He demands our admiration, this court-painter with great technical command, a passion for spontaneity, and such a lively directness in depicting details.

"Lords John and Bernard Stuart" is one of the very best of Van Dyck's English paintings, and the portrait of *King Charles I* from the same period is another. *Jacob Jordaens* also came from the Southern Netherlands; born in 1593 in Antwerp, he died there in 1678. He belongs to the Rubens school, and with Van Dyck, he is considered the most gifted of this circle. The *David Teniers*', both father and son had the same name, continued the tradition initiated by Brueghel; the younger Teniers was superior to his father; he was born in 1610 in Antwerp and died in Brussels in 1690.

Adriaen Brouwer: a Great Artist among the Greatest.

Adriaen Brouwer's work far surpasses the Teniers'. Their work never left the anecdotal. He spent some seven or eight months in Antwerp prison for debts, and died a pauper, in his early thirties. The work of Brouwer reflects not only an unmistakable pictorial emotion, but there is also a certain tragedy about his paintings. A foreboding of an early death, perhaps a reflection on the severity of the times. In his best works, Brouwer certainly shows a relationship to Rembrandt.

208

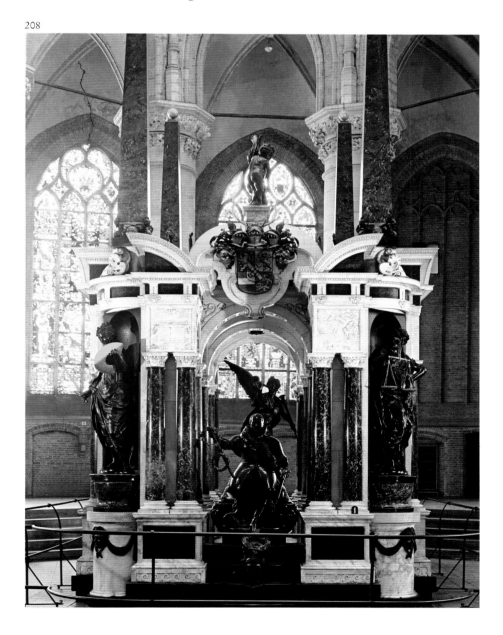

208. Hendrik de Keyser, 1565-1621
Tomb of William the Silent,
1614-1621
Nieuwe Kerk, Delft

143

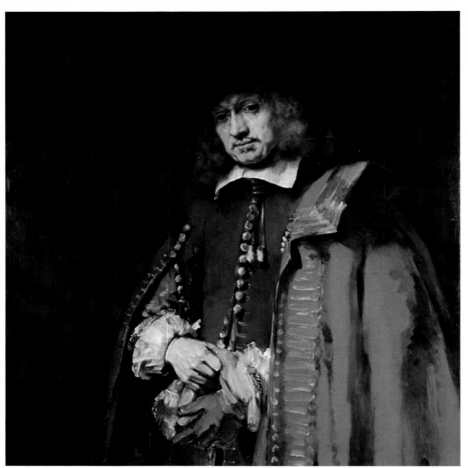

209. *Rembrandt Harmensz. van Rijn,*
1606-1669
Portrait of Jan Six, *1654*
Private Collection

210. *Rembrandt Harmensz. van Rijn*
1606-1669
The Nightwatch, *1642*
(*the company of Captain Frans*
Banning Cocq and Lieutenant
Willem van Ruytenburch)
Rijksmuseum, Amsterdam

209

210

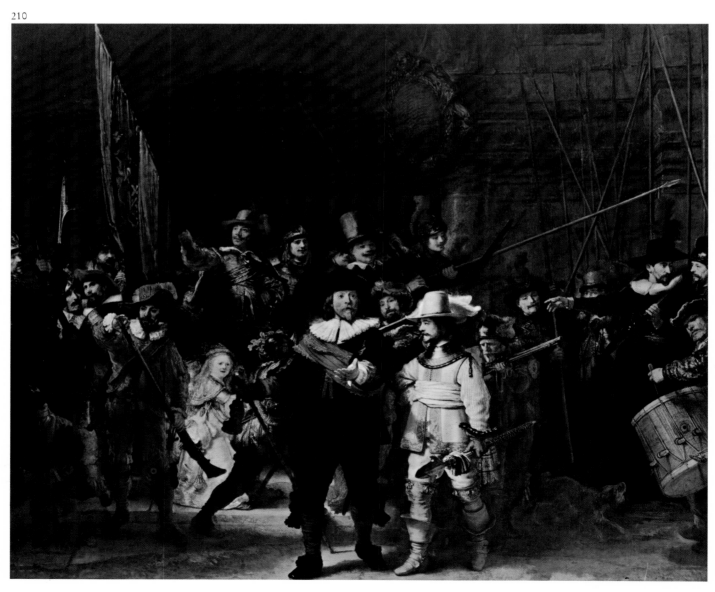

144

211

The Flemish Contribution to Architecture and Sculpture.

Flemish artists contributed to the art of the Northern Netherlands (in contrast with Brouwer who, as a born Dutchman, worked in the south). The work of *Artus Quellijn*, particularly in building the Palace on the Dam in Amsterdam, is one of the most important in the northern Baroque art. *Rombout Verhulst*, an artist born in Mechelen, collaborated with him. He was Quellijn's chief companion, and he created the unique figures, "Silence and Fidelity" for the Palace on the Dam. In portraits, like the one of *Mary of Reygersberg*, he combined the sober realism characteristic of Dutch art with an extremely true reproduction of hair style and clothing details.

The Flemish influence was felt in architecture. In Haarlem, *Lieven de Key*'s major works arose in a handicraft style of construction called strongly Flemish, because of its luxuriant style and plastic impression. Between June 1602 and late 1603, the famous *Vleeshal* (Meat Hall) the outside of which almost spells the name, de Key. This master was a magnificent decorator who created harmonious and quite personal masterpieces, chiefly derived from traditional forms. The "Vleeshal" and the "Nieuwekerkstoren" (New Church Tower) are good examples. *Hendrick de Keyser*, born in 1565,

moved to Amsterdam in 1591. He was an important architect, but he had another ambition: to be a sculptor. Even though his business as an architect was mainly limited to Amsterdam, traces of De Keyser can be found in Delft, and in Hoorn (the design of the Hoorn weigh-house from 1609). De Keyser's name is established in Dutch history by the *Mausoleum* he was commissioned to erect in the Nieuwe Kerk in Delft in honor *of Prince Willem I*. This black and white marble monument with bronze statues, was built in De Keyser's workshop according to his personal design. Its conception was in line with the southern Dutch monumental mausoleums of that time. It is typically Dutch. The most important example of 17th century Dutch architecture is the *City Hall on the Dam*, it became, in 1808, the royal palace. Both Quellijn and Verhulst worked on it. Its architect, *Jacob van Campen*, strove to impress by a sober monumentalism which helped to make Dutch architecture equal to the Italian. Van Campen was closer to the southern Dutch Baroque than most of his contemporaries.

A cultured man, with an admiration for Rubens. Several, typically Baroque details, however, cannot be attributed to Van Campen himself, but to those who participated in the completion of the building.

Later that century, particularly in

145

212

213

212. *Hercules Seghers,*
1589/90-1638
Landscape, *ca 1625*
Museum Boymans-van Beuningen,
Rotterdam

213. *Ferdinand Bol, 1616-1680*
Boy in Polish Costume, *1656*
Museum Boymans-van Beuningen,
Rotterdam

146

the Southern Netherlands, Baroque reached the heights of sculpture; *Michiel Vervoort's pulpit* in the cathedral of Mechelen is a fine example of an extravagant, rhetorical abundance.

A Bourgeois Era

The Baroque community was polarized in two extremes: the courtly, aristocratic on one hand, and the proletarian on the other. Between was the bourgeois world clearly influenced by the Reformation and by humanism.
In the 17th century, the dynasties were again feudalized due to the reaction or rather restoration called Baroque.
A counteraction to the patrician world of the Rinascimento. Under a bourgeoisie, concerned with the feudal, reactionary process, a proletarianism inevitably developed between 1600 and 1789. The typical bourgeois element must not be underestimated in relation to the feudal and proletarian element in the Baroque era.
The bourgeois Baroque, in which the middle-classes played an essential part, was chiefly Dutch. 16th century Holland was bourgeois,

republican, and Protestant. The Baroque was, for the Dutch, a token of their struggle against the Catholic-feudalistic, Catholic-monarchistic Spain. The result of this struggle was a Protestant-republican bourgeoisie.
This bourgeoisie missed the aristocratic allure of a *Tintoretto*, or of a *Greco*. It had something in common with *Rubens*, the Southern Dutchman who belonged to the Spanish Empire, while the Northern Netherlands fought for the right to found a free, bourgeois nation.
Rubens' creations were destined for churches and altars, and for the palaces of the rich; *Rembrandt* worked for the bourgeoisie. Rubens is retrospective, influenced by tradition, and can only be understood through tradition; he was the last master of the feudal, old world, and his type of art is magnificent apotheosis. In painting the "Holy Family", Rubens presented a noble woman accustomed to the world's admiration, who almost coyly looks aside.

Rembrandt, grown away from
Time and Place

Rembrandt; what did he do with this theme? He chose a carpenter's fam-

214. *Frans Hals, ca 1580-1666*
Women Governors of the Haarlem Almshouse
Frans Hals Museum, Haarlem

214

215. *Carel Fabritius, 1622-1654*
Self-portrait
Panel
Museum Boymans-van Beuningen
Rotterdam

215

216

216. *Artus Quellijn, 1609-1668*
Frieze on the Mantlepiece in the
Mayor's Room,
Ca 1650 – marble
Palace on the Dam, Amsterdam

ily, simple people living in a simple, ill-lit room. The mother feeds the child, father is working. One wonders how Rembrandt could so completely reject the past and paint a poor farmer's wife as the Mother of God. The Dutch took everything that could be used in history and religion as a subject and reduced it to petty-bourgeois proportions. To do this, they abandoned the heroic style. The historic art of painting took its own course in Holland very early, deviating from a traditional art. At the beginning of that century, *Pieter Lastman*, Rembrandt's teacher, painted biblical and mythological scenes without any heroic pathos.

Rembrandt was Lastman's pupil for only six months. From the historic point of view, Lastman was by no means the romanticist he is often considered. On the contrary, it was he who introduced a new style that was to become of paramount im-

portance at the beginning of the century. What Rembrandt added to the somewhat anecdotal trend of Lastman, was a new way of expression, which gave a completely different character to the illustration of biblical history. A remark in Constantijn Huygens' autobiography shows that Rembrandt's different "expression" was immediately noticed. Over the years, Rembrandt's art became calmer, simpler, but at the same time, more fervent and profound. As soon as this art reached its height, it stopped being typically Dutch and brushed aside all national limitations. This goes for few other artists. When *Jan Steen* painted the "Wedding at Canaan", or "Christ at Mary's and Martha's" he stayed within the limits of the Dutch bourgeoisie, and there is no sign that these works exceed the Dutch commonplace.

Neither does Rembrandt avoid the commonplace. But this ordinary life

217

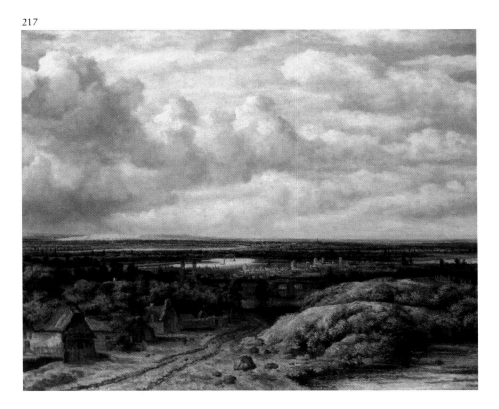

217. *Philips Koninck, 1619-1688*
Landscape with Houses along
a Road, *ca 1670*
Rijksmuseum, Amsterdam

149

is so pregnant with emotions, love, and deference that it takes on another dimension.

Rubens once painted Jupiter and Mercury visiting Philemon and Baucis in their hut. Jupiter has a Herculean torso, and a muscle-packed arm. Mercury and Philemon are talking, while Baucis is busy trying to catch a goose, and Jupiter is making a gesture at the attempt. Rembrandt chose the same group of figures in the same situation. There is no greater contrast possible. Rembrandt shows the modest hut, the age, the inner nobility of an honorable god, but in his painting the psychic relation between the figures comes alive. It is the same atmosphere as in the Christian Emmaus-theme.

Rembrandt repeatedly painted it. Christ wears everyday clothes. But the spectator as well as the disciples in Emmaus get the right notion. Something inexplicable lets them know that the man before them really is Jesus Christ.

218. Johannes Vermeer, 1632-1675
The Lace-maker, *ca 1665*
Louvre, Paris

218

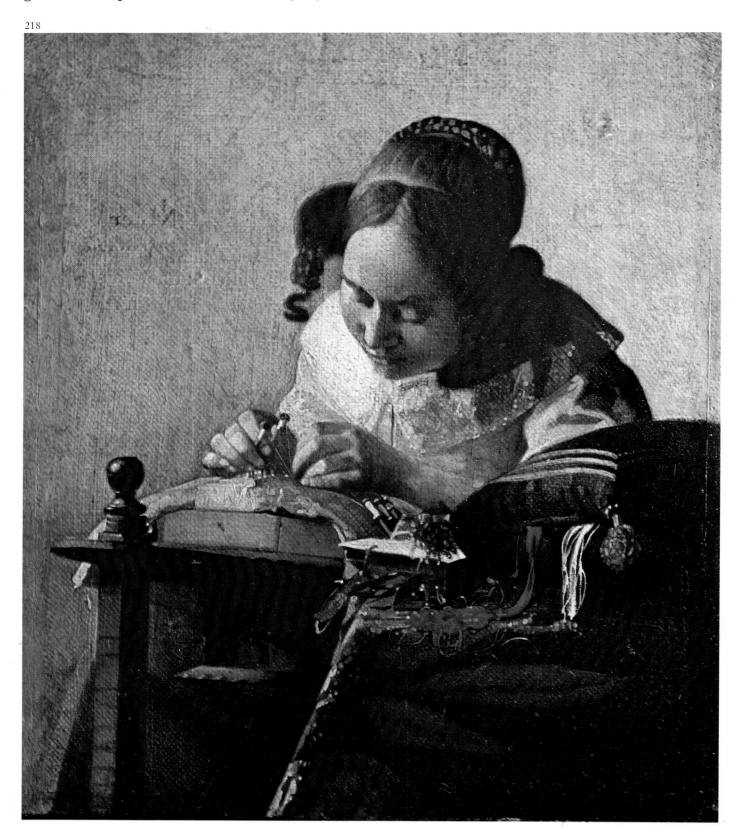

150

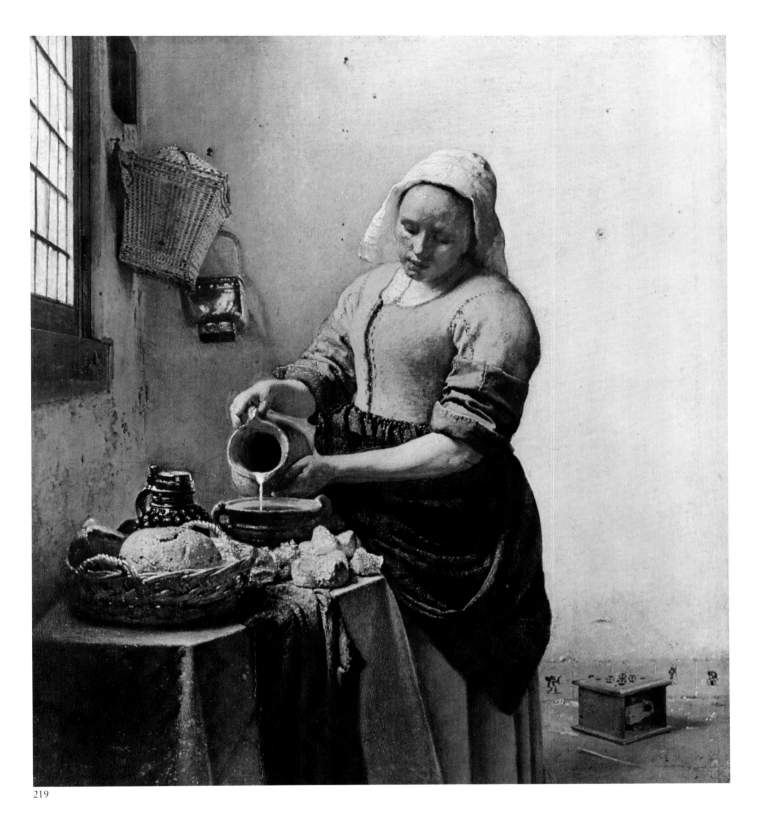

219

219. *Johannes Vermeer, 1632-1675*
The Kitchen Maid, *1658*
Rijksmuseum, Amsterdam

Frans Hals and the Pictorial Instinct.

Frans Hals was most probably born in Antwerp. His career, however, was Dutch. He lived, worked, and died in Haarlem. He was born in 1580, and died in 1666. One of the greatest painters of bourgeois Holland, he was at the same time, a rebel. To the Dutch bourgeois who liked order, he liked the wild life too much. He accumulated debts, was an alcoholic, broke the law, and spent some time in prison. There is no way of proving or disproving his biography. But, there is a curious

connection between his works of art and his alleged life. The hatred with which he depicts the rather hypocritical "decency" of the bourgeois, Calvinistic authorities cannot be misinterpreted. The heads of an orphanage were portraited by a hand that with astonishing certainty creates the likeness, while at the same time reducing the bourgeois faces, and habits to an eerie image: to a ghost of neatness, of bourgeois perfection, love for order, and sobriety. When he was certain of the freedom to paint as he pleased, he took to purely pictorial painting, from his

151

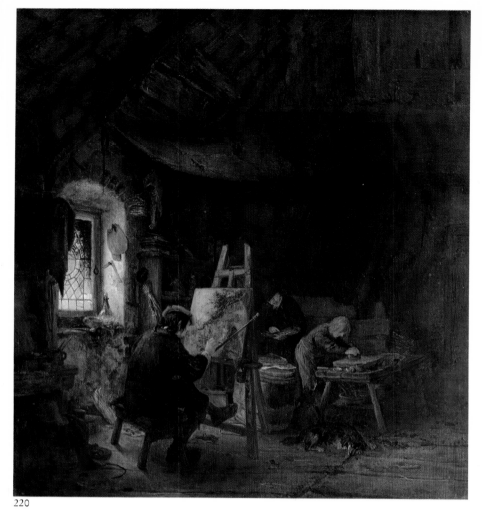

220

221

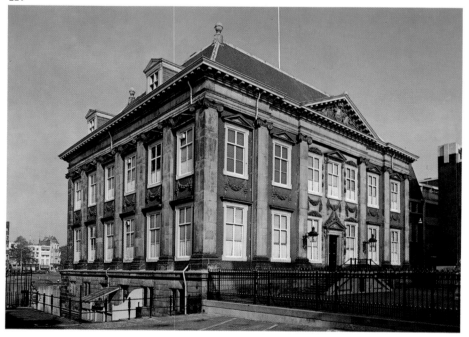

221. *Jacob van Campen, 1595-1657*
Mauritshuis, *ca 1633*
The Hague

220. *Adriaen van Ostade, 1610-1654*
The Workshop
Rijksmuseum, Amsterdam

feelings. He made unbelievable paintings, in a hand that is freer, more direct, and exciting than those of most of his contemporaries, except, of course, for Rembrandt. Hals could only indulge his painter's instincts when he had no official personages as a model: streetwalkers, drunkards, musicians, gypsies and scallywags, were his favorite models.

Seghers, the First of the "Peintres Maudits" (Cursed Painters)

Only in this century has attention turned to an "outsider" in Dutch painting, *Hercules Seghers*. Only fragments of his life are known, but what is known suggests tragedy. Seghers was born in 1590, probably in Haarlem, and he died in 1640. His works had no success. He was poor, and had known only misery. He drank, and, it is believed, his drunkenness caused his last, fatal fall. Seghers' etchings, some of which were printed in a curiously elaborate manner, are evidence of a disturbed psychic life. When painting a landscape, he saw a mystic desolation. When etching a high mountain range, a world of fantastic melancholy was created. He drew a pine – it turned into a ruin. There was an abstract melancholy about him. His experience of the world is derived from a life of seclusion. In some of his work things already seem to have been eaten by decay. This anguish is not so manifest in his paintings of landscapes as it is in his etchings, but an identical melancholy can be felt in the paintings. The grand, pictorial beauty of those landscapes, which can match Rembrandt's, are impregnated with tragedy.

Rembrandt's life and career

Rembrandt remains the most powerful figure in the art of that entire century, and, despite Seghers, it is correct to mark him as the sole figure of 16th century Dutch Baroque, just as Michelangelo or Grünewald were in their times. *Rembrandt Harmensz. van Rijn* was born in 1606, the same year as *Adriaen Brouwer*, who had not yet had his fair share of admiration. When Brouwer died, Rembrandt had not yet painted any of his real masterpieces. Taking only his "The Anatomy Lesson of Doctor Nicolaes Tulp", painted at

152

the age of 26, or the "Self-portrait with his wife Saskia on his knees", it would not be enough to make him superior to Brouwer. Rembrandt, however, outlived him, and reached the age of 63. Rembrandt's life had a promising start by bourgeois standards. As the son of a petty-bourgeois miller from Leiden, he was wed to a rich patrician's daughter; Saskia van Uijlenburgh, daughter of a Friesian mayor.

The young artist received commissions from the whole, well-to-do Amsterdam middle class. He painted outstanding portraits, conventional enough to pass as representative. Rembrandt achieved bourgeois esteem and the bourgeois prosperity to go with it.

Apart from the work that established his official reputation, there was his other work that hardly manifested itself, from 1632 to 1642, during his marriage to Saskia. This other Rembrandt did not appear until Saskia had died in 1642, and others had taken her place. From

that time onwards, his considerable fortune, dwindled to nothing.

In 1665 Rembrandt went bankrupt. He had to leave his patrician mansion in the Antonie Breestraat and moved to the Rozengracht. This bankruptcy, however, meant liberation and the beginning of the real Rembrandt, the artist who not only crowned the Baroque, but the art of painting in general. With the defeat of bourgeois attitudes the paintings gave evidence of true spiritual reality. "Jacob's Blessing", "The Good Samaritan", "Saul and David", "Esther", "The Prodigal Son", "Claudius Civilis", "The Slaughtered Ox", "The Clothmakers" (de Staalmeesters), the range of masterly landscapes, and those fervent paintings dedicated to his mistress Hendrickje Stoffels.

Hendrickje died· some time after Titus, Saskia's son. Once again, Rembrandt was alone, sixty years old, with no-one around him to fill his life. From those later years when he made his last few self-portraits, came Rembrandt's most beautiful

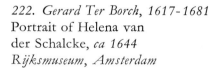

222. Gerard Ter Borch, 1617-1681
Portrait of Helena van
der Schalcke, *ca 1644*
Rijksmuseum, Amsterdam

222

223

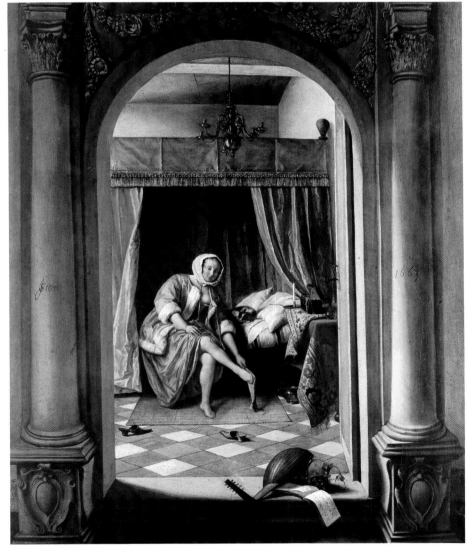

223. Jan Steen, 1626-1679
The Morning Hour, *1663*
Panel
Collection of H.M. the Queen,
England

paintings. They lack the gala-robes and gems, but are enriched by a world of mysterious, sparkling beauty. The so-called "modern" problem of how to apply unbroken colors adjacent to each other on a canvas was already solved by Rembrandt. Some of his canvasses, closely looked at, give the impression of a chaos of red, orange, blue and green areas of paint. With a step back, the chaos of paint unites into large, plastic shapes and colorful harmonies. Stand and admire one of those later works of Rembrandt's, and one can go away with an unforgettable impression of flaming red or glowing yellow created by only one stroke. Eventually, Rembrandt broke completely free, took no more commissions. He painted and drew exclusively what his genius inspired in him.

Rembrandt's School

The best of his pupils got nowhere near him; *Aert de Gelder*, *Barend Fabritius*, *Ferdinand Bol*, *Nicolaes Maes*,

Gerbrand van den Eeckhout. Only *Carel Fabritius*, who at the age of thirty died in the explosion at the Delft powderhouse, could probably have developed to be another great Dutch painter. All of his works mark him as, not only the successor to his master Rembrandt, but also show that he had individually studied the possibilities of light in a prominent application of colors.

With his master Rembrandt, Fabritius shares the refined sense of simplicity in the subject. The small painting "The little gold-finch" lacks any anecdotal content. It is almost a study of the possibilities offered by light: the colorful feathers, a piece of a gray wall, and the light, all this harmonized in a subdued accord, far-reaching and high-pitched.

How close Fabritius came to his master, without actually succeeding him, is evident from his *Self-portrait*.

The best landscape painter from Rembrandt's school was *Philips Koninck*. Rembrandt opened his eyes

to the poetry in vast expanses almost endlessly covered by low weeds, the land stretches away. High above, the clear skies give a view of utter remoteness.

As a painter of the sea, *Jan van de Capelle* was inspired by Rembrandt; he was one of the most subtle colorists among his contemporaries; a man who with great refinement knew how to interpret the delicate and volatile play of light, less prosaic than the average painters of the marine scene, apart from one great exception, *Van de Velde*.

Classical Holland: Vermeer

It would be useless to try and find a painter the equal of Rembrandt. For centuries after, he remained unmatched in depth of feeling, and greatness of artistic quality. Nevertheless, there was one painter, in that same 17th century, also in Holland, who can be mentioned with Rembrandt, despite his totally different character: *Jan Vermeer van Delft*. The first question that is constantly

224

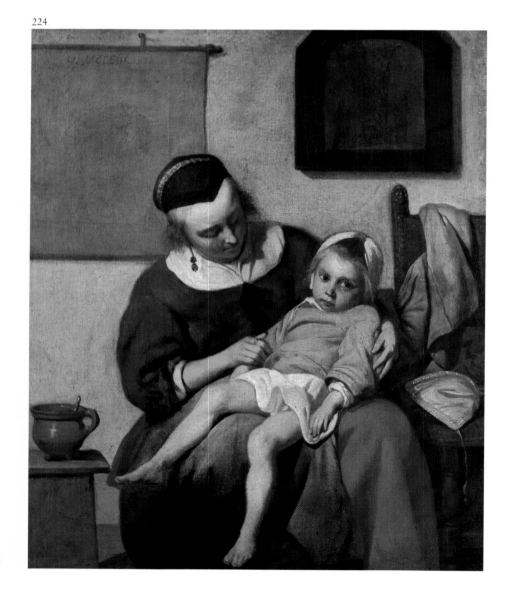

154

224. Gabriel Metsu, 1629-1667
The Sick Child, *ca 1660*
Rijksmuseum, Amsterdam

225. *Salomon van Ruysdael,*
Ca 1600-1670
The Stop at the Inn, *1648*
Panel
Private Collection

226. *Jan van Goyen, 1596-1656*
View of Dordrecht, *ca 1648*
Panel
Rijksmuseum, Amsterdam

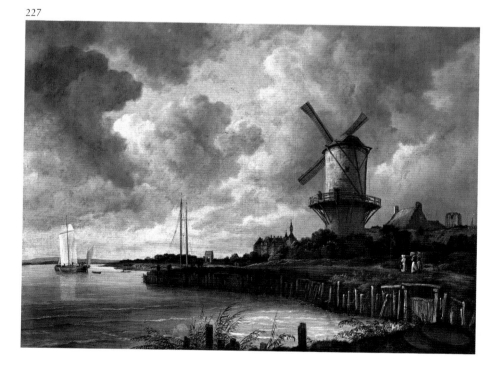

227. *Jacob van Ruisdael,*
1628/29-1682
The Mill near Wijk-bij-Duurstede,
Ca 1670
Rijksmuseum, Amsterdam

155

228

228. The Weigh-House, Nijmegen
17th century

229

229. Pieter de Hooch, 1629 – after
1684
A Small Dutch Court-Yard, ca 1656
National Gallery of Art,
Washington D.C.

asked when Vermeer is mentioned is why is so little known about him. The lives of far less important and less successful painters are better documented than his. The reason for this may well be that Vermeer was not properly recognized until the 20th century.

What we do know about him is this: Vermeer carried on his father's business, as innkeeper, with little interest, and he kept an artshop. A few months after his death, he was 43, his widow was faced with bankruptcy because she was unable to pay the baker's bill – it was so big that it must have covered a number of years. Eleven children shared the inherited poverty.

Vermeer painted Dutch women reading letters or decorating themselves with jewels around their heavy necks; he painted bourgeois rooms with a clear, calm spaciousness; he painted girls who gleamed like pearls, their lips and eyes glit-

tering moist and glistening like pearls. No other Dutch painter had so much in common with the "clarté cartésienne", the poise and geometrical feeling so remarkable in French art. Yet, to most non-Dutch his paintings are a portrait of Holland.

Vermeer never used superficial lights, like Rembrandt, but a diffused kind of natural light from normal illumination. His hues are not warm and golden like Maes', but cool and silvery; Maes' shadows are brown and impenetrable, those of Vermeer have a fine, transparent gray tone.

In his motifs, Vermeer paints simply, almost soberly in an unequalled way. Only a few of his paintings show two or three figures; most of them present a single person, often only half visible. A young woman reading, winding thread into a ball, or sitting at he harpsichord, or doing some household chore. Vermeer's style is one of color composition.

230. Meindert Hobbema, 1638-1709
The Mill with the Red Roof, ca 1670
The Art Institute of Chicago

231. Abraham Bloemaert,
1564-1651
The Preaching of John
the Baptist, ca 1600
Rijksmuseum, Amsterdam

230

231

232

This painter exhibits the purest and most primitive color values in the simplest forms. He preferred the combination of the three elementary colors, red, yellow, and blue. A typical example of this is *The housemaid with the milk-can;* here the yellow, blue, and red are adjacent in saturated areas, the intensity being increased by the radiant white of the wall.

In the choice of subject and the composition of the painting, the only objective was to give a colorful sensation to the eye on a small scale. This attitude demonstrates the disparity between Vermeer and Rembrandt. Rembrandt puts the color to the service of the figure to illustrate the inner being, something not perceptible by the senses, whilst Vermeer puts the figure totally at the service of the color, uses the figure chiefly as a vehicle to realize a composition in color values.

The Genre-paintings

In the paintings by *Adriaen van Ostade*, with rural life as their subject, there is quite a different atmosphere to Brouwer's works. In Van Ostade's works there are some wild, thoughtless scenes, but later on it is a homelier and quieter atmosphere that finds its way into his paintings. Through his later works there runs a thread of almost idyllic peacefulness. His younger brother *Isaäc van Ostade* was even more sober. He occupied himself mainly with the coach and horse traffic in front of country inns.

Jan Steen was the most versatile painter of this group of "Populists". In spite of his trade as an innkeeper, which he started in 1672 in Leiden, he went on painting incessantly, and produced some seven to eight hundred canvasses. Perhaps too often, Steen illustrated his motif too sharply, so that the painting was degraded to a cartoon or anecdote. When he committed himself too much to the motif, the results were poor. But whenever the artist overruled the narrator, it suddenly became apparent what a great master wielded the brush.

Jan Steen's world was made up of peasants and the bourgeoisie, weddings and ball-games, fairs and chicken yards, scientists and pastry-

232. Gerrit van Honthorst, 1590-1656
St. Peter denies Christ
Musée des Beaux Arts, Rennes

233. Hendrick Terbrugghen, 1588-1629
The Flute-playing Shepherd,
Ca 1621
Staatliche Kunstsammlungen, Kassel

233

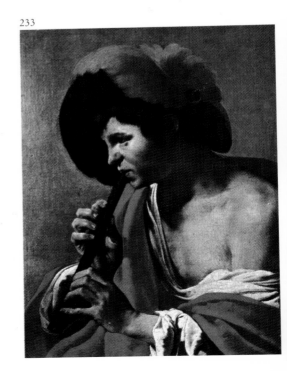

cooks, fishsellers, milkmaids and errand-boys, alchemists and quacks, harlots and preachers. Jan Steen's world offered a place to everybody in his life and activities from the cradle to the grave; he observed people closely, with astuteness and humor, and with clear preference for the undisguised bliss of love. Some of Steen's canvasses are crowded with people; that prove the versatility of his talent. Yet, this is most beautifully developed in the small works, where only a few characters are depicted. The "Young Woman in the Bedroom", and *The Morning Hour* are examples of a poetic feeling that brings the reality of the "pot-de-chambre" into poetry. An example of a gallant innocence which, expressed thus, is unique and typically Dutch.

Gerard Ter Borch's art is severe. His numerous travels made him an exception among his fellow countrymen and painters. He was in London at twenty-eight, five years later in Rome, and he visited Spain, where he made a portrait of Philip IV. In contrast to Jan Steen, in Ter Borch's

works, the anecdotal element played a very minor part. Comparing Steen with Ter Borch is like comparing noise with silence. Characteristic of Ter Borch is the distinguished dignity and cool reserve that established his position amongst his numerous, much louder contemporaries. Ter Borch painted virtuously, avoiding sharp, loud color contrasts. He also avoided showy gestures.

Compared with Ter Borch's art, that of *Gabriël Metsu* appears to be less refined, and mainly bourgeois. Nevertheless, in one of his most beautiful paintings, called *Sick Child*, he displays a magnificent triad of colors against a background of a light gray wall: yellow, blue and red in a classically modest and strict arrangement.

The Dutch Landscape

In the Holland of that time, there was a liking for the painting of animals. *Paulus Potter* ranked highest among these painters. Potter painted the massive bodies of cows, the slow walk of cattle with true Dutch

234. Pieter Jansz. Saenredam, 1597-1665
The Mariaplaats in Utrecht, *1663*
Panel
Museum Boymans-van Beuningen, Rotterdam

234

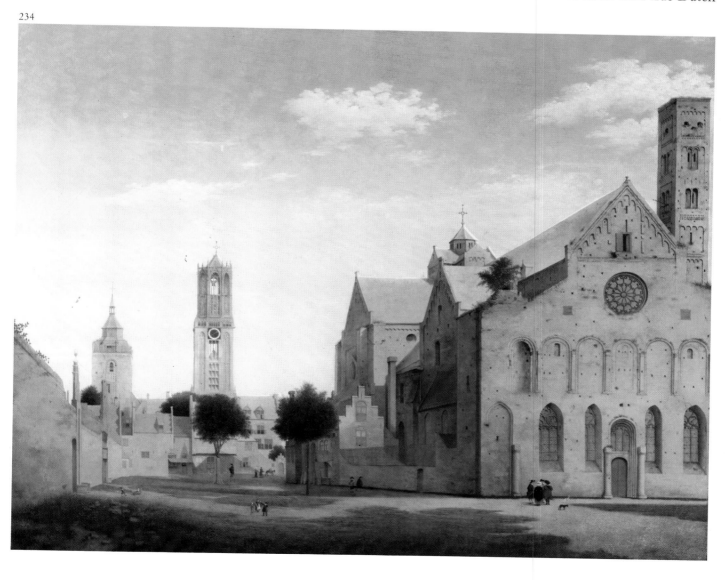

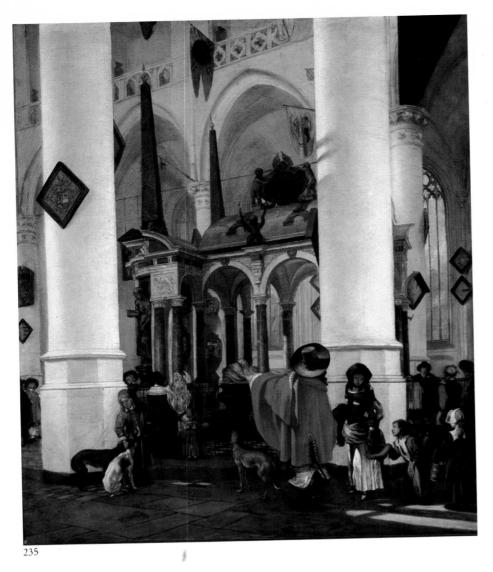

235

235. *Emanuel de Witte, ca 1617-1692*
Interior of the Nieuwe Kerk
in Delft, *1656*
Musée des Beaux Arts, Lille

sobriety. They masticate phlegmatically, and lay in the meadows in imperturbable rest. *Philips Wouwerman* usually painted horses; *Melchior d'Hondecoeter* specialized in poultry.

Much more important than these special lines of art, however, was Dutch landscape painting. It is a characteristic of these landscapes that they lack richness of color; it is a type of painting where coloristic contrasts are avoided. *Jan van Goyen*'s usual subject was the river. Boats quietly moving, often with fishermen taking in their nets. His favorite hue was a misty, damp gray-brown. Like many others Van Goyen could not earn a living from painting, even though he produced over twelve hundred canvasses. He supplemented his income by trading in tulips.

Salomon van Ruysdael created more colorful paintings. In his paintings the trees often stand protectively around the low houses that are covered by a friendly light and exude the peace of rural life. The trees are not threatening; the sun lights the foliage, and trembling,

236

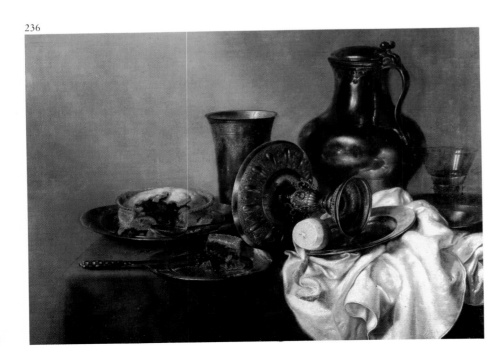

236. *Willem Claesz. Heda,*
1594-1680
Still Life, *1633*
Panel
Frans Hals Museum, Haarlem

237

237. Jan Jansz. van de Velde,
1618/20-ca 1663
Still Life, 1651
Rijksmuseum, Amsterdam

238

238. Adriaen Coorte,
Active ca 1685-1705
A Bunch of Asparagus
Paper on oak
Rijksmuseum, Amsterdam

161

239

239. *Jan Davidsz. de Heem,*
1606-1683/84
Still Life with Flowers
Collection Thyssen-Bornemisza,
Lugano

flutters on into the shadows. End-
less waters reflect the clouds inter-
rupted only by a flat, manned boat in
the foreground, and the flagged masts
of distant ships. The flat boat is a
ferry; taking a horseman, cattle and
a few people to the opposite bank.
In the shelter of trees on the bank a

small boat lies; a bird glides low
over the water. How small man really
is against his surroundings. With
the animals he is subordinated to
the overall composition of clouds,
woods, and water. The hand that
arranged this so well reaches out
over men and animals; everything is

covered by a quiet peacefulness, born from the inner contemplation of the artist.

Have we seen *Jacob van Ruisdael* too much with the eye of a romanticist? Today, we hear again people suggesting that Ruisdael was stricken with a fear of life, a person gnawed at by an "angoisse pascalienne", from which he could only liberate himself in a pantheistic experience of nature

Ruisdael painted more than a thousand canvasses but, like Van Goyen and so many others, could not earn his living from their sale; he got an M.D. degree at Caen. He became a barber and general practitioner, a very common combination at that time, but odd professions to couple with the art of painting.

Meindert Hobbema's art appears happier and more contented than Jacob van Ruisdael's. This artist does not lead us into the mysterious darkness

241

240. *St. John Hospital, Hoorn, 1563*

240

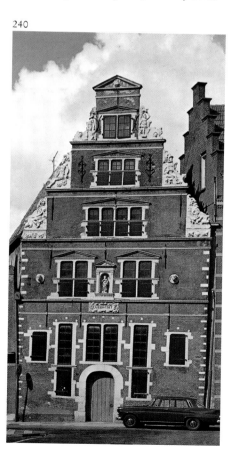

of the woods with age-old trees and silent pools, he does not present the magnificent torrents gushing forth from dense brush, streaming effervescently over sharp rocks. Hobbema shows an inviting, rather friendly nature. Ruisdael, the lonely, painted loneliness; a cemetery, the primeval forest, impenetrable brush. In Hobbema's paintings, the small boats made fast to the shore indicate that the fishermen are nearby. The smoke rising from the friendly huts tells something about the people living in them.

Albert Cuyp was a painter of the skies. Whether painting grazing cattle, or landscapes with people, the main subject was not the earth but the sky. He contrasted the earth, done in dark colors, to the gleaming light of the sky, or the calm, quiet surface of the water to the playful contours of the clouds.

Saenredam, and the Townscape

A special type of painting in the 17th century was the so-called architectural landscape. Fantasy played a great role in this genre at the beginning of that century. The architecture and parks, the colonnades and buildings on *Steenwijck*'s paintings in Antwerp, and *Dirk van Delen*'s paintings are almost total fantasy.

Only the Haarlem painter *Pieter Saenredam* started to depict important buildings objectively, and with his *Square before the Mariakerk at Utrecht* he created a work in which pictorial refinement went hand in hand with a precise reproduction of reality. From 1628, the year when he painted the "Interior of the St. Bavo Church in Haarlem", he devoted himself almost exclusively to painting church interiors. These paintings are evi-

163

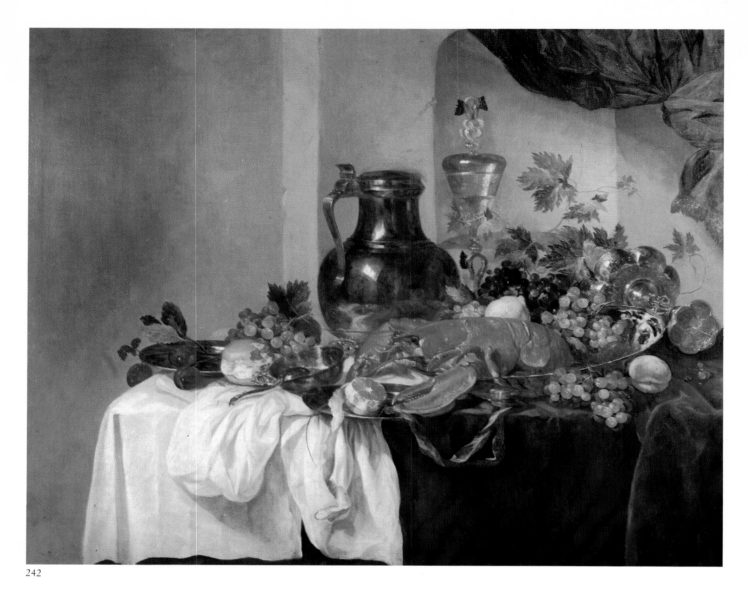

242

242. *Abraham van Beyeren,*
1620-1690
Still Life with a Lobster
Kunsthaus, Zürich

dence of an artistic feeling for space, color, and light. With his pure forms, he reached the almost mystic purity of several primitive painters of the 15th century. The Delft school of painting also produced some masters who specialized in church interiors: *G. Houckgeest, H. C. van Vliet* and *Emanuel de Witte*. None of them, however, possessed that cool tonality of Saenredam, a combination of silvery-gray and pale pink hues.

The 17th Century Still Life

In Holland the still life responded to the movement towards intimacy and contemplation, to the almost mystic cult of the singular character of things, traditional since Van Eyck. In the Dutch still life, two categories emerge from the beginning of this genre: the Banquet and the Bouquet. *Pieter Claesz* and *Heda* in Haarlem created the "monochromous banquet". Claesz is generally recognized as the discoverer of this genre, and the best of his earlier works have

been preserved. Heda, no less precise but, softer and more refined, took it to perfection.

Somewhat later, *Jan Jansz. van de Velde* arranged several simple objects in a still life with a subtle discretion. Among Van de Velde's objects there is usually an earthen pipe and a beer mug. From his themes, of utmost simplicity in the eyes of 20th century art lovers, he appears as one of the most interesting painters of the time. The same goes for the original and poetic work of *Adriaen S. Coorte*, who worked some time later.

Jan Davidsz. de Heem, Dutchman by birth, worked half of his life in Antwerp. He was the bridge between the Flemish and the Dutch still life. In his Baroque ornaments chosen as background, he was definitely influenced by the Antwerp school. At about the middle of the century a change came. The composition of the paintings became more artificial, and color played a greater role. The broad format with the objects lined up sideways was replaced by the tall

164

format. For example, a china bowl, a bellied silver can, and a slender, tall goblet or cup are arranged side by side. A group, formally composed, placed in a transparent darkness broken by warm light. In this way *Willem Kalf* painted still life around 1660. Less austere and less classical in their composition, but also painted with colors intensified by a delicate, transparent darkness, are the fish-portraits by *Abraham van Beyeren*.

The End of a Golden Age

Towards the end of that century, the still life became like a vessel for a virtuous expression of a theme. The painters competed in painting objects with a striking reality. The paintings of bouquets developed in the same way. When *Rachel Ruysch* painted a fly, it was difficult to say whether it was painted or was real and had just stopped to rest. In other fields, too, a decaying process threatened. The portrait sunk to a courtly, French, approval-seeking style.

De Lairesse, a painter, actually asked his colleagues to adopt the "good taste" of the French court style. *Lebrun* was called the greatest of them all and tried to establish a standard. Dutch art became refined, and a style evolved like the Cinquecento. *Adriaen van der Werff* responded to this trend. To indicate how far the Dutch painters had left their origin at the end of the 17th century, it is sufficient to compare the "Banishment of Hagar" (Dresden) with the painting of the same title by Carel Fabritius. With Van der Werff, Hagar seems to be borrowed from one of Raphael's paintings. Furthermore, his *Diana* does not deny her foreign antecedents. Van der Werff died in 1722; the delicate gesture of the Rococo had taken the place of the lofty gesture of the Baroque.

243

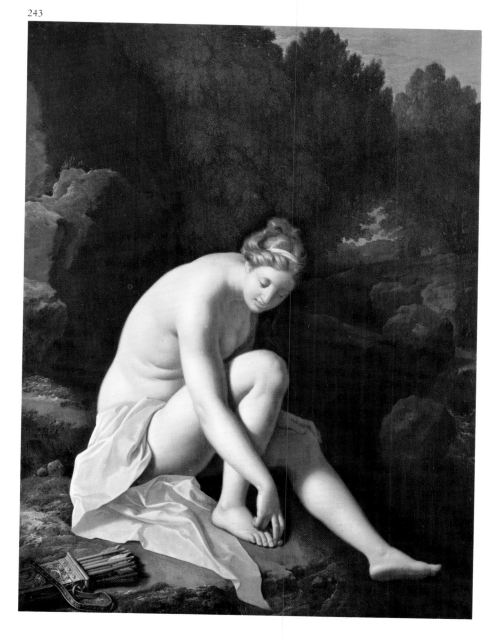

243. Adriaen van der Werff, 1659-1722
Diana, *1722*
Brian Koetser Gallery, London

The Decline of Grandeur

The art of the Rococo period, the 18th century, unlike any other century, only emphasizes the brighter side of this century, and plays down the less attractive aspects, aspects which led, finally, to the French Revolution. What else is there, other than an attractive picture of the past, in the paintings of *Fragonard*, *Boucher* and *Watteau*, and the engravings of *Oudry* and *Gillot?* The innumerable portraits bring history to life. Long vanished personalities are recreated. The people of the 18th century reappear in the work of *Nattier*, *Pater*, *Chardin* and *Roslin*.

The place occupied by Boucher in 18th century French painting is at least equalled by *Jean-Antoine*

Houdon (1741-1828). That he was brilliant is irrefutable. At the age of 26 he was famous. His special gifts attracted the attention of the great spirits of his time; the philosopher Diderot recommended him to Catherine the Great, the Empress of Russia. The marble *Diana*, originally created for the gardens of the Duke of Saxen-Gotha, and bought by Catherine, is a very pure example of a mythological figure in Louis XVI style. The statue now forms part of the Gulbenkian collection in Lisbon. This statue displays a woman as Rococo art preferred to see her: as hunting and hunted, seductive and seduced, with her feet lightly touching the ground. Floating like a

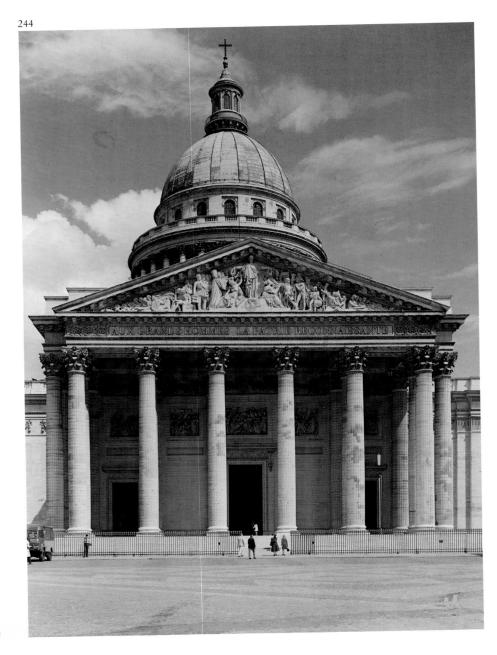

244

244. Panthéon (Sainte Geneviève), Paris
1755-1792

goddess, naked and without guilt. However Houdon's real greatness, as his contemporaries did not fail to establish, lays in another area: Houdon was mainly a portraitist by nature. And when making his sculptural portraits he strived both to catch complete precision in form and likeness and to carefully catch the mentality of his model. For the Freemason Lodge, that he was a member of, with many French greats of his time, he created a bust with such a strong likeness that, when the model died, his mortal remains could be identified with the aid of the sculptured bust. The measures of the marble skull fitted to the millimetre. One of his most famous heads is the one of "Voltaire", made very shortly before Voltaire's death. Houdon succeeded in showing the expression on Voltaire's face as if he, aged and ill as he was, could still crush a good-for-nothing with a few destructive remarks. Some of his models should be mentioned: "Mirabeau", who played an important role in the French Revolution, "Rousseau", the writer who was Voltaire's enemy (or meant to be), "Houdon's wife and

245

167

246

246. Jean-Honoré Fragonard,
1732-1806
Bathers, *1756*
Louvre, Paris

247. Jean-Honoré Fragonard,
1732-1806
Rinaldo and Armida
Private Collection

247

little daughters'' (Houdon knew how
to capture the expression on chil-
dren's faces), ''Benjamin Franklin'',
the American envoy in Paris, who
was also a famous scientist, and
''George Washington''. For the
statue of Washington Houdon cross-
ed the ocean in 1785 and spent two
weeks in Washington's house in
Mount Vernon. Houdon would
have preferred to make an equestrian
statue of George Washington, but
this appeared to be too expensive.
Therefore it became a standing
figure, who, leaning on his walking
stick, looks into the future.

The Cult of Enchantment

The Baroque style of the Grand-
Siècle was attuned by *François Boucher*
to the feminine intimacy of the 18th
century salon. He was a favorite of the
Marquise de Pompadour, the cold,
ambitious yet beautiful woman who
was mistress of the king. Boucher,
born in 1703, accepted no boundaries
to his art. He had been a decorator,
and an historical-, genre-, portrait-
and landscape painter. As a member
of the Academy and drawing teacher
to Madame de Pompadour, he was
highly appreciated in court circles.

168

His nude studies were famous. He can be considered *THE* painter of the Rococo period, the witness to it and the example of it. Boucher stuck to the rules of Rococo art; in his drawings he sought the refinement of elegance and the delicacy of the "volupté".

Compared with Boucher, *Jean-Honoré Fragonard* gives a more robust impression. This painter, born in 1732 in Grasse, had a personality which fitted the period. "Frago" was the darling of a number of ladies in well-to-do circles. His most spectacular conquest was that of the dancer, Madeleine Guimard, whose receptions were attended by everybody in court and financial circles, and the world of art. But Fragonard, at the age of 37, married a lovely middle class girl. He created many

facile works, but his deeper character is interesting, and when he is not flirting with public taste, his work reaches definite heights.

A Poetic World

Antoine Watteau was born in Valenciennes in 1684 and started his apprenticeship in 1705 with *Claude Gillot*, who had been born in 1673 in Langres. After a short time Gillot could not teach him any more; Watteau went to *Gérard Audran* in the Luxembourg and worked there with passion in the technique of the Rubens paintings in the Medici gallery. Until recently Valenciennes was part of the Southern Netherlands and so Watteau could be said to be, in some respects, a countryman of Rubens.

It is said that Watteau had a patho-

248

248. *Lambert-Sigisbert Adam,
1700-1759*
Prometheus, *1757*
Marble
Louvre, Paris

249. *Jean-Antoine Watteau,
1684-1721*
Embarkation for Cythera, *1717*
Louvre, Paris

249

250

251

logical urge for solitude. His lung disease, and the prospect of an early death, drove him to paint incessantly. Watteau returned from a trip to London very ill, and he died in 1721 at Nogent, near Paris. Watteau could not have taken part in the courtly pleasures and the spiritual and sentimental romances that he painted. They remained creations of a poetic world, where the "fêtes galantes" were held, and which his followers would transform into "conversation à la mode". He was the first to introduce into painting the figures of the "Comedia dell'-arte" on the joys of rustic life.

Venus as a Focal Point

François Boucher started as a graphic artist, overshadowed by Watteau. He was born in 1703, and – together with Watteau and Fragonard – makes up the illustrious stars who, between them, gave a name to the painting of that era.
Watteau goes well beyond the boundaries of the conventional Regency style; in his work nature, art and love form a mystical paradise on earth, in which there is only

eternal youth and beauty. Age, sin and death are not allowed to exist.

The Rococo style, with Boucher as its main figure, follows the Regency style. Venus was its mythological focal point. Boucher specialized in paintings of the triumph of Venus. The objects associated with her – rocks and shells, coral and reed, wave and foam – are the source of the Rococo ornamentation. Her element, water, determines the volatility of the forms; her colors, the deep, cool blue of the sea and the white of glittering foam, together with the rosy gradation of the shell and the irridescence of the pearl, constitute the typical Rococo color harmony. No Rococo room can be imagined without a mirror: the symbol of Venus. Even Boucher's

252. From Edmé Bouchardon, 1698-1762
Model for an Equestrian Statue of Louis XV, *1748-1758*
Bronze
Louvre, Paris

252

253. François Boucher, 1703-1770
Odalisque (Miss O'Murphy), *1744-45*
Louvre, Paris

253

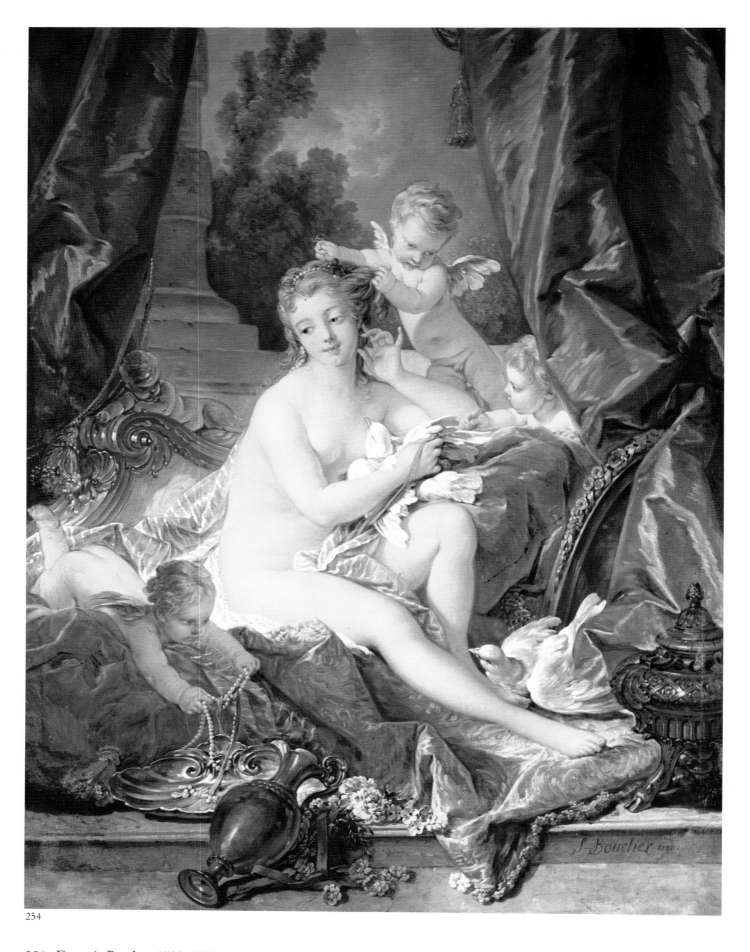

254

254. *François Boucher, 1703-1770*
The Toilette of Venus
Louvre, Paris

final painting – he died at the easel – was of Venus.

Jean-Honoré Fragonard introduced himself to Chardin. Chardin, not caring much for giving lessons, sent the boy to Boucher. It was not long before Fragonard had reached his master's level, so much so that he was able to paint a very good "Boucher". Fragonard is mainly associated with the decorative panels in the Castle Louveciennes, or on the salon-like scenes, painted in the spirit of Boucher.

However, there is another Fragonard, the man who painted the magisterial portraits in the Salle Lacaze; portraits which were often executed rapidly and which dubbed him as the French Frans Hals. He also painted well-endowed nudes, such as the "Chemise enlevée" or the *Baigneuses*.

Sculpture also displayed Rococo characteristics. The *Prometheus*, made in 1767 by *Lambert-Sigisbert Adam*, is a distinctive example of this style.

Of the lesser masters in French Rococo painting is *Jean-Baptiste Pater*, who lived from 1695 to 1736; he was a follower of his teacher Watteau, but with more independence than *Nicolas Lancret* (1690-1745) who tried to become a second Watteau, purely by imitation.

Chardin, the Master of the Intimate

Jean-Baptiste Siméon Chardin, who was born in Paris in 1699 and died there in 1799, was not so much in step with the taste of his time as Watteau and Boucher. He was a pupil of *Jean-Baptiste van Loo*, a painter possibly of Dutch origin, so that one could trace the sometimes Vermeer-like element in Chardin's work to a Dutch influence, but the evidence is missing, and Van Loo's own work does not support such theories. Chardin was admitted to the Academy, in 1728, as a painter of animals and fruit.

Chardin differed from his contemporaries especially in his aversity to courtly elegance and the decorative inclinations of the artists who surrounded him. He was a quiet, middle class man, who probably never knew

255. Jean-Baptiste François Pater, 1695-1735
Soldiers in front of an Inn, *ca 1729*
Schloss Sanssouci, Potsdam

255

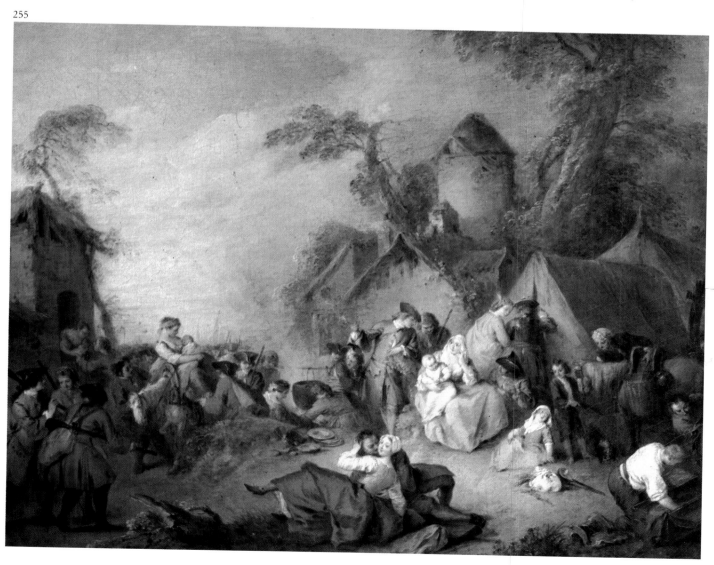

173

how "revolutionary" he was as a painter, and who certainly was not appreciated by his contemporaries for these precise reasons. He preferred simplicity and soberness, and set himself to preserve, in his paintings, the intimacy of daily life. The colors of the "dead" objects in his still life paintings pulsated with modest life and are the outcome of his studies of the subtlety of atmosphere. When his eye sight started to fail, Chardin made intense pastel-portraits. The *Young Girl with Battledore and Shuttlecock* is the best example to confirm popular opinion of Chardin.

Among the courtiers and salon figures, he was the only virtuous one: the simple man who painted the middle class interior and because of it died in poverty, an image which is not strictly true, because, when he died, Chardin left behind a considerable amount of money. Nevertheless his "playing king" is one of the most appealing paintings from the Rococo.

The Dutch Rococo

Look now at the Northern Rococo. *Cornelis Troost*, who worked in the Netscher tradition, is considered to be one of the most important portraitists. But the preparatory study entitled "The Trustees of the Almoner's Orphanage" dated 1729 is a boring and badly executed piece of work both in composition and in style.

Troost's abilities appear to full advantage in the "Town Garden", a delightful scene that conveys a good impression of its time. It is better to concentrate more on the content than on the quality of Troost's work. His pastel *Rumor erat in Casa* can then be considered to advantage.

Venice and the Settecento

The painters who came after Titian, Veronese, Giorgione and Bellini had a more sceptical attitude towards

256. Jean-Marc Nattier, 1685-1766
Portrait of Madame Bouret
as Diana, *1745*
Collection Thyssen-Bornemisza, Lugano

256

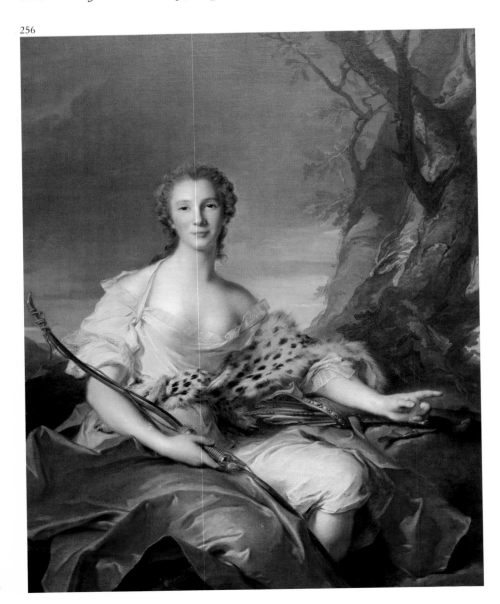

174

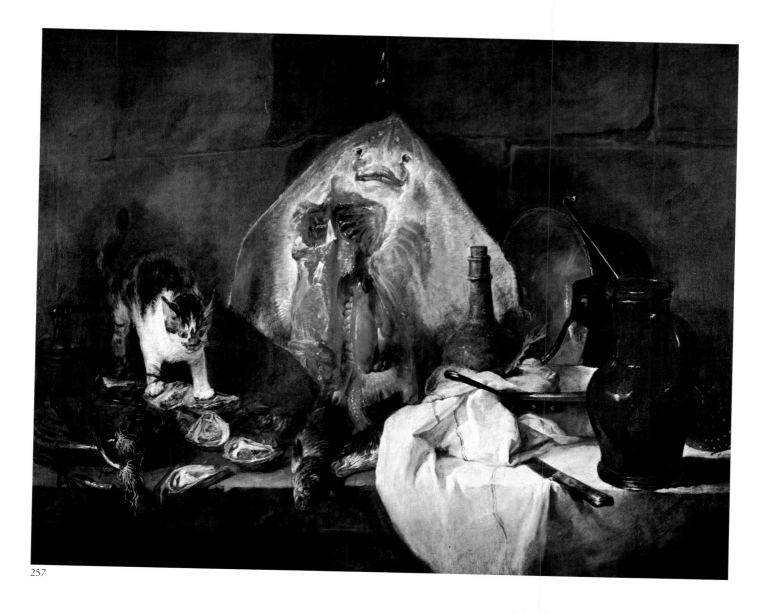

257

257. *Jean-Baptiste Siméon Chardin,*
1699-1779
The Ray, *1728*
Louvre, Paris

258. *Jean-Baptiste Siméon Chardin,*
1699-1779
Little Girl with Battledore
and Shuttlecock, *1741*
Private Collection

258

saints and rulers. For those painters the power of the lagoon-city had already become a legend. They discovered Venice, saw every canal, every bridge, every street corner, every garden, experienced the light on the water and the shadow around the houses. That was the spirit of the Venetian 18th century of *Guardi, Canaletto, Longhi* and *Tiepolo*.

Never before had the shadow under the Rialto been so resplendent, never had the glimpse of gondolas been enjoyed so intensely. Before that time nobody had observed the maskers on St. Mark's Square in such a way, nor had anybody been so delighted about the glory of Venice's crown jewel, the Santa

Maria della Salute. Tiepolo painted sun-lit houses in a superficial black and white, in a way that may be called impressionistic. He put the passers-by on paper, so effectively and so masterfully, that they almost seem to be equal to those by Rembrandt.

Apart from Tiepolo – "impressioniste avant la lettre" – fresco painters moved to the background. At the end of the last century he was still considered as the impetuous follower who had laid violent hands upon the sacred fresco.

A "brilliant decorator" was the highest praise that was bestowed in that time, but the epithel "brilliant" had the doubtful taste of handiness. 175

Gradually opinions changed, under the influence of rediscovered works. Attention moved from the frescos to the canvas, and the painter was given more justice.

Giambattista Tiepolo's early works show how captivated he was by the rampant "caravaggisme" of the time. He learned to control it, showing how you can only free yourself from something if you have it under your thumb.

He took as his task the conquest of those traditions banned by *Caravaggio*. His liberation was actuated by the commission for the great decorations for Udine and Milan. He was looking for a starting point and found it with the great painters of the Counter-Reformation, and moreover in the return to the pure in Venetian tradition of *Veronese*.

He was condemned for the fact that he only completed what Veronese had started. But it should not be forgotten that Caravaggio was the dominant influence of the time; Tiepolo had to fight for his return to the tradition of Veronese.

In that way Tiepolo has become the last of a great Venetian tradition. Right up to the end of the 18th century there is no other town one can think of that was so full of creativity. The intensity of it is still tangible. It seems possible to come into contact with something, that elsewhere only exists as a desire.

259. Nicolas Lancret, 1690-1743
The Swing
Cincinnati Art Museum

259

260

260. Cornelis Troost, 1697-1750
Rumor Erat In Casa
Pastel
Maurtishuis, The Hague

176

261

262

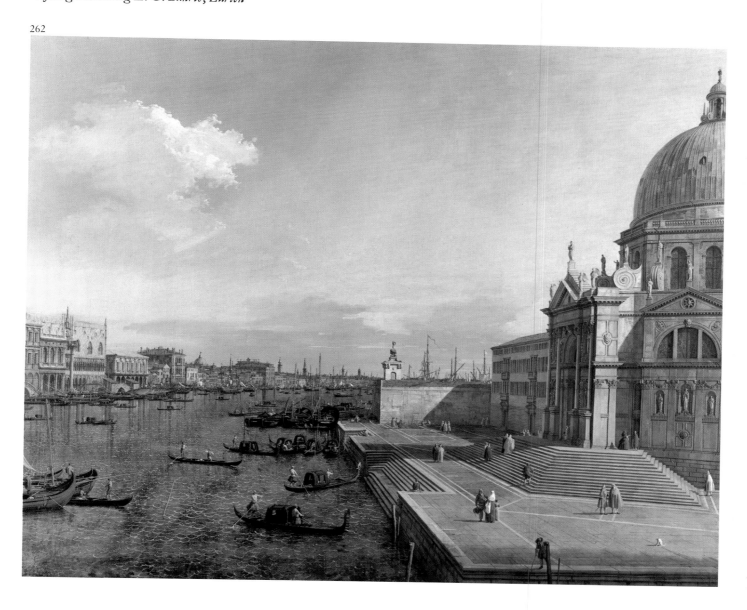

177

263. *Bernardo Bellotto, 1720-1780*
A View of Old Dresden
Palazzo Barberini, Rome

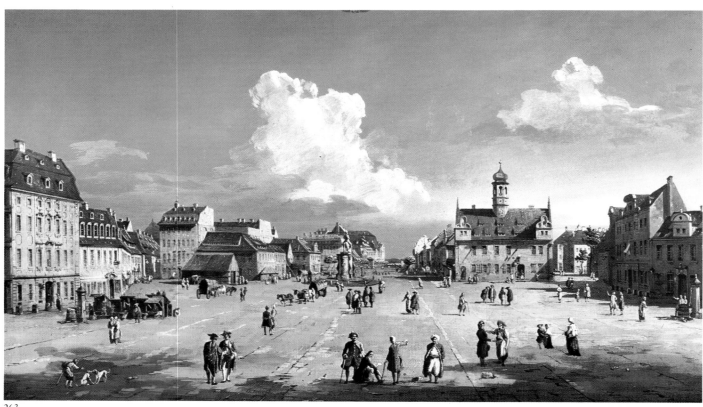

263

264

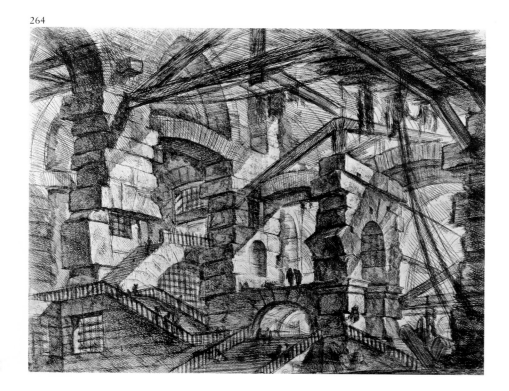

264. Giovanni-Battista Piranesi,
1720-1778
Imaginary Prison, 1745
Bibliothèque Nationale, Paris

178

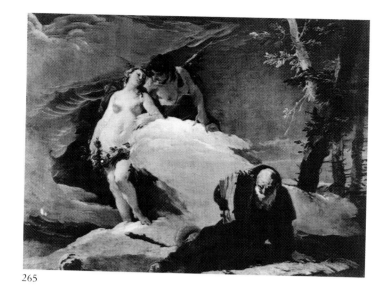

265

Venice is the great sarcophagus of a past, in which for the last time, since the fall of the Greeks, beauty had a supreme power.

Of that beauty the 18th century artists have testified. Never before in the world had there been such a delightful theatre, never a town with such fabulous scenery.

The Town View of the Lagoons

Venice is portrayed most objectively by *Antonio Canaletto*, but in the work of *Francesco Guardi* gained from his spontaneous and mobile touch, its most poetic grace. The greatest of all the painters of Venice views, Guardi was at the same time a great painter in any category. He worked for a small family shop, where his paintings and those by other members of the family were sold in the same way as picture postcards are today.

Pietro Longhi held fast the poetry of the game of life itself: the worldly, well-known maskers move against a vague background of melancholy. While the star of the Doge city sinks behind the lagoon, it shines at its most brilliant, and the glimpse was captured in magisterial pictures: in an *Ascension* from *Giambattista Piazzetta*, or in his "Strand Idyll"; and in the *Temptation of Saint Antony* or the "Death of Hyacinthus" by *Giambattista Tiepolo*.

Hyacinthus' death could be the symbol of Venice's downfall. Apollo, conscious of the fact that his last sanctuary is lost, bends over the dying boy, full of anguish. But by his body the flowers flourish from his blood.

Also among the lesser known there

266

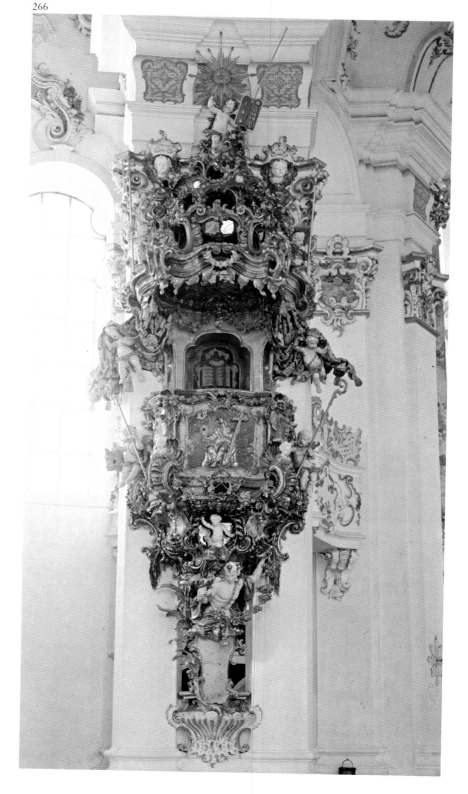

are figures of unrecognized stature: *Allessandro Magnasco* from Genoa for example, who has been justifiably compared with the visionary Goya; his frenetic brush strokes combined with an imaginative, demoniacal world, make him one of the most fascinating figures of his time, in whose talent Rococo and Baroque, Mannerism and Romantic styles become an intensively mixed and unique whole.

Giovanni-Battista Piranesi is also fantastic. He is especially famous as an etcher. His views of Rome, and particularly his famous series "Jails" show a preoccupation with degeneration, with the ominousness of structures, which to Piranesi were not so much established buildings as creations liable to downfall.

267. Interior of the Monastery Church, 1732-1739 Diessen

267

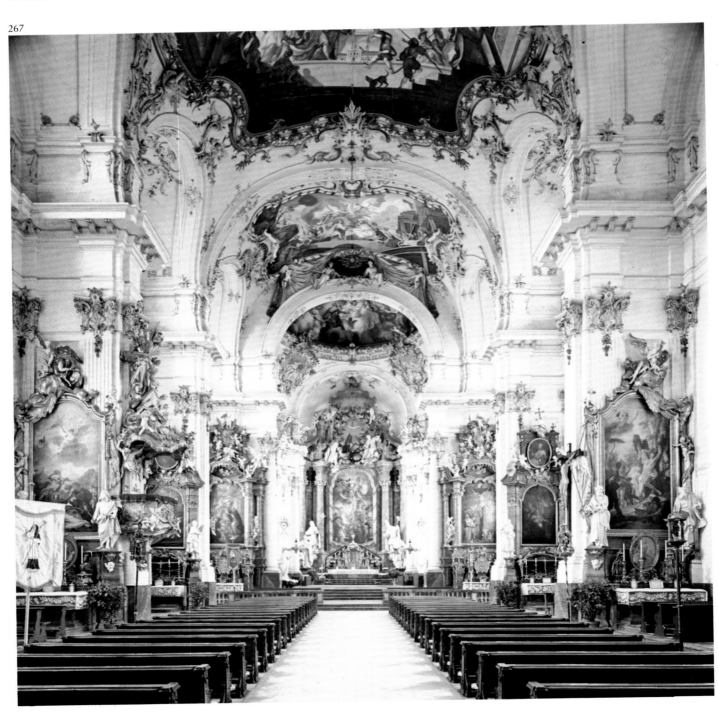

268. *Giambattista Piazzetta,*
1683-1754
The Ascension of the
Virgin Mary, *1735*
National Gallery, London

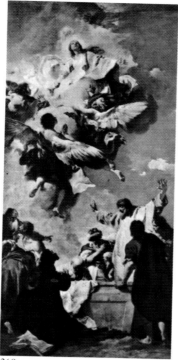

268

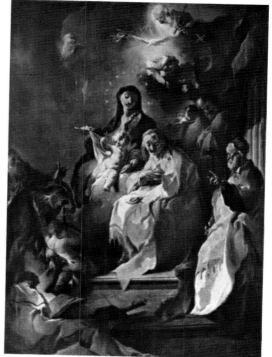

269

269. *Franz Anton Maulpertsch,*
1724-1796
The Holy Family
Kunsthistorisches Museum, Vienna

Bernardo Bellotto, sometimes confused with Canaletto, worked a lot outside Italy; his topographical town views have a cool fascination, an accuracy which, in his case, leads to a poetry, related to that of later Surrealistic or Magic-realistic painters.

The Rococo in Bavaria

In Germany the Rococo reached its high point in the south, in Bavaria. Architecture acquired a religious orientation and also, perhaps, an inspired luxuriousness of the form that was unequalled elsewhere. One of the most Bavarian of all stucco-artists was *Dominikus Zimmermann,* who, amongst other things, built the characteristic *pulpit* for the church in Wies, between 1746 and 1756. A more fantastic design is hardly imaginable; but it fits in well with the architecture, which had already given up the heavier Baroque form for the lyrical, musical style of the Rococo. Other church and monastery interiors from that time – also from Bavaria, from *Diessen* for example – illustrate convincingly what élan and what festivity the Rococo inspired in this part of Germany. The *organ* in the Benedictine abbey of *Ottobeuren* grew from a musical instrument into a sculptural creation, the exuberant forms of which are in happy harmony with Baroque church music.

In an architectural sense painting occupied a subordinate place. In the main it served a purely decorative function. Only this era's classicist masters strived for deeper seriousness.

Foremost among them was *Anton Raphael Mengs;* his influence on the later academicists was great and fatal. His portraits, which were highly admired during his time, are today considered cold and lifeless.

Like Mengs, *Angelica Kauffmann*'s abilities were best displayed in portraits. But these idealized, saccharin works make it clear that 18th century German painting has none of the significance of the Bavarian Rococo. Only *Johann Heinrich Wilhelm Tischbein* escapes oblivion, because of his, now famous, portrait of "Goethe" painted in 1787.

England's Great Century

In a way, *William Hogarth* (1697-1764) can be considered to be the first really English painter: the first to refuse to follow and approve everything that was done in Europe. Moreover he was the first artist to use his art as a critical weapon; and the first to prefer a broad public to a limited, selected group of connoisseurs.

His portraits display a certain unflattering voracity; Hogarth did not like idealizing, which is obvious from his engravings. Moralizing suited him, and his views were spread by his engravings, which – quickly sold – made a care-free life

270

271

271. *Thomas Gainsborough,*
1727-1788
Mary, Countess Howe
Iveagh Bequest, Kenwood, London

270. *Organ, 1754-1756*
Benedictine Abbey Church, Ottobeuren

possible for him. In order to appreciate the pure pictural side of Hogarth's art, one should look at his *Graham Children:* an intelligent and lively work, even if it does not have the unconventional qualities of his "Shrimp Girl" in the National Gallery in London.

Thomas Gainsborough (1727-1788) represents a more elegant, more wordly England than Hogarth. He was also less robust. Gainsborough suffered from an almost morbid over-sensitivity that would be called neurotic today.

Above all he was a fêted portraitist, and an original landscape painter; a man whose free compositions have pronounced qualities. His example was Van Dyck, and consequently Van Dyck's influence is demonstrable in Gainsborough's portraits. His most famous portrait is the "Blue Boy", but in fact Gainsborough is at his best where his different talents are combined on one canvas. The most successful example of this is in his "Morning Walk" painted during

his last, and most sensitive period in Edinburgh, and in which landscape, portrait and fantasy are combined in one vision. But even here his love for landscape dominates.

The third personality from this era of the English school is *Sir Joshua Reynolds* (1723-1792) who has been called a first class painter of the second rank. He came from a family of clergymen and teachers – something which inspired one art historian to utter the malicious remark that it would have been better for English art, if Reynolds had stuck to one of those professions. He put historical painting above all else but managed only to display a weak eclecticism. As a portraitist he had the abilities to rank among the classic masters. The English culture of the 18th century is reflected in Reynolds' work; this goes especially for his portraits – such as that of *Lady Bampfylde* – that illustrate the natural distinction of a certain English class. In no other era has English painting reached such unity, or the

182

272

same level as it did in the 18th century.

Apart from these three greats, a number of other masters worked and contributed their share to the prosperity of English painting: *George Romney, John Hoppner, John Opie* and *Sir Henry Raeburn*, who with *Allan Ramsey* and *Andrew Geddes* formed the group of Scottish portraitists. Then there was the very English school of painters who specialized in sporting scenes especially of riding and hunting.

In this century the foundation was laid for what, in the 19th century, would become English landscape painting; *Richard Wilson* (1714-1782) is the first great English landscape painter; his character is not expressed in his studio-works according to Italian motives, but is strongest in his landscapes from England and Wales. His influence spread to Constable and Turner. But with this we enter the 19th century.

272. William Hogarth, 1697-1764
The Graham Children, *1742*
Tate Gallery, London

273

273. Sir Joshua Reynolds, 1723-1792
Lady Bampfylde, *1776-1777*
Tate Gallery, London

183

The Break with Tradition

The French Revolution made an end to the doubtful balance of the old class society. Strictly segregated classes and ranks no longer existed. Thrones and dynasties began to waver. States and kingdoms appeared and disappeared. Sensational inventions gave the world a new look; distance no longer played the old hampering role. The nobility was largely pushed aside. The citizen had, with pride and self-assurance, entered history. The 19th century would become his age.

The Neo-Classicism:
David, Gros, Ingres, Canova

For only a very short time a doubtful order was clung to: Classicism flourished under Napoleon.
However, soon the foundations of this attitude to life, schooled on the Roman example, could no longer stand the pressure of the newly obtained freedoms. Also in art is seemed that the development could not be arrested. Neither the songs of praise for the glorious victories of the emperor, nor the glorification of

the Roman empire could now be heard.
Jacques-Louis David was born in 1748, and died in exile in the year 1825 in Brussels. When the revolution broke out, he was fifty years old. He put his mighty painting talent enthusiastically at the service of the emperor when Napoleon took power. He created enormous paintings on which he glorified Napoleon. *The coronation* in the Louvre, is his best known painting.
Certainly as famous is his portrait of "Madame Recamier". The second painter whose name was connected to the era of Bonaparte was *Antoine-Jean Gros*. Born in 1771 – died in 1835. As a portraitist Gros was one of the greatest of his time; as a painter of historical pieces he became the origin of an Academicism that later in the century had a disastrous influence. In the service of the youthful Napoleon he found the subjects that suited his very romantic temperament. Where this temperament has its way (see the portraits of Bonaparte he made in his youth: *Napoleon at the bridge of Arcole* is a

275. Antonio Canova, 1757-1822
Pauline Bonaparte Borghese as
Venus Victrix, *1808*
Marble
Galleria Borghese, Rome

274. Jacques-Louis David, 1648-1825
The Coronation of Napoleon I,
1805-1807
Louvre, Paris

274

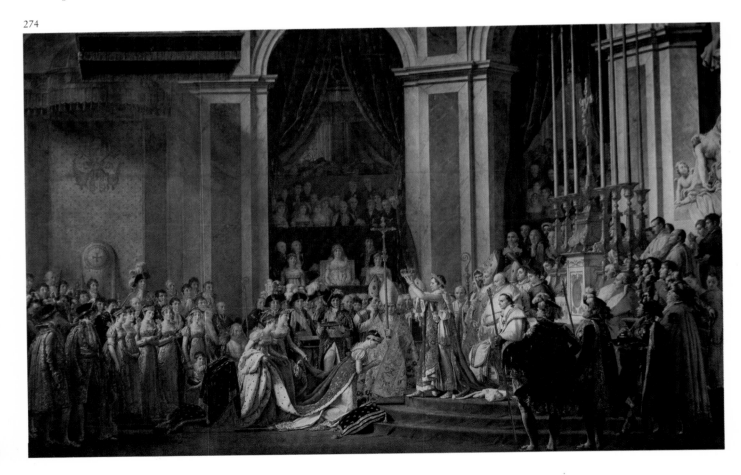

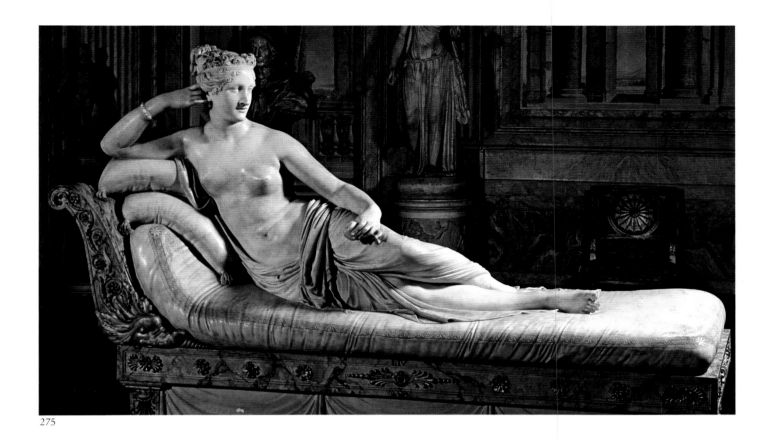

275

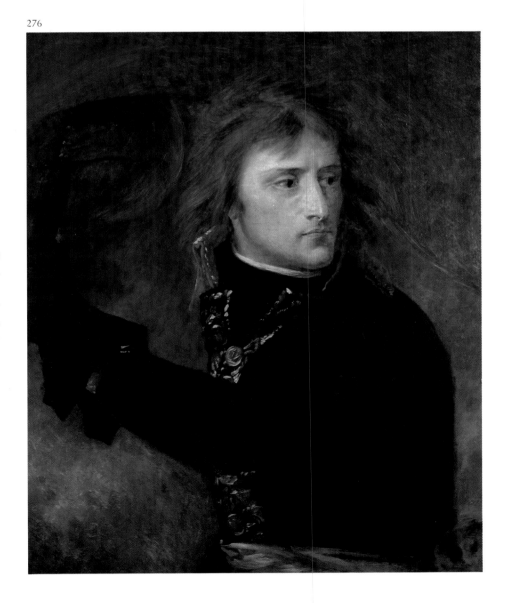

276

276. Antoine-Jean Gros, 1771-1835
Bonaparte near the Bridge of Arcola,
1795
Louvre, Paris

strong example.) Gros is a fasci-
nating painter.

In sculpture *Antonio Canova* was the
leader of the Neo-Classicism; his
Pauline Bonaparte as Venus Victrix
defines, to a certain extent, that style.
Napoleon's sister is represented in a
more or less Greek way; the picture
does not seem so much of a woman
but, rather an apathetic goddess.
Canova worked away the imperfec-
tions of earthly things. Working in a
soft, idealizing way that was con-
sidered in those days, rather Greek.

The only one who worked from the
empirical period right into the
19th century was David's pupil,
Jean-Auguste Dominique Ingres.

Born in 1780, Ingres started in Paris
in the studio of David about 1797.
Before he left for Italy four years
later, he had a well-grounded, paint-
ing technique. Once in Italy, he
achieved a recognition that far
surpassed his Paris fame. Never-
theless he decided to return to his
native country. There he found the

185

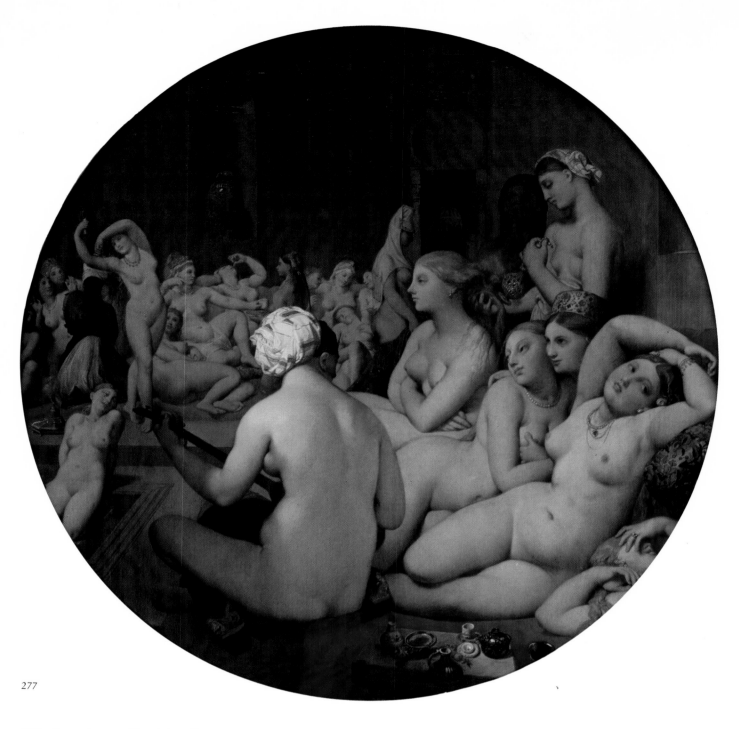

277

277. *Jean-Auguste Dominique Ingres,*
1780-1867
Le Bain Turc, *1863*
Louvre, Paris

former followers of his exiled teacher, David, without a leader.

Ingres seemed by his eminence to be ear-marked to become the great master of Classicism.

Thus, he became the very antipode to the central figure of the Romantic painters, *Eugène Delacroix.* Ingres and Delacroix were very different in every respect. Ingres was a great draftsman, and in his opinion, the way the lines were handled made a good painting. He disliked the moving lines and the flaming colors of his rival. Through Ingres and Delacroix, the contradiction was revived between the followers of *Poussin* and *Rubens* who ruled the art life of France in the 17th century. But the rather pedantic, strict and neat citizen Ingres did not understand how he revealed his own nature by his choice of subjects. He chose strange, often erotic scenes in situations which he and his followers would not have entered: but, it was this very personalized, emotional thing that gave Ingres' paintings the warmth that is missing in the work of Academicians.

After he had again spent a few years in Italy, he returned to Paris, where his life ended in the year 1867. The *Turkish Bath,* a group of naked women, is an important Ingres' painting, one of a series of master works to which the different "Odalisques" and "The Well" belong.

In spite of the many attacks from painters of the *Romantic school* Ingres had a considerable influence on his contemporaries. Even today he is still valued for his accuracy of draftmanship, and for his great talent as a portraitist.

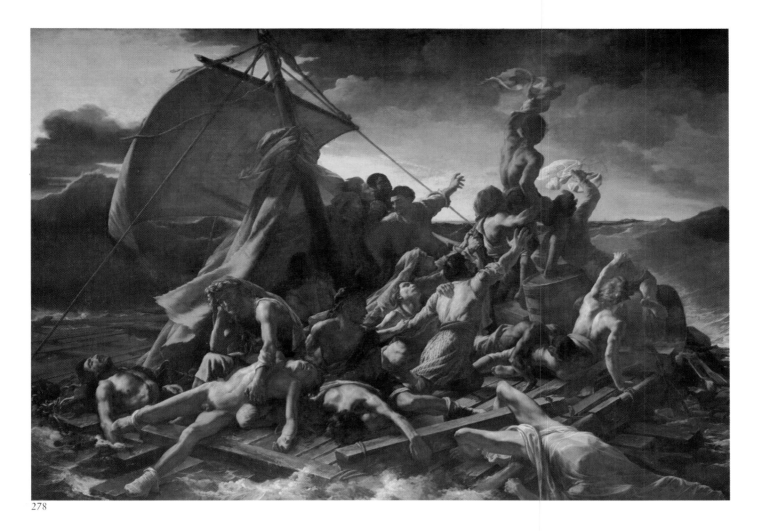

278

278. *Théodore Géricault, 1791-1824*
The Raft of the Medusa, *1819*
Louvre, Paris

279. *Eugène Delacroix, 1798-1863*
Liberty Leading the People, *1830*
Louvre, Paris

279

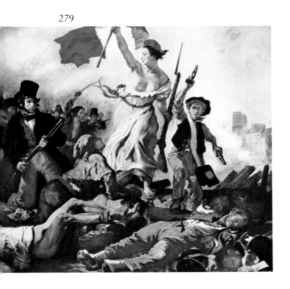

The Romantic: Géricault and Delacroix

In some respects, even before Delacroix, *Théodore Géricault* was the painter who fought against the classical idealism of Ingres. With Géricault no connection can be found with the Classicism of David and his followers. He preferred much more the Venice school of painting, and Rubens.

Accordingly he rejected subjects from the old Romans. Between his journey to Rome and one to London, Géricault created the painting that brought him his initial fame: *The Raft of the Medusa*.

He had just returned from Italy when the details of the shipwreck of the frigate "Medusa" were circulating in Paris.

The ship ran aground, on her way to Senegal, in the vicinity of Cape Blanc. With the remnents of their ship the survivors built a raft. Dying from hunger and thirst they wandered over the sea, and when they were picked up, those that lived, were nearly insane. The government was implicated in the case and the whole thing took on enormous proportions in public discussion. It was not surprising that Géricault,

with his passionate and easily inflamed temperament, immediately started on an enormous canvas which depicted the suffering of the shipwrecked in those last moments as the rescuers approached. The painting took him three years to finish. He started on it towards the end of 1816, and it was finally exhibited on the Salon of 1819. Géricault spent many days in the hospital at Beaujon to make sketches of dying and wounded people.

Not only Géricault, but Eugène Delacroix in his early works, fought against Classicism. His romantic nature is evident from his own words: "I escape from the cruel reality, when I withdraw into the atmosphere of creative art". His most famous painting, inspired by the July-revolution dates from 1830, was called "The Barricade", or *Freedom leads the People*.

His recognition in government circles gave him the chance, to make a trip to Morocco. This trip was a real revelation to the painter. He was deeply impressed by the light and the color of this new country, by the beautiful costumes and the grandiose spectacles he attended there. He stayed in Morocco for months, made

187

numerous sketches and studies, and visited Algeria before he returned to France.

In Algeria he got permission to enter a harem; this experience inspired a number of his later paintings.

A Bridge to the 19th Century

The English landscape painters in the 19th century had considerable influence on art in France. The three great names, to which this influence can be attributed are: *Constable, Bonington* and *Turner. John Constble* who was born in 1776 and died in 1837, had a great triumph on the Salon in 1824. Painters, already fascinated by the Romantic tendencies, paid special homage to him for the emotional, anti-academic character of his work. Delacroix learned from him a new appreciation of color. The technique was inspired.

Constable did not know the fastidious attitude in France against nature; he accepted this without any preconceived opinion. What he was looking for seems completely clear out of a line in a letter from 1833: " light – dews – breezes – bloom – and freshness; not one of which . . . has yet been perfected on the canvas of any painter in the world". He wanted to be that first painter in the world . . .

281. *Richard Parkes Bonington,*
1802-1828
On the Adriatic
Louvre, Paris

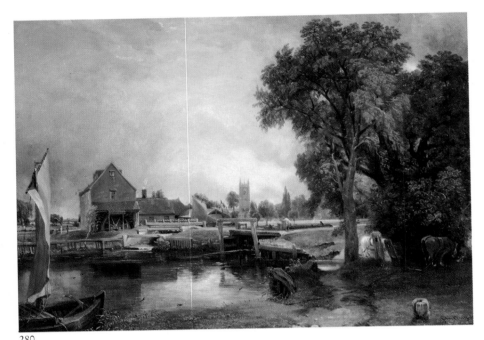

280

280. *John Constable, 1776-1837*
Dedham Mill, *ca 1819*
Victoria and Albert Museum, London

281

282

282. *Joseph Mallard William Turner,*
1775-1851
Landscape, *1835*
Louvre, Paris

Richard Parkes Bonington, – born in 1801 – died in his twenty seventh year. He spent a great deal of his artistic life in France and elsewhere on the continent.

He is considered as the one who breathed new and flourishing life into the art of water painting. If England has brought forth a painter of genius with certain talent, then it was *Joseph Mallard William Turner.*

A competent artist as a teenager, a successful man in his twenties, a great painter at middle age and finally a very great painter till he died, aged 76. Turner's importance to French art goes so far, that he may rightly be considered as *one* of the predecessors of the Impressionism. Turner, who was born in 1775, is, in a way, the link between the landscape art of the French 17th century master Claude Lorrain and the impressionistic master Monet. For example, the way in which his

forms dissolve in the light and the way that the hour of the day determines the light on the canvas, are later outstanding characteristics of Impressionism.

The return to nature, that the English ushered in, helped the French escape from the pressure of the past. The Classicists were possessed by classical Antiquity; the Romanticists by the Middle Ages. Returning to the sources of nature, the Impressionist refound his élan and his freshness, and developed a new language in line with his own sensitivity.

The later progression of Turner's style, in the direction of a cosmetically meant melting of sky and water, got him a fool's reputation in his native country.

However, he was able to perfect his style in a very personal direction.

In the years between 1829 and 1831 Constable's series of paintings of Salisbury cathedral, were created. The "Cathedral in a thunder-storm" – in the National Gallery – and the "Cathedral after the rain" – also in London, in the Victoria and Albert Museum – are the most famous

works from this series. Constable died in 1837, when he was painting the "Arundel Mill".

Goya, the Spanish Tragic Genius

Classicism, in such great demand in France, did not touch the Spanish painter *Francisco José Goya y Lucientes*, who was born in 1746. Goya arose suddenly as a lonely star of the first category. In the year 1780 he was appointed a court painter, and from the period that followed, his first portraits and their mundane success are dated. He became rich and enjoyed great fame.

All this changed in 1792; in that year Goya became ill, and as a result of that illness he lost his hearing.

His "Capricios" date from that era: fantastic etchings in which witches and monsters, and other creatures appear, out of a rich imagination. However, he did not stop painting portraits. In 1799 he made his masterpiece: the portrait of the royal family, now in the Prado.

One could say of Goya that in his oeuvre the Baroque experienced a resurrection; this goes for his early

189

283

283. *Francisco José Goya y Lucientes,*
1746-1828
The Third of May *1808, ca 1814*
Prado, Madrid

work. The later work, showing a pronounced dramatic and expressionistic tendency, and is rightly seen as the birth of modern art. For the first time there appeared subjects in art which had never entered art before. The terrible and demoniac and the human tragedy became themes.

We see it in his famous work *The third of May of the year 1808.* On that picture the condemned die before the firing-party of the French; and they do not die in the name of heavenly justice, but for freedom. It was Goya's tragedy that those same French who – under the leadership of Napoleon – he hoped would bring the eagerly awaited freedom, on the contrary, misused that freedom in the most barbaric way.

Nazarenes and Pre-Raphaelites

German art in the first part of the 19th century made a mark with painters who had settled in Rome in the abandoned monastery of San Isidore, behind the Mountain-of-the-Trinity. There they lived monastically, and tried to return to a way

of life like that of the Middle Ages. In a spiritual as well as an artistic sense.

For these Nazarenes art was a holy thing; their motto was: "We use the colors, but we paint the feeling". The head of the group was the painter *Johann Friedrich Overbeck.* However, although the noble feelings of this group cannot be denied, what they achieved was of only a moderate quality. Overbeck's brother in art, *Peter Cornelius,* returned to Germany and had an enormous influence in his country.

Among the Romanticists in Germany *Caspar David Friedrich* achieved a lasting name. He painted strange landscapes that can be seen as the confession of a certain state of mind: rocks, clefts and caves, mountain sides, bathed in an uncertain and sinister light, full of the mysterious unreality.

While in Germany the Middle Ages went through a resurrection – even if it was more nostalgia than an actual incarnation – of the work of the Nazarenes, in England it was the Pre-Raphaelites who led a similar belief. Spiritual father of this move-

ment was *Ford Madox Brown* (1821-1893); their spokesman and defender was John Ruskin. Around the older Madox Brown *Dante Gabriel Rossetti* (1828-1882), *John Everett Millais* (1829-1910) and *William Holman Hunt* (1827-1910) grouped themselves. As youths they founded together a "Brotherhood".

Pre-Raphaelism was a complicated phenomenon, that was on one side of real spiritual importance, and on the other side propagated by rather

weak figures. Generally these painters looked for what their label implies. A return to the days before Raphael; contrary to the Nazarenes however they looked for salvation in an accurate study of nature.

They broke with the atmospherical representation of reality – as with *Turner* – and restored the solid form, the clear contour and the localized color. The subjects were very often drawn from old-English legends, from Dante or from Christianity.

Edward Burne-Jones (1833-1898) with Rossetti, is considered to be one of the most talented artists of the movement. One of his merits was, that he had a monumental approach – for example, in the glass window, where

William Morris carried out his designs. In that respect the Pre-Raphaelite movement has historical importance, it gave the impulse for the revival of the crafts, although in a Neo-Gothic style.

A figure, whose significance – with that of *William Blake* – seems to become more pronounced during recent years, is *Henry Füssli*, who was born in Zürich in the year 1741. He spent the greater part of his life in England.

Originally he was basically an historical painter.

However, quietly he started to specialize in an art in which a free and fantastic imagination became the most important source of inspiration. It should be said that Füssli

284. Johann Friedrich Overbeck, 1789-1869
The Triumph of Religion in the Arts, *1831-1840*
Städelsches Kunstinstitut, Frankfurt

284

had a leaning towards the sacrifice of the pictural for a festering fantasy; however as a visionary artist he deserves a place alongside the English poet and painter William Blake, a possessed and "Jubilant" spirit, whose exalted Surrealism testifies to a highly personal, spiritual and cosmical vision.

Théodore Chassériau

The painter Chassériau belonged to the French Romanticism. Born in 1819. Pupil of Ingres, he was at the same time an admiror of Delacroix, and this ambiguity stayed with him all his life.

His early death prevented him developing a personal style.

Following a journey to Algeria, in 1845, Chassériau returned with great enthusiasm to the things he saw and experienced there. Under the influence of that journey he broke away more and more from Ingres and consequently came closer to Delacroix. With Delacroix as example he enriched his color; with Ingres as his teacher he remained faithful to a severe and pure draftsmanship.

Rude and Carpeaux

The official – Academic sculpture of the 19th century in France forms an unjust and neglected chapter in international art history. Delving into it one runs into a considerable mass of monuments, portraits and other occasional sculptures; with

285

286

286. *Dante Gabriel Rossetti, 1828-1882*
Ecce Ancilla Domini:
The Annunciation, *1850*
Tate Gallery, London

285. *William Holman Hunt, 1827-1910*
Claudio and Isabella, *1850*
Tate Gallery, London

192

288

287

287. Edward Coley Burne-Jones,
1833-1898
St. George
Time Picture Collection

anecdotal expressions that, in most cases, are no more than the uninspired continuation – and hollowing out – of a tradition. Two exceptions however, need remembering. *François Rude* (1784-1855) and *Jean-Baptiste Carpeaux* (1827-1875). Rude, by origin a Classicist, took up realistic elements and created a pictorial style that is ahead of Rodin. He had a spontaneous temperament and a many-sided talent. An important commission, for one of the sculptural groups of the Arc de Triomphe, marked him as a great artist.

The *Departure* of the volunteers of the revolution army from 1792, the famous so-called "Marseillaise-group", in the hands of Rude were given a high relief, a fullness of life and action.

Rude's pupil, Carpeaux, stood supreme over all his contemporaries. On the one side in his work an era found its completion; on the other side a new art was announced. He remained however tied to an

apparently 18th century tradition.

His work shows the traits and characteristics of the Rococo: formality paired with playfulness, virtuosity and airiness.

Carpeaux created beautiful portrait busts full of grace and refinement. His most famous, and without doubt also his most striking work, is the large dancing group at the foot of the Paris' opera-house façade.

The Landscape in 19th Century
French Painting

From the middle of the 19th century the landscape became a popular subject in French painting. Previously relegated under the influence of *David's* tenets, it returned, encouraged by the English example, and admiration for the masters of the *Dutch school* such as *Ruysdael* and *Hobbema*. This influence is clearly visible in the paintings of *Georges Michel* (1763-1843). Threatening cloudy skies, windmills and other

themes known from the Dutch school are presented; however it is obvious that the greater part of Michel's work started in the studio. In this respect he differed from *Théodore Rousseau* (1812-1867), also a Romantic landscape painter, who withdrew – after a difficult starting period in Paris – to the small town of Barbizon, where a small artist colony had already settled. Rousseau painted in the open air and aimed at expressing the reality of nature. He did not look for so-called picturesque effects or superficial impressions. He had a considerable talent and lived an industrious life of almost monastic simplicity.

Around him were the masters of the *Barbizon school: Diaz, Daubigny, Dupré* and – in a wider sense – *Millet* and *Monticelli.*

Charles François Daubigny, born in 1817, received a small inheritance, which enabled him to completely dedicate himself to painting.

From that moment on – in 1849 – his fame grew, and in 1857, he achieved a remarkable success in the Salon with the painting "Spring" (now in the Louvre). Later orders and honors were bestowed upon him; unfortunately illness plagued the last years of his life. He died in Paris in 1878, leaving behind an extensive collection.

Narcisse-Virgile Diaz de la Peña, known as Diaz, was one of the best painters of the Barbizon school. This master, born in 1809 in Bordeaux, can best be placed between Watteau, from whom he has clearly derived something of the style and choice of subjects, and Monticelli.

It is known that Monticelli held Diaz in high regard. Diaz's work is accentuated by its color qualities, for which his contemporaries valued him. From his first exhibition at the Salon in 1831, success and commissions were guaranteed. There is no longer any question that Diaz was inferior to his young admirer, Monticelli.

Born in Marseille in 1824, *Adolphe Josef Thomas Monticelli* is one of the most fascinating figures in 19th century French painting.

He was a bohemian, who travelled between Paris and Marseille. A slave to absinthe as well as to his art, he was involved in numerous highly emotional love affairs.

Monticelli was admired by Van Gogh and Cézanne, who had a great admiration for his work, and with both of them travelled together to Provence.

However Monticelli never gained real fame. He was forgotten soon after his death and has only recently been rediscovered.

The masters of the Barbizon school including Rousseau were influenced by 17th century Dutch landscape paintings, the exception was *Jean-Baptiste Corot.*

Corot, born in 1796, concentrated on landscapes from the start, but used as his example Italian painters instead of the Dutch. In 1825 he left for his first trip to Italy. That which had already affected his friends in Rome, became, as he went along, the most important quality of Corot's paintings.

His landscapes display a kind of

289

289. *Caspar David Friedrich, 1774-1840*
Landscape on the Island of Rügen, *1818*
Sammlung Oskar Reinhart, Winterthur

290. *François Rude, 1784-1855*
La Marseillaise, *1833-1836*
Stone
Arc de Triomphe, Paris

290

194

291

291. Henry Füssli, 1741-1825
Titania caressing the head of Bottom
1793-94
Kunstmuseum, Zürich

292. *Théodore Chasseriau, 1819-1856*
Arabian Horsemen at the
Fountain of Constantine, *1851*
Musée des Beaux Arts, Lyon

amalgamation of the light of the
"Ile de France" and the landscape
around Rome. Their hazy silvery-
ness gives them a tenuous and dreamy
poetic quality. Nymphs dance along
the borders of misty, marshy ponds,
bordered with garlands of willows.
Contrast made way for nuance; color
values got the better of color con-
trasts.

On his return from Rome, Corot
started working in the environs of
Paris. The "Ile de France" was
nearest to his heart.

The value of Corot's art has in-
creased; the combination of moment
and eternity in his vision of the
landscape is seen now as an extremely
happy harmony. His influence on the
Impressionists, on *Pissarro*, but par-
ticularly on *Monet* and *Sisley*, was
great; even quite different painters
such as *Puvis de Chavannes* and *Fantin-
Latour* were influenced by him.

When the peak of Romantic art
passed, a style arose that attacked Ro-
manticism as much as Romanticism
had attacked Classicism previously.
The new trend, Realism, arose
around 1848, the revolutionary year.
It immediately affected the con-
temporary artists, and demanded
that the painter give himself com-
pletely to his subject, and reproduce
it as accurately as possible. There
was a clear connection between the
spirit of the time and the art of the
realists. The machine-era had begun.
The Romantics had answered it with
a lyrical art that demanded freedom
of feeling and imagination. The

292

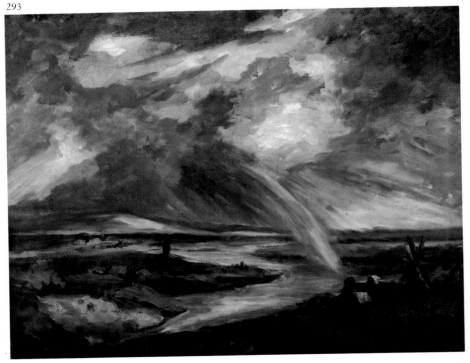

293

293. *Georges Michel, 1763-1843*
Storm in the Seine Valley
Musée des Beaux Arts, Lyon

196

Realists saw in Romanticism a withdrawal from reality and a way of taking refuge in a personal dream world. In their opinion, in a period of science and industrial progress, art should be concerned with real, contemporary subjects. Their leader was *Gustave Courbet* (1819-1877). His "Stonemasons", painted in 1849, created as much sensation and indignation as Caravaggio had two and a half centuries before with his realistic works. In Courbet's art there was no noble idea, or rich imagination. One was only allowed to paint what could be seen, not what the soul thought of it.

One of the greatest masters of the Realistic School was *Honoré Daumier* (1810-1897).

Originally he gained fame from his lithographs, which were often political cartoons.

Although Daumier's lithographs are still admirable, he is now recognized as a masterly painter as well. Daumier's abilities had been recognized during his life by Corot, Delacroix and Rousseau, and after his death

295. Jean-Baptiste Carpeaux,
1827-1875
The Dance, *1869*
Gypsum
Louvre, Paris

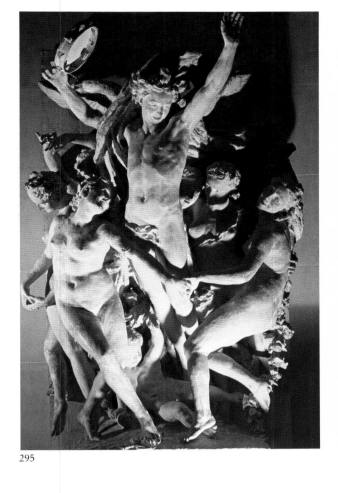

295

294. Narcisse Virgile Diaz de la Peña,
1808-1876
The Enchantment
Musée des Beaux Arts, Lyon

294

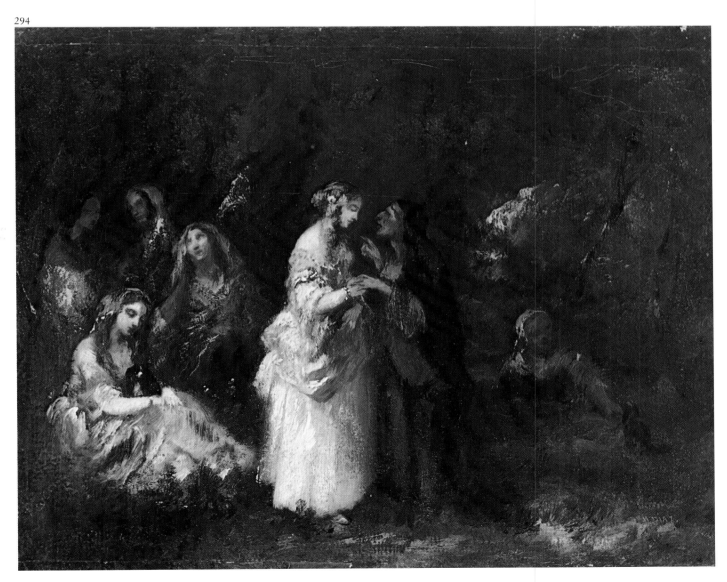

197

that fame increased. Daumier is particularly original and strongly related to the tradition of art.

There is a definite relationship with other artists such as *Hogarth* and *Constable*, *Goya* and *Delacroix*.

As has previously been said, the leader of the Realistic painters was Gustave Courbet.

After 1855 Courbet made the paintings that contributed most to his fame, such as the "Girls on the bank of the Seine" and the "Sleeping Nude by the River". His influence was considerable. Apart from his art he played a prominent role during the Commune. For his time he had very radical political ideas, that pointed in the direction of republican socialism. Immediately after the war of 1870-1871, he was part of the Commune, and was accused of hauling down the column on the Place Vendôme.

He was ordered to pay the costs of re-installing it and that forced him to leave France. He lived in exile in Switzerland, until his death in 1877. Around 1860 Courbet came into contact with Claude Monet and in Honfleur he met Boudin, who he admired very much. These relations formed the link that led to Impressionism.

Edouard Manet (1832-1883) is considered to be among the first to

298. Adolphe Josef Thomas Monticelli, 1824-1886
Les Femmes Savantes, *1883*
Private Collection

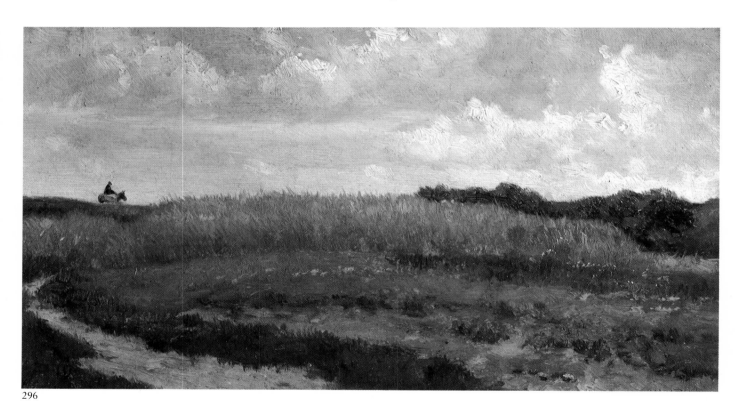

296

296. Charles François Daubigny, 1817-1878
Landscape, *1854*
Aargauer Kunsthaus, Aargau

297

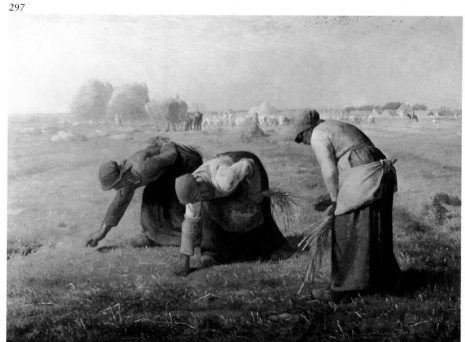

297. Jean François Millet, 1814-1875
The Gleaners, *1857*
Louvre, Paris

198

299. Jean Baptiste Camille Corot,
1796-1875
The Bridge near Narni, 1827
Louvre, Paris

299

was called a "king of airs" by Corot, specialized in expressing on his canvasses the slightest changes in atmosphere. As soon as the light changed by a new piling up of the clouds, by a changed position of the sun, Boudin sketched it with fidelity. The volatility of the necessary technique, the approach, the evanescence, the shutter-quality, to hold an impression, marked him particularly as a predecessor of Impressionism.

In Honfleur Boudin met the Dutch painter Jongkind, a kindred spirit. *Johan Bartold Jongkind* (1819-1891) had been apprenticed in his native land to a painter of the Romantic school, *Andreas Schelfhout*. He succeeded in getting a scholarship for his pupil, and thanks to this support Jongkind could dedicate himself completely to art.

He went to Paris, led a life there that was notable for an excessive use of alcohol, and painted – after having worked in the arusio of Isabey – on the beaches of Normandy. His paint-

300

contribute to the Impressionist movement.

Originally he followed Courbet although he also loved the painters of the Spanish school. Manet painted a lot in the open air, and his paintings seemed to overflow with sunlight; in comparison with which the canvasses of older masters seemed to be gloomy. The impression of great liveliness was made stronger by his style – which has echoes of Frans Hals and Velazquez – that gave movement to his subjects. It was precisely this characteristic which lead a conservative critic, to call this new style "Impressionism" a word that was originally a condemnation because the critics meant that these paintings at their best were only quick impressions, not complete paintings that had a right to be taken seriously.

Eugène Boudin (1824-1890) was of great importance to the Impressionists, and particularly to Monet. Boudin's influence was related to his belief that to paint from nature was to paint outside; an attitude that was very rare at that time. Boudin, who

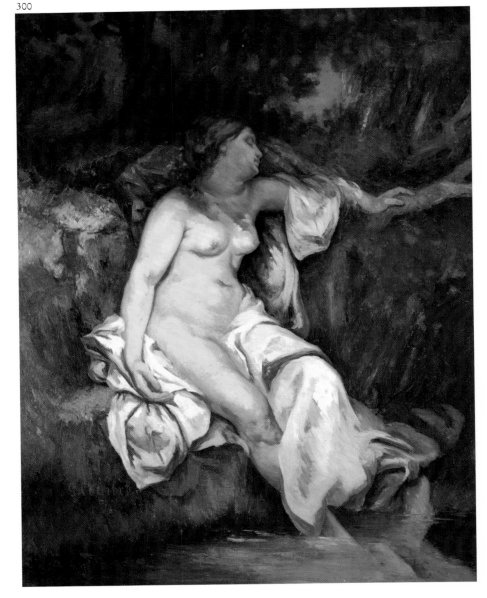

300. Gustave Courbet, 1819-1877
Sleeping Nude by a River, 1845
Sammlung Oskar Reinhart, Winterthur

301

301. Honoré Daumier, 1808-1879
The Chess-players, *1863*
Musée du Petit Palais, Paris

ings as well as his aquarelles were highly appreciated by connoisseurs, but he did not succeed in selling them easily. When, in 1853, the royal subsidy stopped, Jongkind's financial position became critical. He managed to keep his head above water for another couple of years, but in 1856 he was obliged to return to Holland. He remained in Rotterdam until 1860 where he lead a miserable life, unappreciated by his family and his countrymen. Some Paris friends, among them *Corot, Harpignies* and *Isabey,* organized a public sale of their works for Jongkind's benefit, and the proceeds of the sale enabled him to return to Paris.

Afterwards he painted in Honfleur and Le Havre in the company of Boudin and Monet.

In 1878 he settled in the region of Grenoble, where he lived for another thirteen years. He died in 1891 and the woman who had looked after him during the latter part of his life, died a few months later.

Impressionism

The artists who were to become the Impressionists were born between 1830 and 1841.

Pissarro in 1830, *Manet* in 1832, *Degas* in 1834, *Cézanne* and *Sisley* in 1839, *Monet* in 1840, *Renoir* and *Berthe Morisot* in 1841.

Although very different in training, origin and character, all these artists were inspired by the same desire for independence and sincerity. In 1860 they met each other in Paris; a lucky chance achieved the meetings that would be of such far-reaching significance for the development of art in 19th century France. The famous *"Salon of the Refused"* of 1863 was the first, sensational "acte de présence" of the joint Impressionists.

To those "Refused" belonged, amongst others, *Pissarro, Guillaumin, Jongkind, Whistler* and *Cézanne.*

Those who in the official Salon admiringly crowded around the sugar sweet "Venus" of *Cabanel* (purchased by the Emperor) were shocked and outraged by Manet's "Déjeuner sur l'Herbe" (the Picnic). Manet became the leader of the completely independent youth, and the revolution against the Academy. In future colors would not be mixed on the palette, but beside each other on the canvas. The world would be seen as a sequence of impressions, that continually change. No fixed forms anymore, no motionless volume: but vibrating life in light and reflection.

Claude Monet (1840-1926) met Boudin at the age of 16 in Le Havre. Until then he had only made caricatures, but under Boudin's influence he started specializing in landscapes. After two years in the army he returned to Le Havre; he painted for a summer with Jongkind and Boudin. Afterwards he went to Paris, where he came into contact with Pissarro, Renoir and Sisley. Friendship tied him to the painter *Frédéric Bazille,* who placed a studio at his disposal, made trips with him and assisted him financially.

A painting from 1867 – "The Women in the Garden" that he painted outside, and which had been refused

201

by the jury of the Salon, was bought by Bazille. It is now hanging in the "Salon du Jeu de Paume". This canvas already shows how Monet's technique became more and more impressionistic. This did not make it easy for him to sell his paintings, but his heavy debts forced him to sell at the same time two hundred of his works for almost any price.

He married in 1870 and lived on a boat in Argenteuil. Four years later he painted his "Impression, Sun rise", from which would come the name "Impressionist".

In 1892 he was able to buy a house with a garden in Giverny; in the garden he installed a pond full of water-lilies. These were the starting point for the series of canvases called the "Nympheaden"; he completed a second series based on this subject in 1923.

With other canvases, painted in the garden of Giverny, they form not only the keystone of Impressionism but - as became obvious much later – also the point of contact for painters who lived more than half a century later. Monet had made the

302. *Eugène Boudin, 1824-1898*
Trouville, 1874
Private Collection

302

303

202

304

304. Claude Monet, 1840-1926
The Seine near Bougival, 1869
The Currier Gallery of Art,
Manchester (New Hampshire)

acquaintance of *Paul Cézanne* in Paris in 1862, a young painter from the South of France, for whom the ideas of the Impressionists had become the basis for his own art. What separated Cézanne from the Impressionists was a lack of superficiality and preoccupation with the momentary. He concentrated much less on movement and change than the others.

After his father's death in 1886 he inherited a considerable fortune that enabled him to work as he wanted. He was no longer dependent on public favor. He spent a couple of years in the south of France, near Aix-en-Provence.

During that time he freed himself from Pissarro's influence and from the Impressionist view in general.

303. *Johan Bartold Jongkind,*
1819-1891
Village in Showery Weather, *1878*
Collection Jonkheer Mr. J. H. Loudon,
London

He developed, in every respect, a personal style, in which he accentuated the constructive elements in the painting. He reduced the forms present in nature to their geometric basic structure, and built up his composition with these simplified elements. He painted, not according to nature, but with the help of nature.

Only his friends appreciated his works: Monet, Renoir and Dr. Gachet, they all believed in him. The followers of the Impressionistic method, the followers of Academicism, failed to understand why Cézanne's vision of the landscape led to a transposition of natural forms in geometrically-set patterns. Nevertheless his idea of painting offered possibilities, when those of the Impressionist school were exhausted. The painters of the coming generations could make contact with his work, until far into the 20th century.

Auguste Renoir (1841-1919) different from Cézanne, let the spirit and the contemplation play a lesser role in the creation of the art work. Intellectual intentions were foreign to him; he was rather an impulsive and sensual painter.

Renoir always had a preference for women as a pictural theme; the light on her skin was dearer to him than the light on the river. In other themes such as the interiors of cabarets and café-dansants – he also managed to reach a high level, especially in the paintings of the *Moulin de la Galette.*

The interest of his contemporary and friend Cézanne concentrated mainly on form, but Renoir was more occupied with color. He was in love with the matter, stroking with his brush the naked bodies of his bathers.

It has been said of Impressionism that it has not yet created a new world – a realm of imagination – but rather it has shown the spectator the every-day world in a completely new way. Indeed, Impressionism has shown us the world with other eyes. Nobody has revealed the beauties of the landscape with so much devotion as *Alfred Sisley* (1839-1899).

He was exclusively a landscape painter, and limited himself to the "Ile de France"; there he knew the light, the skies and the poetry so well, that today, one cannot see this part of the country with other eyes than his.

203

305

305. *Edouard Manet, 1832-1883*
Lady singer at the Café Concert,
ca 1879
Collection Mme Ernest Rouart, Paris

306

306. *Camille Pissarro, 1830-1903*
The Little Bridge near Pontoise,
1875
Städtische Kunsthalle, Mannheim

204

Sisley had no other means available than those of his art; unlike most of his friends, he never had the chance to reap the fruits of his work. Right up to his death, poverty remained an inseparable companion. Perhaps as a painter he did not reach the height of his friends, Cézanne, Monet or Degas. But he is one of the purest representatives of Impressionism, and one of the truest followers of the Impressionist painting style.

In the same breath as Sisley, the painter *Camille Pissarro*, born in 1830, can be mentioned.
Pissarro's father had sent his son to Paris, so that he could qualify for a trade, but Camille had a greater liking for drawing than for doing business.

He was allowed to become a painter. He took lessons from, amongst others, Corot, and showed his work in the "Salon des Refusés" in 1863.
During the war of 1870 his studio in Louveciennes, close to Paris, was plundered. All but 40 of the 1500 paintings he had left there, were destroyed. It made him as poor as a church-mouse, and he remained so for another 20 years. However, he went on persistently painting, experiencing a series of influences (particularly that of Monet and Seurat) and made many trips. His famous town views are mostly seen from a readily definable spot.
He was a modest and gentle man, who fostered humanistic ideals and who had a great admiration for his friends.

The most important female painter of the Impressionist movement was *Berthe Morisot* (1841-1895). She remained faithful to the group's way of painting until Manet's death. Apart from landscapes, she made many portraits, interior-scenes and figure studies. The hazy charm of her landscapes and the interiors with very personal atmosphere, are what her works are justifiably admired for.

Edgar Degas (1834-1917) was a painter, who painted pictures of the life of his time. But what really kept him busy during his long and active life, were pure painting art problems: those of form and composition and – in his later years – of color.
Although Degas was friendly with the Impressionists and had an im-

307. *Alfred Sisley, 1839-1899*
The Seine near Marly, *1876*
Musée des Beaux Arts, Lyon

307

portant place in their demonstrations and exhibitions, it is difficult to consider him as belonging completely to their group. He remained on his own.

In 1868 he painted *The Musicians of the Orchestra;* this painting is now in the Louvre. In the background of it are some women dancers who would later form Degas' major theme. From 1885 he painted his women dancers.

Slowly his eyesight failed, and in 1881 he started with sculpture. When his eyes failed almost completely, he created statues with the sensitivity of his hands. His contribution to the sculpture of his century belongs to the most convincing that has been produced.

The standing "Dancer", made in bronze, is not only a graceful figure, but a true and strong statue, that distinguishes itself favorably from what was mostly pompous and academic sculpture, produced by the official sculptors of the time. Another essential aspect of the later works of Degas is his water-colors, in which he practised a color-al-

308. *Henri Fantin-Latour, 1836-1904*
Flowers and Fruits, *1865*
Musée du Jeu de Paume, Paris

308

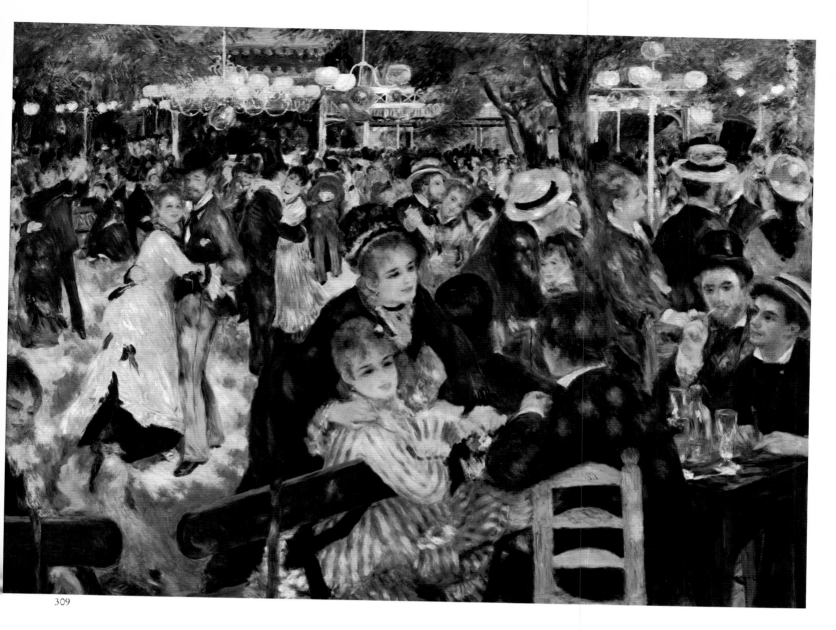

309

309. *Pierre Auguste Renoir,*
1841-1919
Le Moulin de la Galette, *1876*
Louvre, Paris

310

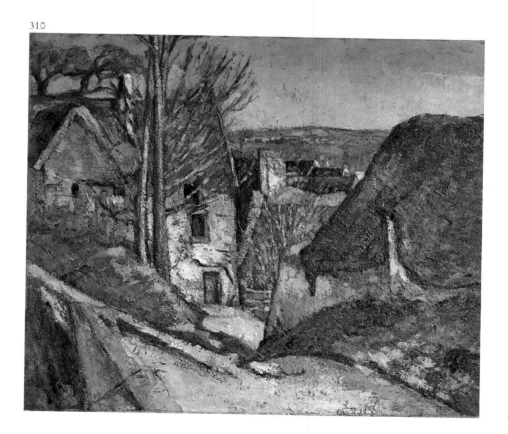

310. *Paul Cézanne, 1839-1906*
The House of the Hanged, *1873*
Louvre, Paris

312. Edgar Degas, 1834-1917
Musicians in the Orchestra, 1872
Städelsches Kunstinstitut, Frankfurt

311. Auguste Rodin, 1840-1917
The Thinker, 1880
Musée Rodin, Paris

311

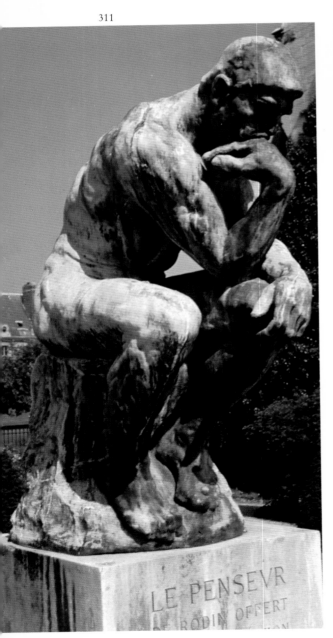

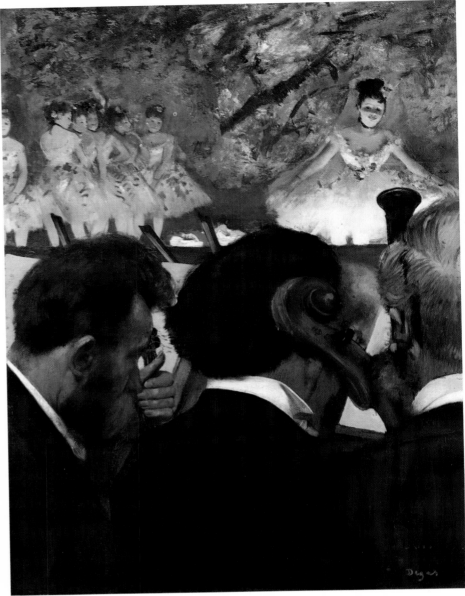

312

chemy that dissolves the forms in a fairy-like and magisterial play of effects. In these water-colors Degas got nearest to that which other Impressionists pursued. In some ways he even surpassed the others with those late pastels.

Degas was not the only painter of the Impressionist movement who was also a sculptor; Renoir contributed his women figures, sensitive and sensual. *Auguste Rodin* is quite a different matter, his water-colors show a picturesque quality that makes him equal to the other Impressionists. Rodin, born in 1840, was above all a sculptor. Impressionism is in his work in the use of every unevenness, to make light work more effectively. Clothing dissolves in picturesque – restless lines, the contour vanishes into movement. The sculpture almost gets the nature of a snapshot in stone. After his early realism, Rodin went the same way that painting took via Courbet, Ma-

net and Monet. This led to the complete triumph of the pictorial over the plastic principle. Though Rodin understood his art pictorially, a statue like "Balzac" proves completely Rodin's genius. In "Balzac", casual reality is invented, turned into symbol, and the matter loses its heaviness to be moulded into ecstacy. *The Thinker*, which was the centrepiece of "The Gates of Hell" shows Rodin's Baroque and picturesque design. It has qualities of a more classical nature and it is related – however distantly – to the figures created by Michelangelo.

The place occupied in art history by *Henri de Toulouse-Lautrec* (1864-1901) is very important, but even more important is his share in the "legend" of his time. In fact he was one of the "peintres maudits", those damned painters, whose lives provided much material for the journalists of the time. Like Vincent van Gogh he died at the age of thirty seven, but he had

a different background to Van Gogh. Van Gogh was the son of a common clergyman, Lautrec was the descendant of one of France's most prominent families. He was pre-destined to follow the feudal life of his forefathers, but at the age of 14 he broke both his legs in a fall and they failed to respond to treatment. A second fall made it certain that his legs would never return to normal, and Lautrec remained a dwarf for the rest of his life. From then on he did nothing else but draw. From the first attempts he showed great talent.

In 1881 he left his birth-place to settle in Paris. The influences on him there, from the Impressionists, were great. He met Berthe Morisot, Degas, Manet and Van Gogh. To these were added the influences of Japanese prints, that started to become popular at that time.

Lautrec lived in Montmartre, a district of Paris that was the centre of a great and fruitful artistic creativity. Moreover, everywhere he found the models and types he needed for his drawings. He spent his nights in the well-known "Mirliton", in the caba-

313. Edgar Degas, 1834-1917
Blue Dancers, *1890*
Louvre, Paris

313

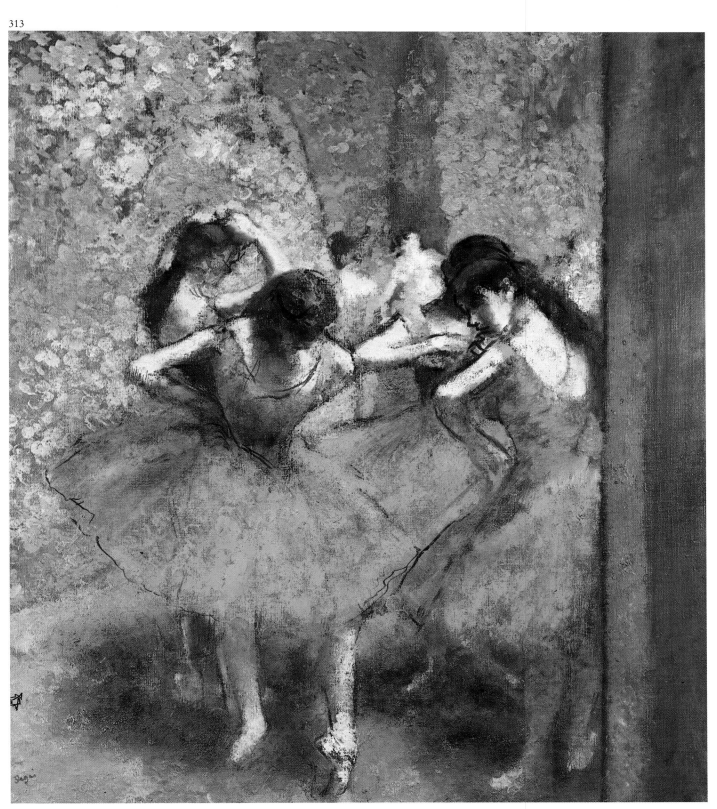

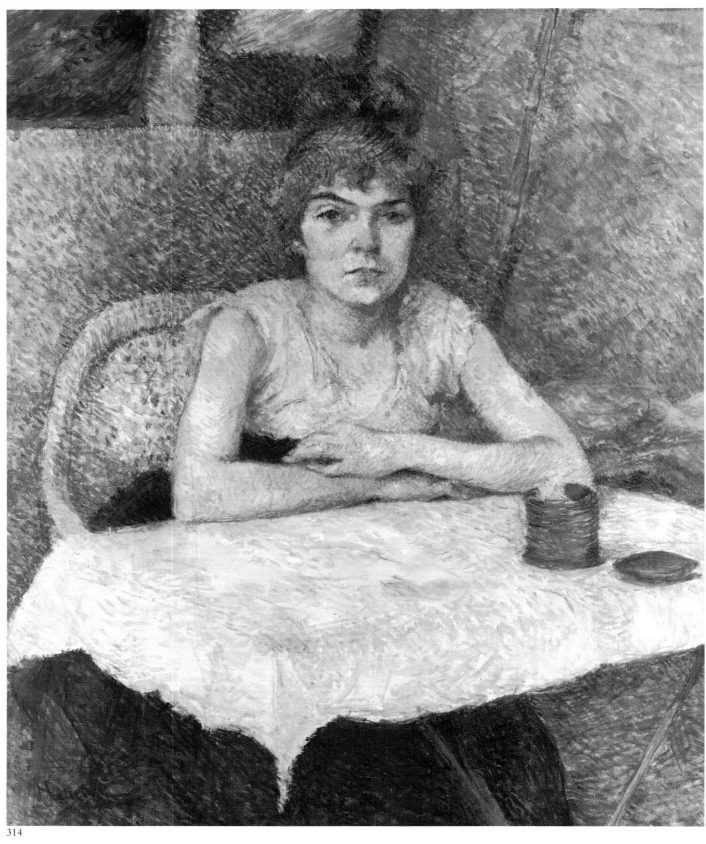

314

314. *Henri de Toulouse-Lautrec,*
1864-1901
Poudre de Riz, *1889*
Stedelijk Museum, Amsterdam

ret of Aristide Bruant or in the "Moulin Rouge" where he was a regular customer. There he was friendly with the women who are perpetuated in his drawings and paintings. He made his first posters for the "Moulin Rouge", and in doing so raised the art of the poster to a new level. He brought this advertising material to an artistic level, that can bear comparison with autonomous artwork. But he designed

for magazines like "*Revue Blanche*" as well as for cabarets, singers and dancers.

After specializing almost exclusively on the night life of Montmartre, he sought inspiration in other subjects: in circus and sports. His numerous portraits are considered to belong to the best painted in his time. Unfortunately alcohol and the night life of Montmartre undermined his health so much, that in 1899 he was admitted

to a hospital, where they tried to combat his poisoning. With the help of a few friends he managed to escape from this clinic, and immediately started drinking again. Two years later he collapsed and was moved to the castle Malromé where his mother lived. He died on the ninth of September 1901.

On his death-bed he was reputed to have said: "life is beautiful".

Two women occupied an important place in Impressionism: Berthe Morisot (1841-1926), sister-in-law of Manet, has already been mentioned, the other was *Mary Cassatt* (1844-1926) born in America, who derived her sense for linear expressiveness from Degas, but the clarity of her palette from the Impressionists. She was shown in the Salon of 1874, (where her exhibit attracted the attention of Degas).

Soon a great friendship based on mutual respect combined the two women. Both had a great predilection for drawing, for precision, for the mobility of line. Mary Cassatt was even an Impressionist in her use of color, in spite of a leaning towards silvery light, her preference for the graphic element remained.

She played a very important role in another aspect. She advised her American friends on their purchases. For that reason she may be considered as the one who in fact introduced Impressionism to the United States. She supported her friends-impressionists by buying, and assisted the artdealer Durand-Ruel when he was in financial difficulties.

With all that, she also left an important and original oeuvre.

Neo-Impressionism

Strictly, Lautrec cannot be considered to belong to the Impressionists, and Degas and Renoir also stand somewhat outside of this movement. Cézanne even resisted, more or less, the intentions of the Impressionists. The case of *Georges Seurat* (1859-1891) can be considered as a reaction. This painter died very young – he was thirty two years old

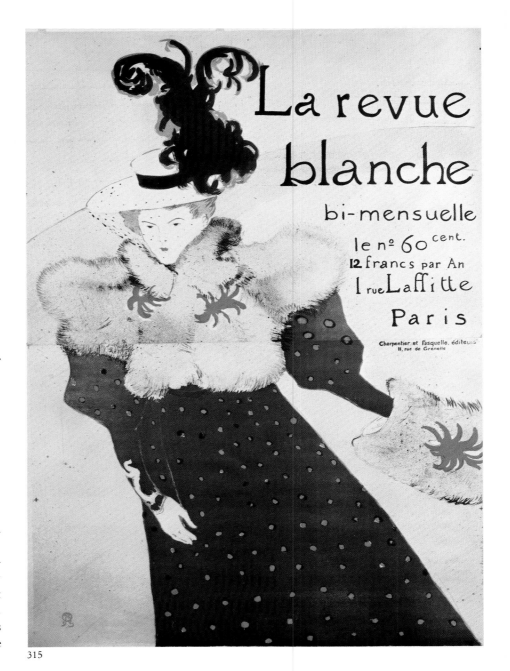

315

316. Mary Cassatt, 1845-1926
Riding Woman and Child, 1881
Philadelphia Museum of Art

316

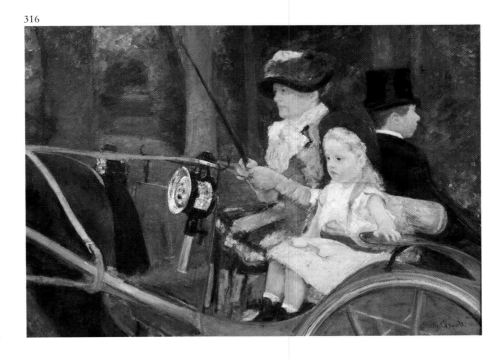

211

earned the name Pointillism. The name explains this system, the application of color in small, detached points. The reason for it was to keep the purity of color as it occurs in light. A work, painted in that way – "Bathing at Asnieres" – was refused by the official Salon, but got a place in the *Salon of Independents*. There it was displayed with the work of *Paul Signac* (1863-1935), who first became Seurat's friend, later his pupil and follower. Seurat also sent a work to the last group exhibition of the Impressionists, *Sunday in the Grande-Jatte*. This canvas did not find general favor with the critics, and roused the indignation of the public. On that occasion the group of Neo-impressionists was formed, which

317. Georges Seurat, 1859-1891
A Sunday Afternoon on the Isle
La Grande Jatte, *1884-86*
The Art Institute of Chicago

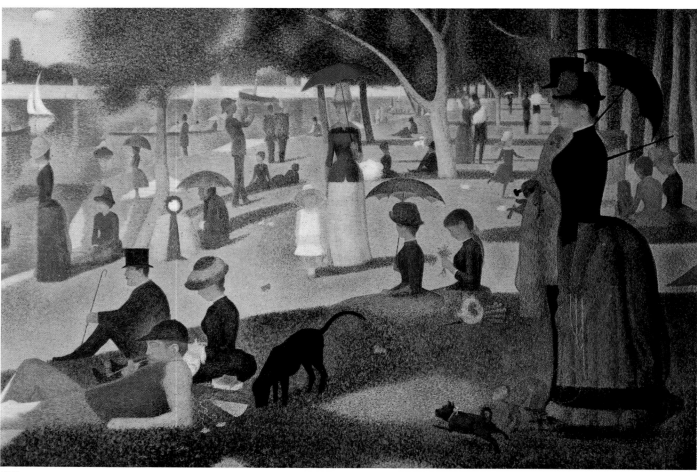

317

318

– perhaps too young to realize what was in his mind.

But what exists is sufficient to prove the originality and the strength of his talent. Therefore his influence was great on his contemporaries as well as the painters of the following generations.

"Art is balance" proclaimed Seurat. He was a creator once more of an ordering, in which the subject is subordinate to the style. Geometric ordering enters, even color is applied with the aid of intellectual supervision. Impelled by scientific theories, Seurat developed a system, that

318. Paul Signac, 1863-1935
View of St. Tropez, *1896*
Musée de l' Annonçiade, St. Tropez

319

included not only Seurat, but also Signac and Pissarro.

Signac became particularly famous as a painter of the waterside; apart from painting, sailing was his great passion. The resistance to Impressionism was strongly expressed in the work of Gauguin and Van Gogh. *Odilon Redon* may also be considered to belong to that resistance.

In the paintings of Gauguin and Van Gogh, the color was originally more important than drawing. In the course of Gauguin's development the emphasis changed in the favor of drawing; as a draftsman he followed Ingres via Degas.

Gauguin after his first Breton period, found the subject for his paintings in the South Seas; one could consider the female nudes from Tahiti as the descendants of Ingres' odalisques.

Paul Gauguin (1848-1903) was born in Paris. He spent his early youth in Peru, and he was thirty five years old before he devoted himself completely to painting.

In 1886 Gauguin had made friends in Paris with Vincent van Gogh. Van Gogh, attracted by the light of Provence and by the sun, settled in Arles. In his letters he tried to induce his new friend to follow him. After a journey to Martinique, and a stay in Breton, Gauguin responded to that request. He left for Provence. The relationship between both painters took an unfortunate and dramatic turn. Gauguin returned to Paris. With the proceeds from an auction of his paintings Gauguin travelled to Tahiti in 1891, where he stayed until 1893. After stopping in Paris and Brittany, he returned to the South Seas. From a melancholic state of mind he tried to visualize the paradise he so passionately looked for.

He needed a source, that was not yet confused by civilization. Refreshed from those sources, his color and drawing gained in strength and intensity. Today Gauguin occupies an honorable place among the great painters of his time; one values his

work for its originality and for the almost magic power that radiates from it.

Vincent van Gogh (1853-1890) led an extravagant life in every respect. His talent, its development, his fate, his life's end, and the fame that came after that end, all had a certain uniqueness.

Van Gogh came from Brabant, the Netherlands, became a pupil in the art trade of Goupil, went to England as a language teacher, took the decision there to become a clergyman, was sent as a missionary to the Borinage, a Belgian mining-district. He developed a conviction that could be called christian-social. Then he started painting. His way of painting between 1880 and 1886 was dark and gloomy. The painting for that period is demonstrated with the "Potato Eaters".

In 1886 Van Gogh went to Paris. There a ripening of his painting art started, that developed extremely quickly. His brother Theo put him

213

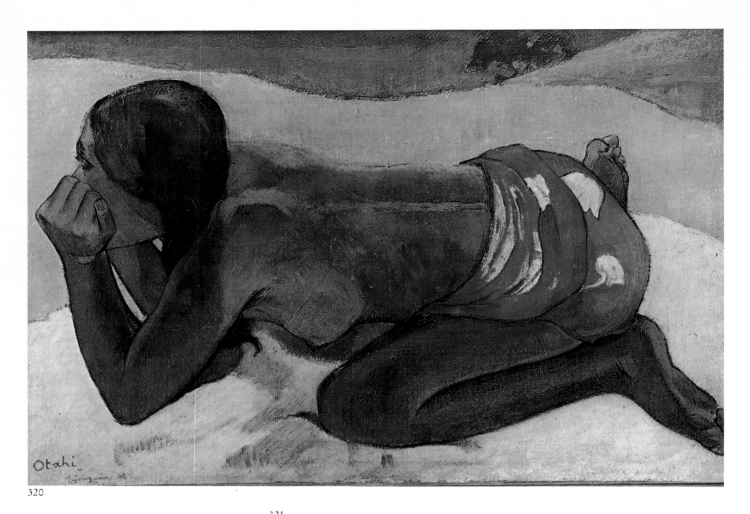

320

320. Paul Gauguin, 1848-1903
Otahi, *1893*
Private Collection

in contact with Monet, and with
Pissarro, who became a fatherly
friend and adviser, as he had been
previously for Cézanne and Gauguin.
Van Gogh also met the eleven years
younger Lautrec and friendship
developed between them. An almost
unbelievable change can be seen in
Van Gogh's work during that two
year period in Paris. His palette be-
came lighter, his touch loose and
mobile; the heavy, sometimes de-
pressing gloom disappeared from his
work.

Van Gogh was on the way to be-
come an Impressionistic painter. A
most important step in that direction
is marked by a fragment of one of
his Paris letters: "It is as necessary to
pass through Impressionism, as it
was earlier necessary to walk through
a Paris studio."

This insight soon became an ac-
complished fact; not long after Van

321

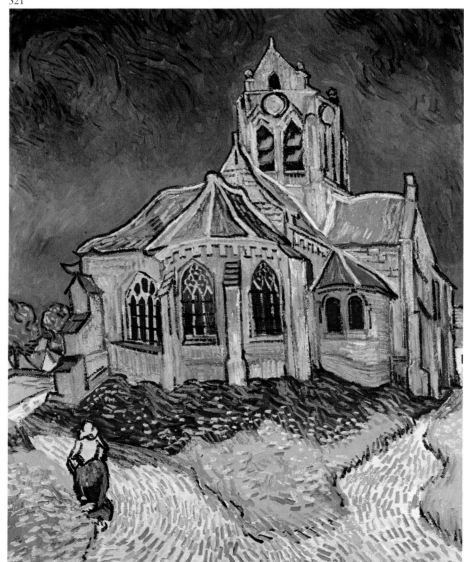

321. Vincent van Gogh, 1853-1890
The Church in Auvers, *1890*
Louvre, Paris

Gogh retreated to Arles, in Southern France.

He lived there during the spring and summer almost in a state of intoxication. In the following two years he created most of the paintings that are linked with the name Van Gogh. His motifs were blossoming orchards, corn fields, portraits of people in his new environment, flower still lifes, a pavement café, a shore with boats, a bridge. Almost every day a new painting was created or a strong drawing made with the reed pen.

After the meeting with Gauguin in Arles, Van Gogh's increasing mental instability made admission into an institution necessary.

At first he went to a hospital in St. Rémy, later he was under treatment by Dr. Gachet in Auvers. In both places, in his better moments, he painted. Landscapes with moving clouds, forms and upwards twisting cypress, self-portraits, a portrait of his doctor, and so on. During his stay in St. Rémy, Van Gogh heard that in Brussels one of his works had found a buyer, the first and only one that was sold during his life. It was "The Red Vineyard".

In the period at St. Rémy he painted more than fifty canvases. In Auvers his last works were created: the town hall of Auvers, the cornfield, above which ravens fly in a thundery sky.

On the twenty seventh of July, 1890, in a field, he shot himself. Two days later he died.

When Van Gogh left Paris, he knew that Impressionism had nothing to offer anymore. From Arles came a letter, saying: "More and more I am looking for a simple technique, that is, perhaps, not impressionistic." This "perhaps" became "certainly". In Van Gogh a new "seeing" was demonstrated.

Henri Rousseau (1844-1910), called "*Le Douanier*", cannot be placed with the Impressionists, nor with the Post-impressionists, although his life runs parallel to most who belonged to those schools. He was what has been called ever since, a "sunday-painter", a "primitive", that means

322. Vincent van Gogh, 1853-1890
Boats on the Shore near
Saintes Maries-de-la-Mer, *1888*
Foundation Vincent van Gogh,
Amsterdam

322

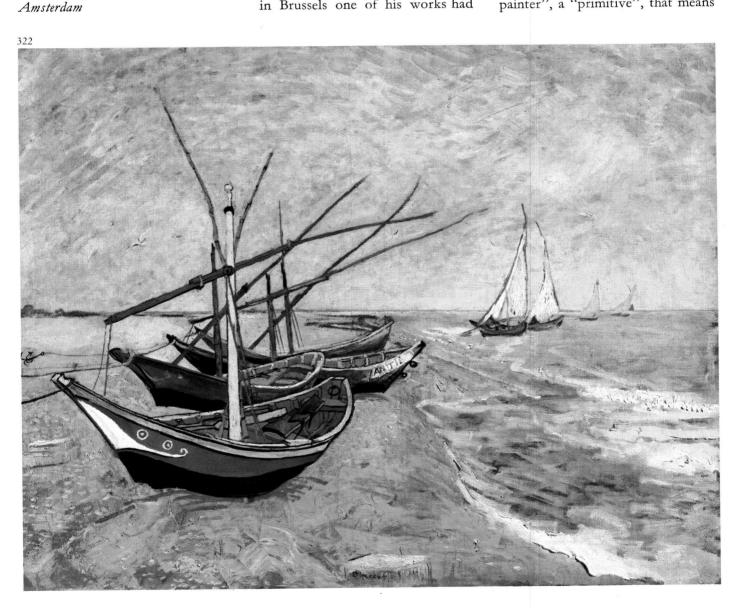

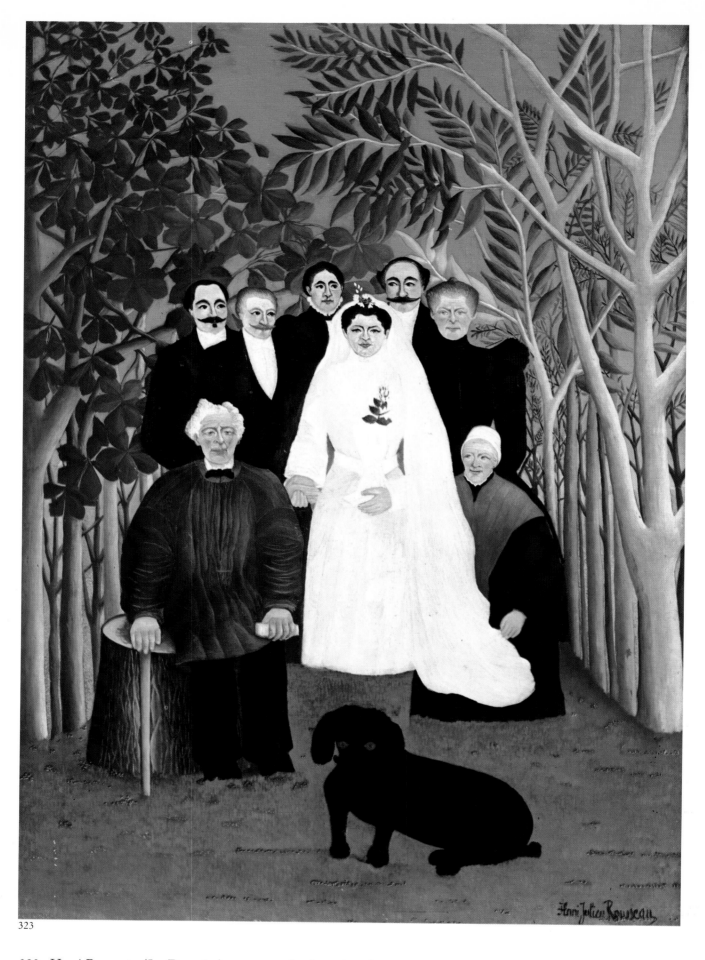

323

323. *Henri Rousseau (Le Douanier),*
1844-1910
The Marriage, *1905*
Collection Mme Jean Walter, Paris

somebody who has no pictorial erudition. He transposes every-day things into a world that belongs more to dreams than to reality. This exceptional ability was attended by an equally extravagant talent. His color choice is original and harmo-

nious, and supports the poetic flights of the representation, in which he makes no attempt to match or imitate.

When Rousseau does start depicting reality as accurately as possible, – as for example in the portrait of a

325. *Pierre Bonnard, 1867-1947*
Reclining Nude, 1899
Musée d' Art Moderne, Paris

324. *Edouard Vuillard, 1868-1940*
Woman with Blue Blouse
Musée de Peinture et de Sculpture,
Grenoble

324

325

married couple – he escapes from the traditional representation, thanks to his lack of scholastic professional knowledge. A pure instinct always keeps the upper hand and gives respect to a world like the one of the "Snake-charmer" in the Louvre; a canvas that combines the ominous fantasy of legend with the creation of a world that only Rousseau could contemplate.

Van Gogh, Gauguin and Cézanne were examples of an approaching revolution, not only in art but in the complete world picture. Unconscious – for the greater part – of the degree in which their pictorial problems symbolized the changes on the social, political and spiritual level, they announced with their work a century in which tradition seems to have lost its sights.

Two artists however are an exception. In their work the past and the present are not yet implacable contradictions. *Pierre Bonnard* (1867-1947) and *Edouard Vuillard* (1868-1940) To a certain degree these two continue with the tradition of Impressionism: with unwithering freshness they remain the nice, appearance-loving artists, who, by the refined light play, the subtle gravity and the modest luxury of their pure pictorial color treatment, end the impressionistic tide in a magisterial way.

Art as Experiment

Art Nouveau or Jugendstil

At the beginning of the 20th century – in fact some dozens of years before – a reaction appeared, particularly in architecture, that up till then had applied style principles, derived from past eras. In church building, as in the profane architecture, there had been a short, flourishing period of Neo-Gothic; parallel to these style trends, elements, derived from the Renaissance, were continuously applied. A modern style, in contradition to a combination of components derived from history, hardly existed. The resistance to it took shape in a movement, called "Jugendstil" or "Art Nouveau". The French name came from the opening of a shop, specializing in modern design, in Paris, in the Rue de Provence; this shop was called "L'Art Nouveau" and about 1900 – five years after the opening of the shop – the name was generally used for indicating a certain aspect of French decorative art. The English considered Art Nouveau as

327. *Gustav Klimt, 1862-1918*
Salomé, *1909*
Galleria dell' Arte Moderna, Venice

327

326. *Egon Schiele, 1890-1918*
Dead Town, *1912*
Kunsthaus, Zürich

326

329. *Art Nouveau*
Avenue Brugman, Brussels

329

328. *Antonio Gaudi, 1852-1926*
Casa Mila, Barcelona

328

a specific French matter, that had no relation to the development in England in this field. Later it appeared that the Art Nouveau was not only a French phenomenon. At the same time in Austria the Jugendstil came into being, deriving its name from a magazine that was edited around 1896 and that was called "Jugend". The style was very decoratively orientated, looking for its strength especially in the revival of the ornament. A most important role in this movement was played by the Belgian artist *Henry van de Velde* (1863-1957) who had worked in Germany since 1900. He was appointed leader of the applied art school in Weimar. His own creations are of importance, for example the Folkwangmuseum in Hagen, from 1902, and the theatre at the "Werkbund" exhibition in Cologne, from 1914. In France, where the Opera House is

one of the last – and we must admit one of the most grandiose, monuments of an architecture bound to the past – a new era was ushered in by the creation of engineer *Eiffel*. The Eiffel tower that is called after him and the mighty viaduct of Garabit, art works in steel that prelude a combining of modern technique and architecture. This combination finds its first realization in the big store "Au Bon Marché", built by Eiffel and *Boileau*, an engineer and an architect. Other stores, like "Printemps" and "Samaritaine" followed. The trend to break with the past, is also embodied in the creations of the brothers *Perret*, who as one of the first, put confidence in reinforced concrete. One of the greatest masters of the Art Nouveau in Spain was *Antonio Gaudi* (1852-1926). Prophet and visionary, Gaudi is also forerunner of certain Ba-

330. Edvard Munch, 1863-1944
Winter on Kragerö, *1925-31*
Kunsthaus, Zürich

330

331

332

roque tendencies in 20th century architecture and creator of a religious architecture that is unequalled. With Horta, Van de Velde and Guimard he belongs to the grandmasters of Art Nouveau architecture. His best known creation is the "Sagrada Familia", a still unfinished cathedral (the existing pieces mainly cover the front and the towers) in Barcelona.

The "Fin de Siècle" in Austria

In Austria it was *Otto Wagner* who imparted typical Austrian Jugendstil accents to architecture. In painting the Jugendstil developed as "Sezessions-Stil". The Sezession group was established by *Gustav Klimt* (1862-1918), who exaggerated the decorative aspects of art in a way that was then unknown. He was a representative of the morbid, but also extravagant, excesses in art, that is known as "Fin de Siècle". *Egon Schiele*, born in 1890, is stronger and more inclined towards the coming Expressionism; his distressing paintings and drawings express a typical European "mal de vivre". Unfortunately Schiele, whose work vibrates with tragic tension, only had a short life; he died in 1918, leaving behind an oeuvre, born from the Jugendstil but, also strongly ushering in Expressionism.

221

333

334. Karl Schmidt-Rottluff, 1884-
Nudes (in Nature), *1913*
*Städtische Galerie im Landesmuseum,
Hanover*

334

In the work of *Edvard Munch*, born in Norway in 1863, there are, particularly in the beginning, many Jugendstil elements; from 1889 till 1892, and again from 1895 till 1897 Munch stayed in Paris, a Paris that had little meaning to him. His work already lived in the canvases he made before he went to Paris. Between his visits to Paris Munch usually stayed in Germany, where he found a more congenial atmosphere than in France. That sphere took shape in a group of artists who chose the name "Die Brücke" and accepted Munch as their master. From this group, the later, more extensive Expressionism was born.

In the work of Munch his background is strongly felt. He was descended from a family of preachers and teachers. He had a rather poor youth, for his father who was a doctor among the poor people of Oslo, asked small, or no fees. His mother died when he was only 5 years old, and his sister eight years

222

335

later. Add to this the strict christianity of his father, his puritanism and his melancholy, and one understands why Munch suffered from his sadly distorted youth. The subjects he preferred: "The Ill Girl", "The Death in the Room", "The Woman and the Death", and "The Dead Mother", are expressions of melancholy from his childhood.

His diary contains a confession of faith, that makes clear how little he was able to break away from his forefathers: "One cannot paint eternally knitting women and reading men; I want to feature creatures who breath, feel, love and suffer. The spectator must come alive to the holiness in them, so that he will discover himself by their presence, as in church".

Expressionism in Germany

In contradiction with the French art, that went rational and logical ways, a mystic, religious trend occurred in German art at the beginning of the century. The influence of philosophic

335. Emil Nolde, 1867-1956
Fall Clouds, *1910*
Nolde Stiftung, Seebüll

336

336. Ernst Barlach, 1870-1938
Ecstasy, *1916*
Wood
Kunsthaus, Zürich

and political protests against a world that was considered at that time as already over-mechanized, created a new searching that drew on intuition for the non-materialistic, on the other side of every day reality. In that art – the art of Expressionism – as Georg Schmidt formulated it "the problematic situation of Europe around the turn of the century is lifted into consciousness". While the French are trying to analyse rationally the form in Cubism, the Germans break through form and color from their feeling. There is a world of difference between the logical form analysis of Cubism and the strong, emotionally fixed, mystical form changes of Expressionism in Germany. In the most important element in the emotionally loaded revolution of the German intelligentia, some have seen resistance to the authoritative belief, that in the course of the 19th century had become stronger and stronger. The tension between authoritative demands and liberal reform movements intensified and an idealistic Romanticism, outside of reality, as previously seen with Böcklin, Feuerbach, Klinger and Marées, was replaced by the more expressive utterances of artists like *Hodler*, Munch, *Corinth* and *Slevogt*, the social realism of *Käthe Kollwitz* and finally, at the beginning of the 20th century, the protest of the Expressionists.

Resistance to the Existing Order

The inner tension, which turns the Expressionistic artist against the world, can be put down to the lack of real relationships to, and in, the home, the school or religion. These contact difficulties can be caused by the restrictive, strict demands of family and society, by a stiff hierarchical order in private and public life, by the respect that authority tries to extort in every field of life. In an environment, in which ideals of complete obedience, duty and order dominate in an excessive way, sensitive people often react with explosive indignation. The stronger the chains, the stronger the resistance to it. In the same measure in which the expressionistic artist rejects a certain authority in family, school or academy, he looks on the other

337. Max Pechstein, 1881-1955
Three Nudes in a Landscape, *1911*
Musée d'Art Moderne, Paris

337

224

hand for a replacement in identification with the powers of nature, eternity, upper-worldly.

This appears unmistakably from the work of artists of "Die Brücke" and "Der Blaue Reiter". Just as the modern man usually tries to abolish a loneliness that has become unbearable, by committing himself to a power that is mightier than himself, by a deindividualizing offered for example by primitive mass-movements, so Expressionist poets and painters have addressed themselves, after having turned their backs on society, to something else, to a cosmic security that would abolish their isolation.

338

339. *Otto Mueller, 1874-1930*
The Gipsy Couple, *1919*
Collection Dr. Ing. Max. Lutze,
Hamburg

339

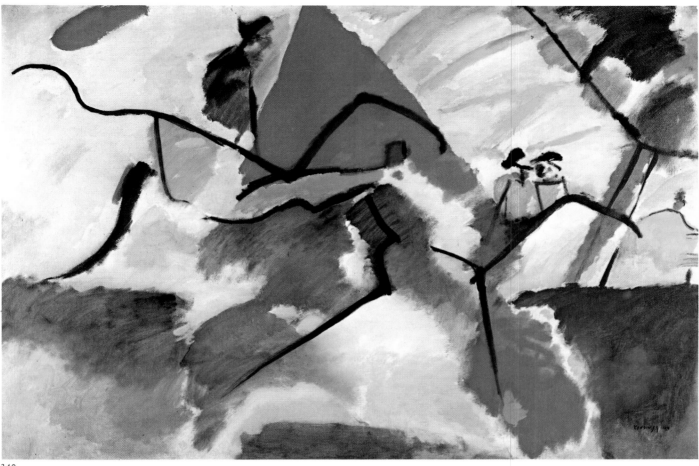

340

341. Raymond Duchamp-Villon,
1876-1918
The Horse, 1914
Bronze
Art Institute of Chicago

341

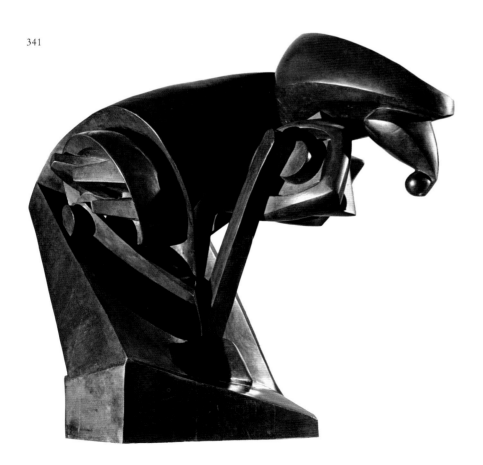

340. Wassily Kandinsky, 1866-1944
Impression No. 5, 1911
Collection Mme Nina Kandinsky,
Neuilly-sur-Seine

Erich Fromm suggests that also the urge for destruction is part of the flight from disappointment and helplessness. The lonely individual sees himself prevented, by the numerous social and cultural taboos, from reaching a spiritual, psychical or other satisfaction. The measure in which the individual needs to indulge is limited, is in equal proportion to the strength of the urge for destruction, that is caused in him. When the striving for self-realization is prevented, the energy often flows down to destructive channels. "The urge for destruction is the result of unlived life."

Destruction of Reality

While with normal mortals disappointments of this character could provoke reactions against society, the artist feels himself impelled to destroy the reality that rejects him. In this way the Expressionistic artists destroy the real appearance of things to reach irrational and spiritual values.

Their often wild and demonic explosions of feelings are exactly the same as reactions of people who plunge themselves into political or social activities.

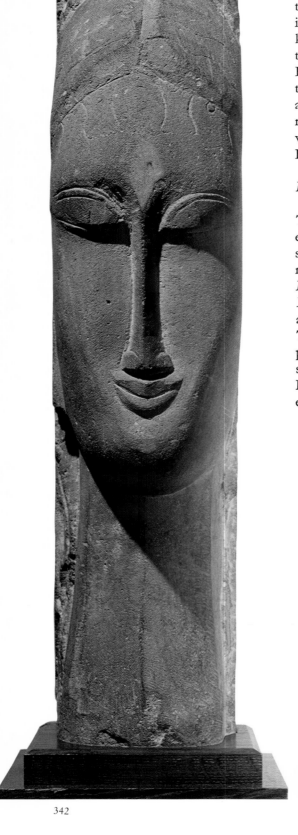

342

Social Realism and Mysticism

In the art of the last generation of the 19th century tensions occur: Social Realism and mysticism manifest themselves simultaneously. Both tendencies unite later in Expressionism. The work of Barlach, Kokoschka, Kircher and many others show this mixture. The artists of the Expressionistic generation express themselves in different ways; one as an independent artist, the other as a member of the organized groups, of which Die Brücke and Der Blaue Reiter are the best known.

Die Brücke

The artists society, Die Brücke was established in June 1905, by four students in architecture at the Technical High School of Dresden: *Ernst Ludwig Kirchner* (1880-1938), *Fritz Bleyl, Erich Heckel* (1883-1970) and *Karl Schmidt-Rottluff* (1884-). They had a common interest in painting. The first exhibitions of the small group took place just outside Dresden, but they aroused no interest. Kirchner drew up the program

343. Auguste Renoir, 1841-1919
The Washerwoman, *1917*
Museum of Modern Art, New York

343

342. Amedeo Modigliani, 1884-1920
Head of a Woman, *1912*
Limestone
228 *Musée d'Art Moderne, Paris*

345. Ludwig Mies van der Rohe,
1886-1969
Building in the
"Werkbundsiedlung", 1927
Weissenhof — Stuttgart

345

344. Paul Klee, 1879-1940
Jörg, 1924
Philadelphia Museum of Art

344

of Die Brücke and Schmidt-Rott-luff invited in February 1906, some kindred spirits to join them. As its name implies the union wanted to bring like-minded artists together. The most important artistic medium of "Die Brücke" was originally the graphic, particularly the wood-cut. Therefore the members were interested in what Munch and also Gauguin had brought about in this field. The great merit of Die Brücke was that it renewed graphic art in Germany and raised it to an independent artistic category. From 1906 on folders were issued yearly, with three pieces of work from members — etchings, lithos or wood-cuts.

The painting art of Die Brücke has its roots mainly, in an historical respect, in the work of Gauguin and Van Gogh, from which the French Fauves had learned a great deal. Die

229

346

346. Alexej von Jawlensky, 1864-1941
The White Feather, *1909*
Staatsgalerie, Stuttgart

Brücke and Les Fauves show resemblances at many points; they are parallel appearances, created from a related situation. In 1906 *Emil Nolde* (1867-1956) joined Die Brücke; although some years later he left. One of the most faithful members – until he was suspended in 1912 – was *Max Pechstein* (1881-1955). Lastly, *Otto Mueller* (1874-1930), who lived in Berlin, joined in 1910. Till that moment there was a great mutual resemblance between the pictures of Kirchner, Schmidt-Rottluff, Heckel and Pechstein. This does not apply to the graphic. In this the different temperaments appear more freely and spontaneously. Kirchner shows a clear preference for the wood-cut, with his typical angular forms, while Heckel uses the wood-cut as well as the lithograph as a medium. Also

with Heckel the forms have a striking angularity: they are loaded with a strong tension. Nolde appears strongest and best in etching and water-color, while Mueller chooses the color litho. Schmidt-Rottluff's preference also was lithography; Pechstein shows a much lesser preference for a definite technique.

Until 1910 the Dresden members of Die Brücke usually worked outside, at the lakes near Moritzburg and – alone or in pairs – on the northern coast of Germany. Heckel, who on an Italian trip came into contact with Etruscan plastics, started specializing in sculpture. The same inclination had already been shown by Kirchner. He had "discovered" negro plastics in the museum in Dresden, at the same time as De Vla-

minck and Derain made this "discovery" in Paris.

In 1908 Pechstein settled in Berlin; in 1910 he established, together with friends who lived there and some Brücke members of Dresden, a movement against the Sezession, that had refused to accept his paintings. To give Pechstein more support in this "Neue Sezession", Kirchner, Heckel and Schmidt-Rottluff settled down in Berlin. From that moment on the Brücke artists in Germany became popular; connections were made with other avant-garde formations. Typical "Grossstadt-Themen" appeared in the work of the artists; also subjects, from circus and variety. A more individual style was developing in the different oeuvres, though the mutual starting point was still recognizable until 1920. For the

230

347

348

231

349

349. *Henri Matisse, 1869-1954*
The Rumanian Blouse, *1940*
Musée d'Art Moderne, Paris

rest Die Brücke came to an earlier end; when Kirchner in 1913 made a chronicle of the union, trouble arose and the group broke up.

Expressionistic Sculpture

Ernst Barlach (1870-1938), like Emil Nolde, was born in Sleeswijk-Holstein. This northern German did not find his own style until he was 36 years old. Following a trip to Russia, the influence of the Russian spirit clearly appears. Barlach figures are, practically without exception, searching and striving, in spite of their massivity. They bow their bodies forwards in space, and seem to perceive its infinity. Also with *Wilhelm Lehmbruck* (1881-1919) this negation of rest.

In the *Kneeling figure*, Lehmbruck leaves the academic view; an internal force takes over the loyalty to the natural form. A spiritualizing occurs, with a quiet sheen of reflection bathing this picture.

Der Blaue Reiter

Die Brücke became less known outside Germany than Der Blaue Reiter. *Kandinsky*, *Jawlensky*, *Kubin*, *Marc* and *Klee*, who belonged to the Blaue Reiter, made an international name; in the work of the Blaue Reiter members, there are elements – particularly late cubistic – that made it more acceptable in the eyes of non-Germans. The artist society Der Blaue Reiter – called after a painting by Kandinsky – had its centre in Munich, that around the turn of the century was the centre of the German Jugendstil, another art that was mainly aimed at the ornamental. In 1896 *Wassily Kandinsky* settled down in Munich; almost at the same time as *Alexander von Jawlensky* and *Marianne von Weber* settled in this town. In 1898 *Alfred Kubin* and *Paul Klee* took up residence there. From 1900 on *Franz Marc* studied in Munich; at that time these artists were not yet aware of each other's

232

existance. They all painted in a more or less traditional way, through the influence of Cézanne, Gauguin and Van Gogh, but even more influenced by the Neo-Impressionism, whose work could be seen at exhibitions.

Jawlensky, Kandinsky and Marianne von Weber (von Werefkin) were all Russians. They brought with them their memories of colorful Russian art, abstract national art and church art. Kandinsky slowly became not only the theorist of Der Blaue Reiter but also one of the most influential personalities in modern painting.

The art of the Blaue Reiter group shows, as well as that of Die Brücke a clear preference for primitivism. But the demonic traits, so characteristic for Die Brücke, fall away. The tender, almost lyrical primi-

351

350

351. Maurice de Vlaminck, 1876-1958
Landscape with Red Trees, *1906*
Musée d'Art Moderne, Paris

350. André Derain, 1880-1954
Self-Portrait, *1904*
Private Collection

233

352

352. *Albert Marquet, 1875-1947*
Le Pont Neuf, *1906*
National Gallery of Art,
Washington D.C.

tivism of *Paul Klee* and *Heinrich Campendonck* distinguishes itself essentially from the barbarian primitivism of Nolde, Kirchner and Schmidt-Rottluff. Also the painters of Die Brücke strongly accentuate the social aspect of the art, the "human content", while the Blaue Reiter looks particularly for the romantic unification with nature and universe. The Blaue Reiter has no style unity and no organizing connection, but does have a program, while Die Brücke has no ideology, but stylistically shows a secretive, closed picture. In 1912 Paul Klee joined Der Blaue Reiter, the group was on its way to consolidate its basis when the war broke out and made an end to all the work. Kandinsky, as well as other Russians, had to leave Germany; *August Macke* was killed in 1914, Marc in 1916. Later in the "Bauhaus" in Weimar, Kandinsky, Klee and *Lyonel Feiniger* met each other again. The idea of Der Blaue Reiter continued to work in a changed form in Bauhaus.

Fauvism

The Expressionism that came into being in Germany owes a lot to Van Gogh; his work fulfils completely the aspirations of the generations after him; also in France Fauvism took examples from some paintings by Van Gogh. The canvas "Le Quatorze Juillet" stimulated the enthusiasm of painters like *Maurice de Vlaminck* (1876-1959) and *André Derain* (1880-1954). De Vlaminck established the *School of Chatou* that later became one of the embryonic cells of Fauvism.

The painting "Le Quatorze Juillet" was the precise example the Fauvists were looking for. Only instinct may lead to the expression of the experience: no deliberation, no considered compository conduct is allowed. No theory was the base of Fauvism; the movement appears from the more or less accidental conferences of painters with related opinions. This group first met on the occasion of the "Salon d'Automne" in 1905;

234

Henri Matisse was the assembly point. At the "Salon des Indépendants" in 1906 the same painters got together again. The group had not yet got a name, and it seems that the name "Fauves" appeared accidentally. In the room where the exhibits of these painters were hanging, there was a small bronze by the sculptor *Albert Marquet*, made in a pseudo-Florentine style. A critic, Louis Vauxcelles, is supposed to have called out: "Donatelli parmi les fauves" (amongst the wild animals). His words spread like wildfire through Paris, and afterwards was used generally to describe the group of wild-color painters.

Fauvism unfolded between the years 1905 and 1907 and covered three groups of different origin. The group that had left the studio of *Gustave Moreau* and the Académie Carrière (Albert Marquet, *Henri Manguin, Charles Camoin* and *Jean Puy*); the group of Chatou (Derain and De Vlaminck) and the group of painters from Le Havre *(Othon Friesz, Raoul Dufy* and *Georges Braque)*, and an independent person, namely *Kees van Dongen*, of Dutch origin. The dominating personality among them was Matisse, the oldest and most influential. Matisse, like *Georges Rouault*, came from the studio of Moreau, a teacher burning with enthusiasm and broad thinking. Under Moreau's supervision every pupil could freely develop his talents; he said of himself "I am the bridge over which some of you can reach the other side".

On the first exhibition Matisse, as well as Marquet, showed paintings worked with pure colors. This exhibition already failed, according to Marquet in 1901. In the same year Matisse and De Vlaminck met each other; De Vlaminck in particular gave himself up to a use of a riot of color. Under his influence Friesz and Dufy turned away from Impressionism. Finally Braque joined the group of the Fauves. When Matisse, Derain, Friesz, Dufy, Rouault, Puy, Manguin and *Louis Valtat* appeared together at the "Salon d'Automne" of 1905, they made an enormous sensation. In 1906 Van Dongen completed the hung works at the "Salon des Indépendants"; Fauvism triumphed.

Van Dongen left Holland around his twentieth year. He was born near Rotterdam, the son of a miller. In Paris he worked as a dock-hand in Les Halles; and he lived there in the "Bateau Lavoir" in Montmartre, before he settled down in Montparnasse. His strong and intense color use made a Fauve of him among the Fauvists. Fauvism shows, in France, a harmony of contradictions, which are difficult to imagine elsewhere; there is a balance of ordering and passion that will never be reached by followers.

The Germans seemed to be very

354. *Jacques Lipchitz, 1891*
Bather, *1915*
Bronze
*Collection Mrs. J. D. Rockefeller,
New York*

354

353

353. *Raoul Dufy, 1877-1953*
The Pier in Honfleur
Musée de l'Annonciade, St. Tropez

235

355

355. Georges Braque, 1882-1963
Still·Life with Guitar
Narodni Galerie, Prague

susceptible to the initiative of the Fauves. With a man like Franz Marc it is striking that in his work the dislike of the sensory perceptible reality concerns the color in advance. A series of paintings of Marc therefore is close to Fauvism, though he does not succeed in the end in remaining true to the artistic credo of Matisse. It is easier for another German: August Macke, who – like the Fauves – is in love with color. His color feeling is shown with women's clothes, shop-windows and cafés; the East gives him sun and variegation. Of all Germans Macke finds the purest and brightest color and also his form remains tight.

A Sensual Lived-Through World Picture

In Matisse, is the natural French harmonious unifying of life's fullness and tradition. He never looks for the psychic conflict, but a sensual lived-through world picture that is raised in colors to its heights; the split personality of the German, from which Expressionism was born, is strange to him. The object, with Matisse, occupies a subordinate place. Even his female figures usually perform an ornamental function without individual expression.

Maurice de Vlaminck (1876-1959) displays a feeling for the dramatic aspects of nature. Though he becomes a somewhat mannerist landscape painter later on, his best works differ from the Mediterranean paradises of Matisse by boorishness and worldly-mindedness; particularly the gloomy, dramatic winter landscapes. Also *Georges Rouault* (1871-1958) differs from the other Fauves; in his early and best work he penetrates with nearly fanatic intensity through to the morbid extremities of life. Rembrandt, Goya, Daumier – and to a certain extent Lautrec – are his examples. Later on, this realism yields to an almost icon-like severity in his paintings; in addition, the mobile, realistic aspect is lost to be

236

356. *Aristide Maillol, 1861-1944*
L'Ile-de-France, *1920-25*
Bronze
Musée d'Art Moderne, Paris

357. *Louis Valtat, 1869-1952*
Woman after the Bath, *1906*
Private Collection

357

358

358. Otto Dix, 1891-
Portrait of a Journalist,
Sylvia von Harden, *1926*
Musée d' Art Moderne, Paris

359

359. Kees van Dongen, 1877-1968
Portrait of Pierre Lafitte, *1919*
Stedelijk Museum, Amsterdam

replaced by a statue-like solemnity. In Fauvism, Kees van Dongen is one of the most brilliant and most authentic artists, being Fauve by origin, all he does is to deploy his own nature to paint as a Fauve. Fauvism could not persist as a movement for a long period; no later than in 1908 Cézanne's influence could be felt, and even De Vlaminck could not withdraw from it. *Othon Friesz* (1879-1949) dedicated himself to a conscientious interpretation of Cézanne; *André Derain* (1880-1954) and Georges Braque changed to Cubism; Van Dongen chose a mundane and fashionable style.

Amedeo Modigliani can neither be classified within Fauvism nor Expressionism. His art as well as his life deviate strongly from the usual. At the age of thirty-six he died an alcoholic, in the Charity Hospital in Paris. When the news was brought

to his girl-friend, she jumped out of a fifth storey window.

Modigliani combined what may be called an Italian feeling for the aestheticism of lines with a deformation which, in the male portraits, emphasizes the expression, and, in his female portraits, high-lighted their graciousness. There is a melancholic composure about most of his works; sometimes it gives their slightly manneristic beauty a touching effect.

The Sculptors of the "École de Paris"

Under the influence of, among others, *Constantin Brancusi*, Modigliani took to sculpture, and created similar deformations as in his paintings. By simplification and purification of the shapes he approached the works of *Raymond Duchamp-Villon* (1876-1918), who was under the influence of Cubism. In about 1910

238

Duchamp created works in which the bodies are dissected and fit into each other with mechanical precision, without any loss of delicacy of line and movement. His *Horse* from 1914 is the first creation in a totally new, depicting language. Strange, how the dynamic movement of Futurism, and the static principle of Cubism harmonize in the "Horse". Duchamp-Villon's early death stopped the further development of his oeuvre. While Brancusi, Duchamp, *Henri Laurens*, *Jacques Lipchitz* and others sought for a new, spatial effect, and for new, plastic effects, *Pierre Auguste Renoir* remained conservative in his *Washer woman*. His nature female figures convince through the calmness of shape and sturdiness, through their warm and sensitive humanity.

Jacques Lipchitz (1891-) worked in the style of analytical Cubism in 1913. His sculptures from that period show the mathematical earnestness, and the stress on the constructive element characteristic of Cubism. Although fragments of shapes indicate a visual origin, Lipchitz comes close to abstraction.

The New Realism (Neue Sachlichkeit)

Around 1920, when Expressionism was generally esteemed, there was still a reaction against the unrest and the imbalance of this trend. This movement announced itself in Germany as the Neue Sachlichkeit (New Realism), meaning another protest in a new form against the relations in that era; *Otto Dix, Georg Grosz* and *Max Beckmann* are the most famous artists of that group. In the Netherlands, with some restrictions, the Magic Realist *Pyke Koch* could be reckoned among them. His *Bertha of Antwerp* breathes a cynical sobriety that is characteristic of Dix' and Grosz' works. But Pyke Koch did not let himself go as far as to caricature, which Grosz quite often did. Consequently, there was no longer any room for Grosz in Hitler's Germany, and he emigrated to America.

360. Kees van Dongen, 1877-1968
Women near the Balustrade, *1911*
Musée de l'Annonciade, St. Tropez

360

Max Beckmann's work (1884-1950) achieved growing importance during the years. He was a lonely man, and he had neither contacts with the Dresden painters in the years of Die Brücke, nor with those at Munich at the time of Der Blaue Reiter. He lived in Berlin until 1933. Stamped as a depraved artist, Beckmann left Germany to live in the Netherlands, where he remained just as lonely as before.

In 1947 he accepted an invitation to America, where he made a rapid career, but he did not enjoy it for long, and died in 1950 in New York. Max Beckmann created an oeuvre which is unique in its combination of great creative power and meaningful subjects. His paintings by their clean but heavy contours, their bright colors reduced their forms to the essence. His main subjects are the great cities, the cabaret, the masked ball, the carnival. To Max Beckmann the world was a stage, a cruel stage with now and then a little humor, but above all difficult, if not tragic.

The Bauhaus and Architecture

In 1918 *Walter Gropius* was designated successor to Henry van de Velde, as the director of the Weimar academy; he started to substitute the conventional teaching system of that time by a national house of architecture, the Bauhaus. Gropius intended to restore the unity of the arts under the supremacy of architecture. His appeal brought a number of prominent artists together, *Lyonel Feininger*, collaborator from 1919 to 1933, *Gerhard Marcks* (1919-1924), *Paul Klee* (1920-1929), *Oskar Schlemmer*

361. George Grosz, 1893-1959
Beauty, I cherish you, *1919*
Private Collection

361

240

363. *Max Beckmann, 1884-1950*
Self-portrait in front of easel, *1945*
Institute of Arts, Detroit
(gift Robert H. Tannahill)

363

362

362. *Miroslav Kraljevic,*
Luxemburg Parc, *1912*
Moderna Galerija, Zagreb

(1921-1929), *Wassily Kandinsky* (1922-1932), *Laszlo Moholy-Nagy* (1923-1928); further *Georg Muche*, later *Herbert Bayer* and others.

A synthesis of the creative arts was the ideal of many great 20th century architects: Walter Gropius (1883-), *Mies van der Rohe* (1886-1969) and *Le Corbusier* (1887-1965). The "Werkbundsiedlung" of Mies van der Rohe from 1927 gives evidence of that aspiration for a "Gesamtkunstwerk", and the Bauhaus has the same basis as the ideal of *Theo van Doesburg* and other members of *De Stijl*. The Bauhaus became the symbol of all that is creative and constructive in a time of economic and political disorder; it remained that symbol even after its decline. Soon after its dissolution in 1933, due to Hitler's cultural politics, the Bauhaus collaborators spread all over the world and achieved greater results in the realization of their ideas than they could ever have expected to get in Germany.

241

364

364. Oskar Schlemmer, 1888-1943
Group of Fifteen
Stedelijk Museum, Amsterdam

Cubism

The start of Cubism as a movement is generally considered to have taken place simultaneously with the creation of Picasso's painting "Les Demoiselles d'Avignon". Picasso began this painting in the spring of 1907, after numerous studies. It would, however, be unjust to reduce the development of Cubism exclusively to Picasso's influence. Several landscapes by Braque, painted in the summer of 1908 in L'Estaque hint at landscapes that Picasso was to paint in the summer of 1909 in Horta de Ebro.

Besides Picasso and Braque, *Juan Gris* and *Fernand Léger* can be named as independent artists, if not as equals. In 1908 at Montmartre, No. 13 Rue Ravignan, the famous group of "Bateau-Lavoir" was formed. In this house there lived with Picasso: Max Jacob, and Juan Gris the artists Apollinaire, Salmon, Raynal, and

Gertrude Stein. To Braque, who used to adhere to Fauvism, color was inferior to shape; Picasso, a born draftsman, only emphasized the colors in the beginning. Both men strove towards a completely new concept for painting. They had a picture in mind that did not copy nature, and did not simulate space, which would certainly be in discordance with the two-dimensionality of the canvas. In this branch of Cubism, prepared by Cézanne, and brought into existance by Picasso and Braque since 1907-1908, the external proportions are determined by the relations of the color areas among each other. The skin, or

365. Pablo Picasso, 1881-1973
Artists, *1902-05*
Staatsgalerie, Stuttgart

365

366

366. Pablo Picasso, 1881-1973
Portrait of the Art-dealer Vollard,
1910
244 *Ermitage, Leningrad*

contour, extends around related, universal shapes, to which the actual shapes can be reduced: ball, cylinder, cone. It is an art of pure harmony of shapes, of reason against the passion of Fauvism.

The most convenient motives for this experiment turned out to be rather limited in number: trees, houses, fruit bowls, bottles, and glasses were the most frequent objects in the beginning, some time later also guitars and musical instruments, that is to say, objects that could be recognized after their transformation in the painting, due to their simple, geometrical structure. In 1910 Braque started to paint figures and still life instead of landscapes. Symptomatic of this second

367. Pablo Picasso, 1881-1973
Portrait of a Woman, 1942
Thompson Collection, USA

367

phase of Cubism was the simultaneity of different aspects in one object. To avoid too much abstraction in the paintings, Picasso and Braque introduced, in 1912, the "papiers collés", in the painting surface; pieces from newspapers and fabrics, glass, and sand.

The latest, synthetic phase of Cubism started in 1913; among those who had an important part in this development were Juan Gris, and Fernand Léger. In Léger's work, Cubist elements were present in 1910, but he had hardly ever participated in analytical experiments, probably because the tendency of those years were in contrast with his inclination towards a monumental and voluminous style. In 1911, Juan Gris, too, started painting in the style of analytic Cubism. He had a decisive part in the change towards the synthetic Cubism in 1913, along with Braque and Picasso. The areas in the paintings became larger, the blendings became less distinct. Cubism ceased to be an experiment. It became a rightful, creative language of art in which the complex and abstract way of thinking of the century was manifested.

Braque developed parallel to Picasso until the outbreak of World War I. After the war, Braque retained his style where he had left it, and consolidated the position he had reached. His geometric idiom changed but slowly; it was replaced by freer, rounder forms. The *Still Life with Fruit Bowl* from 1930 is typical of this.

From 1909 onwards, other artists joined the Cubist movement; in 1910 *Roger de La Fresnaye* (1885-1925), *Louis Marcoussis* (1883-1941), and the three brothers Duchamp, of whom one called himself *Jacques Villon. Raymond Duchamp-Villon* contributed the most important sculptural item to Cubism; the *Athlete* from 1914 did not quite have the

368. Georges Braque, 1882-1963
The Harbour of Antwerp, *1905*
Private Collection, Switzerland

368

369

370

370. *Auguste Perret, 1874-1954*
Théatre des Champs-Elysée,
1910-13
Paris

247

371

371. Juan Gris, 1887-1927
Still Life on a Table, *1916*
Collection Rolf Bürgi, Belp

same importance as the *Horse* from the same year, but it gives a good impression of the versatility of this artist's designing capacity.

Futurism

Futurism arose in Italy, and distinguished itself from the more static Cubism by its dynamic character. Among the Futurists were men like *Carlo Carrà, Umberto Boccioni* – a sculptor – and *Luigi Russolo;* the

poet Marinetti was also a member of that group. When the first exhibition took place in February, 1912 in Paris, it became clear that the Futurist style had to be recognized as an attempt to add a dynamic element to the Cubist manner of composition.

Carrà specialized in the gray tints used by the French Cubists. Boccioni, the theorist of this movement, kept an eye on Picasso's "realism" which was present even in his Cubist

372

372. *Fernand Léger, 1881-1955*
Two Woman and a Still Life, *1920*
Von der Heydt Museum, Wuppertal

373. *Raymond Duchamp-Villon,*
1876-1918
The Athlete, *1910*
Bronze
Musée d'Art Moderne, Paris

374. *Roger de La Fresnaye, 1885-1925*
The Architect, *1923*
Musée d'Art Moderne, Paris

374

373

375

375. *Gino Severini, 1883-1966*
The Dancers, *1912*
Collection Mattioli, Milan

377

377. *Pablo Gargallo, 1881-1934*
The Prophet, *1933*
Iron
Musée d'Art Moderne, Paris

376

376. *Gerrit Thomas Rietveld,*
1888-1964
Private House Schröder, *1924*
Utrecht

379

378. Piet Mondriaan, 1972-1944
Composition in Squares
Private Collection New York

378

compositions. In Russolo's works, the Surrealism of the future announced itself. Particularly Gino Severini, who remained faithful to Seurat's colors, contributed decisively to the exhibition of 1912.

Futurist works of art appeared most times to be a summary of visual impression. A horse was painted with some twenty legs, and a night club turned into a kaleidoscope of fragments.

Umberto Boccioni (1882-1916) had changed from painting to sculpture. His "Shapes continued in Space" (1913) was the beginning, testifying to his immense talent. *Gino Severini* (1883-1966) created his famous dance scenes in 1912, turned to classicism during World War I, and changed over to a decorative Cubism in later years. Carlo Carrà painted the "Rattling Carriage", a programmatic painting; his essential works, however, were not made until he had founded the "School of Metaphysics" together with De Chirico in Ferrara. The "Horseback Rider" dates from

that time, 1917. In the circle of the "Pittura Metafysica" *Giorgio de Chirico* was without doubt the great virtuoso, but he actually had little or nothing to do with Futurism.

Transition towards Abstraction

In France, Braque started to paint in a manner that was a synthesis of all previous experiments; Juan Gris, the youngest of the Cubists, died at forty. His work is more limited than Picasso's, but it has a clear, personal mark. In 1912, *Piet Mondriaan* (1872-1944) joined the group of Cubists. His commitment to the group remained superficial. To appreciate Mondriaan's personality and work it is necessary to know his origin. He was the son of a Calvanist

teacher who was a friend of Abraham Kuyper. Even at the age of twenty-seven, his thoughts wandered between the desire for independence, and a strong commitment to the Calvanist background. He was quite impressed with the works of Krishnamurti and Rudolf Steiner.

Soon Mondriaan developed the abstraction – which in principle was present in Cubism – to a logical climax. Still influenced by Cubism, he painted a series of trees, in which he re-used that same tree in a more and more abstract view: he started off with the figurative, but he ended up with a sort of tree symbol, offering hardly any figurative clues. Around 1915 he reached the point where his paintings merely consisted of rhythms of horizontal and vertical

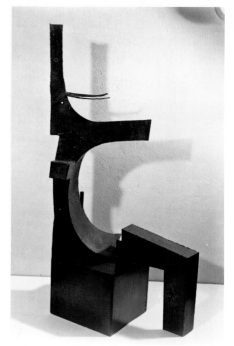

381

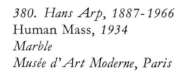

380. *Hans Arp, 1887-1966*
Human Mass, *1934*
Marble
Musée d'Art Moderne, Paris

381. *Julio Gonzalez, 1876-1942*
Sitting Woman, *1935*
Iron
Collection Mme Roberta Gonzalez, Paris

380

382

382. *Ben Nicholson, 1894-*
Kerrowe, 1953
Private Collection, Paris

383. *J. A. Brinkman and*
L. C. van der Vlugt,
Van Nelle Factory, 1928
Rotterdam

383

253

384

384. *Joan Miro, 1893-*
Man, Dog and Sun, *1949*
Emanuel Hoffman Stiftung

385

385. *Kasimir Malevich, 1878-1935*
Eight Red Rectangles, *before 1915*
Stedelijk Museum, Amsterdam

lines. His categorical nature, combined with his passionate search for the plastic equivalent of a universal truth, make Mondriaan one of the dominating figures in the 20th century art world. His concepts strongly influenced architectural and interior design, as can be seen in the *Schröder house* by the De Stijl architect *Gerrit Thomas Rietveld* in 1924, and artists such as Ben Nicholson, Léger and Max Bill. In September 1940 Mondriaan moved to New York, where he eventually eliminated black from his works. The canvas "New York City" contains only yellow, red and blue lines. Cubism also backed up the artists revolution in Russia during the twenties. *Kasimir Malevitch* (1878-

1935) was the founder of Russian Constructivism. *Antoine Pevsner* (1886-) and *Naum Gabo* (1890-) developed into constructivist sculptors in Paris. The Spaniard *Julio Gonzalez* (1876-1942) worked also in Paris, and, like Lipchitz, he started from the transformation of a natural impression, and not exclusively from an independent construction in space. Gonzalez, being painter and sculptor, did not find his personal style until the age of fifty-one. He turned away from painting and dedicated himself completely to sculpture. But he encountered problems with volume. He was willing to delineate it, but, as he put it, without the lump heaviness of a mass. From this pursuit his transparent

254

sculptures arose, and abstraction was inevitable.

After 1932, the solidity returned: the shape once again resembled the natural appearance, the human body, the expression; this development is evident in *Sitting Woman* from 1935.

De Stijl and Architecture

Besides Rietveld, other architects were under the influence of the ideas living in the De Stijl group. Oud and Dudok gave proof of the capacity of living of the Stijl attitudes in architectural aspects. Both knew just as Rietveld did – how to avoid a doctrinary freezing, and to retain their candor. The New Realism in architecture continued the Stijl tradition; the *factory of Van Nelle* at Rotterdam, in 1924 by *J. A. Brinkman* and *L. C. Van der Vlugt*, was an

387. Krsto Hegedusic, 1901-
The Court-Yard, *1958*
Muzej Grada Beograda, Beograd

387

386. Giorgio de Chirico, 1888-
Piazza d'Italia, *1912*
Collection Jesi, Milan

386

255

388

389

important step in the acceptance of this new architecture. The amazing thing about this factory building is the fact that even today it does not appear outdated.

Sunday Painters

On the edge of what may be called the official art of painting, the 20th century recognizes the Naive painters, those who, through spontaneity or unskilfulness, care little about style or artistic problems, about anatomy or the laws of perspective. Their use of colors is marked by the unblended paints out of the tubes. In France, *Séraphine de Senlis, André Bauchant, Camille Bombois, Louis Vivin*, and numerous others reached fame; this phenomenon of the Naives, or "Sunday painters", was not restricted to France. In Poland, *Teofil Ociepka* and *Nikifor* appeared, in America *Grandma Moses* became well-known, and there is the discovery of *Morris Hirshfield*. One of the most fascinating contributions came from Jugoslavia, by figures such as *Ivan Generalić* and *Ivan Rabuzin*. In that country, the genre

*389. Man Ray, 1890-
Dada, 1916
Private Collection*

256

390

390. *Salvador Dali, 1904*
The Temptation of St. Antony, *1946*
Private Collection, Brussels

accrued a degree of importance which far exceeds that of an interesting curiosity. Generalić's way of painting shows a pictorial capacity which is, not in this case, the outcome of a pictorial erudition, but which is very far from clumsiness. A Brueghelesque approach to persons and landscape is exhibited and is manifested in an oeuvre combining authenticity with poetry. Thanks mainly to the efforts of Otto Bihalji-Merin, naive art in general, and that of his home country in particular, gained the reputation and recognition which it deserves.

Surrealism

The last, great, international movement before World War II was Surrealism, in which the aspects of form were not of paramount importance, as in Cubism, but a new content, namely life as it arises out of the subconscious: the miracle, the dream, the hullabaloo of associations, and of make-believe contradictions and coincidences, of forgotten and inhibited inclinations.

Hans Arp spoke of "an order by the laws of coincidence"; *Salvador Dali* of "dream photographs", Klee of a "central organ of all motion, whether it is called brains or heart of creation".

In his first manifesto, Breton defined the Surrealistic manner of painting as a pure psychic automatism, by which one can express the factual working of thinking, orally, in writing, or in another way, and as a dictate of thoughts, without any control by reason, free of aesthetic or moral prejudice. The Surrealist artist strives to free himself from the constricting intellect, which has a traditional, prescribed way of working, and which is trained to think in a certain categorical and causal manner. When he listens to the automatic dictate he is introvert; logic is eliminated, the process of achieving a generally accepted result is inverted, the ultimate power of the causal system is abolished.

So it is obvious that Surrealism in the first place means the disclosure of a new land: the unconscious. Surrealists time and again

257

391

391. *Hans Arp, 1887-1966*
The Watch, *1924*
Private Collection, Liège

paid reverence to Sigmund Freud. The dream is one of the recognitions Surrealism claims for itself: the dream with its absurd encounters. metamorphoses, and paradoxical combinations. The dream is judged to have the same or even stronger rights than the waking state: the sum of the instants of a dream makes the reality, which is considered of more essential value than those moments when one is awake.

As can be seen in the works of Dali, *Yves Tanguy, René Magritte* and *Paul Delvaux,* Surrealism uses the media that served Realism. In their painting everything can be recognized, all objects can be named. But the known objects are confronted with one another in a way that is strange to everyday reality.

The probing into Surrealism by the different artists who had direct or indirect connections with this movement resulted in an elaboration proper to their characters and special gifts. In his first period De Chirico discovered the secret, driving powers of the metaphysical fear. Hans Arp made strange life grow among dead objects. In his paintings, *Max Ernst* added elements to reality born

out of hallucinations. *Joan Miró* created a universe filled with tokens of symbolic significance. *André Masson* depicted the endless struggle of life and death in ourselves and all matter. Yves Tanguy tried to seek out mystery in the endlessness of strange landscapes. Dali erected a metaphysical universe of feverish visions and fearful psychoses. Magritte reached his effects by confronting realistically painted elements. Delvaux created a world in which a certain type of woman appears naked or almost naked in surroundings where her appearance causes a distortion of reality. Others, as for instance *Felix Labisse,* combined erotic obsession with hallucinating effects, born out of the colors, which impart a seductive and at the same time shocking delight.

Ban on the Object

The time between the World Wars is marked by the world of shapes by Picasso, ending all idyllic beauty, the ruthlessness of Beckmann, the absurdity of Dali; the torment of Soutine, the chill serenity of Mondriaan, and the abstraction solidified

258

392

393. *René Magritte, 1898-1967*
The Red Model, *ca 1936*
The Edward James Foundation

393

394

394. *Paul Delvaux, 1897-*
The Red Town, *1944*
Private Collection

to schematicism by Kandinsky.

This enumeration needs rounding off with the poetry of Klee who fell back upon the inner self; the dialogue with an unendurable reality *Oskar Kokoschka*, and the disclosure of solitariness in contemplation of objects by *Giorgio Morandi*. If reality was retained in the paintings, it was a strange one. Abstraction, however, especially after 1945, led the way. The change that was partly announced in the first half of this century, partly realized, became an accomplished fact. Instead of the reproducing picture there is the evocating picture. This compels one to find new means of expression. Thus the painter's studio was changed into a laboratory where new, creative means were sought.

Consequently, the artist's work assumed a distinctly experimental character; the acceptance of the experiment could even go so far that the execution itself assumed an experimental, coincidental character. This brought about a total change of appearance to the painting. The complexity of the technical world replaced the shapes of the organic nature. New, optical sensations, the view from a plane, an express train, or car, resulted in illustrations that lack the static-naturalistic element. The Futurists had already foreseen this change; but it will take a few decades before the dynamics of the

modern world finds adequate expression.

The relations between man and nature, between the ego and the world will find an outcome in the sciences, and throw a shadow, mostly forward, in art.

The bonds between the tendencies in 20th century art and the evolutions in other sections of life is evident. To deny it would be equally nonsensical as the attempt to interpret each historic development as a progress. The ways in which we think we see a development occur, can in later times prove to be unimportant secondary roads.

We got the impression, as early as the late forties, that we move in an endless succession of revolutions. The revolutionary character of these maybe illusive revolutions is uncertain. Even less certain is that the future of the creative arts will profit from the result of these revolutions. If the first half of the 20th century aroused the expectation that a friendly developing mankind was to find its style of living and its expression, in accordance with a respectability inherent in social progress, then the second half will leave very little of that expectation. But who knows whether all that was created in the studios of painters, sculptors, and architects will not carry the hardly perceptive elements of what will become the style of this century.

261

Between Language and Symbol

The Second Half of the 20th Century

Painting during the first half of the 20th century was dominated bij *Pablo Picasso*. After 1945 the Spaniard still overshadowed a great deal of the artistic "happenings". Many followed, but few succeeded in freeing themselves from an idiom that was clearly created by Picasso for his own use. His obviously compelling influence made itself felt as far as the United States; look for example at the early work of Jackson Pollock. A still figurative expressionism shows with, amongst others, Minaux, Lorjou and André Marchand. Certain painting traditions are maintained, but they are mixed with modern elements, derived largely from Picasso.

Paris after World War II

Jean Dubuffet (1901-) was an artist with his own style; a most striking one, too. He not only freed himself from Picasso, he also escaped the influence of the experiments from the first half of the century. He made a step forward. Dubuffet's art is free of all cultural association, it is not related in any way to what was considered as characteristic of painting up to his time. He looked for a new primitivism – and in this respect he comes closest to the Surrealists – to give expression to an experience of

395. Jean Dubuffet, 1901-
Road with Figures, *1944*
Private Collection

396. *Constantin Brancusi, 1876-1957*
The Seal, *1943*
Marble
Musée d'Art Moderne, Paris

reality that is not passed through the cultural filter to produce a one-sided vision.

The art of children and lunatics is close to his; he does not look for outward resemblance, but for an "image" that registers an inward experience, a psychic fact. The *Road with Figures* from Dubuffet's early period (1944) is a good example of that attitude; it gives more the impression of a drawing from a half-grown person, of a child, who has not yet developed a way of seeing and expressing things.

The "Art Brut" claimed by Dubuffet – for himself and for others, like Chaïssac ,discovered by him, stimulated or recognized, – becomes an aspect of post-war art that offers, at least, the advantages of originality and uniqueness.

Changing Reputations

From all that was enacted in France between 1900 and 1940 not everything kept the value it had before the war. But some artists rose in value in the eyes of the artists who came after. For example Piet Mondriaan and *Constantin Brancusi*. The large group classified under the *École de Paris;* – Chagall, Modigliani, Soutine, Pascin, Kisling, Derain, Vlaminck and others like the Japanese Foujita – got some official appreciation, but was partly relegated to oblivion by the impetuous vortex of new art forms. Perhaps wrongly. The final judgement is, of course, reserved for later generations.

A New Sculpture

The aforementioned Brancusi was a man who led a withdrawn life. He worked in loneliness in his studio, lived like a simple peasant, even like a monk. The starting point of his development is the *Sleeping Muse* from 1910. This egg-formed plastic pos-

396

397

397. *Constantin Brancusi, 1876t 1957*
Sleeping Muse, *1909-10*
Bronze
Musée d'Art Moderne, Paris

263

398. *Pablo Picasso, 1881-1973*
Man with a Sheep, 1944
Bronze
Vallauris

sesses in construction the whole work, essentially unaltered, but becoming more comprehensive. His strivings aim at a purifying of everything that only accidentally belongs to the work, that is bound to the moment and flowing past, thus not strictly necessary. *The Seal* is a good example of it; the descriptive, the anecdotical is banished; all that remains is the long-drawn form that is characteristic of the animal.

Picasso's sculpture of a *Man with a Sheep* made one year later, distinguishes itself clearly from Brancusi's purism. With Picasso the need to escape from the descriptive, from the detail, fails completely; a strong anecdotic element is consciously kept. The "Man with a Sheep" is not fully representative of Picasso's work as a sculptor; during his life he made a lot of sculptures and applies a broad gamma of form treatments. Just as many non-descriptive, pure forms are presented as works with a recognizable form.

The First of the "Action Painters"

Apart from Dubuffet, independent from but, equal to him in significance and influence, stands the German painter *Wolfgang Schulze*, who signed with *Wols*. He was a difficult-to-place person, who – working in a desolate farm in the French Ardêche – created his oeuvre in silence and loneliness, protected against the encroachment of reality by continuous drinking.

Born in 1913, died in 1951, he first came into contact with the Surrealistic movement, a contact that is evident from his work up to 1940. During the war Wols disappeared; as a German he was compelled to find a safe place. He was missing from the artistic scene in general. Lack of funds but, also some natural inclination, compelled him to use the pen, water paint and paper. He painted many water-colors of a small insignificant size, nothing more than the crystallization of an inner situation. Wols then gave up dialogue with the outside world.

He held a conversation with himself and its result was contained in the

398

400. *Wols,*
Wolfgang Schulze
1913-1951
Composition
Musée d'Art Moderne, Paris

399. Germaine Richier, 1904-1959
The Storm, *1947-48*
Bronze
Musée d'Art Moderne, Paris

399

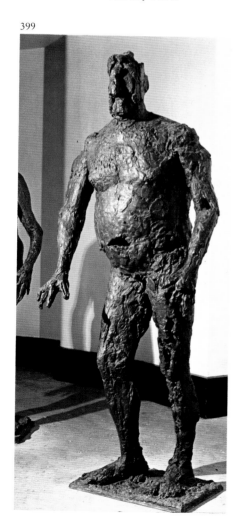

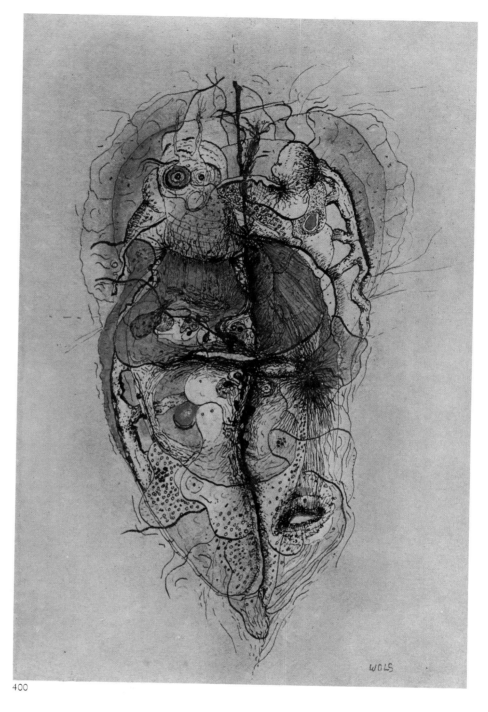

400

movement of his pen, in the gesture of his brush. In the course of time every recognizable, and even associable form disappeared from his water-colors; his handwriting – you could say – was enough in itself.

Wols painted the painting, without being consciously involved in the action. But he did not consider his work as a pastime: he only existed in – and thanks to – the painting. Painting was his breathing, his heart-beat and his gesture. Without realizing it, Wols introduced what is now called Action Painting. His lyrical abstraction was a prelude to an international tendency which reached over the whole world.

Soon after the war Wols was accepted, although only in a small circle; real success never really came,

however, some writers and painters realized the importance of his work. He moved on – stimulated by the art trade – to oil painting, but this medium was not for him. The vibrations he records are too subtle for the heavy matter of oil paint, and to appreciate Wols, it is better to limit oneself to his water-colors.

Aspects of Sculpture in Europe

Surrealism for Wols only had an importance in so far as it stimulated his orientation; probably one could say the same of the sculptor *Germaine Richier* (1904-1959). With *Alberto Giacometti* – also out of the surrealistic corner – she was closely related to the external and to the model of her work, and incidentally also

265

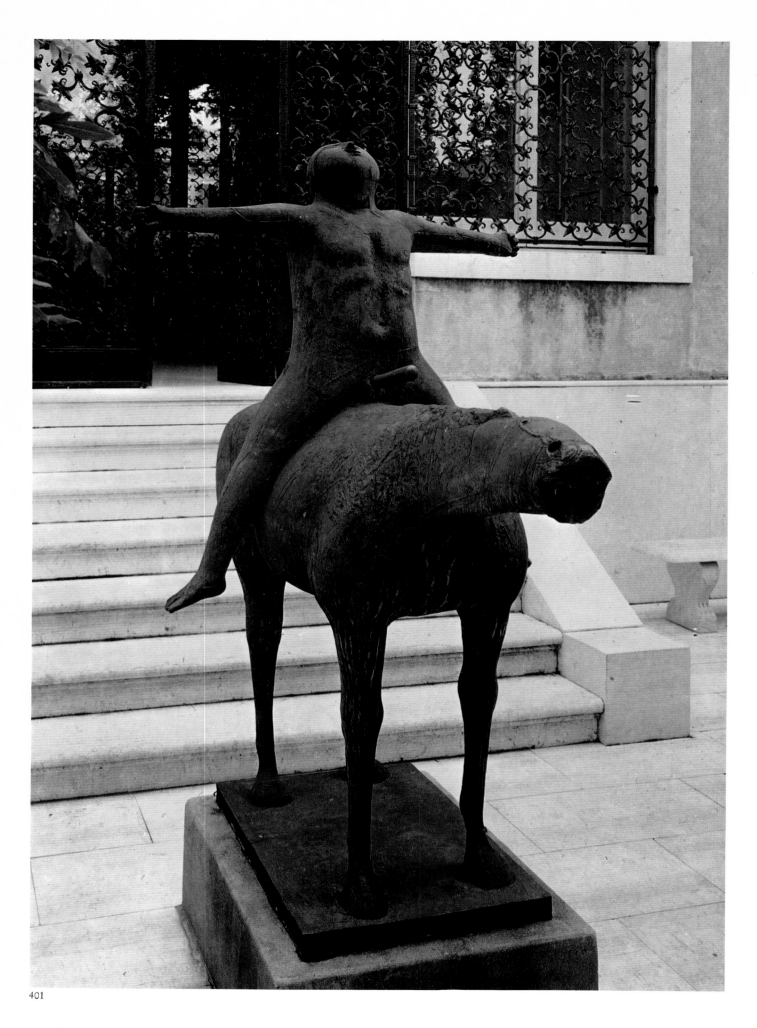

401

401. *Marino Marini, 1901-*
The Angel of the Town, *1949*
Bronze
Collection Peggy Guggenheim, Venice

to her training (the studio of Bourdelle). She dedicated her sculpture to the metamorphosis; giving duration to the nascent. The forms, held in their nascent, rather massive, partly torn open, seem to indicate a homesickness for another element. In the form, the movement is expressed, the always changing, often with threatening aspects.

Her works are, if one understands the nuance of this double negation, not non-figurative; even if they bear names like "The Town" or "The Storm", they are lived in human figures. The impression of a constant changing, flowing form, of a continuing metamorphosis, is reached by her, splitting the surface in such a way that it is as if the flesh drips from the bones. The skin of her figures is decaying.

Was it her intention to express existential alienation (something like Kafka's "Verwandlung") the degeneration of the humane to the bestial? It must remain an open question whether this work belongs more in the literal-associative area or in the plastic-sculptural.

Italy

With *Marino Marini* there is undoubtedly an association with an ideal interpretable background, yet it seldom intrudes. Marini himself accepts completely that his figures are also fancies. He always shows extreme reserve with the non-figurative. When asked for the perspectives of it he gave the answer "I do not attack abstraction, but consider it as the expression of an intellectual art (di un "arte cerebrale"). No artwork can exist that typifies both methods of expression: the real and the abstract. When both melt together in unity, they produce life. That is art."

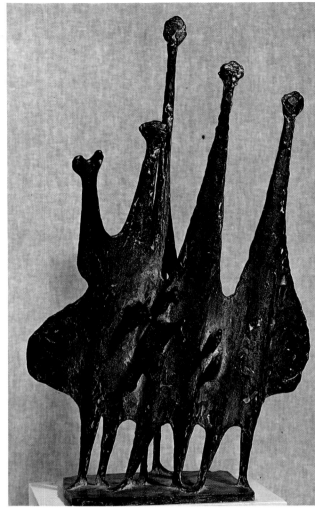

403

403. *Kenneth Armitage, 1906-*
People in the Wind, *1950*
Bronze
Tate Gallery, London

402

402. *Nicolas de Staël, 1914-1955*
Heaven in Honfleur, *1952*
Private Collection

267

404

404. *Jean Fautrier, 1898-1964*
Nude, *1958*
Collection Montaigu, Paris

About 1937 Marini created his first "Horseman", a quiet and controlled figure. This was the beginning of a long series of variations on the same theme. After Marini's Tuscan war experiences the restfulness was replaced by a nervous unrest. The heads of the horses become more drawn out and tensioned. In pictures from 1951-1952 the movement is suddenly set as if they continue to vibrate: the horseman tumbles backwards. A few years later the horse is deformed and becomes a frightening sign, a tense, trembling arabesque that stands up like a sign of destiny.

Marini's evolution in the expressionistic direction is attended with a geometric element that stands out. This prevents his expressive work losing plastic qualities. Abstraction and expression are, fortunately, well balanced.

England

In England at the beginning of this century, *Jacob Epstein* ushered in the revival of sculpture. As a portraitist he was a virtuoso, who perpetuates accurately in bronze the face, character and traits of his models, mostly

famous contemporaries. In addition he gives a personal view in his bigger sculptures that – unconventional in their expressionistic form language and in their ignoring of the taboo of the English decencies – originally caused sensation and scandal before being recognized as real artworks, in which life is strongly present, even if pathetically.

Epstein has written about his career in a very readable way and gives a clear survey of the obstacles that the English "Establishment" tried to place in his way. The first edition of the book, that later on was republished, bore the significant title: "Let there be Sculpture".

After him comes *Henry Moore* who no longer had to contend with such obstacles. Moore draws in his form language a remarkable, strong personal consequence, out of modern art ideas and the primitive strength of that form language has attracted the attention of the whole world. Of his own position in art, Moore declared in 1934 that he does not look for beauty of form, at least, not in the sense that the artists of ancient Greece or the Renaissance gave to that idea. What weighs more heavily for him

405

405. *Alberto Burri, 1915*
Red Plastic Burning, *1957*
Collection Henry Markus, Chicago

406

406. *Antonio Tapies, 1923*
Brown and Ochre
Collection Henry Markus, Chicago

407. *Le Corbusier (Charles Edouard Jeanneret) 1887-1965*
The Chapel Notre-Dame-du-Haut,
1950-55
Ronchamp

than the external beauty of form in the artwork, according to Moore, is the expressiveness, with which the artwork typifies the spiritual vitality of the artist. With that conviction Moore gives his statues an expressiveness that starts absolutely from the sculpture itself and is subordinate to the character of the material.

In that way, in fact, he starts at the beginning of all sculptures; if he works in stone, he wants the form that he creates to be real stone, in its full heaviness and compactness. Only when he has learned to give compact forms their full existence, does he allow them to rise up out of their base and starts breaking them open, until the space, enclosed in the carved cavity, is as important as the mass enclosing this space.

With Moore the more figurative periods relieve each other with non-figurative orientations; with Chadwick and Armitage, there prevails an unspokeness that becomes a mark or style.

In the early work of *Kenneth Armitage* (1906-) reminiscences of Moore's work still play a role. Under the influence of *Lynn Chadwick*, Armitage comes later to a bat-like style, but in the second half of the Fifties he frees

himself of imitation. He creates – like in *People in the Wind* – a rhythmic contra-pointed working of horizontals and verticals on one side, and of global forms and prickly limbs.

A Grandiose End, No New Beginning

The problem, figurative/non-figurative, is probably an unreal one; perhaps it is seldom approached clearly. As soon as the putative or real contradiction is really lived through, it takes, as it did in the case of *Nicolas de Staël*, tragic proportions. De Staël was born in St. Petersburg, as a son of General Vladimir Ivanovitch de Staël-Holstein and a young Russian woman, whose artistic temperament contrasted with the soldierly, severe character of her husband. The Revolution of 1917 forced the family to flee from Russia and to settle down in Poland. In 1937 De Staël moved to Paris.

His oeuvre is both the monument of a great master, and of an artistic failure. His work from the second half of the Forties and early Fifties probably still contains some points of contact with a visual experienced reality. In the execution however, the

407

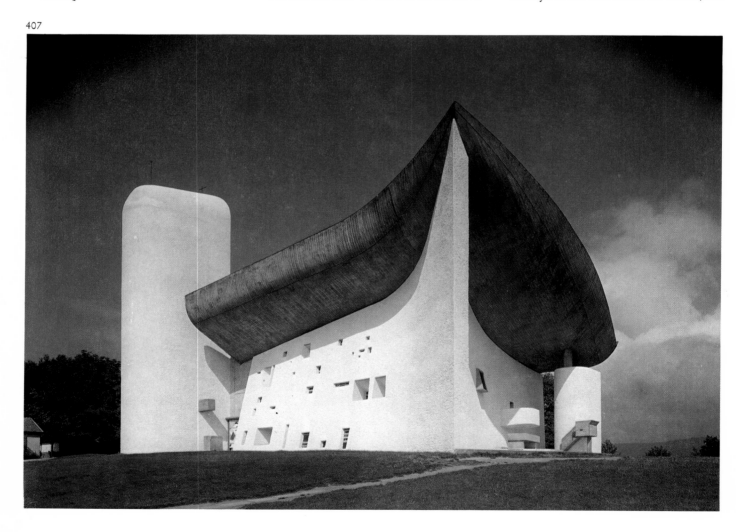

270

408

408. *Maria Helena Vieira da Silva,*
1908-
The Lost Road, *1960*
Galerie Jeanne Bucher, Paris

painter shows a rather light-hearted-ness towards what still could be called the "subject". In time his compositions became completely non-figurative. But, in the "Football Players" for example from 1952 he returns to the subject, though reducing it to abstract compositional elements; the same goes for his landscapes, like the *Heaven in Honfleur* from 1952. This reduction to monumentally set imposingly observed and grandiosely built color symphonies, leading for a certain time to strong paintings, after which the previous problem reappears.

A late painting like the "Piano" from 1955 demonstrates that, with his intention to avoid the anecdotical, the search for reality cannot find a place any more in the painting. It is relevant to consider whether this impasse did not contribute to De Staël's eventual suicide.

The Informals

Also with *Jean Fautrier* (1898-1964) a related research between figuration and abstraction can be found. But about 1945 he left the figurative, and passed on to a painting technique, which brought him – with Wols and contemporaries – near to the *Art Informal*. With this he found a working method which characterizes itself by a very personal use of the materials and is obviously suitable to express deeply-realized psychical experiences.

Alberto Burri (1915-) has the same working method as Fautrier. He also tries to lead the matter to speak without the roundabout way of paintings. He attains with this "method" an enrichment of the non-figurative idiom, analogous to that of *Antonio Tapiès* (1923-) in Spain. His concrete (in the sense of determined by the matter) art con-

409

409. *Georges Mathieu, 1921-*
Olivier III Beheaded, *1958*
Galerie Rive Droite, Paris

tains a protest against the intellectualities in the polished world of chromium, plastic and concrete.

His art offers the mystery of bark and crust, of earth and grain, of weathering and decomposition, of the not-yet-spoiled by "form", of the not-yet-denaturated by the hand of man, as a last recourse to nature in primitive times, away from the world, in which everything is subordinated to the human intellect.

A Still Euclidical World: Le Corbusier

The architecture of *Le Corbusier* belongs in that respect to the contra-world of Burri and Tapiès; it is one of concrete and of accomplished form, at least, as far as his early work is concerned, that still completely belongs to the era of the rational style in glass and concrete.

At the end of the Forties however, Le Corbusier turned his back upon this rationalism in architecture. He passed on to an anti-rational, plastic style, in which real imagination finds a place. His most revolutionary work in this sculptural style is the pilgrim church of *Ronchamp;* the parting of the mathematical style is complete

in this unusual building. The toad-stool form roof, the apparently voluntary division of windows make the church an expressive sculpture as well as a building in anti-euclidical style.

Maria Helena Vieira da Silva, a Portugese from Lisbon, but since 1928 working in Paris, devotes herself almost completely to what one could call the town landscape: town impressions – all over the world – that hang on the linen like cobwebs, so that reality and poetry form an inseparable unity.

Almost of the same generation is *Hans Hartung* (1904-) from German origin. With *Georges Mathieu* (1921-) he is considered to belong to the calligraphs of non-figurative painting. However, there is a real difference between their work. Mathieu is indeed a painter, whose paint gesture is spontaneous and direct; with Hartung the stroke is only apparently born out of elan, but in fact, it is carefully treated. The calligraphy with meaningless signs justifies itself in the degree in which the paint gesture becomes the bearer of an emotional, vital intensity.

Mathieu makes a "show" out of painting, to which he invites the public.

In 1956 he "performed" before two thousand people, on the stage of the theatre Sarah Bernardt in Paris,

410. *Hans Hartung, 1904-*
Painting T57 – E 17, *1957*
Private Collection, Paris

410

411

411. *Jean Bazaine, 1904-*
St. Guénolé, *1960*
Galerie Maeght, Paris

412

412. *Marcel Breuer, 1902-*
IBM Research Center, *1960-62*
La Gaude, Nice

413. *Robert Müller, 1920-*
The Heart, *1963*
Iron
Rijksmuseum Kröller-Müller, Otterlo

413

creating a painting of 12 meters long in thirty minutes.

A Very French Abstraction

The oldest of the generation that immediately after 1945 ruled the scene in France was *Julius Bissière*, followed by *Alfred Manessier, Léon Gischia, Gustave Singier, Maurice Estève* and *Jean Bazaine*.

From an originally, more or less rectilineary open face, Bazaine came to an organic composition, that – without in any respect being descriptive – in fact is the result of a deeply experienced reality. However he does not make a stand on the optical experience, but in experiencing nature he looks for a "unification, in which the human being recognizes every moment his own face in the world".

Manessier remains devoted to a religiousness showing none of the pantheistical aspects of Bazaine, but stays within the framework of Catholicism. He enlarges the iconology by taking away from it every precision. In that way a painting is created that – non-figurative in its execution – allows associations with certain moments that possess the highest value in the christian universe.

Sculpture in Metal

In sculpture, metal, particularly after 1945, completely replaces quarried stone. On the one side there is the work in bronze, by Richier and Giacometti, on the other side the welding of materials by *Julio Gonzalez* and *Alexander Calder*. Also *Robert Müller* welds metal fragments together; his forms associate with the venomous destructivity of the archetypes of scissors, knife and chisel.

274

There is hardly a greater contrast imaginable than that between Müller working in France and *Giacomo Manzu* (1908-) who became famous in Italy. Manzu's art is dominated by an elegiac, sensible intimacy. He seems to be the legitimate heir of a renaissance form canon, and stands – so far – completely outside the experiments that are in course of time determinating the face of 20th century sculpture.

Manzu knows the human body, as it were, in its "breath of life", and has the courage to approach it contemplatively inside reality. He gives that reality an elegiac charm – as the *Young Girl in a Chair*, from 1955 shows – that is exceptional among modern artists.

Antoine Pevsner (1886-1962) approaches from quite a different direction: from Constructivism. Together with *Naum Gabo* he had discovered in 1917 his art principles, according to him, independently from *Vladimir Tatlin*. Whatever it may be: in Mos-

cow Pevsner and Gabo found a response to their ideas from Tatlin and *Kasimir Malevitch*. The two brothers formulated their program in the "Konstructivistisch Manifest" that they stuck on the walls – with the permission of Lenin – in Moscow in 1920. For a short time, they were accepted as professors of the academy but shortly afterwards they were ordered to apply their new theories exclusively to propaganda – sheets and utensils. Pevsner and Gabo refused and emigrated in 1923 with *Wassily Kandinsky* and *Marc Chagall*. Pevsner's attempt to express time by means of kinetic and dynamic elements was new. About his constructions – see the *Monument-project* – he talks of "surfaces développables". This term has two meanings. The plane can be subject to different waves, spirals. This movement can be considered in space as an unlimited continuable. With this the space is as much plastic matter as the elastic, mouldable matter. Also light

and color can play their part in it: the tissue of metal wires – the color of these and the oxidation – create other reflexes at every sun position, at every visual angle.

The Cobra-Group

The development of sculpture in the 20th century leads in one way to a style that is equal to the technical world. The mathematic precision in the work of *Victor Vasarély*, the metallurgy of a Pevsner who handles his métier like an engineer and ascribes a broader place to scientific thinking than to "spontaneous expression", are examples of it. In another a contra-movement has started that manifests itself in the work of Burri and Tapiès, and particularly in the movement known as Cobra. This group that came into being in Paris in 1948, and of which *Asger Jorn* forms part, covers artists who particularly consider spontaneity of expression as essential.

414

414. *Karel Appel, 1921-*
Cry for Freedom, *1948*
Stedelijk Museum, Amsterdam

275

Karel Appel, born in Amsterdam in 1921, is one of the founders of the experimental group, that later on developed to the Cobra-movement. Appel and *Corneille* reject all constructivistic inclinations, desist from conscious, preconceived design and aim – especially with Appel – at the short-circuiting of impulse and creation by means of a color explosion. Every static, even every dynamic schematism is strange to Appel; he accepts no single restriction a priori. His exuberant and deliric color-use knows only one restraint, it is the one of the painter's temperament. If recognizable starting points can be found in his work, these only serve as a pretext to unfold a pure picturesque dramatic. So no content exists independently from the organism of paint. With this reduction to the paint tissue itself as a bearer of a mighty, dionysic rapture an extreme of expressionism is reached.

Corneille is a more lyrical type than Appel: his psychic reserve corresponds with an unexpressed content in the picture. Nevertheless, the diffuse surface of his emotionally dependent, energetic hand makes an evocative total image. The tension from which Corneille takes his psychogrammes is transmitted by the quivering lines. One line may be felt as being searching and probing, the other as tight as a spring, a third one as dynamic and fast, and still another one as hesitant and restrained from inside. In a similar way, the colors can be understood. The whole of the painting becomes an evocation of the psychic energies that guide the painter during his work.

In Asger Jorn's work (1914-) the obsessive return to the fabulous creatures springs from imagination, which had an ultimate origin in Scandinavian folk art. He creates a whirl of shapes in exuberant colors. *Pierre Alechinsky* was a member of the Cobra group in Brussels. In his

415. *Alfred Manessier, 1911-*
The Sixth Hour, *1957-58*
Galerie de France, Paris

415

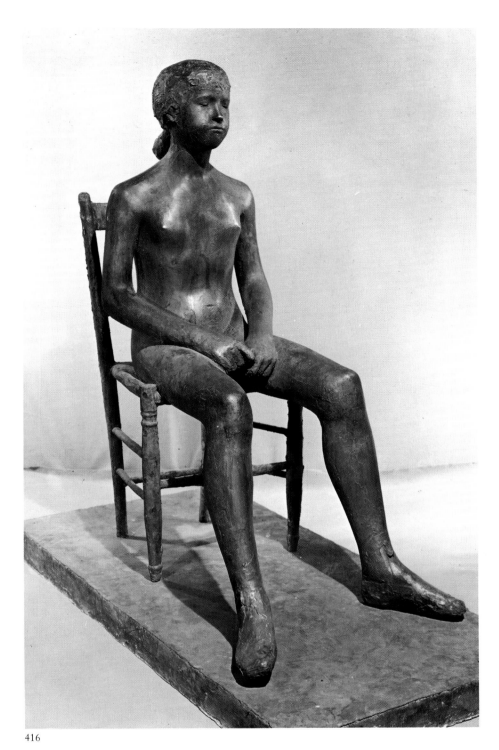

416

later work a change occurred after his stay in Japan. He went in the direction of a tachygraphical style with oriental-like brush strokes.

Serge Poliakoff (1906-1969) took abstraction through contacts with Wassily Kandinsky, *Robert Delaunay* and *Otto Freundlich*. He arranged simple forms with vibrating outlines in a poetic harmony of colors, in which one shape, an inaccurate oval, usually distinguished itself from right-angled shapes. Often the colors in Poliakoff's compositions are compared with Russian icons. A broken ochre, indigo blue, and a deep green should remind us of the spirit of it.

Dutchmen in France

Appel and Corneille were not the only ones who came from the north and determined the image of the French art of painting. In the first place, *Bram van Velde* (1895-) must be mentioned. It is hard to tell what he actually painted. He once said, "Ce qui sortira de mon pinceau" – whatever comes from the brush. Words would be too limited, there are regions of the soul that must remain unexplained. Only a poet and writer like Samuel Beckett, who wrote about Bram van Velde as the man who reverses the universe, could express what moved Bram van Velde. His penetration into the world behind the phenomena was reflected in his work, and became the symbols by which the artist communicated his thoughts. "I don't make paintings", was a quotation of his. Color meant to him no more than

416. *Giacomo Manzu, 1908-*
Young Girl in a Chair, *1955*
Bronze
National Gallery of Canada, Ottawa

417

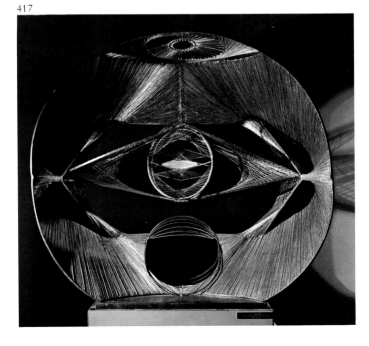

417. *Antoine Pevsner, 1886-1962*
Project for the Monument of the
Unknown Political Prisoner,
*1955-56, also known as "Liberation
of the Spirit"*
Bronze
Musée d'Art Moderne, Paris

418

419

418. Serge Poliakoff, 1906
Composition, *1957*
Galerie Creuzevault, Paris

419. Pierre Alechinsky, 1927-
Mr. Stanley, I Presume, *1960*
Collection Gildo Caputo, Paris

*420. Corneille (Guillaume
Beverloo), 1922-*
Ensemble Métamorphique
Collection Sonja Henie, Oslo

420

the equivalent of a mood. His designs were symbols of a visions that demanded physical expression. Bram van Velde's fame kept growing. Having lived, at the beginning, in poverty and obscurity, in 1974 he was officially recognized by the French authorities by an exhibition of his total works showing their unique character, and giving proof of the lasting topicality of his oeuvre.

The character of *Jean Jacques Gardenier*'s paintings cannot be reduced to a formula. This painter, born in 1930, and living in France, cannot be put into any category; he did not intentionally look for some style, nor for some figuration or abstraction. He agreed with Bazaine's conviction that any predetermination would lead to fatal consequences. In his oeuvre rustical aspects are combined with somber melancholy, and there is a glimpse of intangible mystery. Sometimes, an emotional experience is found in a painting, on other canvases real experiences are shown, such as a townscape, which strips reality of all physical existance, and transposes reality to a landscape without space and time. In these canvases the connection with the optically perceptible reality often becomes associated, also due to an application of colors that does not intend to imitate nature, but instead to reduce reality and intensify it, even sometimes to amorphous, magically illuminate a shadow world, sometimes a cruel highlighted, trembling actuality.

Art Life in Germany

When the anticlimax of 1945 was overcome, *Willi Baumeister* was one of the few artists who continued in Germany, what had developed in the meanwhile in other parts of Europe. He was one of the few "degenerate" artists who remained in Germany, and whose works were burnt by the thousands.

His influence on the younger generation was important and quite marked. The non-figurative work of *Ernst Wilhelm Nay* (1912-) experienced various phases: during the thirties his Lofoten period with monumental contours in a figurative style related to Expressionism, followed by a colorful Expressionism resulting in an abstract game with non-figurative shapes (the illustration shows an aquarelle from that time).

Probably less known, but in the end more valid, is the work of *Julius Bissier* (1893-1965), who mediated through his brush, and whose sensi-

421

421. *Bram van Velde, 1895-*
Gouache, *1961*
Private Collection, Cologne

422

422. *Asger Jorn, 1914-*
Douceur à contrecoeur, *1962*
Collection Ariel, Paris

426. *Lucio Fontana, 1899-1968*
Spatial Conception, *1957*
Marlborough Galleria d'Arte, Rome

423. *Jean Jacques Gardenier, 1930-*
Les Halles *(The Market-Halls of*
Paris)
Collection of the artist

423

425. *César (César Baldaccini), 1921-*
Relief Compressed Automobile,
ca 1960
Collection Countess of Noailles, Paris

425

424

424. *Ernst Wilhelm Nay, 1902-*
Water Color, *1957*
Private Collection of the painter

280

427. *Julius Bissier, 1893-*
Miniature, *1957*
Galerie Daniel Cordier, Paris

427

428

tive hand and poetic touch suggest an admiration for Chinese art. Bissier's small paintings owe their intensity to the accumulated tenseness in which they were created. The gesture seems to be born from contemplation and consideration, and it is like the release of a bridled, sublimate vitality.

The Compressed Car Wreck

César, born in 1921 in Marseilles, concentrated on metal plastic from the very beginning. He used the most heterogenous materials for his creations: machine components, old tins, steel springs, etc. He arranges these objects into figures resembling strange insects, or ghostly birds. For a short period, he chose the human figure as an object, then he surprised everyone by presenting sculptures made up of wrecked cars pressed into blocks. This was around 1960; César did the same thing later, in the 1970's with jewellery; he pressed actual jewellery into block-shaped hangers. At the same time, he developed a versatile, creative activity which included working with chemical resins, collages and montages.

Dyed Canvas and Cool Abstraction

To categorize *Lucio Fontana* (1899-1968) among the sculptors cannot be fully justified, but the same reservation goes for reckoning him among the painters. In his work, the third dimension played a decisive part, a style he called "spatialistic". The surface of the canvas was given more life by means of a hole or cut. Using

428. *Max Bill, 1908-*
Object in Space, *1948-1971*
Brass
Marlborough Fine Arts, Zurich

a razor blade, he cut the canvas, giving it an extra dimension. In the early thirties he strove for an absolute purity in eliminating every figurative element. In those years he was a member of the group, Abstraction-Création, and his favorite ideas brought him close to the equally puristic Swiss sculptor *Max Bill* (1908-). In this aspect, Bill's activities are comprehensive. Besides sculpture, he worked as an architect, painter, writer, and typographer. He also committed himself to industrial design. He wrote a very instructive essay about the "mathematical perception in today's art", published in 1949, in which he stated that it was his intention to "arrange emotional values in a way that they become works of art". The clean beauty of Bill's plastics arose out of a blissful combination of a free, inventive sensibility, and his mathematical approach. In his opinion, there were no boundaries between intuition and science. He considered geometric shapes to be a primary element in all designing; this is why mathematically figured constructions always convey an aesthetic effect. The mutual relations between areas and lines opposed to space materialize an idea which, as Bill himself put it, "leads to the limits of the unknown". Indeed, the undeniable beauty of a

429. Victor Vasarély, 1908-
Cheyt – G, 1970
Collection of the artist

429

430

284

432

432. *Wifredo Lam, 1902-*
The Greenhouse, *1944*
Galerie Krügier, Geneva

433. *Roberto Matta, 1911-*
Who is who, *1955*
Private Collection, New York

building contains an almost enig-
matic element as a *Shape in space:* the
ability to be calculated reversed into
an astounding enigmatism.

Op Art

In his mathematical way of thinking
and his conviction that geometry is
the ultimate origin of all designs, Bill
fully agreed with *Victor Vasarély*
(1908-). Except, the limitation
to pure geometry was worked out
much more strongly by Vasarély. His
compositions were made up of lines
drawn with a ruler, or circles drawn
with a compass, of colors without
relief, and of scientifically studied,
chromatic accords. The importance
of Vasarély's work, still recognized
in these days, may be slightly exag-
gerated. For he added nothing new
to the optical experiments carried
out in about 1928 by the Bauhaus.

The Re-Entry of the Human Being

Bill, Fontana and Vasarély are part of
a world in which the English painter
Francis Bacon (1910-) had no

433

434

434. *Graham Sutherland, 1903-*
Boats
Private Collection

435. *Petar Lubarda, 1905-*
Composition with two Horses, *1953*
Private Collection

435

part. To one critic, Bacon is a figure suffering from sadistic or masochistic complexes, to another he is a master of the disgusting, to a third the prosecutor of mankind in the era of industrial civilization. Bacon's obsessive deformations exclude any thought of mathematically calculable beauty. The term beauty in its usual definition is not applicable. The ugliness, the unpleasantness, the wretchedness are, to absurd consequence, the criteria of a new aesthetics. This statement means a high appraisal by itself, and Bacon is really one of the few who have contributed to this century's art with a serious, true, and figurative work. Bacon uses the solitariness of his figures in their surroundings to confront them with the inevitableness of their existential situation. "We are meat ... we are potential carcasses", he once said, and his canvases are the shrill suffering of this creed of absurdity in the human order.

Alberto Giacometti (1901-1966) accentuated human irreality in another way. His paintings give evidence of the impossibility of bridging the gap that separates the ego and the world. In about 1945 Giacometti found his

287

mature style, a sort of plastering at the first glance, reminiscent of stalagmites, or long, slender but still age-old trees standing motionless in a desolate landscape.

Giacometti was part of the Surrealistic movement for some time; as was the Cuban born painter *Wifredo Lam* (1902-), who in 1942 participated in the New York exhibition of the "First Papers of Surrealism". Lam, whose mother was Afro-Cuban was throughout his life fascinated by elements from the so-called primitive art. This, of course, had its effect on his own work, transposed and integrated, as components of a world populated partly by animals, partly by plants.

Roberto Matta, his full name Roberto Sebastian Matta Echaurren, was of Chilean origin, and he, too, was involved with the Surrealistic movement. He was taught the process of "écriture automatique" – automatic writing – which he combined with his own nuance of an informal definition for art. In the dynamics which Matta added to Surrealism he preceded Action Painting. After the war his style developed more and more towards abstraction. His art is considered as biomorphous, and further to be a symbol of the unrest which was typical of the time.

European Individuals

Graham Sutherland's works also contain elements that could be defined as biomorphous. It is typified by a very non-latin form of mysticism, a queer pantheism, where the shapes are the formal metaphora of a comprehensive, cosmic "happening". The shapes are laden with the power that continually determines and alters the evolution in this world. In these paintings, the digging and searching was converted into the revelation that life blossoms in the deepest darkness. Shimmering figures appear, often resembling roots, larvas, knots, buds, bark, fibres, like forms which life creates out of the blind will of creation. His earlier work was less haunted and contained landscapes in the best English tradition, but still adding something particular: a reflection of the earthiness of land.

In Jugoslavia, where the creative arts could evolve freely in earlier time than elsewhere in Eastern Europe, lyrical abstraction developed rapidly. Painters such as *Petar Lubarda, Janez Bernik, Edo Murtić, Ordan Petlevsky, Oton Gliha* and *Ferdinand Kulmer* represented one facet each of this trend, generally with a clear feeling for the role of the substance, and the expression of the sign. With Lubarda, primary elements of land-

437

437. *Co Westerik, 1928-*
Two Figures, *1959*
Gemeentemuseum, The Hague

scapes – reminiscent of his region of birth, Montenegro – play an important part, but later on the descriptive accents disappeared from his canvases, and an abstract Expressionism remained, which adapted to the contemporary European tradition.

In the 20th century only those Dutchmen who left their own country to settle in either France, as Appel and Corneille did, and before them Jongkind, Van Dongen, and Mondriaan, or in the United States, as De Kooning, reached an international reputation. This is why *Melle*, and *Co*

438. *Wessel Couzijn,*
Corporate Entity, *1963*
Unilever Building, Rotterdam

439

439. *Yves Klein, 1928*
Relief – Blue Sponges, 1958
Wallraf – Richartz Museum, Cologne

the everyday event was at the same time stressed and freed from the limits imposed by reality. The Dutch sculptor, *Wessel Couzijn*, continued the international phenomenon of broken up structures, the strongly vegetative, metal constructions create a remarkable, bizarre effect. The fantastic solidifications, the elementary character of matter, the agression of the shapes, all this give a hallucinating effect which is symbolic of the threats to mankind in this time.

Neo-Dadaism

The troika who determined the French development in the art of painting were *Marcel Duchamp, Francis Picabia*, and *Kurt Schwitters*. The redirection they started was in the works of *Yves Klein* (1928-1962), who also played a decisive part in the artistic sphere by his personality. The first time, he attracted public attention with monochrome paintings; these could be taken to be the logical consequence of Klein's refusal to be distracted by considerations about anecdote, composition, sign and gesture: all of which he believed are obstructions to the purity of a painting. After having tested different colors, he finally covered his canvases with a dark ultramarine. During his short, but intense life, he later introduced leaf-gold, and finally genuine objects instead of the brush. He pressed bodies covered with blue paint onto the canvas, thus achieving a direct expression, short-cutting the detour of the brush. In the course of this activity, he also used sponges dabbed in paint on the painting. To some these works represented a new, cosmic landscape.

Westerik remained unknown beyond the Dutch borders.
Still, Melle's obsessional Surrealism had high pictorial qualities and represented one facet of art which is fully personal, exclusively his own. This applied equally to Westerik's work, which was not in fact Surrealistic, but highly unreal in its penetrating make-believe realism.
Sobriety was in this work expanded to an oppressive, visual experience:

440

440. *Arman (Armand Fernandez)*
1928-
Accumulation of cans, *1961*
Wallraf – Richartz Museum, Cologne

441. *Martial Raysse, 1936-*
Elaine Sturtevant, *1968-69*
Private Collection

441

New Realism

Klein's art is classified in the Nouveau Réalisme, in which *Armand Fernandez* (1928-) participated. Later he called himself *Arman*. As an answer to Klein, who in 1958 chose "Le Vide" as a subject for an exhibition, Arman presented "Le Plein" in 1960, an experiment continued in the series *Accumulations*.

These were compositions of totally heteroclite objects. Later, he embedded these objects in transparent plastic, so as to give durability to perishable materials.

The name attributed to the movement they both belonged to, New Realism does not only lack descriptiveness, but is even misleading.

Martial Raysse (1936-) is also reckoned to be one of them; his work, however, differs considerably from the others. He uses neon illumination and plastics, creating an oeuvre which is simultaneously topical and modern, original and lasting. It reflects the decor of the modern world, and comprises the sensual, journalistic aspects of images, as well as the images taken from the movies and fashion journals.

Central Europe in Turmoil

In Central Europe, the movements described earlier found adherents; sometimes they contributed something that under no circumstances could have developed elsewhere, like that of the Austrian *Friedrich Hundertwasser:* an illegitimate re-birth of the Jugendstil, which was at the same time the result of a labyrinthine obsession. *Konrad Klapheck* (1935-) represented the German branch of Pop Art – an artistic form which, for its iconography, based itself on the mass media, on the everyday environment of the 20th century world.

291

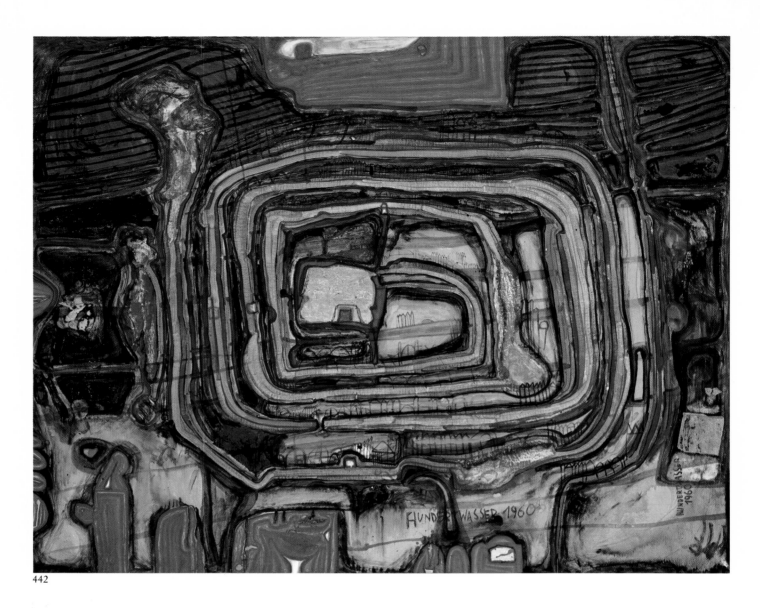

442

442. *Friedrich Hundertwasser, 1928*
Sun and Spirals over the Red Sea,
1960
Collection Siegfried Pappe, Hamburg

443

443. *Konrad Klapheck, 1935-*
Superman, 1962
Neue Galerie, Aachen

It specializes in typewriters, sewing machines, telephones, and faucets. Obviously, these objects are reproduced exactly and true to nature. When blown up, they adapt a sort of symbolic pregnancy.

Wolf Vostell (1932-), Klapheck, and *Gerhard Richter* are classified amongst the German Pop Artists. Vostell made his first public entrée with his "happenings", live actions with the public taking part, and then attended to the "décollage".
This is what he calls the torn-up

292

posters which he rearranged and partly covered with paint. The repertoire of this glue-work was unlimited. Everything put out by the latest publicity organs was used for these décollages. Richter's work (1932-) makes one think in the first instance of enlarged photographs. However, photography only serves as a basis; and Richter's canvases are painted in a diffuse way, so increasing that effect, as for instance with *Emma* coming down the stairs. *Daniel Spoerri* (1930-) continues the integration of heteroclite objects in a piece of art, as Arman had done, moving towards a further consequence. He composes, and presents the "assembly" of objects as a work of art, as for instance his *Still life:* a moment out of life, frozen forever.

Paul Wunderlich (1927-) stood closer to classical Surrealism than to Pop Art. His "Woman with Zebra Skin" combines two characteristics typical of his trend: an articraft that reminds of the German Romanticists, and a veil that mysteriously covers reality, a result of the acute consciousness of the absurdity of situations.
Lambert Maria Wintersberger (1941-) ascribes his vision to the fear of castration, generalized so far as to mean a curb to the world around him. The repressive community generated this fear in him; it violated humanity.

German creative arts found continuation seemingly in whatever had occurred elsewhere in the world, without prejudice or hesitation. After the end of World War II, architecture evidently needed some time, before it could escape the artistic ghetto of the previous years.

In Germany, buildings were erected quickly, well-built, and in great numbers, The new trend in architecture was represented by the television mast, near Stuttgart, by *Fritz Leonhardt*, and, from 1967, the Church of Reconciliation at Dachau, by *Helmut Striffler*.

Pop Art

The term Pop Art is used to define the picture material used in the mass media. It is an art which renders its expression to the modern, commercialized city life. *Richard Hamilton* (1922-) was one of the first to raise this popular, graphic material, which was considered to be vulgar, in the "art" sense. After a visit to the United States in 1963, he made the series *Swinging London;* the process used in America, of application of photographs, could be found in "My Marilyn" and in "Swinging London".

Allan Jones (1937-) is one of the

444. *Wolf Vostell, 1932*
Car Accident, *1965-67*
Neue Galerie, Aachen

444

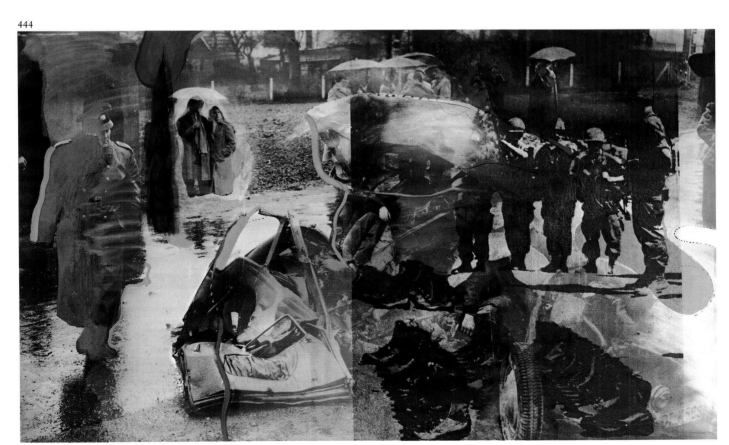

293

445

English Pop Artists generation. Eroticism plays an important role in his work. *David Hockney*'s work (1937-) the part after 1963 – following a Californian journey – can be reckoned to be Pop Art. He specialized in technicolor landscapes with swimming pools and lawns; at the same time, his style of working becomes more definite in line and shape. He starts using picture cliches from magazines and advertisements.

Richard Long (1945-) tended more towards Conceptual Art, which developed after 1965. This style gave more importance to the ideas of the artist than to its material execution. Consequently, Long completely eliminates realization, and preferably creates invisible sculptures. By his personal locomotion in the surroundings he shapes the space connected with that surface.

In Northern Europe, *Öyvind Fahlström* (1928-) sawed small figures out of metal and painted them. These figures are often taken from comic strips. One can move the figures about and re-arrange them with a magnet. "Roulette" from 1966 was a summary of the different components in Fahlström's style. In the Netherlands, *Reinier Lucassen* (1939-) expanded Pop Art by an original idea different from subjects usually chosen in this group. Lucassen integrated the images of existing pieces of art in his compositions. For this purpose, he used reproductions of old as well as modern paintings and other works of art. These are occasionally made up with picture

445. *Gerhard Richter, 1932-*
Emma, Nude on the Stairs, *1966*
Wallraf – Richartz Museum, Cologne

446. *Daniel Spoerri, 1930-*
Still Life (Robert's Table), *1961*
Wallraf – Richartz Museum, Cologne

446

447. *Lambert Maria Wintersberger,*
1941-
Sodoma and Gomorra, *1969*
Neue Galerie, Aachen

postcards and comic strips. The fictitious world of the "Musée imaginaire" (imaginary museum) is in this manner placed side by side with the other consumer goods, and thereby classified as little different from the mass of consumer goods.

Avant-garde Art

Domenico Gnoli (1933-1970), born in Rome, was amongst the Italian avant-garde, as far as this term is still applicable. In fact, towards the end of this century, avant-garde art, strangely enough, is becoming officially recognized. Even more so, nothing else but avant-garde art gets a chance to become official, in the meaning that it is accepted by the musea, art trade, art critics, and collectors. Here the question arises, whether there can be some art style anywhere on the background which could be recognized as true avant-garde art in the future. However, Gnoli achieved a reputation with paintings, realized in a "traditional" manner with oils on canvas, which showed enlarged details of hair styles, footwear, or clothing. He painted, for instance, the lower part of a sleeve with two buttons with almost accuracy, like a natural object instead of a mere reproduction. He elaborated the parting of a man's hair-cut quite as precisely, or the carefully tied knot of a neck-tie. This illustration shows a *Shoe in Profile* from 1966. What separates these subjects so far from reality, despite the manner in which they are painted, is the scale of reproduction. The knot of the neck-tie, for example, covered a canvas of some five by seven feet. An object the size of one or two inches is raised to an effect that makes it almost unrecognizable. In this way, a commonplace facet of reality is withdrawn from its normal connections, and thus presented as being strange, unreal, and, in some cases, bewildering.

447

448

448. *Allan Jones, 1937-*
Falling Figure, *1966-67*
Wallraf – Richartz Museum, Cologne

449

Epilogue

From Craft to Expression

In the previous chapters a journey has been taken along the paths of Man's attempt to express himself, along those ways generally considered to be covered by the idea: art. Wandering in this way, of necessity, has a somewhat arbitrary character. Personal taste, preference, affinity play a part. It is hardly possible any other way, unless one gives up completely the free character of the journey and sticks to a specifically limited route, that in its different aspects (aesthetic, psychologic, social historic etc.) can be deepened. That was not the original intention. However, the image of art that has been briefly summarized, has shown more than only the development of "art". Dutch painting of the 17th century, Flemish Primitives, Italian Renaissance, Greek marble statues and Roman frescos have all been mentioned and we could reasonably con-

sider now what is meant by the idea: "art". Yet, when we come to modern times, this assumption seems to vanish. The multitude of modern expressions is confusing, for the amateur and professional alike. Many contemporary creations have little to do with the craft of the painter or the sculptor, as it was understood in earlier times. And often the question arises: are the expressions of modern art still significant? The question itself is, in fact, only significant if one is also prepared to, more or less, reverse it and ask: were the expressions of ancient art significant?

Valuations in the Past

Let us take a look at the history of the valuation of art and to do it use a few examples. In the seventies of the 15th century there lived a young painter, Hieronymus Bosch, whose star was quickly rising and who was enjoying an increasingly wide admiration for his frank, critical and phantasmagorical expressions.

From a local phenomenon he soon

became internationally famous, and his works – after his death in the 16th century – were collected, particularly by the king of Spain. But at the beginning of the 17th century Karel van Mander, the author of the "Painters book" knew so little about Bosch that all he could say was that he had a facile hand and that he painted effectively. Van Mander admired the craftsmanship of Bosch, but had apparently no eye for the meaning of the work. In fact, the fame of Bosch over the course of time never waned, but it was not until the twenties of this century, that people started – sometimes losing the way in mistaken suppositions – to unravel, the real intention of Hieronymus Bosch. Another example: Rembrandt was a celebrated painter in his time. But at the beginning of the 18th century his fame – and incidentally the fame of many others – was completely overshadowed by Adriaen van der Werff, a painter who has now been forgotten for the greater part and who excelled only with clever, porcellaneous precision. The talents of Adriaen van der Werff may have

296

449. Richard Hamilton, 1922-
Swinging London, 67-II
Wallraf – Richartz Museum, Cologne

450

450. Richard Long, 1945
Oxshott, *1968*
Neue Galerie, Aachen

451

451. David Hockney, 1937
Two Friends in a Cul-de-sac, *1963*
Private Collection

297

been unmistakable, his works (including a fine self-portrait, now in the Rijksmuseum) may make a pleasant impression but, he was far from a great master, let alone a genius. Nevertheless his fame was widespread, whereas the recognition of the genius Rembrandt was again imprisoned in a haze of misunderstandings, that only cleared up little by little over a long period. The famous French Diderot Encyclopaedia around the second half of the 18th century even blamed Rembrandt for his "lack of taste". Other very great masters of the 17th century like Vermeer from Delft and the Frenchman Georges de La Tour had been completely forgotten for centuries! Towards the end of the 18th century in France however, an enormous appreciation

built up of the paintings of Greuze, whose theatrical work-pieces were considered by his contemporaries as extremely significant. Now, we only see preaching in his work or even a hypocritical element. Rembrandt, a man with crude taste? Greuze sublime? Today, we see this in reverse. How significant is significance?

In the 19th century a number of new trends and reputations appeared. France had successful, officially recognized painters who continued an academic decorative style, (Gerôme, Cabanel, Lenepveu, Bouguereau and many others). With great specialistic ability they created; historic, exotic, idyllic or mythologic works, that strike us now as almost complete kitsch, and the same goes for Ary

452. David Hockney, 1937-
Two Boys in a Swimming Pool, *1965*
Collection Lord and Lady Beaumont

452

453. *Reinier Lucassen, 1939-*
Marat, 1966
Stedelijk Museum, Amsterdam

Scheffer from Dordrecht, whose work breathes more conventionality than personality. The independants later to be called Impressionists, remained at first without success, and even admission to the official exhibitions was refused them. In Austria, Makart became popular, so popular that his name became the name for a whole style. And what does Makart mean today? As much or as little as those French decorators. England had the Pre-Raphaelites, a group of painters that created, with capable professional skill, a moralizing and historianizing picture-art, significant in the eyes of their contemporaries. But their time passed and a lot of what they made seems insincere to us today.

What does all the work of Holman Hunt, Millais, Rossetti, Ford Madox Brown, Burne-Jones, mean – Pre-Raphaelites or whatever they may be called – in spite of their great talents, in spite of their great pretentions – compared to a single realistic painting of Courbet or a single sunbathed scene by Claude Monet?

And who became famous in the Netherlands? Alma Tadema, again a capable creator of historic scenes, and Bakker Korff, who certainly knew how to paint the pleasant togetherness of old ladies. Breitner, the Hague school, Van Gogh, Mondriaan, these are reputations that only later – sometimes much later – got a foothold. To what degree were the expressions of previous artists significant? That question should be supplemented by another question: in whose eyes?

The significance for the contemporaries is often quite different from that of later generations, who in their turn, are also continuously reassessing.

The Shaky Criteria

If in the past Art has been subject to many reassessments, to the shifting of preferences, or even to a complete reversal of ideas, how can it be possible to come to a reasonable attitude about the very different expressions in modern art? Indeed, it hardly seems possible. If one goes back far enough,

453

then art is a trade, or rather a craft. This means a technology belonging to that past. And that craft has an original function in the social or religious life of its time.

In the Renaissance, and later, the artist no longer considers himself an exclusive artisan, but as a creator, whose personal vision of his subject is important. The "Nightwatch", a picture of citizen soldiers, has a vision that cannot be found in the works of Rembrandt's contemporaries. Since the Renaissance there has been an increasing value placed on communication between creator and public. This was originally considered of minor importance. From this point, art valuation starts moving and does not stop. Today, the emphasis is placed more heavily on the use of the artistic means in the service of the expression, than the underlying vision. An enormous variety of art trends are evident. Has the essence of the artwork – that in fact represents

art – always been abstract? Then figuration – in the eyes of some – is an obstruction on the way that leads directly to the essence. Away with it. Mondriaan has no apple tree left but a collection of rectangles and squares. Are the lines then only a shackle from which the color working should be freed? Jackson Pollock, for the first time drips the paint on the canvas to create whimsical forms. But what level of whimsicalness should be reached? That of brushes and pencils, that of dripping paint tins or that of a direct human presence?

One creates collages out of remnants which are already artefacts themselves of human culture, the other creates matter – paintings, working with – according to his preference – sand, glass, little steel pipes, little wooden blocks, toothed wheels, nails... and so on. Yves Klein uses for his creations no other materials than paint in a certain color, no

299

454

454. *Domenico Gnoli, 1933-1970*
Shoe in Profile, *1966*
Wallraf – Richartz Museum, Cologne

brushes, no pencils, palette knives, no nothing. Except, of course, for the naked young ladies, he had persuaded to sit in a bath-tub, he had filled with paint! Then, to suitable music and under the watching eyes of a public – interested in "artistic creative urge..." or in beautiful girls – he asked the young ladies to sit or lay down on the spread out canvas and impress their lovely forms on it.

Return to Figuration

Others have felt that classic figuration had a certain significance, provided it was applied not as a mirror of reality but as a state of mind. The painted creatures, objects, landscapes need not look real, they could be improbable, impossible, fairy-like, hallucinationlike combinations, they could express another reality, for example, that of a dream, of panic, of erotic obsession, and so on. Salvador Dali, Max Ernst, René Magritte, Paul Delvaux, Felix Labisse, Melle – to mention only a few – have expressed their dreams and obsessions, each in their own way. Both the abstract and the

figurative trends have, in their turn, created a number of other movements; Op Art, Pop Art, Moving Art, Zero Art; what is the significance of all this? One can only conclude that, after the many Abstract and Surrealistic movements, reality seems to rejoice in a new lease of life as a vehicle for expression.
Take *Renato Guttuso*. He was born in Sicily in 1911. 50 years later he became professor at the Academy of Sculptural Art in Rome. He is everything, but not an academic. He is a modern painter who finds his objects in reality. In 1968 he painted his *Wall Newspaper*, a scene of 2.80 × 4.80 meters, with the shooting of a Vietnamese prisoner, the metal of distorted car wrecks, the scream of a tortured negro, and the red flags of workers, whose faces are just hidden, their personality depressed. Perhaps, this work will later be placed beside Picasso's "Guernica" as a shrill protest against the cruelty of our time.
Or take *Dietmar Ullrich*, from Hamburg, born only in 1940. He remains inside the figuration, but in a com-

455

pletely other, personal way. His *Football Players* from 1970 are all in the same position, in uniform clothing, on a green turf under a blue sky. The human being is between heaven and earth, but it is a mass of man. At other times, other artists and other works will recall again other thoughts, other associations, other feelings. The multitude of spiritual movements in our time also finds expression in a multitude of art expressions, and consequently, a multitude of preferences and . . . rejections. For he who accepts or admires everything equally, can hardly claim . . . to be someone himself.

In any case, art is not significant without a public. It can be, in some cases, an "insider" thing, and, in other cases, a thing that concerns everybody. But, basically it concerns the individual: somebody, who is aware that he is confronted with the expression of somebody else. The question of the significance of it is finally interwoven with the question of the significance of our current existence, and with the conclusions that come from both artist and public.

455. Renato Guttuso, 1911-
May *1968* – Giornale Murale
(Wall newspaper)
Neue Galerie, Aachen

456. Dietmar Ullrich, 1940-
Football-players, *1970*
Neue Galerie, Aachen

456

Edja Wardson

301

Index